ILLINOIS WILDFLOWERS

DON KURZ

TIM ERNST PUBLISHING
JASPER, ARKANSAS

www.TimErnst.com

Cover photo by Don Kurz: columbine, page 139

There have been several scientific name changes since the first printing of this book in 2004 (updated in 2014 & 2021). This is primarily due to taxonomists learning more about the relationships between plants at the molecular level. The previously known plant names are included under the remarks section in those cases where a change has been made.

Book designed by Tim Ernst, Pam Ernst,
and Don Kurz
Other Production Team Members:
Judy Ferguson, Norma Senyard

All photos are by master wildflower photographer Don Kurz

Wild plant uses for medicine or food described in this book are for information purposes only, and should not be read as promotions for medical or herbal prescriptions for self-healing or for nutrition.

To order copies of this guidebook contact:

Tim Ernst Publishing
Jasper, Arkansas

www.TimErnst.com

New dealers welcome!

This book is dedicated to John Richardson, Associate Professor of Botany and Director of Research Photography and Illustration Facility, Southern Illinois University, Carbondale, retired, who provided me with constructive criticism and guidance in my early attempts at wildflower photography and to...

Dr. Robert H. Mohlenbrock, Distinguished Professor, Botany Department, Southern Illinois University, Carbondale, who, through his teaching, provided me with the tools with which to identify plants and write about them.

From an old gravestone in Cumberland,
England, comes this timeless admonition:

The wonder of the world,
the beauty and the power,
the shape of things,
their colours, lights, and shades;
these I saw.
Look ye also while life lasts.

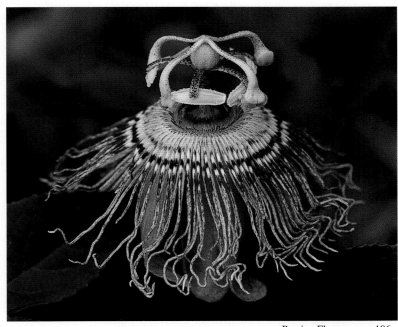

Passion Flower, page 196

Table Of Contents

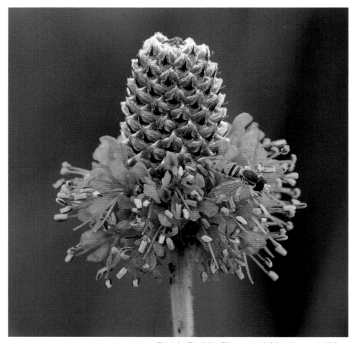

Purple Prairie Clover and friend, page 198

Color Tab Index

To aid in quicker identification the wildflowers in this book are arranged in chapters by color and then season of bloom. Simply determine the flower petals' color and find the matching colored tab located along the outside edge of the chapter pages. The first part of each chapter will contain spring-blooming wildflowers and progress through the season with fall-blooming wildflowers towards the end. There will sometimes be variations in color, so refer to the start of each chapter for suggestions on where else to look.

Acknowledgments

I want to thank my longtime friend, Randy Nÿboer, for his comments about some northern blooming wildflowers and for his encouragement and enthusiastic support of my project. I also appreciate the dedication and commitment to excellence that Tim Ernst has shown in producing this wildflower book, and to his wife, Pam, for the long hours and quality work in scanning the 400+ color slides, and for her great job of copy editing.

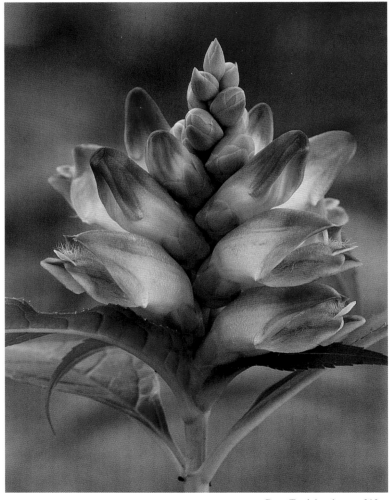

Rose Turtlehead, page 213

Preface

I have always had an interest in plants, especially wildflowers, and began to photograph them in 1972 at Fern Rocks Nature Preserve, Giant City State Park. My mother, Milly, upon hearing of my new hobby, sent me a wildflower book with color pictures and encouraged me to do one of my own. I took her suggestion and began to seriously develop skills in identifying wildflowers and honing my photographic technique.

I then decided in 1973 to take a year off from employment and travel the state photographing wildflowers with the intention of authoring a book on Illinois wildflowers. I did manage to accumulate quite an inventory of color slides of wildflowers but that is about as far as it developed, but my interest in wildflower photography continued and resulted in authoring or contributing to several books, magazines, and calendars over the years.

One interesting thing that I learned during my one year of travel throughout the state is how much the latitude can affect flowering. Illinois is such a long state, oriented in a north/ south direction, which produces a longer growing season in the warmer south compared to the colder north. I discovered that wildflowers begin blooming in the southern part about a month ahead of the northern region and that the flowering period in the south extended a month later in the fall. For example, the peak of fall colors on prairies occurs in the Chicago region on Labor Day (early September) while the same event happens a month later in the Carbondale area. Well, there is a time in the growing season where the blooming periods cross and that is during the third week of July. It is because northern plants begin growing in the spring later and end earlier in the fall compared to the southern plants and at some point their blooming periods overlap. In other words, I found wildflowers of the same species blooming at the same time statewide during the third week of July. I don't think that I would have come about this discovery had I not decided to dedicate a year to traveling the state photographing wildflowers.

It is very rewarding to me that 32 years later my original dream of authoring an Illinois wildflower book has come to fruition. Mom, sometimes I'm a little slow at getting things done, but you probably already knew that. Thanks for your patience.

Don Kurz
June 24, 2004

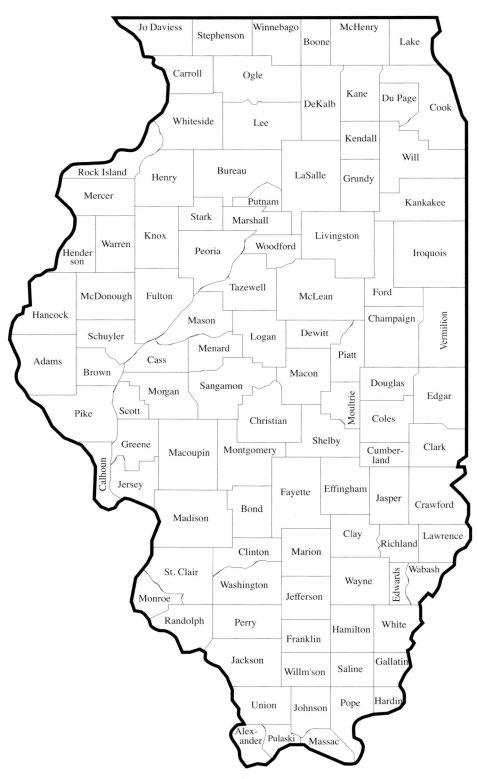

8

Introduction

Illinois is very diverse, with the upper part containing remnant glacial lakes and bogs typically found in more northern states and Canada, to cypress swamps at the southern tip that are reminiscent of traveling through Louisiana bayou country. And, in between, a vast stretch of former grassland that gave the state its nickname as the "Prairie State." Add a mixture of prairie remnants, forests, savannas, open woodlands, glades, cliffs, seeps, springs, streams, and wetlands, and these resulting habitats provide a home to a rich assortment of plants whose total number ranks as one of the highest of any state in the nation.

Although much of Illinois has undergone vast metropolitan and agricultural expansion, there are still a wide variety of public and private lands where one can observe and enjoy a vast array of plant life. One example is the Illinois Nature Preserve System which protects and manages over 320 nature preserves containing over 44,000 acres. These special areas serve as living museums that provide habitat for plants and animals that were once more common during presettlement times. (Visit the following website to find a nature preserve near you: **http://dnr.state.il.us/INPC/NPdir.htm**, or contact your local Illinois Department of Natural Resources office.) Other places that offer great opportunities to observe and photograph wildflowers in Illinois are: state parks, forest preserves, some city and county parks, Nature Conservancy preserves, Fish and Wildlife Service refuges, and Shawnee National Forest lands.

HOW TO USE THIS GUIDE

Within the large and varied landscape of Illinois, there is a great diversity of plant life. According to Robert H. Mohlenbrock (2002), at least 3,248 species and their hybrids are known to occur in the state. Within this diversity of plants, there is a lesser number that are considered wildflowers, a term that lacks a precise definition but is generally understood, flowers that are attractive because of their color, shape, and/or size. Maybe half of the plants encountered in Illinois easily fit this description, but not all are often encountered, plus some are so closely related that one representative example is often sufficient for the average wildflower enthusiast. There are books listed in the back of this guide that can be used to gain a more technical and detailed understanding of the flora of the state.

Photographs and descriptions of 400 species of wildflowers are included in this book. These include wildflowers that are more commonly encountered in Illinois as well as a few uncommon species that are particularly showy and indicative of certain habitats that may be declining. Closely related species are described in the *Remarks* section; this adds another 127 species to this guide. Exotic or weedy plants, those brought in and established from other countries, are also included. Although their flowers are sometimes showy, it is important to distinguish them from the native flora so one can gain a better understanding and appreciation of native plants and the habitats in which they are found.

For ease and speed in identifying plants, wildflowers with similar colors are grouped together. This is not a perfect method, however, since some wildflowers vary in color shades, especially where lighter pinks and blues sometimes grade into white. When a plant has flowers with two colors, the most noticeable color is the one determining its placement in this book. Within each color group, plants are arranged by their flowering sequence so that spring-flowering plants are first and fall-flowering ones are last. Flowers will not always

bloom in the exact same sequence as presented in this book. There will be some variation depending on the climate fluctuations from year to year and in what part of the state the plant is growing. For example, compared to an individual of the same species of wildflower growing in northern Illinois, a spring-flowering plant will bloom earlier and a fall-flowering plant will bloom later in southern Illinois, due to the longer growing season.

Each photograph is accompanied with text, beginning with the plant's **common name.** Often, a wildflower has several different common names, so an attempt was made to select the name most widely used in Illinois. Because of the general confusion surrounding multiple common names, the scientific name is also presented. These names, rendered in Latin or Greek, are more reliable and universally accepted. The scientific name consists of two words. The first word, the **genus,** is the name of a group of plants with similar general characteristics—such as the goldenrods, which are in the genus *Solidago*. The second part of the scientific name is the **specific epithet** or **species,** which identifies the particular species of a plant. The name may honor a person who may have first discovered the plant, it could refer to a geographic location, or it could describe some characteristic of the plant. The plant's scientific name is correctly written in *italics* with the first letter of the genus name capitalized and the first letter of the species name in lower case, for example: *Solidago rigida*.

In a few instances, a plant has a scientific name with a third part, preceded by **var.,** the abbreviation for the word **variety**. This is added when a set of plants differs slightly but consistently from other plants of the same species; these often have distinct ranges. An example would be: *Baptisia bracteata* var. *leucophaea*. The scientific names used in this book are for the most part from Robert H. Mohlenbrock's, 2002, *Vascular Flora of Illinois*, but there have been some more recent name changes and they have been noted in the **Remarks** section for those particular plants that are affected.

Next, the **family** name is listed. For example, the evening primrose family has the scientific name of Onagraceae. (Family names now always end with the suffix –*aceae*.) Families are grouped according to similarities in their structure and biology. As one becomes more familiar with plants, this grouping by family characteristics becomes more obvious.

Each plant has a brief **Description** section that provides information on size and shape of the plant and important characteristics of leaves, flower, and sometimes fruit. It is not intended to describe a plant completely but to provide those features that readily distinguish it from other plants without getting very detailed. Sometimes identification, especially when examining flower parts and hairs, can be aided by the use of a magnifying glass or hand lens, preferably with a magnification of 10 times.

As mentioned earlier, **flowering periods** are approximate and may slightly vary according to seasonal climatic conditions and at what latitude in Illinois the plant is observed.

The **Habitat/Range** section provides information on where the plant occurs and the relative abundance of plants, using such terms as *common, locally common, uncommon,* and *rare*. This gives the reader a general perspective on the plant's status in the state. *Locally common* refers to a plant that can be found in high numbers within a given range. A few plants included in this book are classified as either *endangered* or *threatened*, the status of which has been determined by the Illinois Endangered Species Protection Board. A plant is considered a native to Illinois unless otherwise noted. Many of the plants selected for this book have a wide range of distribution. There are a few, however, that are found only in a particular part of the state, especially those that may be on the edge of their range and are found more commonly elsewhere.

Finally, the **Remarks** section provides an opportunity to describe closely related species

and mention alternative common and scientific names the plant may have once been known by. Also, to increase interest and appreciation of plants, historical information on how plants have been eaten or used as medicine is presented. This information is based on written reports and should not be read as promotions for nutrition or as medical or herbal prescriptions for self-healing. Those interested in historical or modern herbalism, homeopathy, or flower essences should check the reference section in the back of the book.

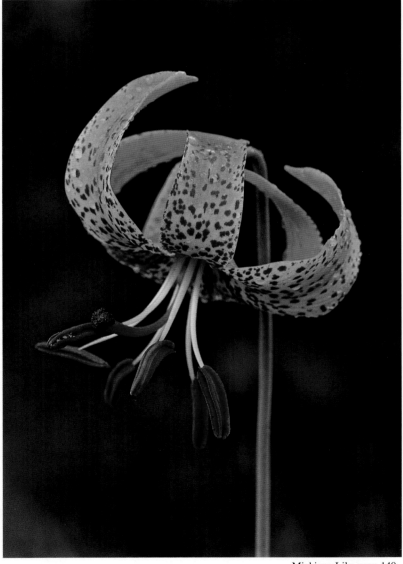

Michigan Lily, page 140

White Flowers

This section includes flowers that are mostly white.
Off-white flowers can grade into light colors of
yellow, green, pink, and blue,
so those sections should also be checked.

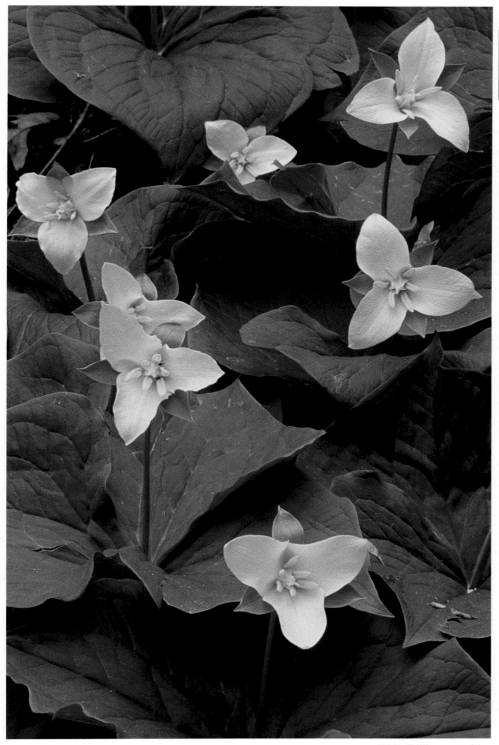

White Trillium, page 24

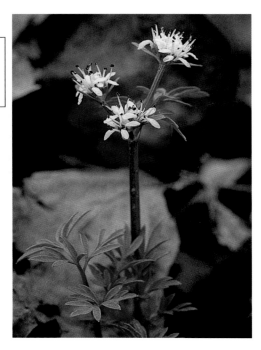

HARBINGER OF SPRING
Erigenia bulbosa
Carrot Family (Apiaceae)

Description: A small, delicate plant with flowering stems to 6" tall. The fern-like leaves are divided into numerous small lobes and may not appear until after flowering has started. The flowers are in clusters at the end of stalks with white petals and dark reddish anthers giving it another common name, "pepper and salt."

February—April

Habitat/Range: Moist woods on slopes and in ravines; occasional; throughout Illinois except for the northwest counties.

Remarks: True to its name, this is one of the first native wildflowers to bloom in spring. It may often be overlooked because of its small stature and partial concealment by fallen leaves.

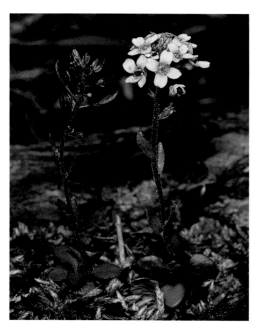

SMALL-FRUITED WHITLOW GRASS
Draba brachycarpa
Mustard Family (Brassicaceae)

Description: A winter annual, its seeds germinate in the fall and its leaves overwinter. The hairy flower stalk appears in early spring with leaves clustered at the base and a few along the stem. Leaves are hairy and up to ½" long. Flowers have 4-notched petals, each about ¼" long.

March—May

Habitat/Range: Prairies, woods, lawns, fields, often in sparse areas with little competition; common in the lower ⅔ of Illinois.

Remarks: The name *whitlow* derives from the ancient belief that some species could cure "whitlows," which are sores that develop around nails, or in the hooves of horses. The common name erroneously implies that this plant is a grass. Another commonly encountered species, common whitlow grass, *Draba reptans*, differs by having leaves only at the base of the stem.

SNOW TRILLIUM
Trillium nivale
Lily Family (Liliaceae)

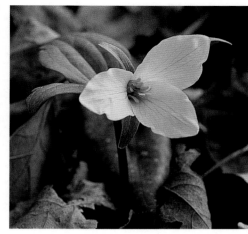

Description: As the name implies, this early spring wildflower sometimes appears through the snow. The un-branched stems rise up to 6" tall ending with a whorl of 3 rounded leaves up to 3" long. The three showy petals are each about 1" long. The fruit is 3-sided.

March—April

Habitat/Range: Moist woods; found in the upper ½ of the state.

Remarks: Also known as dwarf white trillium in some states, snow trillium often appears in large colonies with the plants shriveling and disappearing by late July. The species name *nivale* is Latin for "snow."

SPRING BEAUTY
Claytonia virginica
Purslane Family (Portulacaceae)

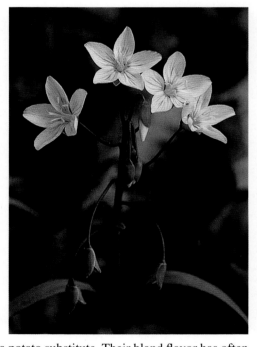

Description: Plants arise from bulbs with flower stalks to 6" tall. One pair of opposite, grass-like leaves occur about halfway up the stem. A single, strap-like leaf up to 7" long is produced at the base. Not all plants flower in a year, but their single leaf identifies their presence. Flowers, usually less than ½" across, vary from white to pink, with distinctive darker pink veins running the length of the 5 petals. There is a pair of green sepals below the petals. The 5 anthers are typically pink.

March—June

Habitat/Range: Moist woods and lawns; common throughout the state.

Remarks: Both Native American Indians and early settlers dug the small, round tuberous roots and ate them raw or boiled as a potato substitute. Their bland flavor has often been likened to that of chestnuts. The succulent leaves were used in salads. Deer are known to browse on the leaves when they first appear, and wild turkeys and rodents eat the tubers.

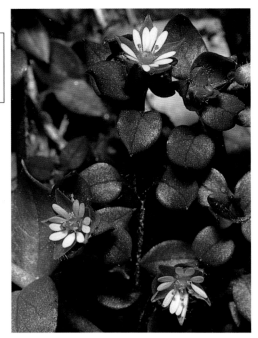

COMMON CHICKWEED
Stellaria media
Pink Family (Caryophyllaceae)

Description: A highly variable annual plant with weak stems up to 18" in length. The leaves are opposite along the stem, smooth, variable in shape but generally rounded from ½-1½" long. The small flowers are divided into 5 white petals with deep lobes giving the appearance of 10 petals. The petals are shorter than the 5 green sepals below them.

March—December

Habitat/Range: Disturbed sites, especially fields, lawns, and gardens; native to Europe; common throughout the state.

Remarks: The plants are usually compact at first but later grow loose branches in dense masses. Young shoots have been used as edible greens, either eaten raw in salads or cooked, although there is little taste.

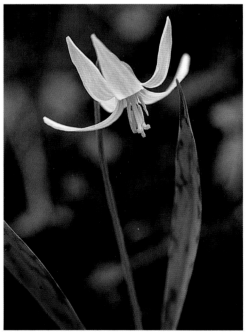

WHITE DOGTOOTH VIOLET
Erythronium albidum
Lily Family (Liliaceae)

Description: A single-flowering plant originating from a corm with stalks up to 6" tall. Flowering plants have a pair of flat to slightly folded leaves emerging from the base, while the more numerous nonflowering plants produce only single leaves. The leaves, up to 6" long, are mottled with brown and resemble the pattern on a trout, hence the other common name, "trout lily." The 3 sepals and 3 petals are similar and curve backwards as the flower ages. The flowers are about 1" wide, with large yellow stamens.

March—May

Habitat/Range: Lower wooded slopes and valleys where soils are moist, usually in colonies; common throughout the state.

Remarks: Dogtooth violet is named for the shape of its underground corm. Large colonies often can be found with few plants in flower. The deeply buried corm has the ability to send out side shoots to produce new plants, each with a single leaf. Native American Indians used root tea for fevers, and a warm mass of leaves was applied to the skin for hard-to-heal ulcers. A similar species, prairie dogtooth violet, *Erythronium mesochoreum*, has strongly folded leaves lacking mottling and spreading flowers that do not bend back; found mostly in west central Illinois.

RUE ANEMONE
Thalictrum thalictroides
Buttercup Family (Ranunculaceae)

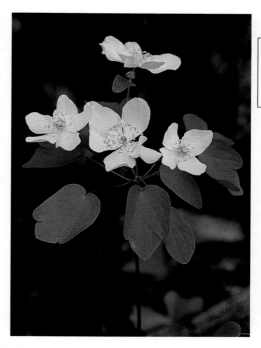

Description: A plant with upright, smooth, unbranched stems up to 8" tall. The leaves at the base are compound, divided into 3 divisions, with each division divided into 3 leaflets; a whorl of 6 leaflets occurs just below the flower stalks. Each leaflet is smooth, 3-lobed, and up to ¾" across. There are usually 1–4 flowers, each about 1" across, occurring at the end of a stalk; each flower has 5–9 petal-like sepals and numerous stamens; there are no petals. The sepals vary in color from white to pink to lavender.

March—May

Habitat/Range: Dry to moist open woods; occasional throughout Illinois.

Remarks: Also known as *Anemonella thalictroides*, rue anemone is sometimes confused with false rue anemone, *Enemion biternatum*, but the latter occurs in moister sites in valleys, grows in colonies, and has leaflets more numerous on the stem with their lobes more deeply cut.

FALSE RUE ANEMONE
Enemion biternatum
Buttercup Family (Ranunculaceae)

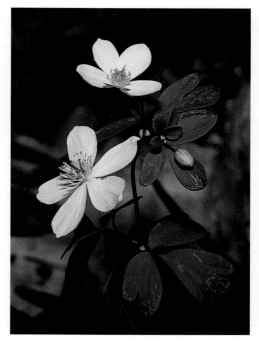

Description: A delicate plant with branched, smooth stems to 10" tall. The leaves are compound, divided into 3 leaflets with each leaflet with 3 lobes. The leaves at the base are on stalks, the upper leaves nearly stalkless. The flowers have 5 petal-like sepals about ½" across with numerous stamens; there are no petals. The sepals are always white.

March—May

Habitat/Range: Moist woods on lower slopes and valley floors; common throughout Illinois.

Remarks: The white flowers of false rue anemone are among the earliest of spring. Petal-like buds give the plant an unusual beauty even before the flowers open. Also known as *Isopyrum biternatum*, it is similar to rue anemone, *Anemonella thalictroides*, but the latter occurs on drier sites in woods, grows more solitarily, has a whorl of 6 leaflets below the flowers, has 5–9 petal-like sepals, and varies in color from white to pink to lavender.

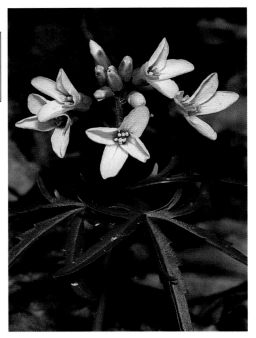

TOOTHWORT
Cardamine concatenata
Mustard Family (Brassicaceae)

Description: A plant with an unbranched, smooth, upright stem up to 10" tall. The leaves appear in whorls of 3 about midway up the stem, each leaf with 3–5 deeply cut segments with teeth along the margins; young leaves are often tinged with purple. Another set of leaves develops at the base of the plant after flowering. Nonflowering plants produce a single leaf. The 4-petaled flowers are up to ¾" long and are sometimes tinged with pink as they get older. The flowers are often nodding and may only partially open on cloudy days.

March—May

Habitat/Range: Moist woods; common throughout Illinois.

Remarks: Also known as *Dentaria laciniata*. The common name may come from the tooth-like shape of the fleshy root; it was also used as a folk remedy for toothaches. Pioneers gathered the little tuberous roots in early spring and used them throughout the year for seasoning soups, stews, meats, and other dishes. Eaten raw, the little tubers have the flavor of a radish or mild horseradish.

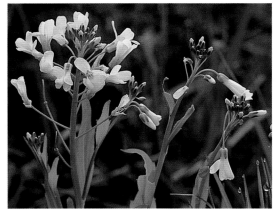

SPRING CRESS
Cardamine bulbosa
Mustard Family (Brassicaceae)

Description: A smooth, sparingly branched plant to 18" tall. Leaves at the base are round, to 1½" long, sometimes toothed, and on long stalks; stem leaves are scattered, mostly without stalks, longer than broad, and toothed. Flowers are small and 4-petaled; appearing in clusters at the end of a stalk.

March—June

Habitat/Range: Low wet woods, margins of spring branches and streams, fens; occasional to common throughout Illinois.

Remarks: Pioneers used the young shoots and leaves of spring cress to give a peppery-pungent taste to salads and as cooked greens. The base of the stem and the roots were used as a mild horseradish.

SHARP-LOBED HEPATICA
Anemone acutiloba
Buttercup Family (Ranunculaceae)

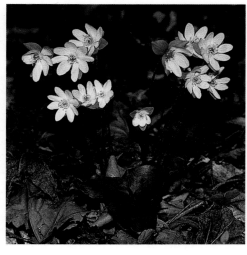

Description: Stems are absent in this low-growing plant, with leaves at the base that overwinter. The leaves are on hairy stalks, 3-lobed, with pointed tips, leathery, and up to 2½" across. The flowers are single, on long somewhat hairy stalks up to 8" tall. Each flower is about 1" across and can vary in color from white to lavender to purple. The 6–10 "petals" are actually sepals.

March—April

Habitat/Range: Moist woods; occasional throughout the state.

Remarks: Formerly known as *Hepatica acutiloba* and *Hepatica nobilis* var. *acuta*. Another common name, "liverleaf," refers to the overwintering leaves that turn a deep reddish brown, the color of liver. The Chippewas gave root tea from this plant to children who had convulsions. Leaf tea was used for liver ailments, poor indigestion, and as a laxative. A closely related plant, round-lobed hepatica, *Anemone americana (*formerly known as *Hepatica americana)*, is almost identical except that it has leaves with rounded tips. Found in moist woods, it is uncommon and confined to the northeast counties of Illinois.

SMOOTH ROCKCRESS
Arabis laevigata
Mustard Family (Brassicaceae)

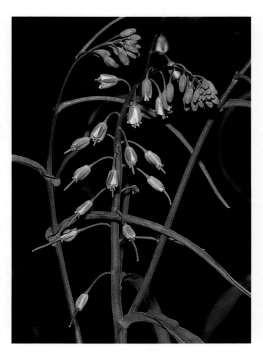

Description: A single, leafy stem, up to 3' tall, arises from a cluster of leaves at the base. The smooth leaves clasp the stem by their eared bases and are somewhat toothed along the margins. The small white or yellowish-white flowers have 4 petals, each about ¼" long. The fruit forms pods, up to 4" long, which spread outward and downward.

March—August

Habitat/Range: Moist woods; common throughout the state.

Remarks: The overwintering leaves at the base of the plant are often purplish. A similar species, sicklepod, *Arabis canadensis*, has hairy leaves along the stem, which lack the eared flaps at the base. Sicklepod occurs in moist woods statewide.

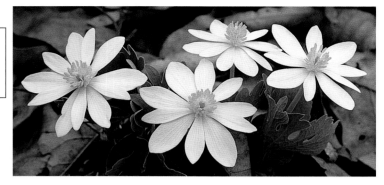

BLOODROOT
Sanguinaria canadensis
Poppy Family (Papaveraceae)

Description: This showy, low-growing plant produces a single flower that normally blooms for only a day. A single, light green leaf, paler underneath, emerges from the ground wrapped around the flower stalk. The leaf may open with the flower or shortly after to a width of 3" with 3–9 lobes. The fragrant flower opens to 1½" wide and usually has 8 petals, 4 of which are slightly longer; 24 yellow stamens surround the single pistil.

March—April

Habitat/Range: Lower slopes of moist woods and in moist wooded valleys; common throughout Illinois.

Remarks: The large, fleshy root emits a red sap, as does the rest of the plant. Native American Indians used bloodroot as a dye for fabrics, tools, and war paint. The red sap was mixed with oak bark, which is a source of tannin, to set the color, making it more permanent. The plant was used by Native American Indians and settlers to treat hemorrhages, fevers, rheumatism, poor digestion, colds, and coughs. Today, bloodroot is used commercially as a plaque-inhibiting agent in toothpaste and mouthwashes.

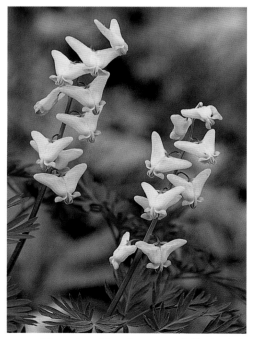

DUTCHMAN'S BREECHES
Dicentra cucullaria
Fumitory Family (Fumariaceae)

Description: A perennial with smooth, slender, often leaning stems to 10" long. The gray-green fern-like leaves are finely dissected and emerge from the base on long stalks. Single leaves appear on flowerless plants. The 4–10 flowers appear on leafless stalks and hang in a one-sided cluster. The V-shaped or "breeches-shaped" petals are up to ¾" long and sometimes tinged with pink.

March—May

Habitat/Range: Moist woods near the bases of slopes and in wooded valleys; common throughout the state.

Remarks: The Iroquois used Dutchman's breeches in an ointment to make athletes' legs more limber. Settlers used a tea from the scaly bulb as a diuretic to treat urinary problems and to promote sweating. It is poisonous and can cause skin rashes. The plant, especially the bulb, contains an alkaloid toxic to cattle.

20

SQUIRREL CORN
Dicentra canadensis
Fumitory Family (Fumariaceae)

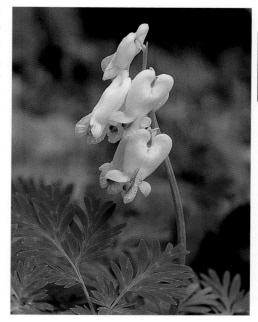

Description: Similar in appearance to Dutchman's breeches with smooth, slender stems up to 12" long. The leaves are finely dissected, fern-like, and smooth. Single leaves appear on flowerless plants. The nodding, fragrant, white flowers are up to ¾" long, notched at the top and spreading at the bottom.

April—May

Habitat/Range: Moist woods; scattered throughout the state

Remarks: Squirrel corn can be found flowering about 2 weeks after Dutchman's breeches and often in the same habitat. The roots of squirrel corn are yellow, kernel-like tubers that resemble something a squirrel would have buried.

MAYAPPLE
Podophyllum peltatum
Barberry Family (Berberidaceae)

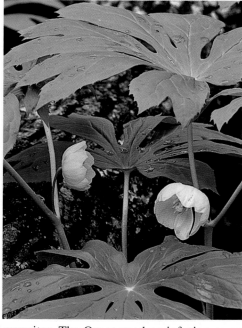

Description: This distinctive plant has extensive underground rhizomes and can grow to a height of 2'. The large, umbrella-like, usually smooth, paired leaves are up to 14" across and have 5–9 deeply cut lobes. Plants with single leaves are young and do not flower. At the base of the leaf stalks, a single slightly nodding flower is produced with 6 sepals and 6 petals, all cream colored. The flower is up to 2" across and has 12 yellow stamens. The large green fruit turns yellow when ripe and is up to 2" wide.

April—June

Habitat/Range: In low moist or dry open woods and in pastures at the edge of woods, usually in colonies; common; in every county.

Remarks: The Cherokee used a root tea for treating constipation, deafness, rheumatism, sores, and ulcers, and for expelling intestinal parasites. The Osage used an infusion as an antidote for poisons. Early settlers used the powdered rhizomes in an infusion to treat a wide range of common diseases. The active component, podophyllum, still is the most widely used treatment for venereal warts. Ripened fruits lose their toxicity and are edible, but the rest of the plant is considered a powerful intestinal irritant, acting as an emetic and purgative. If misused, it can be fatal.

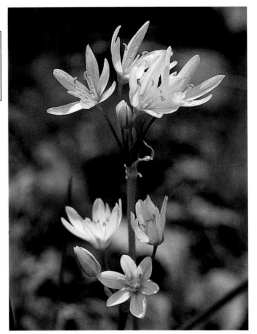

FALSE GARLIC
Nothoscordum bivalve
Lily Family (Liliaceae)

Description: A slender plant that grows from a bulb, producing leafless stems to 12" tall. The smooth, grass-like leaves that emerge from the base are long and narrow. The 5–12 fragrant flowers, each less than 1" wide, are on stalks that arise from a common point on top of the stem. There are 3 petals and 3 sepals, all about the same size and white to slightly yellow in color.

April—June; also in fall

Habitat/Range: Dry woods, bluffs, prairies; occasional in the south ½ of the state; also DuPage County.

Remarks: False garlic is related to the onion, which it resembles, but there is no characteristic onion odor.

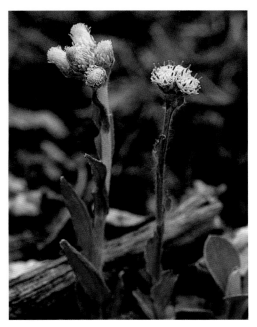

PUSSYTOES
Antennaria parlinii
Aster Family (Asteraceae)

Description: A slender plant spreading by underground runners to form large colonies. The stems, which reach to 15" high, are covered with a dense mat of woolly hairs. The leaves at the base are somewhat oval, about ¾" or wider, with 3 prominent veins and woolly underneath. The leaves along the stem are much narrower and very hairy. The woolly flower heads are either male or female. The male flowers are in low, rounded heads with reddish-yellow stamens. The female flowers are more elongated and sometimes have a pinkish color.

April—June

Habitat/Range: Open woods, pastures, fields; occasional throughout Illinois.

Remarks: Formerly known as *Antennaria plantaginifolia*. The woolly flower heads account for the plant's common name. Early folk medicine sometimes prescribed a tea of pussytoes leaves taken every day for two weeks after childbirth to keep the mother from getting sick. An extract from the plant was once used to treat stomach disorders, and the flowers have been used to make cough syrup. Another species, narrow-leaved pussytoes, *Antennaria neglecta*, has leaves with 1 prominent vein and less than ¾" across; occurs in fields, prairie remnants, open woods; scattered across the state.

CORN SALAD
Valerianella radiata
Valerian Family (Valerianaceae)

Description: Although a native plant, this small, succulent annual often occurs in disturbed soil and is somewhat weedy. The much-branched stem is angled, has sparse hairs, and grows to 15" tall. The leaves are opposite on the stem, stalkless, and slightly toothed on the lower margins. The white flowers are packed tight at the ends of the branched stalks, forming a flat top with the stamens extending just beyond the petals.

April—May

Habitat/Range: Low woods, wet fields, disturbed areas; occasional to common in the south ½ of Illinois.

Remarks: The young tender leaves gathered before the flowers appear have been used in salads or prepared like spinach.

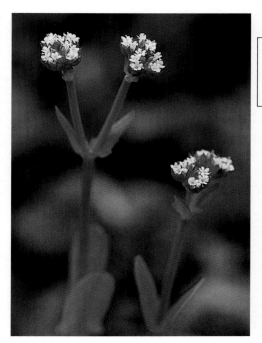

WILD CHERVIL
Chaerophyllum procumbens
Carrot Family (Apiaceae)

Description: A low-growing annual with stems weak, spreading, and branched, to 15" long. The leaves are so deeply cut, they appear fern-like. Minute white flowers occur at the ends of stalks.

April—June

Habitat/Range: Moist woods, along streams, floodplains, along railroads, and highways; common; throughout Illinois.

Remarks: Wild chervil sometimes forms a nearly solid mat of fern-like leaves, sharing the forest floor with more showy spring wildflowers.

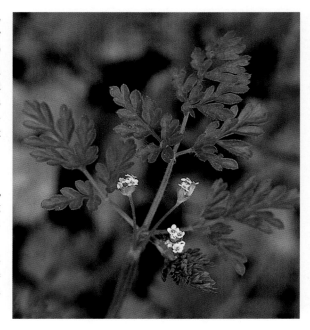

23

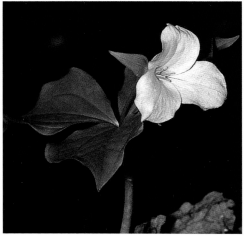

LARGE-FLOWERED TRILLIUM
Trillium grandiflorum
Lily Family (Liliaceae)

Description: A single-flowered plant up to 18" tall, with a single whorl of 3 leaves at the top of each stem. Leaves are up to 6" long and ½ as wide to nearly as wide. The large flower, which is about 3" across, has 3 white petals emerging from the leaves on a stalk 1–3" long. The wavy-edged petals turn pinkish with age.

April—May

Habitat/Range: Moist woods; occasional in the northern ½ of the state, rare elsewhere.

Remarks: Large-flowered trillium has a tendency to grow in large patches, which makes for an attractive display on the forest floor. A slow growing plant, often taking 6 years to flower, it is rarely grown from seed in the nursery trade. Plants offered for sale are probably root-dug from the wild and should be avoided.

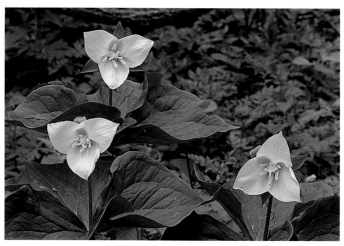

WHITE TRILLIUM
Trillium flexipes
Lily Family (Liliaceae)

Description: A showy spring wildflower with unbranched stems that rise up to 2' tall and spread a whorl of 3 very broad leaves that are up to 5" across and about as long. A single nodding flower about 3" across is attached to an arched stalk up to 4" long. There are 3 white petals, 3 green sepals, and 6 creamy white stamens. The fruit, which is 1" in diameter, turns a rose color during summer.

April—May

Habitat/Range: Moist woods on lower slopes and in wooded valleys or ravines; occasional throughout the state.

Remarks: Various tribes used trilliums to treat open wounds and sores, menstrual disorders, menopause, internal bleeding, to induce childbirth, and as an aphrodisiac. Settlers called it "birthroot" because of its labor-inducing properties.

ROBIN'S PLANTAIN
Erigeron pulchellus
Aster Family (Asteraceae)

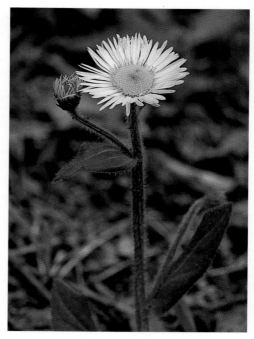

Description: This plant often forms small colonies by sending out leafy runners at its base. The stems are unbranched, to 15" tall, hollow, with long, soft hairs. The leaves at the base of the stem are very hairy and spoon-shaped with shallow lobes; the leaves along the stem are scattered, smaller toward the top, and clasp the stem. The flower heads are loose and showy on long stalks, about 1" across, and white or lilac. The flower heads have 50–75 thread-like white ray flowers surrounding a circle of densely packed, yellow disk flowers.

April—June

Habitat/Range: Open woods, clearings; occasional throughout the state.

Remarks: A similar species, marsh fleabane, *Erigeron philadelphicus*, differs by lacking leafy runners at the base of the plant and having 150–200 thread-like white ray flowers; moist prairies, fields, disturbed areas; common throughout the state.

TALL ANEMONE
Anemone virginiana
Buttercup Family (Ranunculaceae)

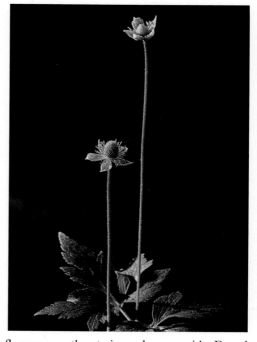

Description: A long-stalked plant up to 3' tall. The leaves are divided in 3, with deep lobes and large teeth along the margins. Both of the basal and stem leaves are on stalks. There are 1–3 flowers, about 1" across with 5 white to greenish-white sepals; the petals are lacking. The fruits develop on a dense cylinder, less than twice as long as wide, in the center of the flower, which resembles a thimble, hence, the other common name "thimbleweed." The fluffy, white mass of seeds often remains on the stalk through winter.

April—August

Habitat/Range: Open, typically dry woods; common throughout the state.

Remarks: A closely related species, thimbleweed, *Anemone cylindrica*, has leaves 5–9 and the dense cylinder in the center of the flower more than twice as long as wide. Found in open woods; limited to the north ¾ of the state; also Jackson and Gallatin counties.

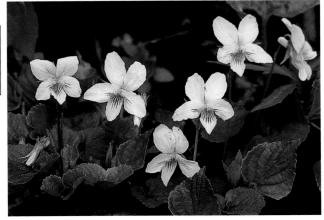

CREAM VIOLET
Viola striata
Violet Family (Violaceae)

Description: Several stems rise from the base of the plant up to 10" tall. The stems are smooth and angular. The leaves are round, heart-shaped at the base, smooth, with round teeth along the edges, and about 1½" across. The flowers emerge solitarily from the axils of the leaves on long stalks. The flowers are white or creamy white, about 1¼" long, with 5 petals, some with purple lines.

April—June

Habitat/Range: Moist woods, open areas; common in the south ½ of the state, rare in the north ½.

Remarks: In general, the blue violets in Illinois lack above ground stems while the yellow and white violets generally have aerial stems.

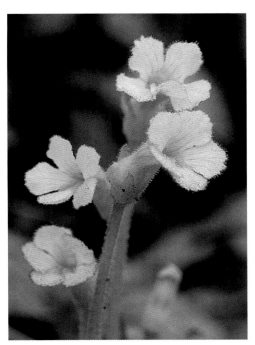

ONE-FLOWERED BROOMRAPE
Orobanche uniflora
Broomrape Family (Orobanchaceae)

Description: Several branchless hairy stalks emerge from this plant to a height of 8". Brownish scales, which are actually rudimentary leaves, are found at the base of the stalks. The flowers, which are about 1" long, are solitary at the tip of the stems. The petals are united below into an elongated, curved tube with 4 yellow stamens found within. The flowers range from white to lavender.

Late April—June

Habitat/Range: Woods; scattered throughout the state.

Remarks: This plant lacks chlorophyll (the green pigment associated with photosynthesis), so it must rely on other plants for its food. It parasitizes the roots of oaks, asters, goldenrods, and others; the other common name "one-flowered cancer root," probably comes from its having been used as a folk remedy for cancer.

SWEET CICELY
Osmorhiza claytonii
Carrot Family (Apiaceae)

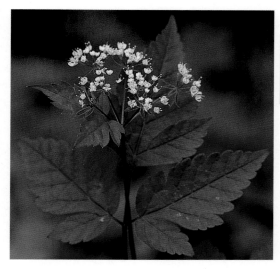

Description: An upright, branching plant with white hairs along the stem and up to 3' tall. The large, hairy leaves, as much as a foot across on lower parts of the plant, are divided into 3 parts and then either further subdivided or deeply lobed to appear somewhat fern-like. The tiny white flowers are carried in loose, umbrella-shaped sprays. The 5 petals are curved at the tip. The 5 stamens may extend just beyond the petals, but the styles (female stalk) are shorter than the petals.

April—June

Habitat/Range: Moist woods; occasional; throughout Illinois.

Remarks: The carrot-like root contains anise oil and has been used as a flavoring for cookies, cakes, and candies. The Illinois-Miami Indians used sweet cicely to treat eye ailments. The Ojibwa used a root extract for treating sore throats. Settlers used the root to relieve colic, gas, indigestion, and to improve the appetite. Another species, anise root, *Osmorhiza longistylis*, differs by having the styles (female stalk in the flower) slightly longer than the petals; a determination is often difficult to make. Its roots have been reported to be higher in anise oil content; moist woods; occasional throughout the state.

WILD STONECROP
Sedum ternatum
Stonecrop Family (Crassulaceae)

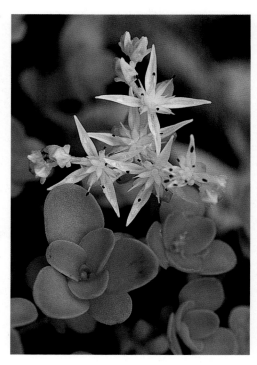

Description: A low spreading succulent with creeping stems that forms a mat. The leaves are in whorls of 3 with each leaf about ⅜" across. Each plant produces several leafy, sterile shoots and one leafy flowering stem up to 7" tall. The flowers are clustered on top, each with 4 spreading, white petals, about ¼" long.

April—June

Habitat/Range: Moist wooded ravines, open places in woods; occasional; scattered throughout the state.

Remarks: Wild stonecrop makes an attractive ground cover and can be propagated from cuttings that will root when in contact with the ground.

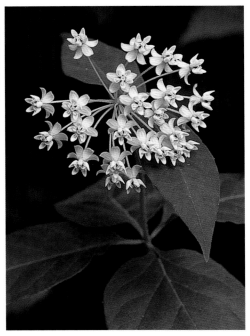

WHORLED MILKWEED
Asclepias quadrifolia
Milkweed Family (Asclepiadaceae)

Description: A slender, single-stemmed plant with whorled leaves to 18" tall. The long-pointed, smooth leaves are usually in 1 or 2 whorls of 4, plus 1 or 2 pairs along the stem. The flowers are in 1–4 clusters at the end of the stem, often causing it to bend. The flowers are about ¼" across on slender stalks up to 1" long, causing them also to turn downward. The 5 petals are white to pink and turned back, displaying the 5 cup-like hoods characteristic of milkweeds. The seed pods are smooth, slender, and up to 5" long.

April—May

Habitat/Range: Dry or rocky open woods; occasional in the south ⅔ of Illinois, rare elsewhere.

Remarks: This is the first milkweed to bloom in Illinois. Like most milkweeds, the sap is milky.

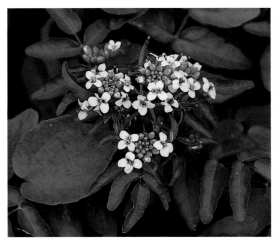

WATER CRESS
Nasturtium officinale
Mustard Family (Brassicaceae)

Description: This floating aquatic plant, found in large colonies, grows only in spring water, up to a height of 12". The succulent, smooth stems root at the nodes enabling it to creep along in moist soil or in the streambed. The leaves are alternate and deeply divided into 3–9 leaflets, each leaflet about 1" long. The flowers are about ¼" across and numerous.

April—October

Habitat/Range: Cool springs and spring-fed branches and streams; occasional throughout the state.

Remarks: Formerly known as *Rorippa nasturtium-aquaticum*, water cress is used in salads and for garnishing meats and other dishes where a tangy or peppery flavor is desired. Some books treat water cress as a native of Europe and introduced in North America. However, water cress surely is native, because it is found in virtually every cold spring in the Midwest, no matter how remote the location.

LONG-LEAVED BLUETS
Houstonia longifolia
Madder Family (Rubiaceae)

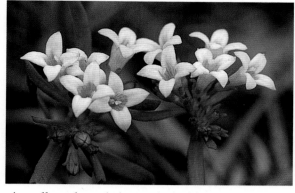

Description: Low slender plants with several stems arising from the base to a height of 8". Leaves at the base of the stem are narrow and long; leaves along the stem are opposite, narrow, and smooth, to 1" long. The flowers are white but sometimes tinged with pink, small, about ¼" across, and clustered at the tops of leaf axils. The 4 small petals are hairy on the inside and the stamens extend just beyond the petals.

April—July

Habitat/Range: Rocky open woods, prairies, fields; occasional in the north and south ¼ of the state, absent elsewhere.

Remarks: Long-leaved bluets was formerly known as *Hedyotis longifolia*.

WILD STRAWBERRY
Fragaria virginiana
Rose Family (Rosaceae)

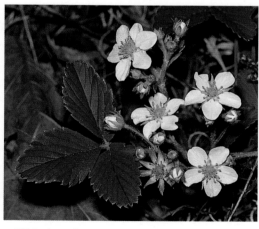

Description: This low ground-hugging plant spreads by runners, often forming large colonies. Along the runners, hairy stalks up to 6" long support leaves, each of which are divided into 3 leaflets with teeth along the margins. The flowers, about 1" across, are in small clusters, shorter than the leaves, and contain 5 white petals, 5 green sepals, alternating with 5 leaf-like bracts, and numerous stamens. The fruit ripens June—July, to an attractive scarlet color and grows to about ½" in length.

April—July

Habitat/Range: Woods, prairies, fields; common throughout the state.

Remarks: Another species, hillside strawberry, *Frageria americana*, has flower clusters arising above the leaves; found on wooded slopes; occasional to rare; occurring in north ¾ of the state. Some say wild strawberries are sweeter than the typical garden-variety strawberries, which are hybrids between the wild strawberry and the Chilean strawberry. Wild strawberries were greatly appreciated by Native American Indians and later, by early travelers and settlers.

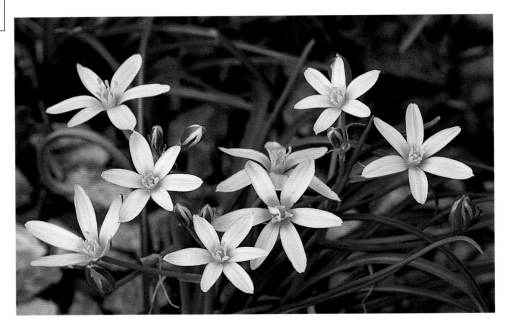

STAR OF BETHLEHEM
Ornithogalum umbellatum
Lily Family (Liliaceae)

Description: These showy plants with their star-shaped flowers and grass-like leaves colonize disturbed sites. From underground bulbs the leaves emerge to a length of about 12". The margins of the leaves are curved inward with a white strip down the middle. The flowers are on stalks up to 12" tall, with each stalk bearing 3–7 flowers. The flowers are about 1" across and have 6 petals with a green stripe down the back of each petal.

April—June

Habitat/Range: Along roadsides, lawns, fields, open woods; native to Europe; common throughout the state.

Remarks: This exotic plant is very aggressive, producing bulbs at a rapid rate, and is very difficult to eradicate once established. The leaves and bulbs are poisonous, containing toxic alkaloids, and should be kept away from children and domestic animals.

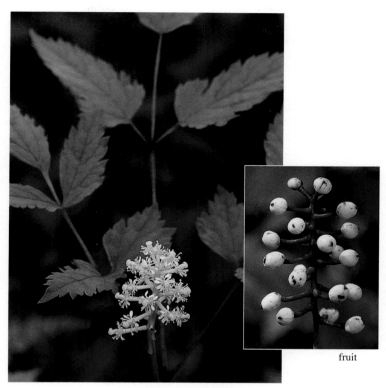

fruit

DOLL'S EYES
Actaea pachypoda
Buttercup Family (Ranunculaceae)

Description: This stately plant is bushy in appearance and grows to about 2' tall. The large leaves are divided twice, ending in 3–5 leaflets that vary in shape. The leaflets, especially the end ones, may have 3 irregular lobes. The leaf margins are sharply toothed. The flowers appear in a tight rounded shape on the end of a stout stalk. The petals fall away early, leaving a mass of creamy white stamens, giving the flower its basic color. The fruits are a loose cluster of oval, shiny, white berries marked with a dark purple spot at one end, which accounts for the common name.

April—June

Habitat/Range: Moist woods; occasional throughout most of the state.

Remarks: Also called white baneberry. Both Native American Indians and settlers made a tea of the root for relieving pain of childbirth. Settlers also used the plant to improve circulation and to cure headache or eyestrain. The plant is poisonous and all parts may cause severe gastrointestinal inflammation and skin blisters. A related species, red baneberry, *Actaea rubra*, is similar in appearance but with red berries; not common; confined to the north ¼ of the state.

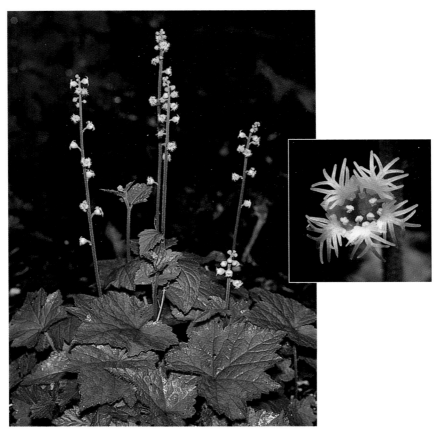

BISHOP'S CAP
Mitella diphylla
Saxifrage Family (Saxifragaceae)

Description: The 3–5 lobed leaves are mostly clustered around the base of this plant but there is a pair of opposite leaves along the flowering stem giving the plant its other common name of two-leaved mitrewort. The attractive white flowers are arranged along a stem up to 6" long. Flowers are small, with 5 deeply dissected petals appearing as snowflakes.

April—May

Habitat/Range: Moist wooded slopes, especially in deep ravines; occasional in the north ½ of the state and rare elsewhere.

Remarks: One really needs a 10x magnifying lens to better appreciate the delicate pattern of the flowers.

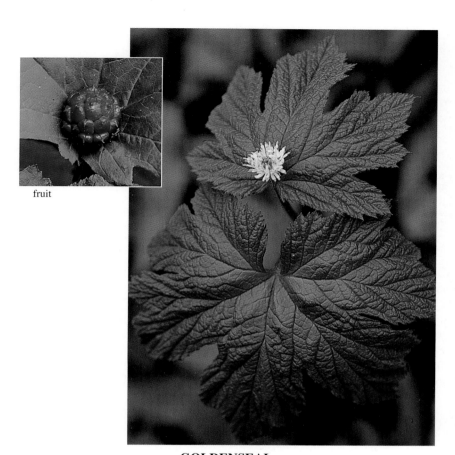

fruit

GOLDENSEAL
Hydrastis canadensis
Buttercup Family (Ranunculaceae)

Description: The attractive, coarsely textured leaves easily identify this woodland wildflower. Hairy, unbranched stems to 10" tall support a pair of broad, 5–9 lobed leaves. The leaves, up to 6" across, are hairy and irregularly toothed along the margins. One leaf, about 9" across, is found at the base. A small single flower emerges at the top of the uppermost leaf. The flower, about ½" across, has 3 whitish sepals that fall away early; there are no petals. The numerous white stamens give the flower its color. The distinctive red fruit, resembling a red raspberry, persists for some time.

April—May

Habitat/Range: Moist woods; occasional; often forming large colonies; scattered throughout the state.

Remarks: Goldenseal is declining throughout its range due to root diggers; the plant can be cultivated for commercial use. The perennial rhizome, with its distinctive yellow sap, was used by Native American Indians and settlers as a tonic, stimulant, and astringent. The plant has a wide use with herbalists today.

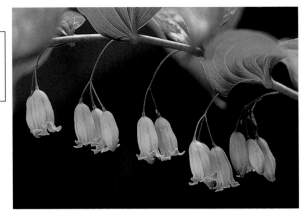

SOLOMON'S SEAL
Polygonatum biflorum
Lily Family (Liliaceae)

Description: A gracefully arching plant with alternate leaves; it may reach to 5' in length. The stems are smooth, unbranched, and stout, supporting several leaves up to 7" long and 3" wide. The leaves have parallel veins and pale undersides. The greenish-white flowers are about ¾" long and hang from slender stalks in clusters. The fruits are dark blue berries about ½" in diameter.

April—June

Habitat/Range: Moist woods, along prairie streams; common; in every county.

Remarks: This includes *Polygonatum commutatum*. A related species, small Solomon's seal, *Polygonatum pubescens*, has short hairs on the veins underneath the leaf; found in moist woods; restricted to a few extreme northern counties. Native American Indians used the rhizome of Solomon's seal in a tea for treating internal pains. Externally, it was used as a wash for poison ivy, skin irritations, and hemorrhoids. Settlers used root tea for rheumatism, arthritis, and skin irritations. The young shoots, when boiled, are said to taste like asparagus, while the starchy rootstocks have served as a substitute for potatoes.

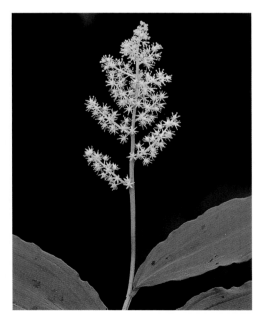

FALSE SOLOMON'S SEAL
Maianthemum racemosum
Lily Family (Liliaceae)

Description: The slightly zigzag stem stiffly arches to a length of up to 3'. The firm spreading leaves alternate along the finely hairy stem. The leaves are 3–6" long, 3" wide, with smooth margins, and very short stalks. Tiny creamy white star-shaped flowers with 6 petals are borne in a branched cluster at the end of stems. Clusters are up to 4" long. The fruits are ruby red berries about ¼" across and often speckled with brown or purple.

April—June

Habitat/Range: Moist woods; common; in every county.

Remarks: Formerly known as *Smilacena racemosa*. The Mesquakie tribe burned the root as a smudge to quiet a crying baby and to return someone to normal after temporary insanity. They also used the root with food during times of plague to prevent sickness. The plant was also used for its internal cleansing effect. A related species, starry Solomon's seal, *Maianthmum stellatum* (formerly known as *Smilacena stellata),* has black berries; found in moist woods, occasional in the north ⅗ of the state.

SLENDER SANDWORT
Minuartia patula
Pink Family (Caryophyllaceae)

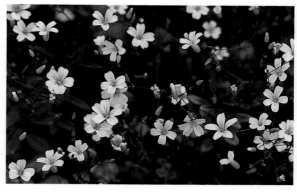

Description: A slender-stemmed winter annual that provides numerous spreading branches from the base to 12" tall. The leaves at the base form mats of cedar-like soft foliage with linear needle-like leaves that are opposite; the stem leaves are also soft, opposite, and very narrow. The white flowers are ¼" across with 5 notched petals, 5 sepals, and 10 stamens.

May—July

Habitat/Range: Wooded slopes especially where beds of limestone are near the surface of the ground; classified as state threatened; restricted to a few northeast counties.

Remarks: As a winter annual, the seeds germinate in the fall and overwinter as thread-like minute leaves on the ground. Formerly called *Arenaria patula*, a related species, stiff sandwort, *Minuartia michauxii*, (formerly *Arenaria stricta*), differs by having more than 2 leaves clustered together and with tufts of smaller leaves in the main axils. The leaves are stiff and needle-like. A perennial with deep roots, it is found where beds of limestone are near the surface of the ground, also, low sand ridges and gravel hill prairies; uncommon; confined to the north ⅓ of the state and St. Clair County.

GARLIC MUSTARD
Alliaria petiolata
Mustard Family (Brassicaceae)

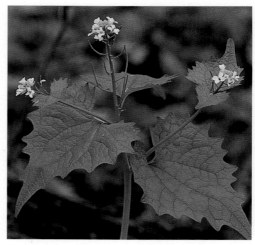

Description: A biennial plant, up to 3' tall with few branches. The leaves, when crushed, have the odor of garlic. Leaves are alternate on the stem, up to 2½" long, broadest at the base, narrow at the tip, and coarsely toothed along the margins. The flowers have four white petals, each up to ½" long. Fruit pods are narrow, 4-sided, up to 2½" long.

May—June

Habitat/Range: Moist woods and wood margins; native to Europe; common in the north ½ of the state and spreading elsewhere.

Remarks: Garlic mustard spreads rapidly with each plant producing thousands of minute seeds. Once established, this aggressive weed forms dense stands that smother spring wildflowers and lowers the diversity of woodlands. The first year's growth produces a single heart-shaped leaf that overwinters. Hand pulling is the easiest way to eradicate this exotic pest through successive visits.

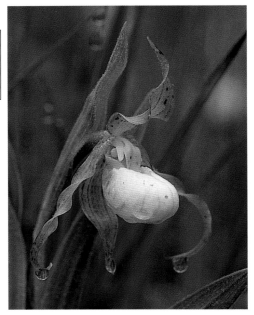

WHITE LADY'S SLIPPER ORCHID
Cypripedium candidum
Orchid Family (Orchidaceae)

Description: Short plants, less that 1' tall that can form large colonies. The 3 or 4 leaves along the stem are finely hairy, up to 6" long, 2" wide, and slightly pleated along their length. The flower has a broad, white "slipper" about 1" long, with two twisted greenish petals that slant downward and away from the slipper. Above and below the slipper are two greenish flower parts called sepals.

May—June

Habitat/Range: Low, moist areas in prairies, springy areas; classified as state threatened; northern ½ of state.

Remarks: With the destruction of most of its former habitat, finding the white lady's slipper orchid is a special occasion. Fortunately, there are protected public lands where this delicate jewel of the wildflower world can still be admired.

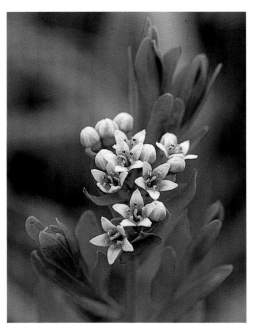

FALSE TOADFLAX
Comandra umbellata
Sandalwood Family (Santalaceae)

Description: A creeping underground rhizome sends up yellow-green stems to a height of 12". The smooth stems produce alternate narrow leaves up to 1½" long that lack stalks. Flattened clusters of flowers emerge at the top. Each flower is about ¼" long with 5 sepals; petals are absent. The fruit is urn-shaped, green, maturing to a chestnut brown or purplish brown. The flowers and fruits persist for some time.

May—August

Habitat/Range: Dry or rocky open woodlands, prairies; occasional throughout Illinois.

Remarks: Formerly known as *Comandra richardsiana*. Like other species in the sandalwood family, false toadflax is parasitic on other plants. However, it may be considered only partially parasitic since the plant has its own green leaves that photosynthesize and provide energy for growth. Like mistletoe, it may only need its host plant for water. Native American Indians ate the fruits, which are sweet, but consuming too many could produce nausea.

MEADOW ANEMONE
Anemone canadensis
Buttercup Family (Ranunculaceae)

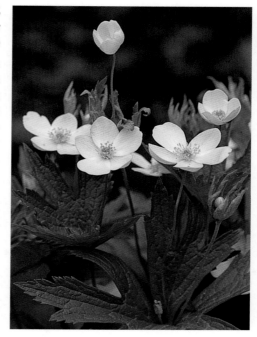

Description: Hairy leaves on long stalks are clustered at the base of the plant with a branching stem up to 2' tall supporting solitary flowers. Deeply cut leaves occur in whorls along the stem. The white flowers are up to 2" across. The seed head is a bur-like cluster of flattened fruits with beaks.

May—July

Habitat/Range: Low woods, moist depressions in prairies, along streams, and roadsides; occasional in the north ⅔ of Illinois.

Remarks: Also called Canada anemone, it can often be found occurring in large, matted colonies. North American Indians used a preparation of the roots and leaves to treat wounds, sores, and nosebleeds.

WILD SARSAPARILLA
Aralia nudicaulis
Ginseng Family (Araliaceae)

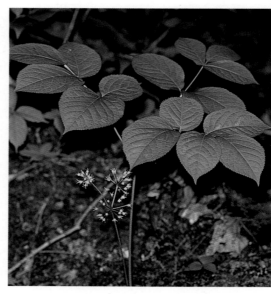

Description: An umbrella-like plant, up to 2' tall, with compound leaves that arise on long, bare stalks. The leaves are divided into leaflets, with each leaflet up to 6" long, oval-shaped, toothed along the margins, and with pointed tips. Below the leaves, 2–3 flower clusters on long stalks contain numerous small, greenish-white flowers. The fruits are small, dark purple berries.

May—June

Habitat/Range: Moist wooded slopes, dune woods, bogs; occasional in the north ½ of the state.

Remarks: The spicy, aromatic roots have been used to make tea and root beer. Native American Indians used root tea as a beverage, "blood-purifier," and to treat stomachaches and coughs. Wild sarsaparilla was widely used in "tonic" and "blood-purifier" patent medicines of the late 19th century.

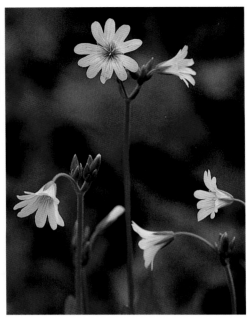

FIELD CHICKWEED
Cerastium arvense
Pink Family (Caryophyllaceae)

Description: The stems are slender, sprawling and up to 15" tall. The narrow, opposite leaves are about 1" long and ⅛" wide. The main stem leaves have tufts of smaller leaves at their base. Flowers are in branched clusters on slender stalks at the top of the plant. Flowers are ½" wide with 5 white petals, each notched about half their length.

May—June

Habitat/Range: Open woods, riverbanks, sandy prairies, and low grassy areas; scattered throughout the state.

Remarks: There are three chickweeds native to Illinois and seven chickweeds from Europe that are also found in the state. Field chickweed is by far the showiest and can be planted in areas where it is allowed to spread.

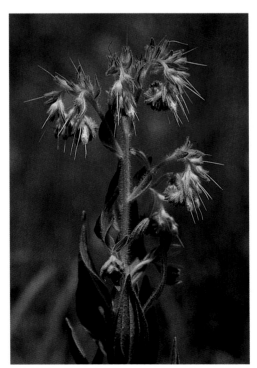

MARBLESEED
Onosmodium molle
Borage Family (Boraginaceae)

Description: A hairy-stemmed perennial from 1–4' tall, with numerous leaves along the stem. The leaves are alternate along the stem, hairy, narrow, and 1–3" long. The flowers are densely coiled at the ends of the upper branches. The tube-like flowers are dull white to greenish white, with 5 lobes and about ½" long.

May—July

Habitat/Range: Rocky woods, rocky prairies, limestone glades; not common; scattered throughout Illinois.

Remarks: Marbleseed is named for the hard, white nutlet or seed. Another common name "false gromwell," the latter meaning gritty meal, refers to its resemblance to nutlets of the genus *Lithospermum*.

EVENING CAMPION
Silene latifolia
Pink Family (Caryophyllaceae)

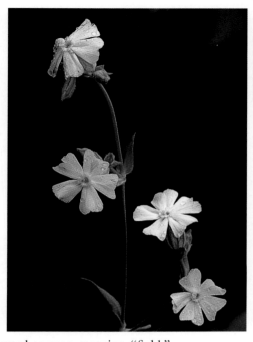

Description: An annual, biennial, or perennial depending on conditions, with a stem, sticky to the touch, up to 4' tall. Stem leaves—as many as 10 pairs, each 14" long and broadly rounded. The flower display is much branched with 5 white petals from 1–1½" long. The petals are notched over half their length. The male flowers with stamens and the female flowers with pistils occur on separate plants.

May—October

Habitat/Range: Disturbed ground, roadsides, fields; native to Europe and Asia; occurs in scattered counties across the state.

Remarks: Evening campion is also known as *Silene pratensis* and *Lychnis alba*. The flowers open at night, hence the common name and campion is derived from the Latin word *campus*, meaning, "field."

PALE BEARDTONGUE
Penstemon pallidus
Plantain Family (Plantaginaceae)

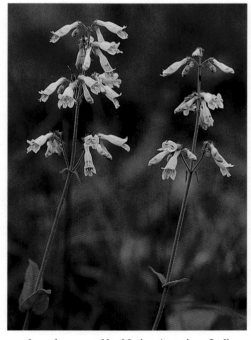

Description: Slender, unbranched, hairy-stemmed plants typically to 2' tall with opposite leaves that tend to point upwards. The leaves are firm, pale, and velvety-hairy on both sides with the margins randomly toothed. The leaves partly clasp the stem at the base and taper to a point on the end. The flowers are in branched clusters at the end of the stalk. Each tubular flower is about 1" long and marked inside with fine purple lines. The front of the flower has a 2-lobed upper lip and a 3-lobed lower lip. At the mouth of the flower is a large sterile stamen with bright yellow hairs.

May—July

Habitat/Range: Dry or rocky woods, prairies; common in the south ½ of Illinois.

Remarks: Various members of the genus *Penstemon* have been used by Native American Indians in the form of root tea for treating chest pains, stomachaches, and to stop vomiting. Parts of the plant were used by the Navahos to treat burns, toothache, snakebite, eagle bite, and backache.

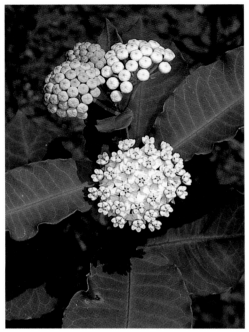

WHITE MILKWEED
Asclepias variegata
Milkweed Family (Asclepiadaceae)

Description: This attractive large-flowering milkweed has a stout purple stem up to 3' tall. The leaves, about 5" long, are opposite on the stem but some may be whorled. The leaf base tapers to a stalk, and the leaf margins are smooth but often wavy. The large vein running the length of the leaf is yellow and sometimes red. The flowers are in clusters of 1–4. The 5 white petals are turned back, revealing purple markings at their base. The 5 cup-like hoods in the center are characteristic of milkweeds. The sap is milky.

May—July

Habitat/Range: Dry or rocky woods; occasional; restricted to the south ¼ of the state.

Remarks: Also called "variegated milkweed," it is the only milkweed in the state with bright white flowers with purple centers, which makes this a particularly showy milkweed.

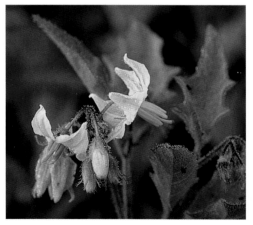

HORSE NETTLE
Solanum carolinense
Nightshade Family (Solanaceae)

Description: An upright, branched plant with spiny stems up to 3' tall. The leaves, up to 6" long, are alternate, pointed at the tips, and tapering at the base. The leaf margins are wavy with deep lobes and spines along the veins on the underside and along the leaf stalk. The flowers are few, loosely clustered at the end of stalks, and about ¾" across. The 5 petals are united at the base. There are 5 large, bright yellow stamens. The fruit, about ⅔" in diameter, is a smooth yellow berry, like a tiny tomato, which persists through the winter.

May—October

Habitat/Range: Open woods, waste ground, cultivated fields, and roadsides; in every county.

Remarks: Horse nettle and other nightshades are closely related to tomatoes and eggplant. However, the attractive bright yellow berries are toxic, and fatalities have been reported in children. Native American Indians gargled wilted leaf tea for sore throats, applied wilted leaves to the skin for poison ivy rash, and drank tea for worms. There are 10 species in the genus *Solanum* in Illinois, two of which are native to the state.

WHITE SWEET CLOVER
Melilotus officinalis
Pea Family (Fabaceae)

Description: This legume, depending on conditions, grows as an annual or biennial. The branching, smooth stems can be found up to 7' tall. The leaves are alternate, divided into 3 leaflets, with each leaflet about 1" long, oval, rounded at the tip, and finely toothed. The flowers are white or yellow, fragrant and clustered on 4" stalks, and each is about ⅜" long.

May—November

Habitat/Range: Disturbed ground; can invade prairies and glades; native to Europe; in every county.

Remarks: Formerly known as *Melilotus albus*. This weedy plant is highly drought resistant and has spread from its intended use as hay, pasture, and green manure. It is also a popular honey plant by beekeepers. The leaves have a sweet vanilla-like odor when crushed. The young leaves, before the flowers appear, can be added to salads or boiled for 5 minutes and used as cooked greens. The pea-like fruits can be used to flavor soups and stews. The dried leaves can be used as a vanilla-like flavoring for pastries.

WILD CARROT
Daucus carota
Carrot Family (Apiaceae)

Description: A biennial with a large taproot and stout, branching, hairy stems to 4' tall. Both basal and stem leaves are large and finely divided on long hairy stalks. Tiny white flowers are tightly grouped in clusters, which in turn form a larger umbrella-shaped cluster about 4" across. In the center, there is often 1 purple flower. As the flowers fade, the feather-like stalks curl into a tight bird nest shape supporting numerous oval, bristly, dried fruits that are up to ⅛" long.

May—October

Habitat/Range: Fields, waste ground, roadsides, and disturbed prairies; native to Europe; common throughout the state.

Remarks: Another name "Queen Anne's lace," refers to Anne of Denmark, wife of James I, who loved fine clothes and lace. Wild carrot is the ancestor of the cultivated carrot. Its root is white, instead of orange, due to a lack of beta carotene. It does, however, contain provitamin A carotene and vitamins C and B complex. The first-year roots have been eaten raw or boiled as a vegetable, but care must be taken not to mistake the leaves for that of poison hemlock, which has smooth leaf stalks. Root tea has been used as a diuretic, to prevent and eliminate urinary stones and intestinal worms.

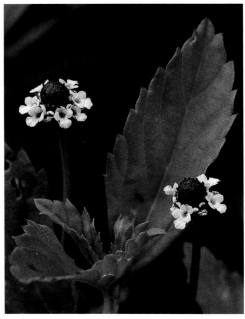

FOG FRUIT
Phyla lanceolata
Vervain Family (Verbenaceae)

Description: These moist-soil-loving plants mostly creep along, rooting at the nodes (point of leaf attachment to the stem), up to 1½' long. The leaves are opposite, up to 2" long, lance-shaped, pointed at the tip, and coarsely toothed along the margin. Several flowers, less than ¼" long, are clustered on small heads that emerge from the axils of leaves on long stalks. The 4 petals are more or less united into a pair of 2-lobed lips. The flowers are white, with some showing pink or purple.

May—September

Habitat/Range: Wet soil of ponds, ditches, low meadows; common; in every county.

Remarks: Also known as *Lippia lanceolata*. This plant is also known as "frog fruit." The small seeds are a source of food for waterfowl.

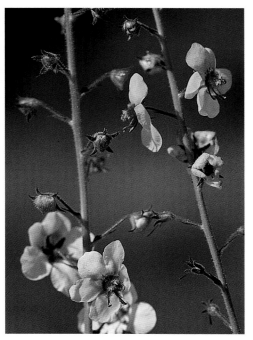

MOTH MULLEIN
Verbascum blattaria
Figwort Family (Scrophulariaceae)

Description: A biennial plant with a slender form up to 5' tall. The stem is either single or branched, and is smooth on the lower part with round gland-tipped hairs above. The leaves at the base are large, tapering to the base, and toothed along the margins. The leaves along the stem are smaller, alternate, and somewhat clasping or simply lacking a stalk. The flowers, about 1" across, are loosely spaced along the branch. The 5 petals are either white or yellow with 5 stamens displaying woolly filaments that are violet to reddish brown.

May—September

Habitat/Range: Pastures, fields, roadsides and other disturbed sites; native to Europe; scattered throughout the state.

Remarks: Both white- and yellow-flowering moth mulleins appear equally as common. Looking at the flower, with some imagination, one may see a moth, hence the common name; others say it is because the flowers attract moths.

HEDGE BINDWEED
Calystegia sepium
Morning Glory Family (Convolvulaceae)

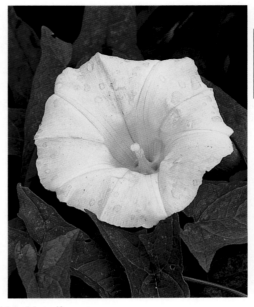

Description: A twining vine that creeps along the ground or climbs with branching stems up to 9' long. The leaves, up to 4" long, are alternate along the stem and triangular with 2 squarish lobes at the base. The long-stalked flowers arise singly from leaf axils. The flowers are funnel-shaped, large (up to 2½" across), and white to pink in color.

May—September

Habitat/Range: Moist soil, fields, roadsides, disturbed ground; probably in every county.

Remarks: Formerly known as *Convolvulus sepium*. On sunny days the flowers close by midday. The pulpy roots have historically been used as a purgative—a medicine stronger than a laxative; also to treat jaundice and gall bladder ailments.

WILD POTATO VINE
Ipomoea pandurata
Morning Glory Family
(Convolvulaceae)

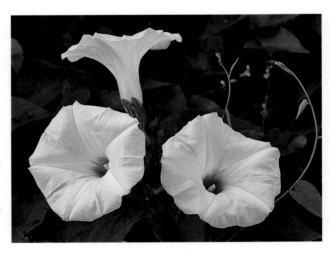

Description: A trailing or climbing vine 10–15' long. The leaves are alternate, heart-shaped, smooth, and up to 6" long and nearly as wide. The leaf veins, margins, and leaf stalk are often purplish. There are 1–7 flowers on long stalks that emerge at the junction of the leaf and stem. The flowers are funnel-shaped, about 3" wide, with red or purple centers. The flowers close about midday.

May—September

Habitat/Range: Fields, low ground along streams, borders of lakes, roadsides, fencerows; occasional to common in the south ¾ of Illinois, less common elsewhere.

Remarks: The large root, which can weigh over twenty pounds, was used as a food source by Native American Indians. The root was heated and applied to the skin to treat rheumatism and "hard tumors." Root tea was used by settlers as a diuretic and a laxative, and for treating coughs, asthma, and the early stages of tuberculosis. Since the root is a strong laxative when eaten raw, it was often boiled like a potato to neutralize its effect before consuming. The taste is said to be somewhat bitter.

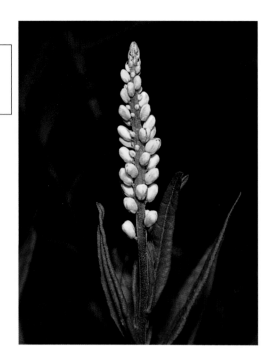

SENECA SNAKEROOT
Polygala senega
Milkwort Family (Polygalaceae)

Description: Several stems emerge from one base, up to 20" tall. The leaves are alternate along the stem and up to 3½" long and less than 1" wide, the lower progressively smaller. The small, white flowers, about ⅛" wide, are clustered along the upper part of the stem.

May—September

Habitat/Range: Wooded slopes and prairies; occasional in the north ¾ of the state, absent elsewhere.

Remarks: Seneca snakeroot was used by North American Indians to treat snakebite, hence the common name. A root tea was used for respiratory ailments.

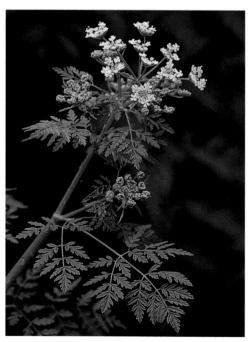

POISON HEMLOCK
Conium maculatum
Carrot Family (Apiaceae)

Description: A robust biennial with large, highly dissected leaves, reaching a height of up to 9'. The branching, furrowed stems are smooth with purple spots and hollow centers. The leaves are up to 14" long, highly dissected into numerous leaflets, and almost fern-like. The numerous flowers are produced in loose, flat-topped clusters 4–5" across.

May—August

Habitat/Range: Disturbed soil, low ground, pastures, fields, roadsides; native to Europe; occasional; throughout Illinois.

Remarks: This is the infamous plant that was used to put Socrates to death in 399 B.C. All parts of the hemlock, especially the green, almost ripe seeds, are deadly poisonous and may also cause contact dermatitis.

44

COW PARSNIP
Heracleum maximum
Carrot Family (Apiaceae)

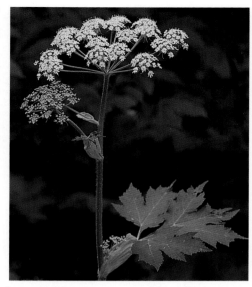

Description: A tall, stout, hairy-stemmed plant, up to 6', with large alternate, compound leaves with stalks that clasp the stem at their wide papery bases. Each leaf is divided into 3 or more lobed leaflets up to 15" long and about as wide, with teeth along the margins. Flowers are in flat umbrella-like heads up to 10" across, with 15–30 clusters in each head. Each flower is about ¼" across with 5 petals that are often notched at the tips.

May—August

Habitat/Range: Low, moist woods, roadsides; occasional in the north ⅔ of the state, rare elsewhere.

Remarks: Also called *Heracleum lanatum*. Native American Indians used the stalks as a food source and root tea was used for colds, cramps, headaches, sore throats, colds, coughs, flu; applied externally for sores, bruises, and swellings. The foliage is poisonous to livestock and the sap can cause blisters when handled by some people.

GOAT'S BEARD
Aruncus dioicus
Rose Family (Rosaceae)

Description: A bushy plant with showy branching plumes that reaches a height of 6'. The single stalk is smooth with few but very large leaves to 20" long. The compound leaves are divided into 5–7 leaflets. The lower leaflets may be further divided. Each leaflet is pointed at the tip and finely toothed along the margin. The flowers are numerous, small, about ¹⁄₁₆" across, and appear in plume-like clusters. The male and female flowers occur on separate plants. All flowers have 5 petals and 5 sepals, but the male flowers have 15 or more stamens, and the female flowers have 3 pistils and 15 or more incompletely developed stamens.

May—June

Habitat/Range: Moist woods, along lower wooded slopes, at the bases of bluffs; occasional throughout the state; absent in the northeast counties.

Remarks: Although the male and female flowers are on separate plants, they are easily distinguished by the showier stamens on the male plant. The foliage turns yellow in the fall. The somewhat scraggly appearance of the spikes of flowers account for the plant's common name. The Cherokee applied pounded root on bee stings. Root tea was used to diminish bleeding after childbirth and to reduce profuse urination. Tea was also used externally to bathe swollen feet.

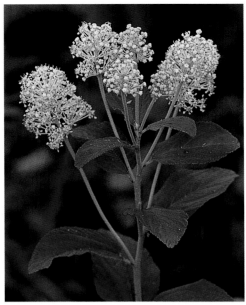

NEW JERSEY TEA
Ceanothus americanus
Buckthorn Family (Rhamnaceae)

Description: A small shrub, up to 3' tall, with spreading branches. The stem is woody with greenish-brown bark that becomes brown and flaky on older stems. The upper branches are mostly herbaceous, often dying back in winter. The leaves are alternate, up to 4" long and 2½" wide. The leaf margin is toothed, the upper leaf surface is hairy, and the lower leaf surface is gray and velvety hairy. The leaf stalks are about ½" long. The flowers are on branched clusters arising on long stalks from the base of leaves. The 5 petals are hooded, usually notched, each resembling a miniature ladle. There are 5 white stamens.

May—August

Habitat/Range: Woodlands, moist to dry prairies; occasional throughout the state.

Remarks: The leaves were used by Native American Indians to make a tea. Tribes along the Atlantic Coast probably taught the colonists the use of New Jersey tea, which was used as a patriotic substitute for black tea during the American Revolution after tea was dumped in Boston Harbor. Native Americans also used a root tea for treating colds, fevers, snakebites, stomach disorders, diarrhea, lung ailments, constipation, and as a blood tonic.

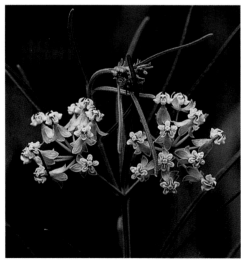

HORSETAIL MILKWEED
Asclepias verticillata
Milkweed Family (Asclepiadaceae)

Description: Slender plants, sparingly branched, up to 2½' tall, with milky sap. The soft, thread-like leaves, up to 2" long, are mostly in whorls along the stem. The flowers are arranged in clusters of 2–14, with less than 20 flowers in each cluster. There are 5 greenish-white petals and, in the center of the flower, 5 white hoods. The seedpods are smooth, narrow, and about 3" long.

May—September

Habitat/Range: Dry open woods, prairies, fields, pastures; occasional to common throughout the state.

Remarks: A tea from the whole plant was given to Lakota mothers unable to produce milk. The theory behind this practice is similar to the medieval concept of the doctrine of signatures, the belief that certain characteristics of a plant signify its uses. In this case, the milky sap was thought to signify that the milkweed would promote the production of milk. This milkweed is poisonous to cattle but is rarely taken in enough quantity to cause problems.

WILD QUININE
Parthenium integrifolium
Aster Family (Asteraceae)

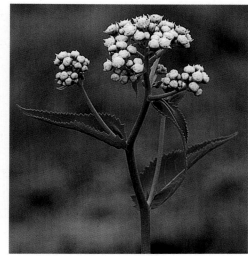

Description: The sometimes branched stems are smooth in the lower portion and rough with a few hairs in the upper portion and up to 3' tall. The leaves at the base of the stem are up to 8" long and 4" wide and taper into long stalks; the stem leaves are alternate, smaller, lacking stalks, hairy, and toothed along the margin. The flowers are numerous in flat-topped or slightly rounded clusters. Each individual flower head is ⅓" wide, with 5 tiny petal-like ray flowers with stamens that surround a thick head of sterile disk flowers.

May—September

Habitat/Range: Dry woodlands, prairies, glades; common throughout the state.

Remarks: This plant is also known as "American feverfew." The flowering tops of wild quinine were once used for intermittent fevers like malaria. This plant served as a substitute when the tropical supply of quinine from the bark of the cinchona tree was cut off during World War I. The roots were used as a diuretic for kidney and bladder ailments. One study suggests that wild quinine may stimulate the immune system. The plant may cause dermatitis or allergies in some people. A similar species, *Parthenium hispidum*, has somewhat shorter stems with noticeable spreading rough hairs, and long hairs on the lower surfaces of the leaves. Found on dry open woods, prairies; scattered in Illinois.

WHITE AVENS
Geum canadense
Rose Family (Rosaceae)

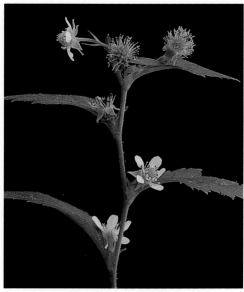

Description: Often several slender stems emerge from the base to form spreading branches to 2½' tall. The leaves at the base are on long stalks with the leaf margins sometimes cut into 3–5 deep lobes. The stem leaves have 3 leaflets and have a very short stalk or are stalkless. The leaf margins are toothed and the tip pointed. The basal leaves are green all winter. The flowers are few, on velvety stalks. The 5 white petals are interspersed with 5 green sepals. Stamens are from 10 to many. The fruit has numerous hooked ends that attach to clothing and fur, which aids in the plant's dispersal.

May—September

Habitat/Range: Moist or rocky woods on hillsides, in valleys along streams, and in ravines; common throughout the state.

Remarks: The leaves are browsed by white-tailed deer, and wild turkeys eat the seeds in fall and winter.

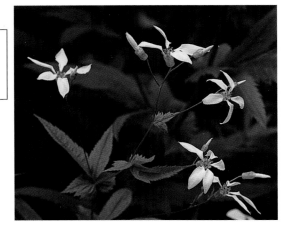

INDIAN PHYSIC
Gillenia stipulata
Rose Family (Rosaceae)

Description: A leafy, branching plant with thin soft-hairy stems to 3' tall. The basal leaves are divided several times into small leaflets and appear fern-like. The leaves along the stem appear to be divided into 5 leaflets, but the bottom 2 are actually large, leaf-like stipules. The leaflets are lance-shaped, sharply toothed, and up to 3" long. The flowers are on long stalks with 5 very narrow, spreading petals and about 20 stamens.

May—July

Habitat/Range: Dry woods; occasional in the south ½ of the state; also LaSalle County.

Remarks: Formerly known as *Porteranthus stipulatus*. Another common name is "American ipecac." Both common names refer to Native American Indian use of this plant for internal cleansing, a widespread ceremonial custom. An "ipecac" is an emetic (an agent that causes vomiting), in this case derived from certain dried roots. The roots are potentially toxic. The foliage is attractive in fall, varying from yellow to red.

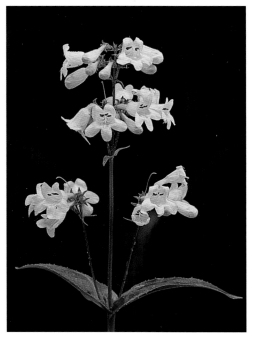

FOXGLOVE BEARDTONGUE
Penstemon digitalis
Plantain Family (Plantaginaceae)

Description: A sturdy, shiny plant with unbranched stems to a height of 4' tall. The basal leaves are on long stalks and arranged in a rosette. The stem leaves are up to 4" long, opposite, without stalks, with their edges curved inward and toothed. The flowers are on spreading branched stalks at the top of the stem. The white tubular flowers are ¾–1¼" long with 2 upper lobes and 3 lower lobes. There are purple lines running down the white throat of the flower.

May—July

Habitat/Range: Woods, prairies, fields, roadsides; common throughout the state.

Remarks: The common name "foxglove" and the species name *digitalis* refers to the similarity of the flower to *Digitalis purpurea*, the foxglove from England used to treat heart ailments.

PURPLE MEADOW RUE
Thalictrum dasycarpum
Buttercup Family (Ranunculaceae)

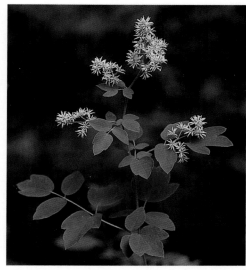

Description: A stout-stemmed plant to 5' tall, with the stem sometimes purplish, with compound leaves. The leaves are divided into numerous leaflets, each up to 2" long with 3 pointed lobes at the tip. The flowers are in branching clusters with male and female flowers on separate plants. There are no petals, and the sepals drop early. The male flowers have many showy thread-like stamens; the female flowers have a bur-like head of pistils.

May—June

Habitat/Range: Moist wooded ravines, stream banks, moist prairies; occasional; scattered throughout the state.

Remarks: The Dakota broke off fruits when they were approaching maturity and stored them away for their pleasant odor, later rubbing and scattering them over their clothing. The hollow stems were used by small boys to make toy flutes. The Pawnees used this plant as a stimulant for horses, by mixing plant material with a certain white clay and applying it as a snuff on the muzzle of the horse. This was done when making forced marches of three or more days' duration in order to escape enemies. A related species, waxy meadow rue, *Thalictrum revolutum*, occurs in similar habitats. The leaves have a bad odor when crushed and have gland-tipped hairs on their undersides. Another, early meadow rue, *Thalictrum dioicum*, also occurring in similar habitats, has middle and upper leaves on stalks; leaflets with 3–12 lobes, and their margins have rounded teeth.

WHITE PRAIRIE CLOVER
Dalea candida
Pea Family (Fabaceae)

Description: A finely leaved plant having a single or few stems arising from a common base, up to 2' tall. The leaves are smooth, divided into typically 7 narrow leaflets, each up to 1¼" long and less than ¼" wide. The flowers are crowded into cylindrical spikes 1–3" long at the tops of the stems. The small flowers, each about ¼" long, bloom first at the bottom and progress upwards along the column, forming a skirt of white petals.

May—October

Habitat/Range: Prairies, open woodlands; occasional throughout Illinois.

Remarks: Formerly known as *Petalostemon candidum*. White prairie clover is sensitive to disturbance, especially grazing; its presence, in addition to other highly selective plants, is an indicator of high-quality habitat. Some Native American Indians used the leaves for tea. The Ponca chewed the root for its pleasant taste. The Pawnee used the tough, elastic stems to make brooms. They also drank root tea to keep away disease.

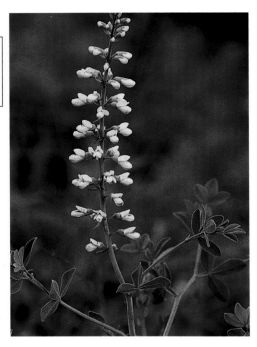

WHITE WILD INDIGO
Baptisia alba var. *macrophylla*
Pea Family (Fabaceae)

Description: A smooth, shrubby plant to 5' tall, although sometimes taller, often with a thin white coating on the stem and leaves. The branched stems have alternate leaves that are each divided into 3 leaflets, 1–3" long, that are round at the tip and tapering at the base. Stems emerge above the leaves with showy white flowers, each about 1" long, having the structure of other flowers typical of the pea family.

May—August

Habitat/Range: Prairies, streamsides, fields, pastures, roadsides; occasional to common throughout the state.

Remarks: Formerly known as *Baptisia leucantha*. These deep-rooted plants can persist in converted pastures and fields long after native prairie has been destroyed. Plants in the genus *Baptisia* have been used medicinally by Native American Indians and settlers as a tea for internal cleansing and externally for treating skin wounds. White wild indigo has been known to poison cattle if eaten in large quantities.

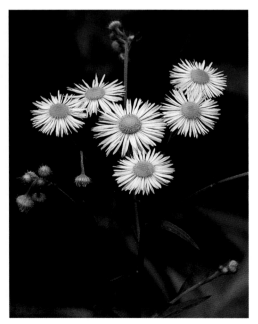

DAISY FLEABANE
Erigeron strigosus
Aster Family (Asteraceae)

Descriptions: An annual or rarely biennial plant with hairy stems to 2½' tall, with small daisy-like flowers. All leaves are narrow, less than 1" wide; the basal leaves are toothed and on stalks, while the stem leaves are alternate, without teeth, and stalkless. The flowers are in spreading clusters at the top of branched stems. The flower heads are about 1" across with over 40 white, thread-like, ray flowers surrounding a yellow center of densely packed disk flowers.

May—September

Habitat/Range: Open woods, dry prairies, fields, pastures, roadsides, disturbed areas; common throughout the state.

Remarks: A related species, annual fleabane, *Erigeron annuus*, has spreading, rigid hairs on the stem and wider, sharply toothed leaves; occurring in similar habitats in every county. Annual fleabane was used by the Lakota to make a tea to treat children with sore mouths and adults who had difficulty urinating.

YARROW
Achillea millefolium
Aster Family (Asteraceae)

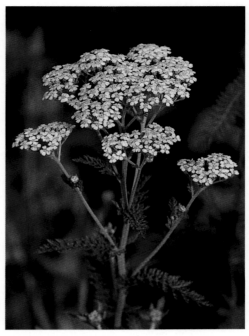

Description: Unbranched, strongly scented, hairy plants to 2' tall, with alternate fern-like leaves and flat-topped flower clusters. The lower leaves are up to 10" long on stalks; the upper leaves are smaller and without stalks. Numerous flower heads are arranged in a branching, flat-topped flower cluster. Each head is about ¼" across with 4–6 white ray flowers surrounding a central disk of up to 20 yellow disk flowers.

May—October

Habitat/Range: Fields, roadsides, pastures, disturbed sites; native to Eurasia as well as North America; common; in every county.

Remarks: Also called milfoil, fossil records reveal yarrow pollen in Neanderthal burial caves. More recently, yarrow has been used in a wide variety of medicinal treatments by at least 58 Native American Indian tribes as a stimulant, laxative, painkiller, diuretic, wound healer, antiseptic, and tonic, to name a few.

OX-EYE DAISY
Leucanthemum vulgare
Aster Family (Asteraceae)

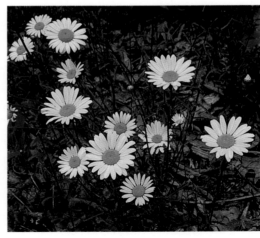

Description: Plants are often multi-stemmed to 2½' tall, displaying a bouquet-like arrangement of attractive daisies. The basal leaves are round to spoon-shaped, toothed, and on stalks; the stem leaves are narrow, deeply cut, and lack stalks. The flower heads are up to 2" across with about 30 white ray flowers surrounding a central disk of numerous bright yellow tubular disk flowers.

May—August

Habitat/Range: Fields, pastures, roadsides; native to Europe; common throughout Illinois.

Remarks: In the lore of ancient Greece, ox-eye daisy was considered a sacred plant to the soldiers of Artemis (the hunter-goddess of the moon and women). The practice of picking the petals (ray flowers) one by one, to find if one is loved or not, dates back to medieval times. The plant has been used for treating gastritis, enteritis, diarrhea, and infections of the upper respiratory tract. It has also been used externally for skin disorders, wounds, and bruises. In Europe, the young leaves are used in salads and soups.

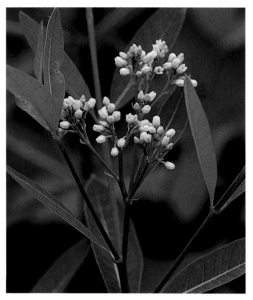

INDIAN HEMP
Apocynum cannabinum
Dogbane Family (Apocynaceae)

Description: The shrub-like plants are up to 4' tall with reddish stems, milky sap, and upright leaves with white to red veins. The leaves are opposite, stalked, widest at the middle, pointed at the tip, with smooth margins, and up to 6" long and 3" wide. The flower clusters are usually overtopped by the side branches. The flowers are small, less than ¼" wide, and bell-shaped with 5 tiny lobes. The seedpods are in pairs, slender, long-pointed at the tip, and up to 6" long, with seeds that have silky hairs attached at one end.

May—August

Habitat/Range: Open woods, prairies, fields, pastures, and roadsides; common; in every county.

Remarks: Indian hemp fibers have been found in fabric from the early Archaic period, from 3,000–5,000 years ago. The fibers were also used for rope and nets. Root tea was used to treat colds, dropsy, fevers, headaches, and sore throats. The Blackfeet used the tea as a laxative and as a wash to prevent hair loss. The Kiowas made chewing gum from the milky latex of the sap by letting it harden. Another species, prairie Indian hemp, *Apocynum sibiricum*, has stalkless leaves; occupies similar habitats; found throughout the state. And another species, spreading dogbane, *Apocynum androsaemifolium*, has pink or pink tinged flowers, rarely white; found in woods, prairies; scattered in the north ½ of the state.

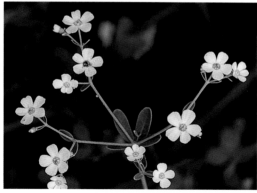

FLOWERING SPURGE
Euphorbia corollata
Spurge Family (Euphorbiaceae)

Description: A smooth, leafy plant, up to 3' tall, usually single stemmed, with milky sap and widely branching flower clusters. The narrow, smooth-edged leaves are alternate on the lower stem but opposite or whorled near the flower clusters. The flower heads are numerous, about ⅓" across, with 5 chalky white false petals surrounding a cup of tiny yellow male flowers and a single female flower. The fruit is a 3-parted ball on a tiny stalk.

May—October

Habitat/Range: Open woods, prairies, fields, pastures, and roadsides; common; in every county.

Remarks: Native American Indians used a leaf or root tea to treat chronic constipation, rheumatism, and diabetes. The root was mashed and applied to the skin to treat snakebites. The flowers, fruits, and leaves are eaten by wild turkey. The seeds are eaten by bobwhite quail and mourning doves.

LEAFCUP
Polymnia canadensis
Aster Family (Asteraceae)

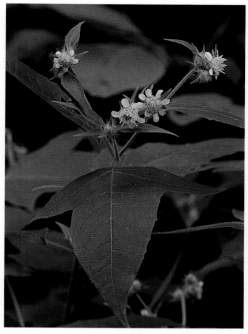

Description: A tall, very hairy, branching plant to 5' in height, with large, soft leaves that are aromatic when crushed. The leaves are opposite, 3–5 lobed, with small teeth scattered along the margin. The base of the leaf tapers onto the upper part of the leaf stalk. The flower heads are few, small, with 5 white ray flowers, usually 3-lobed, that surround the yellow disk flowers.

May—October

Habitat/Range: Moist woods on slopes; common throughout the state.

Remarks: A related species, bear's foot, *Smallanthus uvedalius*, formerly *Polymnia uvedalia*, has yellow ray flowers, leaf tissue that extends down the length of the leaf stalk, and leaves that are 3-lobed. Found in moist woods; occasional in southern Illinois, extending north to St. Clair County; also Vermilion County.

CLEAVERS
Galium aparine
Madder Family (Rubiaceae)

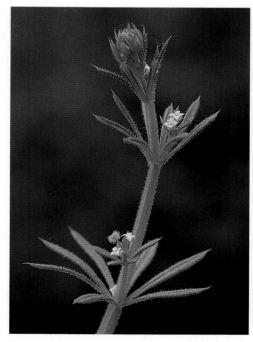

Description: A spreading, sprawling annual plant with a 4-sided stem. The leaves occur along the stem in whorls of 6–8, each about 2" long and very narrow. The stem and leaves have recurved hairs that cling (cleave) to animal hair as well as the clothing of hikers, hence the name. The small white flowers have 4 petals and are attached on long stalks arising from leaf axils.

May—July

Habitat/Range: Moist woods, shaded disturbed areas; common throughout the state.

Remarks: The other common name "bedstraw," refers to settlers' use of the aromatic plants as "hay" to fill bedding. There are 16 species in the genus *Galium* in Illinois, all of which have in common the whorls of leaves along the stem and small, 4-petaled flowers.

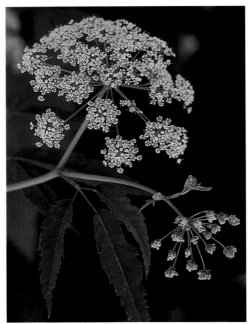

WATER HEMLOCK
Cicuta maculata
Carrot Family (Apiaceae)

Description: A biennial plant up to 6' tall with several branches holding umbrella-shaped clusters of tiny white flowers. The stem is streaked or spotted with purple and is hollow toward the base. The leaves are alternate on the stem, up to 12" long, and divided into numerous, sharply toothed leaflets. The umbrella-shaped flower heads contain tiny 5-petaled, white flowers, each less than ⅛" wide.

May—September

Habitat/Range: Marshes, wet prairies, low ground along streams, wet ditches; common; throughout the state.

Remarks: This plant is highly poisonous. Members of many Native American tribes used the roots to commit suicide. Children have been poisoned by using the hollow stems as peashooters. A walnut-sized piece of the root is enough to kill a cow. The closely related bulblet water hemlock, *Cicuta bulbifera*, has narrow leaves with the upper leaves bearing small bulbs in some of their axils; found in marshes, borders of lakes and ponds; not common; north ½ of Illinois; also Union and Washington counties.

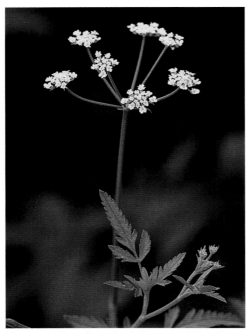

HEDGE PARSLEY
Torilis arvensis
Carrot Family (Apiaceae)

Description: A hairy, much-branched plant up to 2½' tall. The leaves are finely dissected and resemble parsley. The small flowers occur in flat-topped clusters on long stalks that extend well above the leaves. The fruit is densely covered with bristles that attach to clothes and fur.

June—August

Habitat/Range: Disturbed sites and fields, and along roadsides and railroads; native to Europe; common; throughout Illinois.

Remarks: A similar species, Japanese hedge parsley, *Torilis japonica*, has several leaf-like structures below each flower cluster while hedge parsley has none or one; also the fruit on the former has small prickles with hooks while the latter has straight prickles. Japanese hedge parsley also occupies disturbed sites; native to Europe; occasional throughout the state.

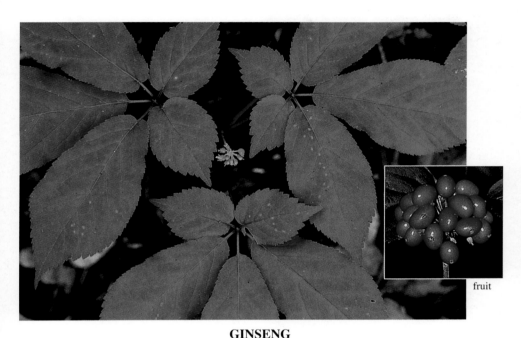

fruit

GINSENG
Panax quinquefolius
Ginseng Family (Araliaceae)

Description: Plants up to 2' tall with a whorl of 3–4 leaves, each divided into 5 stalked leaflets. A leafless stem arises from the ground supporting a cluster of small, greenish-white flowers. Bright red berries develop in late summer.

June—July

Habitat/Range: Moist woods; occasional throughout the state.

Remarks: The roots of ginseng have long been known to have medicinal properties that aid in mental efficiency and physical performance. However, large doses are said to raise blood pressure. Over-collecting of the roots has decreased populations over many areas which has led to harvest regulations and quotas nationwide.

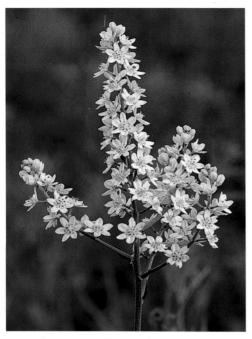

BUNCHFLOWER
Melanthium virginicum
Lily Family (Liliaceae)

Description: Erect, stout plants up to 5' tall, with long grass-like leaves at the base, which alternate up the stem. The leaves are up to 20" long and up to 1" wide, with upper leaves being much shorter. The flowers occur along branches at the top, up to 18" tall. Individual stalked flowers are ½–1" across, with 6 creamy white petals.

June—July

Habitat/Range: Moist prairies; rare in the west and southwest counties, absent elsewhere; classified as state threatened.

Remarks: Also known as *Veratrum virginicum*. The towering plumes of white flowers are very conspicuous in open areas making their identification from a distance very easy. The roots and stems are poisonous to livestock, and the root has been used to kill intestinal parasites. The flower turns black with age.

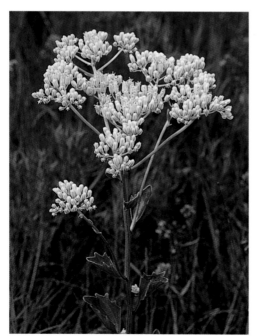

PRAIRIE INDIAN PLANTAIN
Arnoglossum plantagineum
Aster Family (Asteraceae)

Description: This plant has large distinctive leaves at the base and a flowering stalk up to 5' tall but usually less. The single stem is smooth and angled and grooved along the surface. The leaves along the stem are few, alternate, small, and lack teeth along the margins. The basal leaves are large with parallel veins and long leaf stalks. The flower heads are numerous in open branches forming a flat-topped cluster. Each head is up to 1" tall, containing 5 white tubular flowers.

June—August

Habitat/Range: Prairies, fens, marshes; not common; widely scattered in the state.

Remarks: This species was formerly known as *Cacalia tuberosa*. Native American Indians applied mashed leaves to the skin to treat cancers, cuts, and bruises, and to draw out blood or poisonous substances.

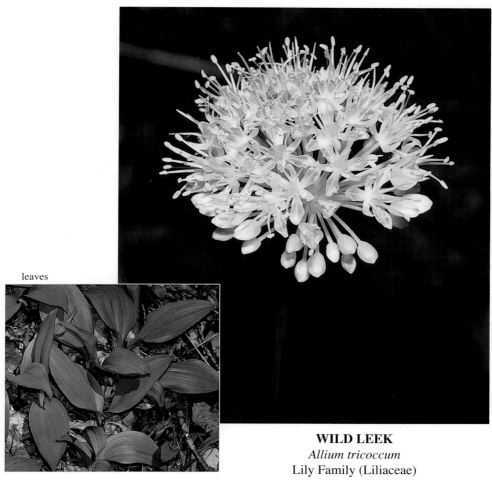

leaves

WILD LEEK
Allium tricoccum
Lily Family (Liliaceae)

Description: An onion odor is detected with this plant along with its pair of leaves arising at its base that are about 6" long and 1½" wide. The leaves have reddish stalks and appear in the spring only to wither away before flowering time. The numerous white flowers are clustered at the tops of bare stems, which are up to 18" tall.

June—July

Habitat/Range: Moist woods; occasional in the north ½ of the state, rare elsewhere.

Remarks: Also called "wild ramp," the onion-like flavor of the leaves and bulbs have a long history of being eaten by North American Indians and pioneers, as well as modern day enthusiasts.

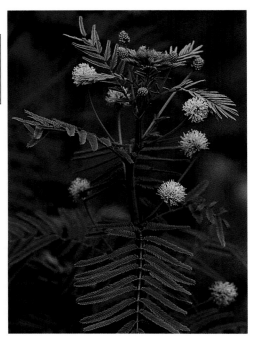

ILLINOIS BUNDLEFLOWER
Desmanthus illinoensis
Pea Family (Fabaceae)

Description: Smooth, bushy plants to 4' tall. The angled stem supports alternate, highly dissected leaves with numerous paired leaflets that appear fern-like. At the axils of the leaves, slender stalks emerge that support small, round flower clusters about ½" across. The fine, long stamens projecting from each flower give the cluster a fuzzy appearance. The fruit is a round cluster up to 1½" across with twisted or curved pods with 2–6 smooth seeds in each pod.

June—August

Habitat/Range: Prairies, moist soil, roadsides, pastures; occasional throughout the state except for the northwest counties.

Remarks: The children of some tribes used the dried seed pods as rattles. The boiled leaves were used by the Pawnee as a wash to relieve itching. The leaves and seeds are considered an important source of protein for wildlife and livestock.

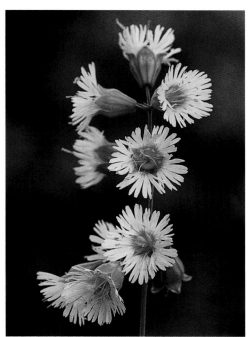

STARRY CAMPION
Silene stellata
Pink Family (Caryophyllaceae)

Description: Several stiff, slender stems emerge from the base to 3' tall. The leaves are in whorls of 4 along the stem with pointed tips and up to 3" long. Showy bell-shaped flowers with fringed margins open to ¾" across.

June—October

Habitat/Range: Open woods, prairies; occasional throughout the state.

Remarks: The lacy fringe of the petals produces the "starry" appearance from which the common name is derived. The Potawatomi and Mesquakie tribes used the roots as a poultice (plant material mashed and applied warm) to dry up infected sores. Starry campion is related to the carnations and pinks familiar to flower gardeners.

HORSEWEED
Conyza canadensis
Aster Family (Asteraceae)

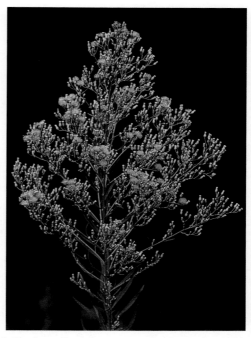

Description: A tall annual with a single stem to a height of 7' tall. The slender leaves, up to 3" long and ⅜" wide, are alternate along the stem and hairy. The flower heads are small and numerous.

June—November

Habitat/Range: Disturbed soil, fields, roadsides; very common; in every county.

Remarks: Formerly called *Erigeron canadensis*. Native American Indians and settlers boiled the leaves and drank the liquid to treat dysentery. An oil obtained by distilling the plant has been used to treat diarrhea, hemorrhoids, and pulmonary problems. The pollen is an irritant to some hay fever sufferers, and the plant can cause skin irritation. A related species, dwarf fleabane, *Conyza ramosissima*, has stems thickly branched from near the base; purplish rays; less than 10" tall; occurs in disturbed soil; occasional throughout the state.

CANADA MILK VETCH
Astragalus canadensis
Pea Family (Fabaceae)

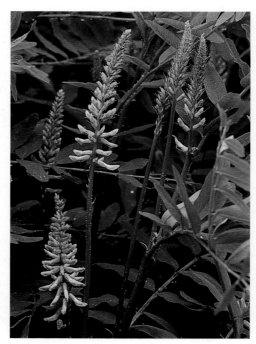

Description: Sturdy plant to 5' tall, with compound leaves alternating along the stem. The leaves are divided into 11–31 leaflets that are narrowly oval, smooth along the edges, and each 1–1½" long and ⅜–½" wide. The creamy white, ½" long flowers are crowded along a stalk that emerges above the leaves. The pods are numerous, crowded, erect, up to ¾" long.

June—August

Habitat/Range: Moist, open woods, banks of larger streams, moist thickets; occasional throughout the state.

Remarks: Young Omaha-Ponca boys used the stalks with persistent dry pods as rattles in games where they imitated the tribal dances. Milk vetches, in general, had a reputation for increasing a cow's or goat's milk yield.

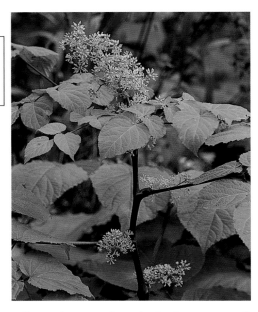

SPIKENARD
Aralia racemosa
Ginseng Family (Araliaceae)

Description: A bushy looking plant up to 5' tall and nearly as wide, with broad spreading leaves divided into large leaflets, each up to 6" long. Flowers are arranged in branched clusters. Each flower is about ⅛" wide with 5 greenish-white petals and 5 protruding stamens.

June—August

Habitat/Range: Moist woods and wooded ravines; occasional throughout the state.

Remarks: Spikenard can send rhizomes long distances, up to 50', to initiate new plants. Native American Indians used the spicy-aromatic roots to improve the flavor of other medicines. The unusual name, spikenard, comes from the Latin *spica*, a spike and *nardus*, an aromatic root.

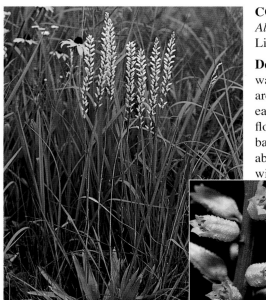

COLIC ROOT
Aletris farinosa
Lily Family (Liliaceae)

Description: A smooth, single-stemmed, wand-like plant, up to 2½' tall. The leaves are clustered at the base of the plant, with each strap-like leaf up to 8" long. The flowers are clustered at the top of a mostly bare stem. The white tubular flowers are about ¼" long, with 6 lobes and covered with a rough surface.

June—August

Habitat/Range: Moist, sandy prairies, sandy flats, open woods, marshes, roadsides; restricted to the north ⅓ of the state.

Remarks: The root was used to make a bitter tonic to treat indigestion and colic, and to promote appetite; also for rheumatism, diarrhea, and jaundice.

CULVER'S ROOT
Veronicastrum virginicum
Plantain Family (Plantaginaceae)

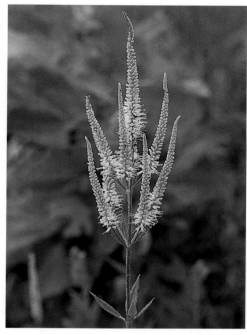

Description: A tall, graceful plant growing to a height of 6', with branching flower stems that resemble a candelabra. The leaves are in whorls of 3–8 and up to 6" long and 1" wide. The leaf margins are finely toothed. The flowers are in dense clusters on spikes 3–9" long. The stamens have noticeable yellow to brownish-red tips.

June—September

Habitat/Range: Moist prairies, open woods; occasional to common throughout the state.

Remarks: The Cherokee drank a root tea for treating backaches, fever, hepatitis, and typhus. The Seneca made a root tea to use as a mild laxative. For the Menomini, Culver's root served as a strong physic, a reviver, and as a means of purification when they had been defiled by the touch of a bereaved person. Early doctors used the root to treat a variety of ailments including liver disorders, pleurisy, and venereal diseases.

WOOLLY CROTON
Croton capitatus
Spurge Family (Euphorbiaceae)

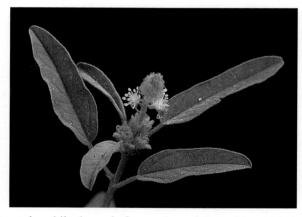

Description: Small, annual plants, up to 18" tall, with a dense woolly layer of tiny star-shaped hairs on the stems and leaves. The leaves are alternate, stalked, up to 4" long and 1" wide, smooth along the margins, and with rounded bases. The flowers are in short compact clusters near the ends of branches. Tiny male and female flowers are in each cluster. The female flowers lack petals, while the male flowers have 5 tiny white petals.

June—September

Habitat/Range: Sandy soil, glades, pastures, idle fields, and other disturbed areas; occasional in the south ½ of the state, less common in the north ½.

Remarks: Also called "hogwort," the oil is toxic, and cattle have been poisoned from eating hay containing the plants. A smaller species, prairie tea, *Croton monanthogynus*, has smaller leaves and flower clusters, and occurs in similar habitats, but it is less weedy; occasional in the south ½ of the state, rare in the north ½.

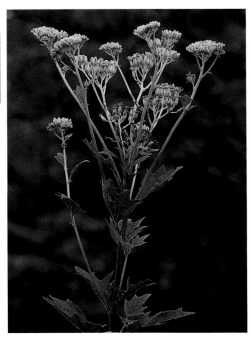

PALE INDIAN PLANTAIN
Arnoglossum atriplicifolium
Aster Family (Asteraceae)

Description: A plant with a smooth whitish cast and widely spaced leaves, growing to a height of 4–6' tall but sometimes to 8'. The leaves are alternate on the stem and have a whitish coating on the underside. The lower leaves are large and broadly triangular. Numerous flower heads form a somewhat flattened top with the flowers in the center of the cluster opening first.

June — October

Habitat/Range: Moist woods, dry open woods, prairies, dune slopes; occasional; throughout the state.

Remarks: Formerly known as *Cacalia atriplicifolia*. A closely related species, Indian plantain, *Arnoglossum reniforme*, formerly known as *Cacalia muehlenbergii*, differs by having the stem and leaves green (lacking a whitish coating) and having the lower leaves semicircular or lima-bean-shaped. Found in moist woods; not common; scattered in most of the state except for the northeast counties.

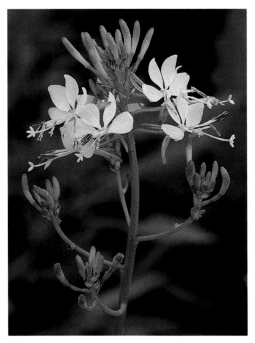

LARGE-FLOWERED GAURA
Oenothera filiformis
Evening Primrose Family (Onagraceae)

Description: A tall annual or biennial plant reaching a height of 7' tall, branching toward the top with curved hairs lying flat along the stems. The leaves are alternate on the stems, each up to 6" long, ⅜" wide, with widely spaced teeth along the margins, and fine silky hairs along both surfaces. The flowers are about 1" long and ¾" wide, with 4 white petals that fade to pink with age.

June — September

Habitat/Range: Open woods, prairies, old fields, roadsides, other disturbed sites; occasional throughout Illinois.

Remarks: Formerly known as *Gaura longiflora*. A closely related species, biennial gaura (*Oenothera gaura*, formerly known as *Gaura biennis*) is less than 6' tall, with straight hairs spreading away from the stem; found in similar habitat throughout Illinois.

EASTERN PRAIRIE-FRINGED ORCHID

Platanthera leucophaea
Orchid Family (Orchidaceae)

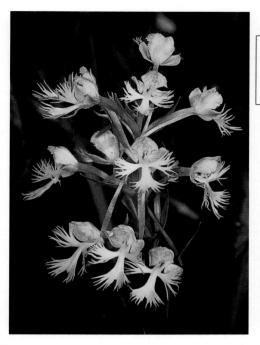

Description: A smooth, single-stemmed orchid, growing up to 2½' tall. The leaves are alternate along the stem, up to 10" long, and clasp the stem. Twenty or more flowers are located along the top of the stem, with each creamy white flower containing a hood above and a lower lip with 3-fringed lobes. A tube-like spur, about 2" long, points downward and away from the flower.

June—July

Habitat/Range: Moist to wet prairies; classified as state threatened; restricted to the north ⅔ of the state.

Remarks: Formerly known as *Habenaria leucophaea*. Once more common, eastern prairie-fringed orchid is federally listed as threatened, due to loss of prairie habitat across its range. The fragrant flowers are pollinated at night by hawk moths.

DODDER

Cuscuta spp. *(several species)*
Dodder Family (Cuscutaceae)

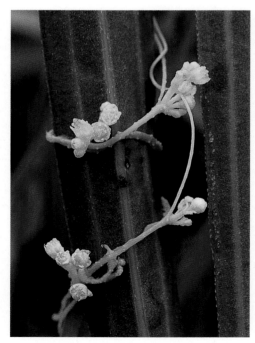

Description: Leafless plants, with stringy orange stems that twine around and over other plants. Since dodder lacks green chlorophyll, which is needed to produce food from sunlight, these parasitic plants attach to a host plant with special roots that penetrate the host plant's stem and absorb its nutrients. The flowers appear in dense clusters scattered along the stems. Each flower is small, about ¼" across, with 5 spreading white lobes.

June—October

Habitat/Range: Low wet woods, edges of streams, prairies, fields, thickets, and open ground; occasional to common depending on the species; some are found throughout the state.

Remarks: There are 10 species of dodder that occur in Illinois. All are difficult to identify. Most dodder species have specific host plants such as members of the aster family like goldenrods, asters, sunflowers, ragweeds, and fleabanes; also milkweeds, penstemon, alders, buttonbush, water willow, smartweed, and others.

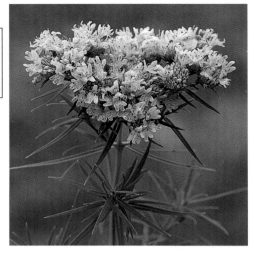

SLENDER MOUNTAIN MINT
Pycnanthemum tenuifolium
Mint Family (Lamiaceae)

Description: Aromatic plants with smooth, square stems growing to a height of 3'. The stem, with numerous pairs of leaves, branches toward the top. The narrow, pointed leaves are up to 2" long and ¼" wide. Flower heads are densely packed with small, 2-lipped flowers often with small purple spots.

June—September

Habitat/Range: Open woods, prairies, old fields, pastures, roadsides; occasional to common throughout the state.

Remarks: Native American Indians used mountain mint, with its alluring scent, to bait mink traps; also as a tea for treating a rundown condition. The tea has been used as a seasoning in cooking. Common mountain mint, *Pycnanthemum virginianum*, has slightly wider leaves and has hairs along the stem angles; occurs in marshes, fens, prairies; occasional to common in the north ½ of the state, less common southward. Hairy mountain mint, *Pycnanthemum pilosum*, has hairy stems and leaves; found in dry woods, prairies; occasional in central counties, less common to rare in the north and south counties.

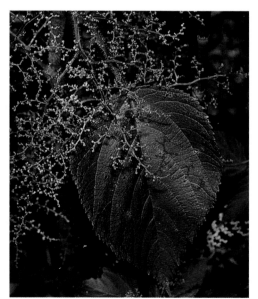

WOOD NETTLE
Laportea canadensis
Nettle Family (Urticaceae)

Description: An upright branched or unbranched plant with a somewhat zigzagged stem up to 3' tall. The stem and leaves have numerous stinging hairs. The alternate leaves are broad, up to 6" long, with coarse teeth along the margins. The tiny flowers are crowded into branched clusters; the male and female flowers are separate but on the same plant.

June—September

Habitat/Range: Wet or moist low woodlands, in valleys, and along streams; common throughout Illinois.

Remarks: Also called "stinging nettle." The stinging hairs contain formic acid, like that felt in the bite of an ant. One preventive measure when hiking in lowland woods is to wear thick material like fairly new blue jeans, which prevents the needle-like hairs from reaching the skin. Once stung, the juice from the soft stem of spotted touch-me-not or pale touch-me-not, when applied to the skin, can reduce the sting. A similar species, tall nettle, *Urtica gracilis* (formerly *dioica*), has opposite narrower leaves, with a single stem; found in moist woods, thickets; occasional to common in the north ½ of the state, rare in the south ½.

RATTLESNAKE MASTER
Eryngium yuccifolium
Carrot Family (Apiaceae)

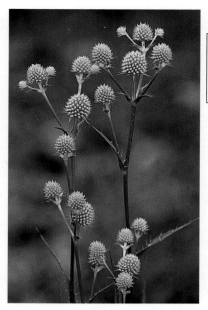

Description: This stout-stemmed plant can grow to a height of 5', with bluish-green leaves at the base that resemble a yucca. The leaves are up to 2' long, 1⅜" wide, with pointed tips, and small, soft, needle-like bristles scattered along the margin. The tiny flowers are tightly packed in round balls up to 1" across. Whitish bracts stick out sharply from the flowers, which gives the flower head a rough, prickly feel and appearance.

July—August

Habitat/Range: Open woods, prairies; occasional; throughout Illinois.

Remarks: The Mesquakies used the leaves and fruit in their rattlesnake medicine song and dance. They used the root for bladder problems and for treating poisons including rattlesnake bites. They also used the roots mashed in cold water to make a drink for relieving muscular pains.

PALE SMARTWEED
Persicaria lapathifolia
Smartweed Family (Polygonaceae)

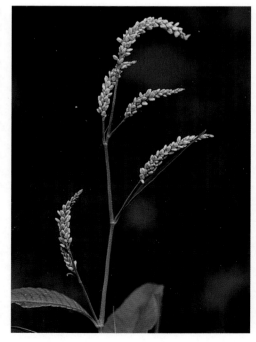

Description: Annual plants with slender stems branching and upright to sprawling to a length of 6'. The stem is segmented by joints. The joints have sheaths surrounding them that lack hairs or bristles. The slender leaves are broad at the base and taper to a pointed tip. They are attached to the stem on short stalks. The flower heads are drooping with numerous, small, white to pink flowers.

July—October

Habitat/Range: Wet ground along streams, edges of ponds, cultivated fields and other disturbed areas; common; throughout the state.

Remarks: Formerly *Polygonum lapathifolium*. There are 17 species of smartweeds in the state. Several Native American tribes used smartweed for treating fevers, upset stomachs, colds, and diarrhea. Externally it was used for treating hemorrhoids, mouth sores, and wounds. The bitter tasting leaves (hence the name "smartweed") were rubbed on a child's thumb to stop thumb sucking. The fresh juice may irritate the skin.

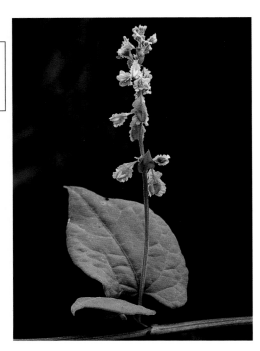

CLIMBING BUCKWHEAT
Fallopia scandens
Smartweed Family (Polygonaceae)

Description: A climbing, twining, annual plant often forming curtain-like masses of flowers and leaves. The red stems support round to heart-shaped leaves up to 6" long. Numerous, small flowers on long stalks form showy clusters.

July—October

Habitat/Range: Moist, open or shaded bottomlands, floodplains, and thickets; occasional to common throughout Illinois.

Remarks: Formerly known as *Polygonum scandens*, the black, shiny seeds look and taste like buckwheat.

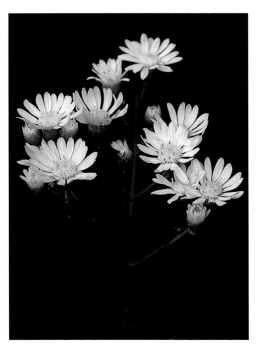

STIFF ASTER
Solidago ptarmicoides
Aster Family (Asteraceae)

Description: Slender, branching plants to 2' tall. The leaves are narrow, alternate, and widely spaced along the stem. The flower heads form an open, flat-topped cluster, with each head about ¾" across with white, petal-like ray flowers and a pale yellow central disk.

July—October

Habitat/Range: Prairies, sandy soil; occasional in the north ½ of the state, absent elsewhere.

Remarks: Also known as *Oligoneuron album*, stiff aster was once in the genus *Aster* but is now considered to be more closely related to goldenrods, since it has been found to hybridize with them.

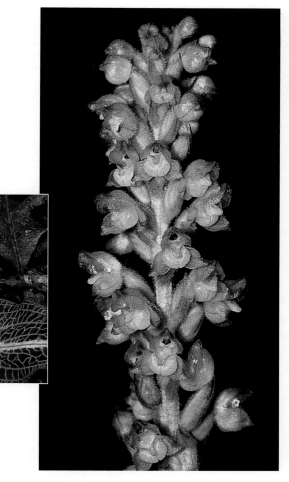

leaves

RATTLESNAKE PLANTAIN
Goodyera pubescens
Orchid Family (Orchidaceae)

Description: An orchid with a finely hairy, slender stalk, up to 12" tall, with an attractive rosette of bluish-green basal leaves that overwinter. The 5–7 basal leaves are from 1½–2" long and about 1" wide, with a prominent network of silvery white veins. The flowers appear in an alternate, spiral-like pattern towards the top of the stem. Each white flower is ⅜" long, with 3 petal-like sepals; 2 slightly smaller petals; and a pointed, sac-like lower lip.

July—August

Habitat/Range: Moist woods; not common; scattered throughout Illinois.

Remarks: The genus name is in honor of John Goodyer, a 17th century English botanist. The common name "rattlesnake" is for the similarity of the leaf shape and venation pattern to the head of a snake, while another source states that the name is derived from the early belief that the leaves, when chewed and applied to a rattlesnake bite, would provide antidotal relief. The name "plantain" is for the similarity of the leaves to that of the common plantain.

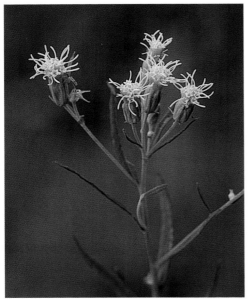

FALSE BONESET
Brickellia eupatorioides
Aster Family (Asteraceae)

Description: One or more often reddish stems emerge from the base of this whitish or cream-colored plant to a height of 3'. The somewhat hairy leaves are alternate, up to 4" long and 1⅜" wide, with prominent raised veins on the underside. The small, numerous, white or yellowish flowers occur in clusters at the tips of branches. The styles extend beyond the flowers, giving them a fringed look.

July—October

Habitat/Range: Prairies, savannas, dry, open woods; occasional to common in the north ¾ of the state, much less common elsewhere.

Remarks: Formerly known as *Eupatorium eupatorioides*. Great Plains Indians used false boneset to reduce swelling. Its bitter taste restricted its use as a medicine or food plant. The dried seed head has been used in winter flower arrangements. False boneset is sometimes confused with tall boneset; false boneset has alternate leaves with one central vein, while tall boneset has opposite leaves with 3 veins.

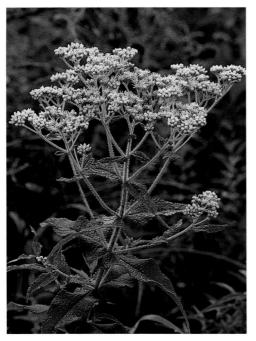

COMMON BONESET
Eupatorium perfoliatum
Aster Family (Asteraceae)

Description: A plant up to 4' tall with noticeable spreading hairs on the stem and leaves. The leaves are up to 8" long and opposite, with their bases joining and circling the stem. The leaves taper toward the end and the margins are toothed. The dome-shaped flower clusters have flower heads that contain 9–23 small disk flowers but no ray flowers.

July—October

Habitat/Range: Moist to wet ground, prairies, marshes, and along streams; common throughout the state.

Remarks: The settlers called boneset "Indian sage" because it was widely used by Native American Indians, who considered it a panacea for all ills, aches, and pains. The settlers' use of the name "boneset" is confusing because it refers to its use in the treatment of flu, rather than for treating bones–a flu that caused severe body aches was called a "breakbone fever."

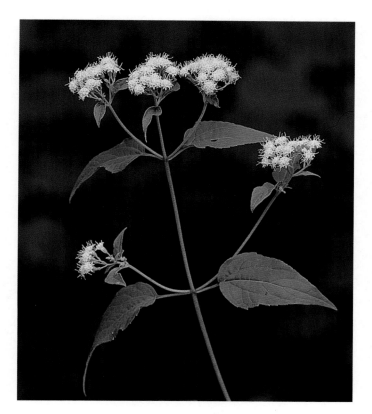

WHITE SNAKEROOT
Ageratina altissima
Aster Family (Asteraceae)

Description: A plant growing to 4' tall, with branching stems toward the top. The leaves are up to 6" long, opposite, long-stalked, and somewhat heart-shaped, with large teeth along the margins. The network of veins is conspicuous, giving the leaf a slightly crinkled appearance. The flower heads are arranged in branching, flat-topped clusters 2–3" across. Each flower head has small white flowers with extended styles that give them a tufted look.

July—October

Habitat/Range: Moist or dry woods, woodland borders, and disturbed sites; common; throughout the state.

Remarks: Also known as *Eupatorium rugosum*. Native American Indians used a root tea for treating diarrhea, painful urination, fevers, and kidney stones, and as an application for snakebites. White snakeroot was responsible for "milk sickness," a deadly disease encountered during early settlement by Europeans. Cows that eat the plant secrete a poison into their milk. The cattle themselves develop a disease called "trembles" for its chief symptom. In 1818, Abraham Lincoln's mother, Nancy Hanks Lincoln, died from a brief, agonizing bout of milk sickness. Research has shown that the active ingredient eupatorin in white snakeroot may have anticancer properties.

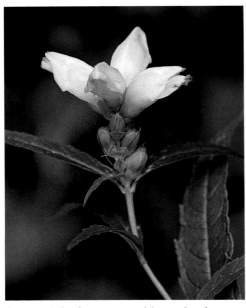

WHITE TURTLEHEAD
Chelone glabra
Plantain Family (Plantaginaceae)

Description: An upright, usually unbranched plant, up to 3' tall, with angled stems. The leaves are opposite along the stem, broadest at the middle, toothed along the margin, and up to 6" long and 1½" wide. The white flowers are clustered at the top, each about 1" long. The upper lip of the flower has two lobes, which extend over the 3-lobed lower lip.

July—October

Habitat/Range: Low areas in wet soil, marshes, wet woods, fens; uncommon; scattered throughout the state.

Remarks: The common name is very fitting especially when viewing the profile of the flower. A leaf tea was said to stimulate appetite, also a folk remedy for worms, fevers, jaundice, and as a laxative.

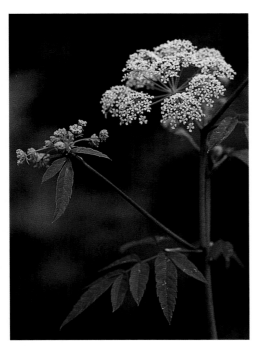

WATER PARSNIP
Sium suave
Carrot Family (Apiaceae)

Description: A tall plant, up to 6', with a sturdy, smooth stem that is hollow towards the base. The alternate leaves are divided into 7–17 leaflets, each up to 4" long. The leaflets are toothed with a pointed tip. There are several umbrella-shaped flower clusters, up to 3" across, at the top of stems. Each small flower is about ⅛" across with 5 white petals.

July—September

Habitat/Range: Shallow water of marshes, ponds, wet ditches, low woods, ponds; occasional throughout the state.

Remarks: Native American Indians boiled the root and leaves for food. Because of its similarity to poison hemlock, water parsnip should be avoided as a food plant.

COWBANE
Oxypolis rigidior
Carrot Family (Apiaceae)

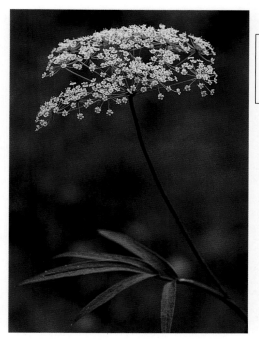

Description: A slender plant, up to 5' tall, with alternate leaves that are divided into 5–9 leaflets. These leaflets are smooth and up to 5" long and 1⅜" wide on the lower part of the stem and smaller towards the top. The flowers are in flat, dome-shaped clusters up to 6" wide. Each tiny white flower has 5 petals.

July—September

Habitat/Range: Marshes, wet prairies, depressions in moist prairies, and in wet soils along streams; occasional throughout the state.

Remarks: The roots and leaves of cowbane are poisonous and have been known to poison cattle as the name implies. Skin contact with the plant can cause dermatitis among some individuals.

FIREWEED
Erechtites hieracifolia
Aster Family (Asteraceae)

Description: An annual plant up to 8' tall with a grooved, often hairy stem. The leaves are alternate, somewhat lance-shaped, with ragged to deeply cut teeth along the margins, and stalkless, with the midvein of the leaf sometimes whitish. The flower heads are surrounded by cylindrical green bracts that enclose numerous small disk flowers that are barely visible.

July—November

Habitat/Range: Moist woods, eroding slopes, disturbed ground, recently burned areas; common throughout the state.

Remarks: The common name "fireweed" refers to the plant's tendency to grow in recently burned over areas. Seeds often lie dormant for many years until overlying debris is burned off or cleared away, which stimulates the seeds to germinate.

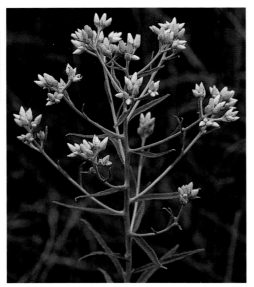

SWEET EVERLASTING
Pseudognaphalium obtusifolium
Aster Family (Asteraceae)

Description: A biennial plant, up to 2½' tall, with felt-like hairs on the stems and undersides of leaves that give it a whitish cast. The leaves are alternate, narrow, up to 4" long and ½" wide, green on the top, white below, and lacking teeth along the margins. Numerous small flower heads occur on branches near the top. Each flower head is about ¼" tall, with white bracts surrounding a narrow tubular head of yellowish-white disk flowers.

July—November

Habitat/Range: Open woods, prairies, fields, pastures; common throughout Illinois.

Remarks: Also known as *Gnaphalium obtusifolium*. Dried plants have a maple or balsam fragrance, hence the other name "old field balsam." Pillows filled with dried flowers were used to quiet coughing. Plants laid in drawers and wardrobes kept away moths. The Mesquakies burned sweet everlasting as a smudge to restore consciousness or to treat insanity. Other tribes used it for colds, fever, and other infirmities. When chewed, it increases saliva flow. Because of this quality, it was given to cattle that had lost the ability to ruminate (produce cud); this is supposedly why it is also called "cudweed."

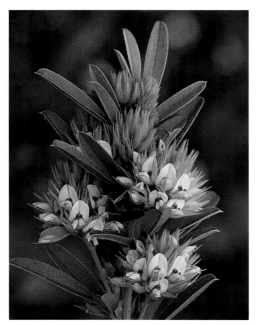

ROUND-HEADED BUSH CLOVER
Lespedeza capitata
Pea Family (Fabaceae)

Description: A slender, unbranched legume that grows to 5' high and is covered with fine, silvery hairs. The leaves are alternate along the stem and divided into 3 narrow leaflets. The flowers occur in dense rounded heads up to 1½" in diameter. The flowers are creamy white with a reddish to purplish spot at the base. Each flower has an upper petal, 2 side petals, and a lower lip.

July—October

Habitat/Range: Prairies, savannas, woodlands; occasional to common throughout Illinois.

Remarks: The Comanche used the leaves to make a tea. The Omahas and Poncas moistened one end of a short piece of the stem so it would stick to the skin, then lit the other end and allowed it to burn down to the skin. This was used to treat the sharp pain associated with nerves and rheumatism. The leaves and seeds are eaten by wild turkey. The seeds are eaten by songbirds, gamebirds, and other wildlife. This plant provides nutritious, high-protein forage for livestock.

TALL WHITE LETTUCE
Prenanthes altissima
Aster Family (Asteraceae)

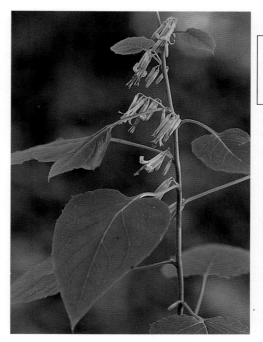

Description: A slender plant with milky sap to 6' tall, with the upper branches supporting hanging cream-colored flowers. The thin leaves are alternate, smooth, on stalks, and variable in shape. The long, slender flower heads each contain 5–6 flowers.

July—October

Habitat/Range: Moist woods and ravines; occasional in east and south Illinois; also Cook and Lake counties.

Remarks: Also known as "rattlesnake root," because Native American Indians used the leaves and roots for treating snakebites, as well as bites from dogs. A tea was drunk for dysentery. There are 5 species of white lettuce in Illinois.

ROUGH WHITE LETTUCE
Prenanthes aspera
Aster Family (Asteraceae)

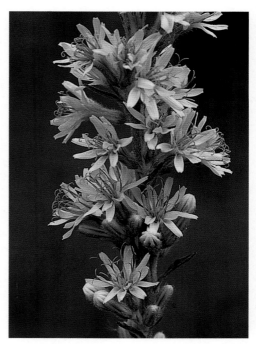

Description: Tall, slender plants, up to 6' in height, with unbranched, hairy stems and milky sap. The leaves are alternate, up to 4" long and 1¾" wide, and somewhat toothed along the margins. The lower leaves are stalked, while the upper leaves are smaller and lack stalks, with the leaf bases often clasping the stem. The flowers are clustered along the upper portion of the stem. Each cylindrical head is up to ¾" long, with 10–14 creamy white, fragrant flowers. Each petal-like ray flower has 5 small teeth at the tip.

August—October

Habitat/Range: Prairies, open woods; occasional in the north ⅔ of Illinois, less common southward.

Remarks: The Choctaws made a tea of the roots and tops to increase urine flow and to relieve pain. The bitter roots of this plant were once used to treat snakebite, hence its other name, "rattlesnake root."

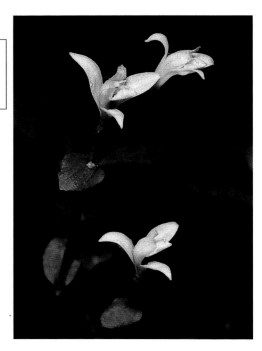

NODDING POGONIA
Triphora trianthophora
Orchid Family (Orchidaceae)

Description: A short, delicate orchid with a smooth stem, from 3–8" tall. The stem leaves are alternate, about ½" long, broadest at the base, and clasping the stem. There are from 1–6 white to pinkish flowers, upright or nodding, each lasting but a day. The flowers are about ½" long, with a 3-lobed lip.

August—October

Habitat/Range: Moist woods; not common; scattered throughout the state.

Remarks: Also called "three-birds orchid," for its tendency to produce 3 flowers. This small, slender orchid is easily overlooked on the forest floor.

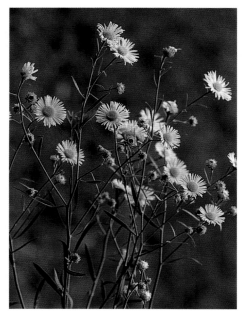

FALSE ASTER
Boltonia asteroides
Aster Family (Asteraceae)

Description: A much-branched plant, up to 6' tall, with alternate leaves broadly linear to broadest below the middle. Leaves are up to 6" long and ¾" wide, reduced in size upward along the stem. The flower heads are numerous, about ½" across, with 25–35 white petal-like ray flowers and yellow disk flowers.

August—October

Habitat/Range: Moist ground, marshes, prairies; common throughout the state.

Remarks: The genus name is in honor of James Bolton, an 18th century English botanist.

PALE GENTIAN
Gentiana alba
Gentian Family (Gentianaceae)

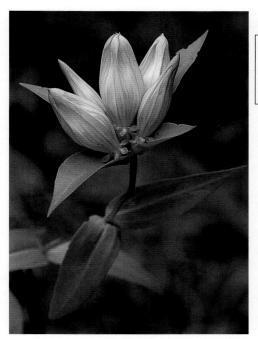

Description: Stems are erect to somewhat reclining, unbranched, and up to 2' tall. Leaves are smooth, opposite, attached to the stem without a stalk, up to 4" long, and about 1" wide at the base. The flowers are greenish white or yellowish white, bottle-shaped, closed to slightly open at the tip, and up to 1½" long.

August—October

Habitat/Range: Prairies, moist wooded slopes; not common; scattered throughout the state.

Remarks: Formerly known as *Gentiana flavida*. The bitter-tasting root of several species of gentian was used to increase the flow of gastric juice, promoting the appetite and aiding digestion. The bumblebee is one of the few insects strong enough to open the bottle-shaped flower and achieve pollination.

BEECHDROPS
Epifagus virginiana
Broomrape Family (Orobanchaceae)

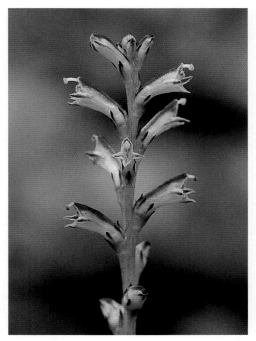

Description: A parasitic plant on the roots of beech trees, the wiry brown stems with several branches are up to 20" tall. Minute leaf scales are alternate along the stem. The white flowers have purplish-brown stripes, about ⅜" long, with 4 lobes at the tip. The lower flowers along the stem are fertile (produce fruit).

August—October

Habitat/Range: Parasitic on beech roots in moist woods; restricted to the south ¼ of the state; also Clark, Crawford, Edgar, and Lawrence counties.

Remarks: The plants lack green chlorophyll necessary for food production so they attach to the roots of beech trees in order to obtain nutrients. The highly bitter tea was once used for diarrhea, dysentery, mouth sores, and cold sores.

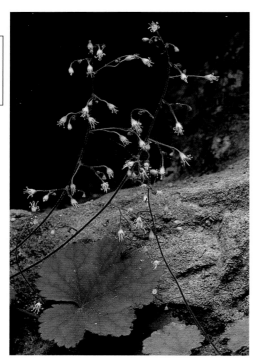

LATE ALUMROOT
Heuchera parviflora
Saxifrage Family (Saxifragaceae)

Description: Small, sparse-looking plants with flower stalks extending to a height of not more that 1½'. The leaf and flower stalks are covered with gland-tipped hairs. The rounded leaves emerge from the base of the plant on long stalks; large, coarse teeth line the margins of the leaf. The underside of the leaf is usually red. The small flowers appear on spreading branches and have 5 petals that curl back, revealing yellow stamens.

August—November

Habitat/Range: Moist sandstone cliffs; common in the south ⅙ of Illinois.

Remarks: Native American Indians and early settlers used a powder made from the roots of various species of alumroots as an astringent to close wounds. This powder also served as a treatment for diarrhea and for sore throats. The common name is derived from the puckering alum-like taste imparted by the root. It is the latest alumroot to flower in Illinois.

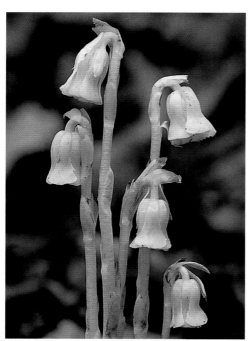

INDIAN PIPE
Monotropa uniflora
Heath Family (Ericaceae)

Description: Small, single-flowered plants with several stems arising from the base to 8" tall. The fleshy stem has rudimentary, scale-like leaves. The flowers droop to form the "pipe," then become erect as the fruit forms. The flowers are about 1" long, with 4–6 whitish petals that slightly flare at the end.

August—October

Habitat/Range: Moist woods, ravines, on slopes of ridges, usually in dense leaf mulch; occasional throughout the state.

Remarks: The plants are white and lack green chlorophyll needed to produce their own food. They feed on fungi, obtaining nutrients from decaying organic material in the soil. Native American Indians and early settlers used the juice of Indian pipe for treating sore eyes. One Indian legend tells that this plant always appeared on the exact spot where some Indian had knocked the white ashes of his pipe on the forest floor.

HAIRY ASTER
Symphyotrichum pilosum
Aster Family (Asteraceae)

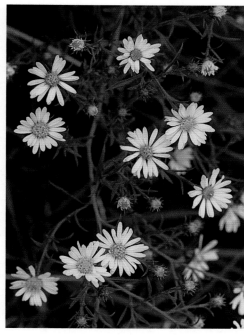

Description: A widely branched, spreading aster to a length of 4'. The leaves at the base are up to 4" long and usually die back before the flowers emerge. The stem leaves are alternate, thin, and needle-like. The flowers are numerous, about ½" wide, with 15–30 white, petal-like ray flowers and a central yellow disk with 20 or more disk flowers.

August — November

Habitat/Range: Old fields, pastures, roadsides, cleared woods; common throughout the state.

Remarks: Formerly known as *Aster pilosus*. Several tribes thought the smoke from burning aster plants was helpful in reviving a person who had fainted. Some tribes brewed a tea of the aster plant for headaches. The green basal leaves are eaten by white-tailed deer in the spring while the stem and flower heads are eaten during summer and early autumn. Songbirds, especially various sparrows, eat the seeds.

ARROW-LEAVED ASTER
Symphyotrichum urophyllum
Aster Family (Asteraceae)

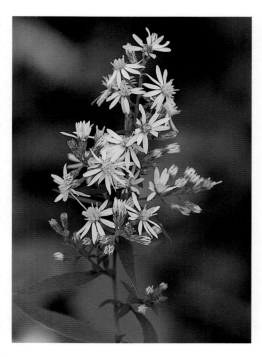

Description: A widely branching aster, up to 5' tall. The leaves are alternate, lacking hairs, shallowly toothed, arrow-shaped, with a heart-shaped base, a long and winged stalk, and small teeth along the margins. Leaves on the upper part of the stem are narrow and taper at the base. The flower heads are numerous and are typically white, but shades of pale blue or lilac are also possible. There are 8–20 petal-like ray flowers surrounding the yellow disk flowers.

August — October

Habitat/Range: Dry and moist woods, prairies; common throughout the state.

Remarks: Formerly known as *Aster sagittifolius*. There are 38 species in the genus *Aster* in Illinois.

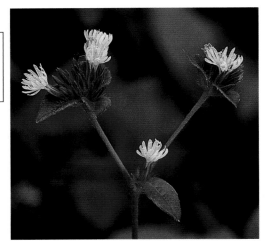

ELEPHANT'S FOOT
Elephantopus carolinianus
Aster Family (Asteraceae)

Description: A branching plant, up to 3' tall, with large basal leaves in proportion to the size of the plant. The leaves are alternate, up to 8" long and 4" wide, with rounded teeth along the margins, and a leaf base that abruptly ends to a long leaf stalk. The large basal leaves are often absent at the time of flowering. The upper leaves are smaller and lack stalks. Below the flower cluster are 1–3 leaf-like bracts. Each cluster has 2–5 small flowers that are white to violet to lavender.

August—October

Habitat/Range: Dry woods to wooded lowlands in valleys, ravines, along streams; occasional in the south ⅓ of Illinois.

Remarks: *Elephantopus* is Greek for "elephant foot," which may describe the basal leaves of these mainly tropical plants. Although the basal leaves of the 3 species in North America are large, they in no way suggest the feet of a pachyderm.

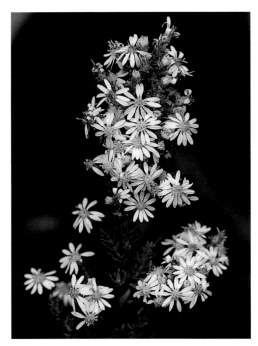

HEATH ASTER
Symphyotrichum ericoides
Aster Family (Asteraceae)

Description: Low compact plants up to 3' tall, with leaves alternate, narrow, less than 3" long and about ¼" wide. The stem leaves wither at flowering, leaving a bare stem. The flowers are tightly bunched along a branched column with tiny leaves. The white flowers are about ½" wide, with up to 20 petal-like ray flowers surrounding a small yellow disk.

September—October

Habitat/Range: Prairies, pastures, old fields; common throughout the state.

Remarks: Heath aster's appearance when flowering is similar to that of heath plants and explains the use of the species name *ericoides*, which is Greek for "heath-like."

FROSTWEED
Verbesina virginica
Aster Family (Asteraceae)

Description: Stout plants with leafy wings along the stem and up to 7' tall. The leaves are alternate and lance-shaped to 7" long, with widely spaced, small teeth. The flower heads are about 1–1½" across and clustered at the end of the stem on branches. Each flower head has 3–5 white petal-like ray flowers that surround each white disk.

August—October

Habitat/Range: Open woods, valleys, and streamsides; not common; extreme southeast part of the state.

Remarks: In late fall, during hard freezes, frostweed produces "frost flowers." These are ribbons of ice oozing out of cracks at the base of the stem. Sap from still-active roots freezes as it emerges from the dead stem,

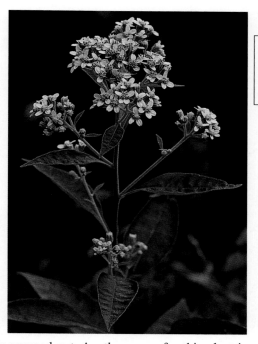

growing like a white ribbon as more fluid is pumped out. Another name for this plant is "white crownbeard."

TALL BONESET
Eupatorium altissimum
Aster Family (Asteraceae)

Description: Hairy plants, 3–6' tall, with a single stem that branches towards the top. The opposite leaves are either attached to the stem or sometimes on short stalks. They are up to 5" long and 1½" wide, with 3 prominent veins along the length of the blade and a few widely spaced small teeth on the upper half of the leaf. Narrow, flattish clusters of flower heads branch at the top of the stem. Each flower head has 3–7 tubular flowers.

August—October

Habitat/Range: Open woodlands, prairies, pastures, old fields; common throughout the state.

Remarks: A closely related species, late boneset, *Eupatorium serotinum*, has leaves

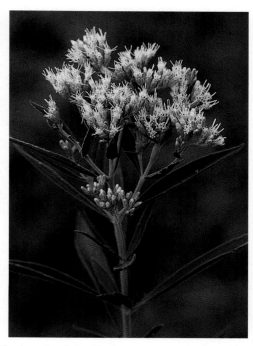

with long stalks, 1 prominent vein running the length of the blade, coarse teeth along the leaf margins, and 12–15 flowers in each flower head. Found in moist open woods, pastures, disturbed areas; common throughout the state.

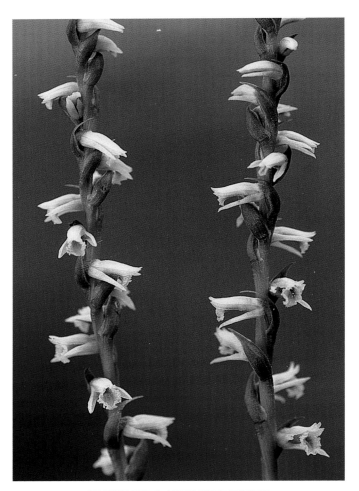

SLENDER LADIES' TRESSES
Spiranthes lacera
Orchid Family (Orchidaceae)

Description: This slender, delicate orchid has a single stalk that grows to 1' tall. There are 2–3 round basal leaves, with the stem leaves reduced to scales. The upper part of the stalk twists with a graceful spiral of evenly spaced flowers along the spike. The flowers are about ¼" long and white, with green on the center of the lip. The sepals and petals form a tube surrounding the ragged-edged lip.

August—October

Habitat/Range: Dry upland woods; rare; restricted to the north ½ of the state.

Remarks: A similar species, little ladies' tresses, *Spiranthes tuberosa*, differs by being less than 10" tall and having a more irregular spiral of flowers and a lower lip lacking a green spot. Found in dry, open woods; confined to the south ⅕ of the state.

NODDING LADIES' TRESSES
Spiranthes cernua
Orchid Family (Orchidaceae)

Description: A slender orchid, up to 10" tall, with fine hairs on the stem and flowers. The 3–4 basal leaves are grass-like, up to 9" long, and often die back at the time of flowering. The upper stem leaves are reduced to scales. The flowers are up to ½" long, slightly nodding, with the sepals and petals forming a tube around the lip. The mouth of the flower is sometimes light yellow. The creamy flowers have a light vanilla-like scent.

August—October

Habitat/Range: Dry or moist woods, prairies, old fields; occasional throughout the state.

Remarks: A closely related species, Great Plains ladies' tresses, *Spiranthes magnicamporum*, differs by having a strong vanilla-like scent, the sepals on either side of the lip spreading, and a yellow center on the lip. Found in dry prairies; scattered throughout the state except the southernmost counties.

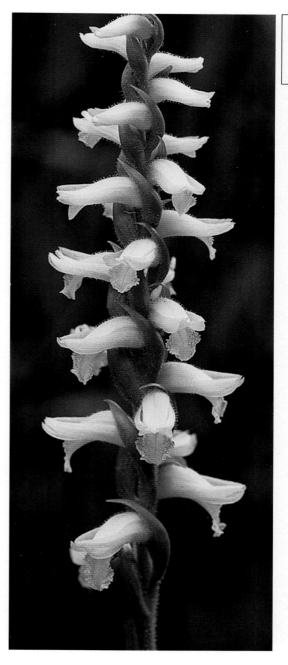

Yellow Flowers

This section includes yellow, golden, and
yellowish orange to pale, creamy yellow flowers.
Also, multiple-colored flowers that are predominantly yellow
are included in this section.

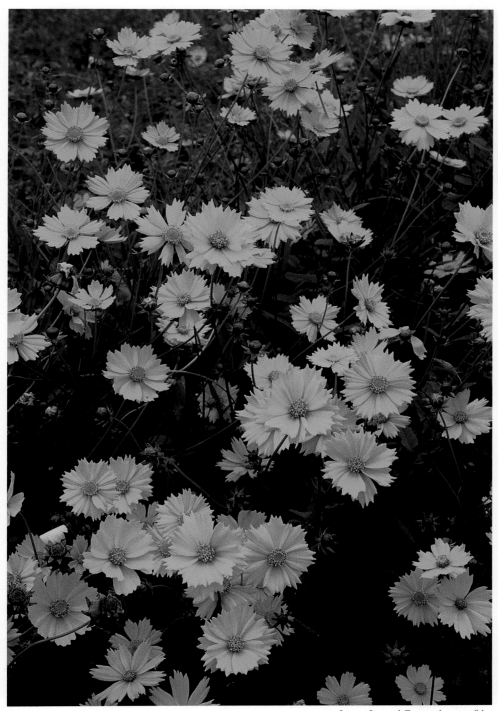

Lance-Leaved Coreopsis, page 94

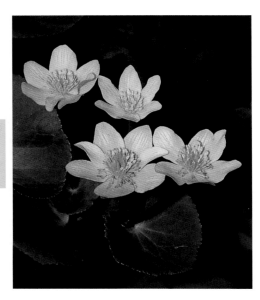

MARSH MARIGOLD
Caltha palustris
Buttercup Family (Ranunculaceae)

Description: A low, spreading plant, up to 2' long, with hollow ridged stems and shiny alternate, heart-shaped leaves, each up to 7" long. Flowers are bright yellow, up to 2" wide, with 5 or 6 glossy petal-like sepals instead of petals. Stamens are numerous.

April—June

Habitat/Range: Low wet woodlands, marshes, open swamps, seeps; occasional in the north ⅔ of Illinois.

Remarks: The young leaves and stems of marsh marigold have been cooked in boiling water in 2 or 3 changes to remove the bitter taste and pickled in hot vinegar for later consumption similar to spinach.

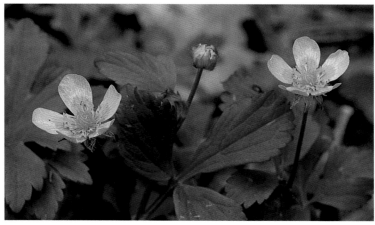

BRISTLY BUTTERCUP
Ranunculus hispidus
Buttercup Family (Ranunculaceae)

Description: Sparse to densely hairy plant up to 1' tall. The basal leaves are on long stalks and divided into 3 leaflets. The stem leaves lack stalks and are usually divided into 3 narrow, irregular lobes. The stems just below the flowers usually lack hairs. Each flower has 5 waxy yellow petals and many stamens.

March—May

Habitat/Range: Dry, open woods; occasional throughout the state.

Remarks: Illinois-Miami Indians used crushed roots of buttercups to treat gunshot or arrow wounds. Cherokees used the juice from the leaves as a sedative or in a tea for treating sore throats. Modern medical opinion is that these plants are poisonous if taken internally. There are 27 species of buttercups in the genus *Ranunculus* in Illinois.

YELLOW DOGTOOTH VIOLET
Erythronium americanum
Lily Family (Liliaceae)

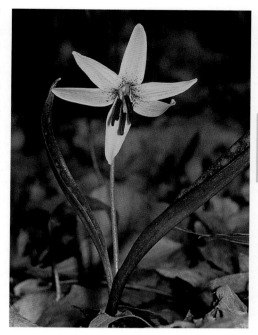

Description: Often forming large colonies, the smooth, fleshy plants are up to 10" tall, with brown mottled leaves that are of equal width throughout their length and tapering at both ends. A single stalk emerges from a pair of leaves with a solitary nodding flower at the top; single-leaved plants do not produce flowers. The yellow flowers are up to 3½" across, with 6 petal-like parts that tend to curve backward.

April—May

Habitat/Range: Moist woods, wooded ravines, shaded bluffs; occasional in the northeast, east central, and south part of the state.

Remarks: This plant is also called "yellow trout lily," because the mottled leaves resemble the sides of a brown or brook trout. Dogtooth is so named for the shape of the corm, a type of root.

YELLOW VIOLET
Viola pubescens
Violet Family (Violaceae)

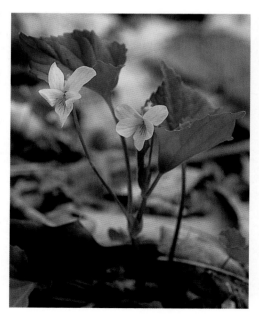

Description: Small plants with smooth to slightly hairy stems up to 10" tall. The basal leaves plus 2–4 on the upper stem are heart-shaped, up to 2" across, on long stalks, with rounded teeth along the margins. The flowers are on long stalks, with 5 bright yellow petals with brown-purple veins near the base.

March—May

Habitat/Range: Moist woods; common; throughout the state.

Remarks: Formerly known as *Viola pensylvanica*. There are 29 species of violets in the genus *Viola* in Illinois.

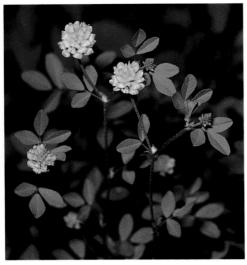

BLACK MEDIC
Medicago lupulina
Pea Family (Fabaceae)

Description: A sprawling annual plant that sometimes grows to 20" long. The branching stem has soft hairs with alternate leaves divided into 3 leaflets. The leaflets are up to ¾" long with very shallow teeth along the margins. The flowers are crowded together in dense heads up to ¾" long with the heads attached to a long stalk that emerges from the leaf axil. The flowers are small, with 5 yellow petals in an arrangement typical of the pea family.

April—August

Habitat/Range: Disturbed ground, lawns, fields, along roadsides; native to Eurasia and Africa and established throughout Illinois.

Remarks: Black medic was introduced into the United States for livestock forage but generally has a low yield. The seeds can be parched and eaten out of hand or ground into flour. There are 5 species and 1 hybrid of black medic in the genus *Medicago* in the state. None are native to the United States.

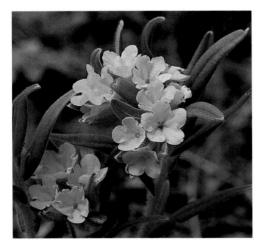

HOARY PUCCOON
Lithospermum canescens
Borage Family (Boraginaceae)

Description: Single stems, with several emerging from the base of older plants, grow to 6–18" tall, with dense soft hairs that give the plant a gray-green color. The leaves are alternate, stalkless, about 2½" long and less than ½" wide, and lack teeth. The deep golden flowers are in a flattened cluster at the top of the plant. Each flower is about ½" wide, about ½" long, with 5 spreading, rounded lobes.

April—June

Habitat/Range: Dry to moist prairies, open woodlands; occasional to common throughout the state.

Remarks: North American Indians used leaf tea (as a wash) for fevers accompanied by spasms and as a wash rubbed on persons thought to be near convulsions. To the Menomini, the white, ripened seed of this plant was a type of sacred bead used in special ceremonies. A red dye was extracted from the roots. Another species, yellow or fringed puccoon, *Lithospermum incisum*, has narrow leaves about ¼" wide and a flower about 1" long with 5 fringed lobes. Found in prairies, open sandy areas; occasional in the north ½ of Illinois, less common in the south ½.

YELLOW STAR GRASS
Hypoxis hirsuta
Lily Family (Liliaceae)

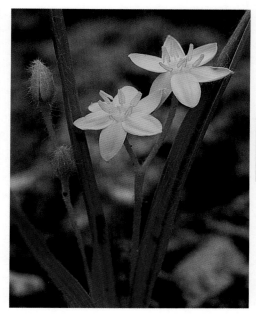

Description: Small, hairy plants producing yellow star-like flowers with grassy leaves, hence the common name. When flowering begins the plants are about 5" tall; as they mature, they may reach up to 1' in height. The long grass-like leaves are about 8" long and ¼" wide. The flower stalks are shorter than the leaves with 2–7 flowers appearing in succession. The flowers are about ½" wide, with 6 yellow petals and 6 yellow stamens.

April—June

Habitat/Range: Prairies, dry woods, sandstone outcroppings, fens, fields; occasional throughout the state.

Remarks: The seeds are eaten by bobwhite quail.

WOOD BETONY
Pedicularis canadensis
Broomrape Family (Orobanchaceae)

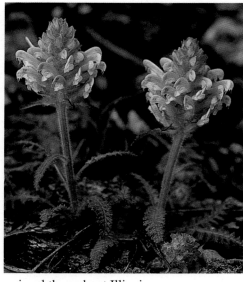

Description: Several hairy stems emerge from a clump of fern-like basal leaves. The stems are about 6–10" tall when in flower and grow to about 18" tall as they mature. The basal leaves are narrow, deeply divided, and about 6" long. In the spring, they start out as a beautiful wine color before they turn green. Leaves along the stem are scattered and alternate. The snapdragon-like flowers are nearly 1" long and densely clustered at the top of the stem. There are two lips: The upper lip is flattened and curves in a long arch to form a hood. The lower lip has 3 rounded lobes.

April—June

Habitat/Range: Prairies, dry open woods; occasional throughout Illinois.

Remarks: Also called "lousewort," from the belief that cattle and sheep grazing in pastures with this plant were once expected to become infested with lice. The Mesquakie and Potawatomi boiled the whole plant to make a tea for reducing internal swelling, tumors, and some types of external swelling. The Ojibwa used the plant as a love charm. The chopped-up root was put into food that was cooking, without the knowledge of the couple who were to eat it. If they had been quarrelsome, then they would again become lovers. Another species, swamp wood betony, *Pedicularis lanceolata*, has stem leaves opposite; occurs in fens; occasional in the north ½ of the state, uncommon in the south ½.

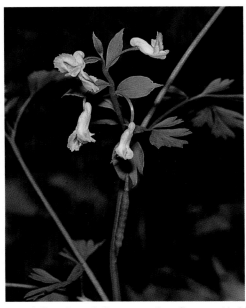

PALE CORYDALIS
Corydalis flavula
Fumitory Family (Fumariaceae)

Description: A delicate, low-growing plant, much branched, up to 10" tall. The leaves are green, fern-like, alternate, the lowermost on long stalks, the uppermost on short or no stalks. There are several yellow flowers clustered at the end of a stalk, with each flower less than ½" long. There are 4 petals, one of them protruding at the base into a spur, the inner petals each with a toothed ridge down its back.

April—May

Habitat/Range: Moist woods; common in the south counties, less common northward.

Remarks: Another species, golden corydalis, *Corydalis aurea*, has flowers ½–¾" long and silvery green leaves; it occurs in rocky soil; classified as state endangered; confined to the north ½ of the state.

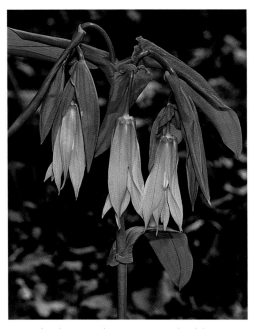

YELLOW BELLWORT
Uvularia grandiflora
Lily Family (Liliaceae)

Description: A graceful plant, with several smooth stems, with a whitish coating, emerging from a common base up to 18" tall. The stem is usually branched at the top, but only one branch carries flowers and leaves. The leaves are alternate, without teeth, smooth, up to 4" long, with the base of the leaf surrounding the stem. The flowers are solitary, drooping, up to 1½" long, with 6 long petals.

April—May

Habitat/Range: Moist woods; occasional to common throughout Illinois.

Remarks: Early settlers cooked the upper stem and leaves as greens. The upper stems served as a substitute for asparagus. Canker sores in the mouth were treated with a concoction made from the roots. Another species, sessile-leaved bellwort, *Uvularia sessilifolia*, has the base of the leaf not encircling the stem and has smaller leaves and flowers; moist woods; not common; confined to the south ⅓ of the state.

PRAIRIE PARSLEY
Polytaenia nuttallii
Carrot Family (Apiaceae)

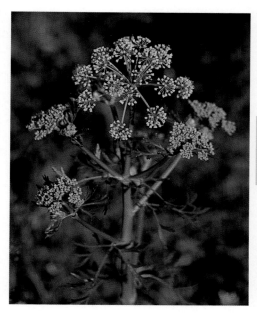

Description: A stout plant, to 3' tall, with thick, long-stalked, alternate, highly dissected leaves. The leaf stalks have wide, flat bases that clasp the stem. The flowers are clustered in numerous branches that form a flat-topped head. Each cluster has 15–25 pale yellow flowers, each about ⅛" wide, with 5 tiny petals.

April—June

Habitat/Range: Prairies, rocky, open woods; occasional; throughout Illinois.

Remarks: Prairie parsley is the tallest wildflower blooming in prairies in early spring, towering over Indian paintbrush, yellow star grass, hoary puccoon, shooting star, and others.

YELLOW ROCKET
Barbarea vulgaris
Mustard Family (Brassicaceae)

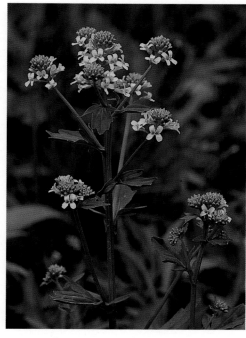

Description: A biennial plant, branched, smooth, and up to 2' tall. The basal leaves are up to 5" long, feather-like, with the end leaflet larger than the rest, and on long stalks. The upper leaves are alternate, toothed, and usually without a stalk. The flowers are crowded together at the end of a stem with each flower up to ⅜" across with 4 bright yellow petals. The fruit has elongated pods up to 1½" long.

April—June

Habitat/Range: Idle and cultivated fields, pastures, wet ground near streams, and along roadsides; native to Europe; common throughout the state.

Remarks: Yellow rocket was introduced into the United States early. Cherokees ate the greens as a "blood purifier." Leaf tea was used to treat coughs and scurvy and to stimulate appetite. Studies indicate this plant may cause kidney malfunctions, so internal use should be avoided.

FIELD MUSTARD
Brassica rapa
Mustard Family (Brassicaceae)

Description: An annual that germinates in the fall and overwinters, growing to 3' tall in the spring. The upper leaves are stalkless, toothed and clasp the stem; the lower leaves have deep lobes along the margins and are on stalks. The yellow flowers are clustered at the tips of branches, with each flower about ½" across and containing 4 petals.

April—September

Habitat/Range: Disturbed areas; native to Europe; occasional throughout the state.

Remarks: A similar species, Black Mustard, *Brassica nigra*, differs by having leaves with stalks on the upper and lower parts of the stem; also native to Europe; found in disturbed sites throughout the state.

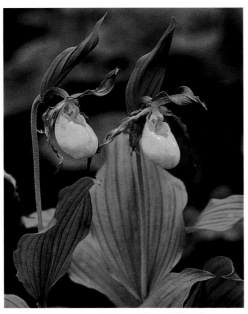

LARGE YELLOW LADY'S SLIPPER ORCHID
Cypripedium parviflorum var. *pubescens*
Orchid Family (Orchidaceae)

Description: Stout, unbranched stems often forming clumps from a single base up to 2' tall. The stems and leaves are finely hairy with the base of the 3–5 alternate leaves forming a sheath around the stem. The leaves are pleated with parallel veins and vary from narrow to round with pointed tips and up to 9" long and 5" wide. There are 1–2 flowers per stem. Each flower has 2 twisted narrow petals on either side of an inflated petal, called a "slipper," which can be up to 2" long. Above and below the slipper are 2 broad sepals. The sepals and lateral petals are yellowish green to purplish brown.

April—May

Habitat/Range: Moist to dry woods; not common; scattered throughout Illinois.

Remarks: To come across any species of orchid is a treat since they are all fairly uncommon. It is best that they be admired only in their natural setting, since they do not transplant well. Native American Indians used the powdered root as a sedative, tranquilizer, and pain reliever. Another species, small yellow lady's slipper orchid, *Cypripedium parviflorum* var. *parviflorum*, has a small slipper usually less than 1" long and the sepals and lateral petals dark purple; occurs in wet borders, bogs, and marshes; classified as state endangered; restricted to a few north counties.

CELANDINE POPPY
Stylophorum diphyllum
Poppy Family
(Papaveraceae)

Description: More or less upright plant to 12" long, hairy, with yellow sap and showy yellow flowers. Leaves at the base of the plant and along the stem are divided into 5–7 segments,

with large, irregular teeth along each segment. The flowers are arranged in clusters of 1–4 at the end of stems; each flower is up to 2" across and growing from hairy stalks. The 4 petals are bright yellow, 1½–2" across, and rounded at the tips.

April—May

Habitat/Range: Moist wooded slopes and ravines; not common; restricted to the south counties; also Cook and Vermillion counties.

Remarks: A yellow dye was made from the root. This is a showy wildflower that adapts well to shaded gardens.

MEADOW PARSNIP
Thaspium trifoliatum
Carrot Family (Apiaceae)

Description: A much-branched plant, up to 2½' tall and lacking hairs. The basal leaves are simple, heart-shaped or sometimes divided into 3 leaflets. The leaves along the stem are on long stalks and divided into 3 leaflets, with a rounded base and small teeth along the margins. The flower heads are on stalks forming an umbrella-shaped cluster, with numerous, very small flowers that are yellow but sometimes dark purple. The flowers are all on short stalks.

April—June

Habitat/Range: Prairies, rocky open woods, thickets; scattered throughout the state.

Remarks: Another species, hairy meadow parsnip, *Thaspium barbinode*, has a fringe of hairs at the nodes (the point at which the leaf emerges from the stem); found in moist woods, usually near streams; occasional in the north ½ of the state, rare or absent elsewhere. Meadow parsnip can sometimes be confused with golden alexanders, *Zizia aurea*, but differs most noticeably by the latter having the central flower in a flower head without a stalk so that the flower is slightly recessed.

GOLDEN ALEXANDERS
Zizia aurea
Carrot Family (Apiaceae)

Description: A smooth, branched plant up to 3' tall, with alternate leaves divided into 3 leaflets. The leaflets can sometimes be divided again into 1–3 leaflets. The lance-shaped leaflets are up to 3" long and 1" wide, with teeth along the margins. The flower heads are flat-topped and have several branches arising from a common point on the stem. The central flower within each cluster lacks a stalk causing the central flower to be slightly depressed.

April—June

Habitat/Range: Moist woods, prairies, savannas, and along streams; occasional in the north ¾ of Illinois, less common in the south ¼.

Remarks: The Mesquakie used the root to reduce fever. Early settlers considered the plant useful for treating syphilis and for healing wounds. Another species, heart-leaved meadow parsnip, *Zizia aptera*, has leaves at the base of the stem not divided into leaflets and the leaf bases are heart-shaped; found in dry prairies, rocky woods; not common; north ⅕ of the state; also Hardin County.

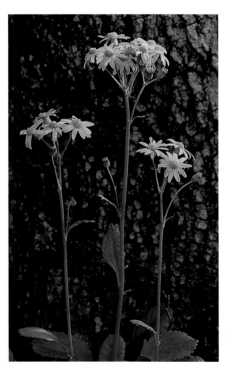

ROUND-LEAVED GROUNDSEL
Packera obovata
Aster Family (Asteraceae)

Description: Unbranched stems to 2' tall, with creeping roots that form colonies. The basal leaves are roundish and blunt with teeth along the margins and tapering at the base to continue as leafy tissue along the stalks. The leaves along the stem are alternate, narrow, with teeth along the margins, and lack stalks. The flower heads are clustered into an umbrella shape with bright yellow flowers. There are 10–15 ray flowers that surround the central disk flowers.

April—June

Habitat/Range: Moist woods, rocky outcrops; rare; scattered in the south ¾ of Illinois; rare or absent elsewhere.

Remarks: Formerly known as *Senecio obovatus*. Plants in the genus *Packera (Senecio)* were used to increase perspiration and to treat kidney stones and lung troubles. They were used by Native American Indian women for general health. The plants are now considered poisonous.

GOLDEN RAGWORT
Packera aurea
Aster Family (Asteraceae)

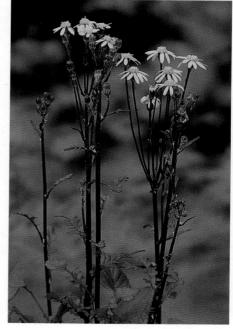

Description: A smooth, branching plant, up to 2½' tall, with a reddish-brown stem. The leaves are mostly basal, long stalked, heart-shaped, with coarse teeth along the margins. The stem leaves are fewer and smaller, with deeply cut lobes. The flower heads are in a somewhat flat-topped cluster. Each flower head has 8–12 golden yellow ray flowers surrounding a central yellow disk.

April—June

Habitat/Range: Wet ground along spring branches, streams, and in moist low woods and wooded ravine slopes; occasional throughout Illinois.

Remarks: Formerly known as *Senecio aureus*. Native American Indians, settlers, and herbalists used root and leaf tea to treat delayed and irregular menstruation and childbirth complications; it was also used for lung ailments, dysentery, and difficult urination. Like many ragworts, this plant is now considered highly toxic.

BUTTERWEED
Packera glabella
Aster Family (Asteraceae)

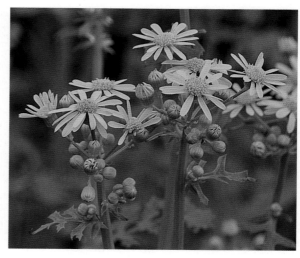

Description: An annual from slender roots, with a smooth, unbranched stem, up to 3' tall. The leaves at the base of the stem are deeply divided with lobes and teeth, up to 8" long and 3" wide. The stem leaves are similar and gradually reduced in size upward. The flowers are in a terminal cluster with numerous flower heads. The flower heads are ¾–1" across, with 12–20 yellow petal-like ray flowers surrounding a yellow disk.

April—July

Habitat/Range: Low, wet woods, fields, roadsides; common in the south ½ of Illinois

Remarks: Formerly known as *Senecio glabellus*. The genus *Senecio* is from the Latin *senex*, an old man; an allusion to the gray-haired tufts of filaments attached to the seeds. Butterweed is in reference to the color of the flowers.

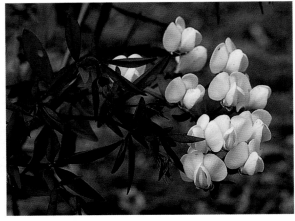

CREAM WILD INDIGO

Baptisia bracteata var. *leucophaea*
Pea Family (Fabaceae)

Description: A coarse, hairy, bush-like plant with spreading branches up to 2' tall. The leaves are alternate on the stem and divided into 3 leaflets, each up to 3½" long. The bracts at the base of the leaflets are large and give the appearance of 5 leaflets instead of 3. The flower spike, up to 1' long, droops with numerous pale yellow flowers, each about 1" long and having the arrangement typical of members of the pea family. The seed pods are black, pointed at the tip, and up to 2" long.

May—June

Habitat/Range: Moist prairies and open woods; occasional in the north ⅘ of Illinois, rare elsewhere.

Remarks: Formerly known as *Baptisia leucophaea*. Native American Indians used the plant to treat cuts and certain fevers. The Pawnee pulverized the seeds, mixed the powder with buffalo fat, and rubbed it on the stomach as a treatment for colic. Indian boys often used seedpods as rattles when they imitated their elders doing a ceremonial dance.

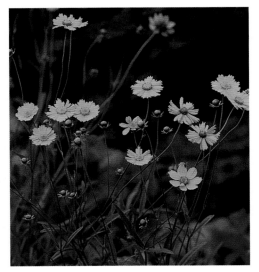

LANCE-LEAVED COREOPSIS

Coreopsis lanceolata
Aster Family (Asteraceae)

Description: Branching plants with several smooth stems emerging from a clump to 2' tall. Leaves mainly near the base, up to 8" long and 1" wide, lacking teeth along the margins. The showy flower heads are on long stalks. Each head has 8–10 fan-shaped ray flowers with jagged teeth at the tip and numerous central disk flowers.

May—August

Habitat/Range: Dry prairies, sandy or rocky soil; scattered throughout the state.

Remarks: This showy, long-blooming perennial is easily grown from seed. Another species, large-flowered coreopsis, *Coreopsis grandiflora*, has opposite, threadlike leaves along the lower stem, a smaller flower disk, and 8 fan-shaped ray flowers with fringe-like teeth at the tip; native to the west U.S. and adventive in disturbed soil; scattered in Illinois. Another species, star tickseed, *Coreopsis pubescens*, is hairy throughout and has broad leaves scattered along the stem; occurs in dry woods; not common; only in south ¼ of the state.

COMMON CINQUEFOIL
Potentilla simplex
Rose Family
(Rosaceae)

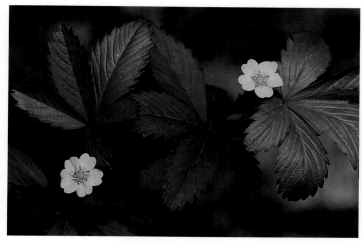

Description: A trailing plant often rooting at the nodes, with a stiff hairy stem up to 3' long. The leaves are alternate along the stem, with long stalks. The leaflets are arranged like 5 fingers on a palm, each up to 3" long, with teeth along the upper ½ of the leaflets. The flowers are on long stalks emerging at the axil of the stem and leaf. Each flower is about ½" across, with 5 rounded petals and about 20 stamens.

May—June

Habitat/Range: Prairies, dry open woods, fields; common; in every county.

Remarks: In folk medicine, a tea made from various species of cinquefoil was used to treat a variety of inflammations, for throat and stomach ulcers, and for fever and diarrhea. As a mouthwash and gargle, the tea was used to treat sore throat, tonsil, and gum inflammations.

YELLOW PIMPERNEL
Taenidia integerrima
Carrot Family (Apiaceae)

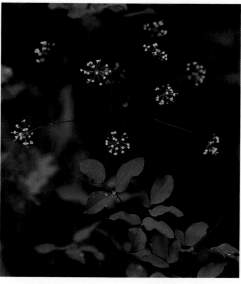

Description: Slender, delicate plants with a whitish powdered appearance up to 3' tall. The leaves are alternate and divided into 2–3 segments with 3–5 leaflets per segment. The leaflets are almost rounded, ½–1" long, and lack teeth along the margins. The flower heads form a loose umbrella-shaped cluster to 3" across. The cluster contains 10–20 stalks, each tipped with its own small head of flowers. Each tiny flower has 5 yellow petals that curve inward at their tips.

May—July

Habitat/Range: Prairies, dry, often rocky open woods, savannas; occasional; throughout the state.

Remarks: Both Native American Indians and settlers mixed the root of yellow pimpernel with other medicines to impart a pleasant aroma. The Mesquakie used it as a seasoning agent for some of their foods. In early folk medicine, a root tea was given for lung ailments. Yellow pimpernel is similar in appearance to golden alexanders, *Zizia aurea*, but the latter has teeth along the leaf margins.

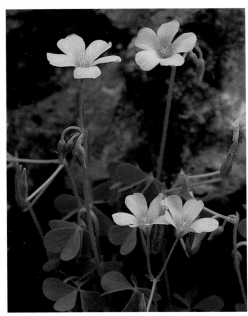

YELLOW WOOD SORREL
Oxalis dillenii
Wood Sorrel Family (Oxalidaceae)

Description: Small hairs lying flat along the stem give the plant a grayish appearance. The stems grow 6–12" tall. The leaves have 3 leaflets on long stalks. Individual flowers are on long stalks and arranged in a loose cluster at the tips of branches. Each flower is about ½" across with 5 yellow petals. The fruits are upright, hairy, and attached to stalks that are at right angles to the stem.

May—November

Habitat/Range: Prairies, open woods, fields, roadsides; common; in every county.

Remarks: The leaves and flowers were eaten by Native American Indians of various tribes. The powdered leaves were boiled in water and used to expel intestinal worms, reduce fevers, and to increase the flow of urine. The distinctive sour taste, which comes from oxalic acid, has been used to flavor salads. A similar species, which shares the common name of yellow wood sorrel, is *Oxalis stricta*, which has the fruit stalk upright and hairs that are spreading and not with a grayish cast. Found in open woods, prairies, roadsides; common; in every county.

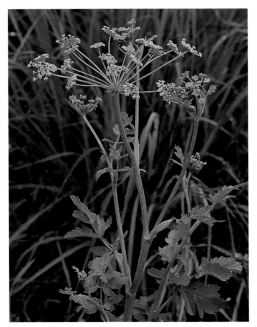

WILD PARSNIP
Pastinaca sativa
Carrot Family (Apiaceae)

Description: A stout, smooth-stemmed, biennial plant to 5' tall with grooves along the stem. The leaves are alternate and divided into leaflets up to 3" long that are round and deeply lobed, with teeth along the margins. The flower heads are large, up to 5" across, on long stalks, and shaped like an umbrella. Numerous yellow flowers, each with 5 petals and 5 stamens, are borne on slender stalks.

May—October

Habitat/Range: Roadsides, fields, disturbed ground; native to Europe and Asia; common in the north ¾ of the state, occasional in the south ¼, but in every county.

Remarks: The sap from this plant reacts with sunlight to form a toxin and can cause a skin rash similar to that of poison ivy on some individuals, with the affected area remaining reddened for several months. The fleshy taproots from the first year reportedly can be excellent when eaten raw or as a cooked vegetable.

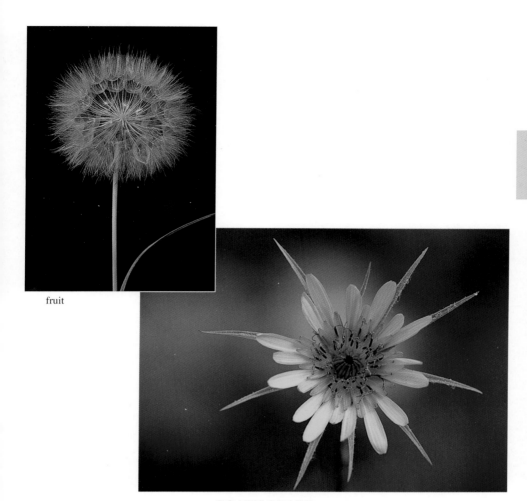

fruit

GOAT'S BEARD
Tragopogon dubius
Aster Family (Asteraceae)

Description: A biennial plant, with milky sap, growing to a height of 2'. The stem is smooth and noticeably thickened just below the flower head. The leaves are alternate, long, and narrow, with the base of the leaves clasping the stem. The flower head opens up to 3" across with pointed green bracts that extend beyond the yellow ray flowers. The flowers close just around midday. The fruit is similar to that of a dandelion but much larger.

May—September

Habitat/Range: Fields, pastures, roadsides, disturbed soil; native to Europe; common throughout the state.

Remarks: The young, tender leaves at the base of the stem can be eaten raw in salads or cooked as greens. The roots, harvested in autumn or winter, are boiled or roasted and eaten. The taste varies from parsnip-like to oyster-like. Another common goat's beard, *Tragopogon pratensis*, has pointed green bracts that do not extend beyond the yellow ray flowers; also native to Europe; found in disturbed sites; common throughout Illinois.

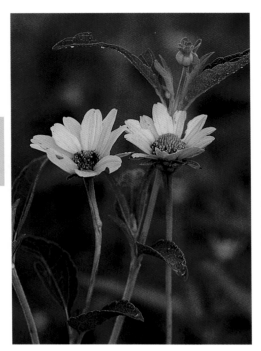

OX-EYE SUNFLOWER
Heliopsis helianthoides
Aster Family (Asteraceae)

Description: A spreading, branched plant to 5' tall. The leaves are opposite, on stalks, shaped like arrowheads, and up to 6" long and 3" wide. The margins have coarse teeth. The flower head is 2–4" across and on a long stalk. There are up to 20 pale to golden yellow ray flowers surrounding a conical yellow disk.

May—October

Habitat/Range: Open woods, savannas, prairies; common throughout the state.

Remarks: Ox-eye sunflower blooms over a long period, making this plant a good candidate for a wildflower garden; however, it can be aggressive.

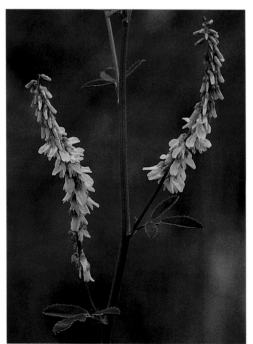

YELLOW SWEET CLOVER
Melilotus officinalis
Pea Family (Fabaceae)

Description: This legume, depending on conditions, grows as an annual or biennial. The branching, smooth stems may reach 7' tall. The leaves are alternate, divided into 3 leaflets, with each leaflet about 1" long, oval, rounded at the top, and finely toothed. The flowers are yellow or white, clustered on 4" stalks, with each flower about ¾" long and fragrant.

May—November

Habitat/Range: Roadsides, fields, waste ground, invasive in dry and moist prairies; native to Asia; common in every county.

Remarks: This plant is similar in all respects to white sweet clover except for the flower color and the fact that yellow sweet clover blooms two weeks earlier than white sweet clover. This weedy plant is highly drought resistant and has spread from its intended use as hay, pasture, and green manure. It is also a popular honey plant by beekeepers. The leaves have a sweet vanilla-like odor when crushed.

FALSE DANDELION
Pyrrhopappus carolinianus
Aster Family (Asteraceae)

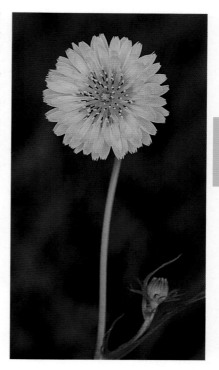

Description: A winter annual or biennial plant, branched, smooth, up to 3' tall with milky sap. The leaves at the base of the stem are lobed, the leaves along the stem are barely toothed or without teeth, narrow, and up to 6" long. The flower heads are up to 1½" across with numerous sulphur yellow ray flowers and 5 teeth along the tip of the petals. The fruit is similar to that of a dandelion.

May—June

Habitat/Range: Dry open woods, prairies, roadsides, disturbed ground; occasional to common in the south ½ of the state.

Remarks: The flowers are open during the morning hours.

DWARF DANDELION
Krigia biflora
Aster Family (Asteraceae)

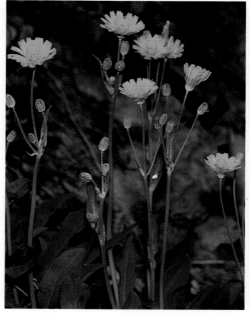

Description: A dandelion-like plant with milky sap and a branching smooth bluish green stem to 2' tall. The leaves at the base of the plant are spoon-shaped on a long stalk. The 1–3 stem leaves are much smaller and clasp the stem. There are 2–7 orangish-yellow flower heads on each stem with each head about 1½" across.

May—September

Habitat/Range: Open woods, prairies, and along streams; common throughout Illinois.

Remarks: Also called "two-flowered Cynthia." A similar species, potato dandelion, *Krigia dandelion*, is named for its tuberous root; it has no leaves on the flowering stem, which is about 12–15" tall, with only 1 flower per stem; open woods; occasional in the south ⅓ of Illinois. Another dwarf dandelion, *Krigia virginica*, has a hairy flowering stem only up to 8" tall and also lacks leaves on the stem; sandy soil; occasional in the north and west part of the state, rare elsewhere.

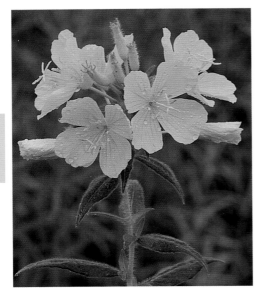

PRAIRIE SUNDROPS
Oenothera pilosella
Evening Primrose Family (Onagraceae)

Description: Unbranched alternate-leaved plants, up to 2½' tall, with soft hairy stems and leaves. The leaves are widest at the middle, up to 4" long and 1" wide. The yellow flowers arise singly at the axils of the leaves. Flowers are about 2" across, with 4 broadly rounded petals with irregular edges.

May—July

Habitat/Range: Moist prairies, low wet areas; occasional throughout the state.

Remarks: Prairie Sundrops flowers bloom once during the day, unlike most others in the primrose family, which are one-time night bloomers.

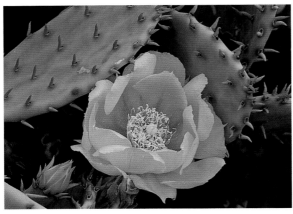

COMMON PRICKLY PEAR
Opuntia humifusa
Cactus Family (Cactaceae)

Description: A low-growing cactus with enlarged fleshy, spiny, green stems that often grow in colonies. The stem segments or pads are narrow, up to 5" long and 3" wide. The upper ⅓ of the pad may have 1–2 needle-like spines, spreading, which emerge from clusters of small bristles. These clusters or tufts are scattered across the surface of the pad. The showy flowers are up to 4" across and open from single buds along the edge of the pad (new pads also emerge along the edge). The 8–12 bright yellow petals have a waxy surface, often with a reddish center. Numerous yellow stamens surround a stout central style. The fruit is cylindrical, up to 2" long, and red when ripe.

May—July

Habitat/Range: Dry sandy soil, on exposed cliffs and sandstone glades; scattered throughout the state.

Remarks: The common name refers to the red, bristly, pear-like fruit. The spines and bristles are covered with microscopic reflexed barbs at their tips, making them difficult to extract. Native American Indians ate the ripe fruit, pads, buds, and flowers raw, cooked, or dried. Another species, plains prickly pear, *Opuntia macrorhiza*, has 2–3 spines per cluster that are turned back (reflexed) against the pad, and the spines are found along the upper ⅔ of the pad; found on the edge of cliffs; confined to a few cliffs on the west side of the state.

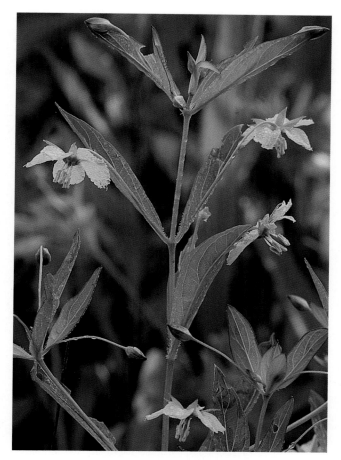

LANCE-LEAVED LOOSESTRIFE
Lysimachia lanceolata
Primrose Family (Primulaceae)

Description: Stems up to 2' tall, with short side branches. The leaves are opposite and vary in shape from rounded and stalked on the lower stem to narrow and tapering on the middle and upper stem. The stem leaves are up to 6" long, less than ¾" wide, pointed at the tip, tapering to the base, and pale green to whitish on the underside. The flowers dangle on long individual short stalks, with each flower about ¾" wide. The 5 yellow petals have ragged edges and finely pointed tips.

May—August

Habitat/Range: Prairies, savannas, pastures, and woodlands; common throughout the state.

Remarks: Another species, lowland yellow loosestrife (*Lysimachia hybrida*), is taller, up to 30", stout stems, leaf stalks with long spreading hairs where they attached to the stem, leaves green on both surfaces; found in moist woods, borders of streams, and moist roadsides; common throughout the state. And there's fringed loosestrife (*Lysimachia ciliata*), with leaves over 1" wide and a fringe of short hairs along the margins; moist woods, bottomlands; common throughout the state. There are 14 species of loosestrifes of the genus *Lysimachia* in Illinois.

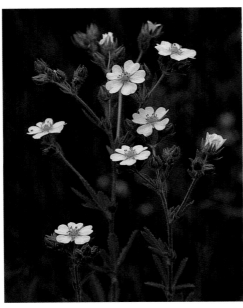

SULFUR CINQUEFOIL
Potentilla recta
Rose Family (Rosaceae)

Description: A stout, hairy, much-branched plant up to 2' tall. The leaves are alternate, with 5–7 finger-like leaflets. The leaflets are rounded at the tip, tapering at the base, with teeth along the margins, hairy, and up to 3" long. The flowers are bright sulfur yellow, up to ¾" across, and attached to hairy stalks. The 5 petals are free from each other and shallowly notched at the tip. The fruits have a wrinkled surface, which explains the other common name "rough-fruited cinquefoil."

May—July

Habitat/Range: Fields, pastures, roadsides, disturbed ground; native to Europe; common throughout Illinois.

Remarks: In folk medicine, a tea made from various species of cinquefoil was used to treat a variety of inflammations, for throat and stomach ulcers, and for fever and diarrhea. As a mouthwash and gargle, the tea was used to treat sore throat, tonsil, and gum inflammations.

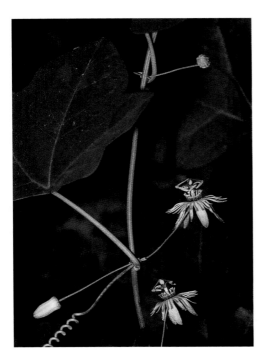

YELLOW PASSION FLOWER
Passiflora lutea
Passion Flower Family (Passifloraceae)

Description: A vine, up to 15' long, that climbs or sprawls with the help of tendrils. The leaves are alternate, with 3 broad, rounded lobes, usually smooth, and up to 4" across. The unusual flowers are single, arising on stalks from the axils of leaves. Individual flowers are small, about 1" across, with several greenish-yellow petals and a greenish-yellow fringe. There are 5 drooping stamens around the pistil, which has 3–4 curved stigmas. The fruit is oval, smooth, black when ripe, up to ½" long, and contains dark brown seeds with gelatinous coverings.

May—September

Habitat/Range: Moist or rocky woods, thickets; occasional to common in the south ½ of the state, rare or absent in the north ½.

Remarks: The young shoots and tendrils of the plant are eaten by wild turkey.

HAIRY HAWKWEED
Hieracium gronovii
Aster Family (Asteraceae)

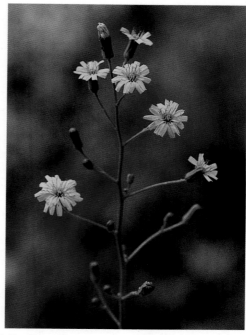

Description: Slender stems up to 4' tall, with conspicuous spreading hairs, up to ¼" long, near the base. The leaves at the base and lower part of the stem are up to 8" long and up to 2" wide, bristly hairy on the upper surface, with star-shaped hairs on the lower surface. The flower heads are branched along the upper stem with gland-tipped hairs along the flower stalks. Each flower head has 15–30 yellow ray flowers.

May—October

Habitat/Range: Dry open woods, savannas, thickets, and fields; occasional in Illinois but rare in the northwest counties.

Remarks: Another species, long-bearded hawkweed, *Hieracium longipilum*, has long, dense hairs on the lower stem leaves over ½" long, narrower cluster of flower heads, and 40–60 ray flowers on each head; open woods, prairies, fields; occasional throughout the state. Another, rough hawkweed, *Hieracium scabrum*, has hairs on the lower stem leaves less than ½" and ray flowers more than 40; dry woods, savannas, fields; occasional throughout the state.

PENCIL FLOWER
Stylosanthes biflora
Pea Family (Fabaceae)

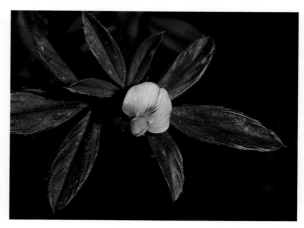

Description: A small wiry-stemmed plant, often branched at the base, hairy, up to 8" tall. The leaves are alternate, divided into 3 leaflets, each up to 2" long and ½" wide. There are widely scattered bristles along the leaf margins. The flowers are nested in leafy clusters at the tops of branches and are arranged in the style typical of the pea family. The orange-yellow flowers are about ¼" long.

May—September

Habitat/Range: Dry open woods, savannas, fields; common in the south ¼ of the state, rare or absent elsewhere.

Remarks: The bean-like seeds are eaten by wild turkey and bobwhite quail.

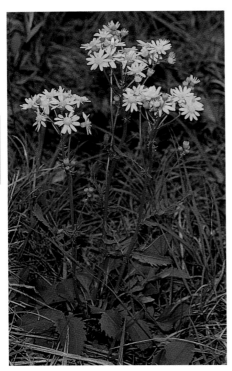

PRAIRIE RAGWORT
Senecio plattensis
Aster Family (Asteraceae)

Description: Mostly unbranched stems, up to 2' tall, with alternate leaves and dense hairs on the flower heads, stems, and leaves. The basal leaves are up to 3" long and 1½" wide (less than 3 times as long as wide), long stalked, with large teeth along the margins. The stem leaves are smaller, stalkless, with lobes along the margins. About 10 flower heads occur in a flat cluster on the top of the stem. Each flower head is ½–1" across, with 6–15 yellow, petal-like ray flowers surrounding small, yellow-orange disk flowers.

May—June

Habitat/Range: Dry prairies, sand prairies, sandy woods, fields; common across Illinois but excluded from the south central counties.

Remarks: Another species, balsam or northern ragwort, *Senecio pauperculus*, has basal leaves narrower, more than 3 times as long as wide, and lacking dense hairs on the flower heads, stems, and leaves. Found in moist and wet prairies, sand flats, sedge meadows; common in the north ½ of Illinois, rare in the south ½.

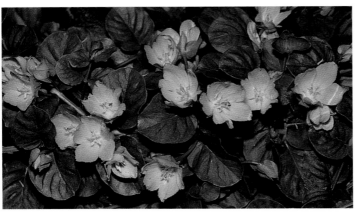

MONEYWORT
Lysimachia nummularia
Primrose Family (Primulaceae)

Description: Creeping stems spread low over the ground, with small almost round, opposite semi-evergreen leaves, up to 1" long and wide. Flowers are yellow on slender stalks emerging from the leaf axils, about 1" across with 5 petals.

June—August

Habitat/Range: Moist, partially shaded areas; native to Europe; common throughout the state.

Remarks: The species Latin name *nummularia* means coin-shaped in reference to the leaves.

104

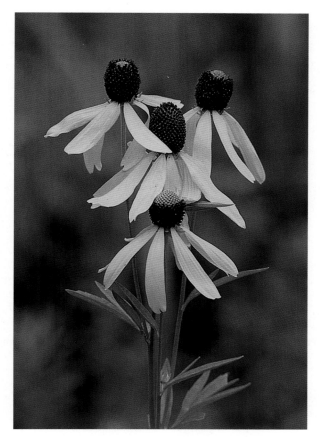

GRAY-HEADED CONEFLOWER
Ratibida pinnata
Aster Family (Asteraceae)

Description: A slender, hairy-stemmed plant, up to 5' tall, often branching toward the top. The leaves are divided into 3–7 slender leaflets with a few teeth or small side lobes along the margins. The leaves at the base of the stem are on long stalks with the leaf blade up to 7" long. The leaves on the stem are alternate and smaller. Each flower head has its own long stalk. The 5–10 yellow ray flowers droop downward, each about 2" long and less than ½" wide. They surround a conical disk about ¾" tall. Prior to opening, the small disk flowers are ashy gray, hence the common name, but they turn brown as the flowers open. The crushed seed heads have a distinct anise scent.

June—September

Habitat/Range: Prairies, savannas; common in the north ¾ of the state, occasional in the south ¼.

Remarks: Native American Indians made a tea from the flower cones and leaves. The Mesquakie used the root to cure toothaches. Another species, long-headed coneflower, *Ratibida columnifera*, has a central disk that is shaped like a cylinder, much longer than wide, and ray flowers that are sometimes partly or completely red or purple; found along railroads; native to western U.S.; scattered in the north ⅔ of Illinois.

105

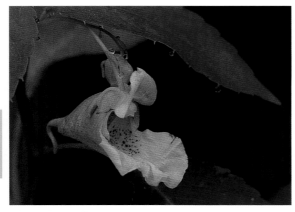

PALE TOUCH-ME-NOT
Impatiens pallida
Jewelweed Family (Balsiminaceae)

Description: Annual plants growing to 4' tall, with branched stems that are weak and watery. The stems are pale green and translucent with leaves alternate, oval, thin, and bluish green. The leaves are up to 3½" long with long stalks and widely spaced teeth along the margins. Flowers are shaped like a cornucopia up to 1¼" long and hang on a slender stalk. The smaller end of the flower is a curved spur that holds the nectar. The fruit is a slender capsule about 1" long, which splits and propels the seed when touched.

June—October

Habitat/Range: Moist to wet woodlands and banks of streams; common throughout the state.

Remarks: The Potawatomi and settlers applied the juice of touch-me-not to relieve the itch of poison ivy. Today, the juice is used to relieve the burning sensation of stinging nettle, which is often found occupying the same habitat as touch-me-nots. The juice is also thought to neutralize the oil of poison ivy after contact. Livestock have been poisoned by eating large amounts of the fresh green plants.

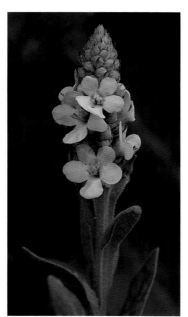

WOOLLY MULLEIN
Verbascum thapsus
Figwort Family (Scrophulariaceae)

Description: This stocky biennial can reach a height of 6' with large woolly leaves and a spike of densely packed yellow flowers. The first year's leaves form a basal rosette with each leaf up to 1' long, with soft, woolly hairs. The second year, a flower stalk emerges with alternate leaves scattered along the stem. The leaf bases extend down the stem forming wings. The short, tubular flower opens to about 1" across, with 5 yellow lobes.

June—September

Habitat/Range: Dry fields, pastures, disturbed ground, and along roadsides; native to Europe; common; in every county.

Remarks: In ancient Greece, the leaves were rolled, dried, and made into wicks for oil lamps and candles. Dioscorides used mullein to treat lung diseases, diarrhea, insomnia, and to relieve pain. In the Middle Ages, carrying a twig of mullein was said to protect a person from witchcraft and wild beasts. Arriving early with settlers in the United States, the plant was used by Native American Indians as a leaf tea for treating coughs. Settlers used the large leaves for baby diapers, and early pioneers and even today's campers have used the woolly leaves in place of toilet paper.

106

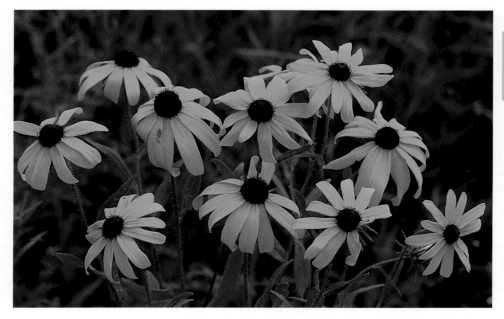

BLACK-EYED SUSAN
Rudbeckia hirta
Aster Family (Asteraceae)

Description: This short-lived perennial grows 1–3' tall with rough and hairy leaves and stems. The basal leaves are up to 5" long and 1" wide. Along the stem, the leaves are alternate, up to 4" long, widest in the middle, and tapering towards the tip. Flower heads are single at the top of each stem branch with showy heads about 2–3" across. There are 10–20 ray flowers that surround a dark brown to purple-brown, dome-shaped disk.

June—October

Habitat/Range: Prairies, savannas, open woods, pastures, old fields, and along roadsides; occasional throughout the state.

Remarks: The Potawatomi prepared a root tea for curing colds. Early settlers used the plant as a stimulant and a diuretic. A yellow dye is made from this plant. Another species, orange coneflower, *Rudbeckia fulgida*, has runners at the base that often form large colonies. Leaves at the base are on long stalks, with flower heads about 2" wide; petals are short and wide, often marked with dark yellow or orange at the base. Found in dry open woods; scattered in the south ½ of Illinois.

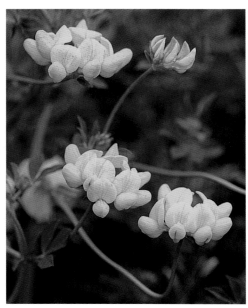

BIRD'S FOOT TREFOIL
Lotus corniculatus
Pea Family (Fabaceae)

Description: A sprawling plant, up to 2' long, with the branching stems upright toward the tips. The leaves are divided into 5 leaflets, each up to ¾" long, with the 2 lower leaflets some distance below the 3 upper leaflets. The flowers are clustered on a long stalk that arises from a leaf axil. The flowers are golden yellow, about ¾" long, and arranged in the pattern typical of members of the pea family. The seeds form in slender, upright pods.

June—September

Habitat/Range: Fields, roadsides, and disturbed sites; native to Europe; occasional to common throughout Illinois.

Remarks: Bird's foot trefoil is low growing and has been planted along roadsides to reduce mowing. It has also been cultivated for its pasture value. Because it can be weedy and spreads into habitat occupied by native vegetation, its use should be discouraged.

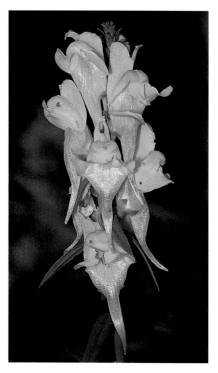

BUTTER-AND-EGGS
Linaria vulgaris
Figwort Family (Scrophulariaceae)

Description: A colonial plant by creeping roots, from 12–30" tall, with narrow, alternate, blue-green leaves ¾–2" long. Flowers, up to 1½" long including the spur (tail), are crowded along the upper stem with two bright yellow lips. Note the lower lip has an orange palate (a conspicuous bulge in the throat).

June—November

Habitat/Range: Roadsides, fields, escapes from cultivation; native to Europe; common throughout Illinois.

Remarks: Butter-and-Eggs is named for its color combination. The bright orange on the flower's lip attracts bees, particularly bumblebees that are about the only insects strong enough to open the lips and reach down inside the spur-like tube to obtain the nectar.

YELLOW CROWNBEARD
Verbesina helianthoides
Aster Family (Asteraceae)

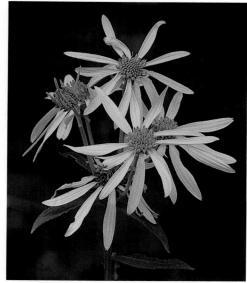

Description: Flaps of leaf tissue or "wings" run down the length of the hairy stem, which can reach a height of 3½'. The leaves are alternate, up to 6" long, with coarse hairs on the upper surface, soft-hairy on the lower surface, with teeth along the margins. The flower heads are large, with 8–15 yellow petal-like ray flowers surrounding a yellow disk.

June—July

Habitat/Range: Prairies, open woods, savannas, along streams; common in the south ⅗ of the state, absent elsewhere.

Remarks: This plant is also known as "yellow wingstem." Bobwhite quail, songbirds, and small mammals eat the seeds.

WILD FLAX
Linum sulcatum
Flax Family (Linaceae)

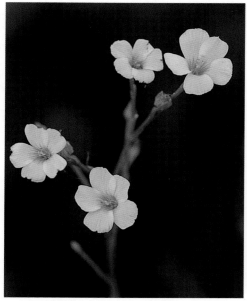

Description: A pale green annual plant, up to 2½' tall, with a stiff stem that branches near the top. The branches have conspicuous grooves or ridges. The leaves are alternate on the stem, about 1" long and only ⅛" wide, pointed at the tip, and stalkless. Two tiny round glands are found where the leaf attaches to the stem. The flowers are scattered among the branches on short flower stalks. The flowers are about ¾" across, with 5 pale yellow petals that drop off shortly after flowering.

June—September

Habitat/Range: Sandy soil, hill prairies; occasional throughout the state.

Remarks: A related species, small yellow flax, *Linum medium* var. *texanum*, is a perennial, lacks the small round glands at the base of the leaf, and lacks the grooves or furrows on the branches. Found in dry soil, pond shores; occasional in south ½ of Illinois, rare in north ½. Various species of flax have been cultivated since before recorded history for the fibers in their stems, used to make linen, and the oil in their seeds, linseed oil. The seeds were also used for a variety of medicinal remedies. The most widely used common flax, *Linum usitatissimum*, has blue flowers and originated in Europe. Found in disturbed areas and occasional throughout the state.

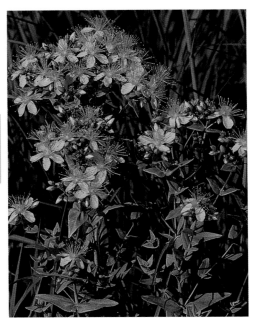

SPOTTED ST. JOHN'S WORT
Hypericum punctatum
St. John's Wort Family (Clusiaceae)

Description: The sturdy stem of this plant is somewhat branched at the top and up to 3' tall. The undersides of the leaves, sepals, and petals are covered with numerous tiny black dots. The leaves are opposite, lacking stalks, up to 2½" long and ¼" wide, and thick and leathery in texture. The flowers are clustered at the top of the stem and in short side branches. Each flower is about ½" across with 5 yellow petals and numerous stamens surrounding a flask-shaped central ovary.

June—August

Habitat/Range: Woods, along streams, fields, and roadsides; common throughout the state; in every county.

Remarks: The Menomini treated tuberculosis with a type of St. John's wort; they also mixed it with raspberry root for treating kidney troubles. A similar species, common St. John's wort, *Hypericum perforatum*, has black dots along the margins of the petals, sepals, and stems, with stems much branched; native to Europe and has been popularized recently by its ability to treat depression.

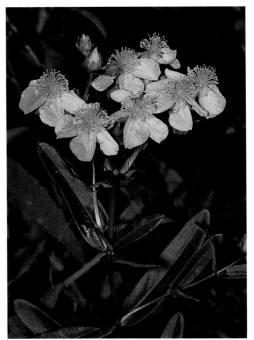

ROUND-FRUITED ST. JOHN'S WORT
Hypericum sphaerocarpum
St. John's Wort Family (Clusiaceae)

Description: The stem is somewhat woody and often branched at the base, up to 30" tall. The leaves are linear and of equal width throughout. The flowers are compact and much branched at the top, with 5 yellow petals, each about ⅜" long, with 45–85 stamens.

June—September

Habitat/Range: Woods, roadsides, fields; scattered throughout the state

Remarks: St. John's wort is said to have gotten its common name from the red resin that is contained in small, black glands in the flower petals of some of the species. In the Middle Ages, it was said that this was the blood shed by St. John the Baptist when he was beheaded. The word "wort" is an old English word for plant.

BROWN-EYED SUSAN
Rudbeckia triloba
Aster Family (Asteraceae)

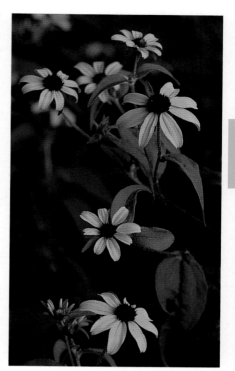

Description: A bushy plant with several often reddish-colored branches, up to 5' tall, with spreading hairs on the stems. The leaves are alternate, hairy, with the lower ones 3-lobed and often shed at the time of flowering. The upper stem leaves are narrow, stalkless, about 4" long, and with toothed edges. The flower heads are numerous, with each head up to 1¾" across. Each head has 6–12 yellow petal-like ray flowers surrounding a dome-shaped brown disk.

June—October

Habitat/Range: Woods, fields, moist thickets, stream banks; common throughout the state.

Remarks: The flower heads of brown-eyed Susan are smaller and much more numerous than those of black-eyed Susan. The plants are also taller and widely branched, which also helps to differentiate them from black-eyed Susan.

MULLEIN FOXGLOVE
Dasistoma macrophylla
Broomrape Family (Orobanchaceae)

Description: A stout, biennial plant with branching stems to 7' tall. The basal leaves are large, up to 10" long, and deeply cut. The basal leaves in early spring are an attractive reddish purple before turning green. The stem leaves are progressively smaller toward the top of the plant, lance-shaped, and smooth along the margins. The flowers lack stalks and emerge directly from the axil of the leaves and stem. The flower is a short tube, woolly inside, less than ¾" long, with 5 yellow petals and 4 stamens.

June—September

Habitat/Range: Moist to dry woods, rocky slopes, thickets; occasional throughout Illinois.

Remarks: Mullein foxglove was formerly known as *Seymeria macrophylla*. The plant, although rarely seen in large numbers, is a preferred food of white-tailed deer.

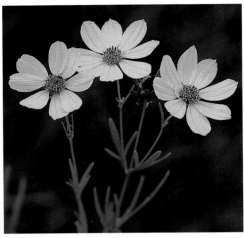

PRAIRIE COREOPSIS
Coreopsis palmata
Aster Family (Asteraceae)

Description: Narrow, rigid-stemmed plants, usually 1–2½' tall. The leaves are opposite on the stem, with each leaf divided into 3 long, narrow segments. The middle segment can sometimes be divided again for another 1–2 segments. The flower heads are on individual stalks, with each head having 8 yellow, petal-like ray flowers that surround a yellow central disk. The ends of the ray flowers are notched or toothed.

June—August

Habitat/Range: Prairies, dry open woods, savannas; common in the north ¾ of the state, occasional in the south ¼.

Remarks: The Mesquakie boiled the seeds and drank the brew. Some tribes applied the boiled seeds to painful areas of the body to relieve ailments such as rheumatism.

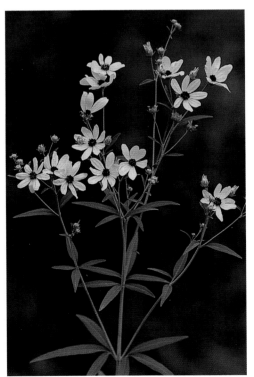

TALL COREOPSIS
Coreopsis tripteris
Aster Family (Asteraceae)

Description: Tall, stout stems, sometimes with a whitish coating, up to a height of 8' but typically shorter. The leaves are opposite, with stalks, and divided into 3, and sometimes 5, narrow leaflets. The flower heads are on several slender stalks at the top of the plant. Each head is about 1½" across, with 6–10 yellow, petal-like ray flowers surrounding a brown central disk. The flower heads have an anise scent.

July—October

Habitat/Range: Prairies, dry open woods, savannas; common throughout Illinois.

Remarks: Also called tall tickseed. The Mesquakies boiled the plant to make a drink to treat internal pains and bleeding.

PLAINS COREOPSIS
Coreopsis tinctoria
Aster Family (Asteraceae)

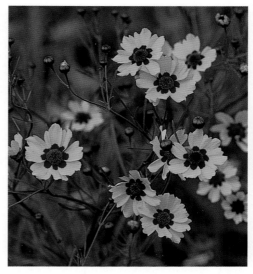

Description: A multibranched, annual plant 2–4' tall, with smooth stems and opposite leaves. The leaves are up to 4" long and divided into very narrow leaflets. The flower heads are about 1" across, numerous, on long stalks, and very showy. The 7–9 petal-like ray flowers are yellow with a prominent reddish spot at the base and are toothed at the tip. The central disk is reddish brown.

June—September

Habitat/Range: Escapes from gardens into disturbed soil; native to the western United States; scattered throughout the state.

Remarks: Also called golden coreopsis, this plant is a popular ornamental in gardens and in restoration sites where quick color is desired. The Lakotas boiled the flowers in water, which turned red, and used it as a beverage. The plant tops were used in a tea to strengthen the blood. The Mesquakies boiled the plant to make a drink to treat internal pains and bleeding.

PRAIRIE CINQUEFOIL
Drymocallis arguta
Rose Family (Rosaceae)

Description: Single-stemmed plants below the flower clusters, up to 3' tall, with spreading hairs on the stems and leaves. The leaves are alternate along the stem, with each leaf composed of 3–11 toothed leaflets. The end leaflet is the longest, up to 3". The flowers, each about ¾" across, appear on branched stems, each with 5 creamy white to pale yellow, rounded petals.

June—July

Habitat/Range: Prairies; occasional in the north ½ of the state.

Remarks: The whole plant, including the root, has been used in tea or as a poultice (moist, warm plant material applied to the skin) to stop bleeding (astringent to capillaries) on cuts and wounds, and for diarrhea and dysentery.

113

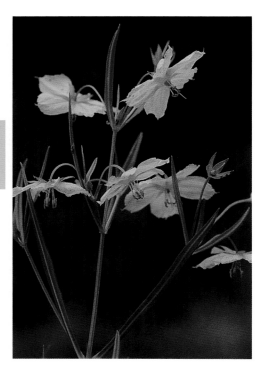

NARROW-LEAVED LOOSESTRIFE
Lysimachia quadriflora
Primrose Family (Primulaceae)

Description: Slender plants up to 2' tall, with very narrow stalkless leaves that are opposite on the stem. The leaves are 3" long, less than ¼" wide, with smooth edges that are slightly turned down. The flowers are on long slender stalks that bend, causing the flowers to droop. There are 5 broad yellow petals that are somewhat ragged along the outer edges.

June—August

Habitat/Range: Moist prairies, marshes, bogs; occasional in the north ½ of the state.

Remarks: Native American Indians made tea from loosestrife plants for kidney trouble, bowel complaints, and other problems. Tea from the root was used to induce vomiting. There are 14 loosestrife species in the genus *Lysimachia* in Illinois.

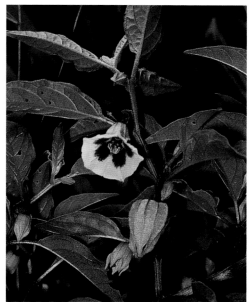

SMOOTH GROUNDCHERRY
Physalis subglabrata
Nightshade Family (Solanaceae)

Description: An upright, branching plant, up to 1' tall, with sparsely hairy to smooth stems and leaves. The leaves are alternate along the stem, up to 2" long and about 1" across. The flowers dangle from slender stalks that arise from the base of the leaf stalks and the stem. The yellow, bell-shaped flowers are about ½–¾" across with purple blotches inside. The papery, lantern-shaped fruit is from 1–1½" long.

June—August

Habitat/Range: Disturbed woods, fields, pastures; occasional throughout the state.

Remarks: There are 15 species of groundcherry in Illinois, with 5 not being native to the state. The potentially toxic groundcherries have been useful for treating difficult urination, fevers, and inflammation, and are being researched for antitumor activity.

114

SEEDBOX
Ludwigia alternifolia
Evening Primrose Family (Onagraceae)

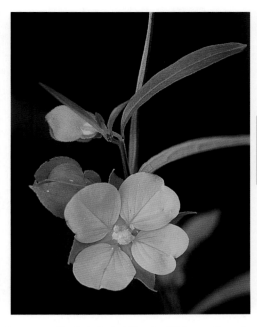

Description: A widely branching plant, up to 4' tall. The leaves are alternate, up to 4" long and less than 1" wide, broadest at the middle and tapering to the tip and base. The flowers are single, on short stalks, and arising at the junction of the leaf and stem. Each flower is about ¾" wide, with 4 yellow petals, which fall shortly after flowering, and 4 stamens. The seed capsules are distinctly square, up to ¼" across, angled or narrowly winged, and containing numerous small seeds.

June—August

Habitat/Range: Wet ground in prairies and meadows, along streams, shores of ponds and lakes, and in moist idle fields and roadside ditches; occasional throughout Illinois.

Remarks: There are 7 species of seedbox in the genus *Ludwigia* in Illinois. This seedbox is the only one in the state with sharply angled square fruits; the others have tubular to slightly squarish fruits.

EVENING PRIMROSE
Oenothera biennis
Evening Primrose Family (Onagraceae)

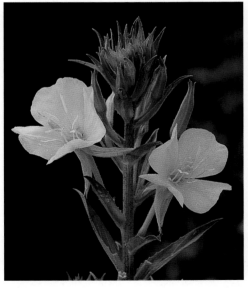

Description: A biennial with a stout, sometimes hairy stem tinged with red, as are parts of the older leaves, up to 7' tall. The leaves are alternate, lance-shaped, pointed at the tip, hairy on both sides, toothed along the margin, and up to 6" long. The flowers are numerous along a long column, with yellow petals that open to 2½" across. The 4 yellow petals have a shallow notch at the end. There are 8 yellow stamens.

June—October

Habitat/Range: Prairies, fields, pastures, roadsides, disturbed ground; common; in every county.

Remarks: The flowers open in the evening and close by midmorning on sunny days. The flowers emit a creosote smell that attracts night-flying sphinx moths. Native American Indians ate the seeds and the first-year roots (the second-year roots are too woody). After this plant was introduced to Europe from North America in the early 1600s, Europeans ate its roots and put the young shoots into salads. The entire plant was prepared and used to treat whooping cough, hiccups, and asthma.

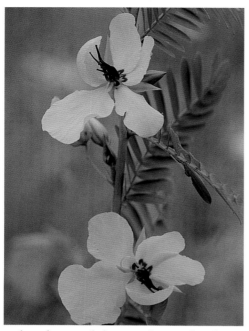

PARTRIDGE PEA
Chamaecrista fasciculata
Bean Family (Fabaceae)

Description: An annual plant, up to 2' tall, with alternate leaves, each divided into about 20 pairs of leaflets. The leaflets are narrow, less than 1" long, and rounded at both ends, with a small bristle-like tip. Near the middle of each leaf stalk there is a small, saucer-shaped gland. There are 1–6 flowers, up to 1½" across, on slender stalks that emerge at the axil of the leaf and stem. There are 5 yellow petals, with 3 slightly smaller than the other 2. There is a tinge of red at the base of each petal. There are 10 yellow to dark red stamens.

June—October

Habitat/Range: Prairies, savannas, roadsides, fields, disturbed ground; common throughout the state.

Remarks: Partridge pea was formerly known as *Cassia fasciculata*. Cherokees and settlers used the root for treating fevers, cramps, heart ailments, and constipation. A closely related species, sensitive partridge pea, *Chamaecrista (Cassia) nictitans*, has smaller flowers (less than ¾" wide), 5 stamens, and a short stalk below the saucer-shaped gland on the leaf stalk. Occurs in edge of woods, fields, roadsides; occasional in the south ½ of Illinois, less common elsewhere.

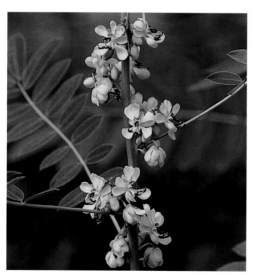

WILD SENNA
Senna marilandica
Bean Family (Fabaceae)

Description: A perennial plant, often with a single stem up to 6' tall, with large, alternate leaves. The leaves are divided into 8–12 pairs of leaflets, each about 2" long and 1" wide, with small, bristle-like points at the tips. The flowers vary from being numerous on branched clusters to only 1–4 on stalks emerging from the junction of a leaf and stem. Each flower is about 1" across, with 5 narrow yellow petals that are often curled and 10 brownish-red stamens.

July—August

Habitat/Range: Moist areas along streams, bottomland woods along streams, edges of woods, open fields, and thickets; occasional throughout the state.

Remarks: Wild senna was formerly called *Cassia marilandica*. The Mesquakies ate the seeds, softened by soaking, as a mucilaginous medicine for sore throat. The Cherokees used the bruised root moistened with water for dressing sores. They also used the root in a tea to cure fevers and as a laxative.

PURPLE-HEADED SNEEZEWEED
Helenium flexuosum
Aster Family (Asteraceae)

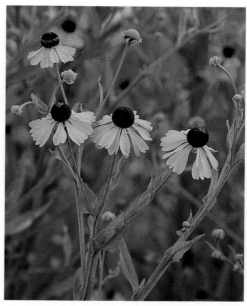

Description: A single-stemmed plant, up to 3' tall, with branching toward the top. The stem has leafy wings that originate at the base of the leaf and continue down the stem. The leaves are alternate, lacking stalks, up to 3" long, and less than 1" wide. The distinctive flower head has a round, brownish-purple central disk surrounded by 8–14 fan-shaped, yellow, petal-like ray flowers, each with 3 lobes. Each flower head is about 1" across.

June — September

Habitat/Range: Moist areas along streams, pastures, and old fields; occasional in the south ½ of the state, rare in the north ½.

Remarks: Sneezeweeds are considered poisonous to cattle if eaten in sufficient quantity. This is unlikely to happen, however, because of the plant's bitter taste. The plant is also poisonous to fishes and worms as well as to insects. Research by the National Cancer Institute has demonstrated significant antitumor activity in this plant's chemistry.

BITTERWEED
Helenium amarum
Aster Family (Asteraceae)

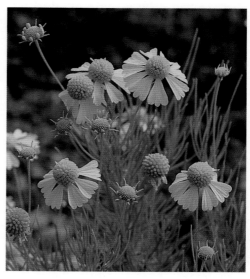

Description: A very leafy, much-branched annual plant to 1' tall. The leaves are thread-like, alternate but sometimes whorled on the stem, up to 1½" long. The flower heads are fan-shaped, up to 1" across, with yellow, petal-like ray flowers that have notches on the ends, and a central dome-shaped yellow disk.

July — October

Habitat/Range: Fields, pastures, disturbed soil, and along roadsides; occasional in the south ½ of Illinois, absent in the north ½.

Remarks: This plant has a strong bitter smell. Cattle often avoid it, and those that graze on the plant give milk with a bitter flavor, hence the common name. There are cases of sheep, cattle, horses, and mules having been poisoned from eating this plant.

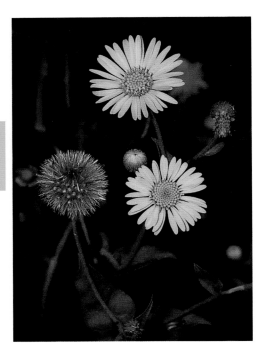

GOLDEN ASTER
Heterotheca camporum
Aster Family (Asteraceae)

Description: A stout plant, up to 40" tall, with alternate leaves that are around 3" long and ¾" wide. The leaf margins are mostly smooth, but sometimes with a few small, sharp teeth. The yellow flower heads have 20–34 petal-like ray flowers, each about ½" long, with a central disk about ½" across.

June—September

Habitat/Range: Sandy disturbed areas; occasional throughout the state.

Remarks: Formerly known as *Chrysopsis villosa* and *Chrysopsis camporum.*This is a drought tolerant plant and a good source of nectar for a variety of butterflies. Seeds sown in early spring will produce flowering plants the first year.

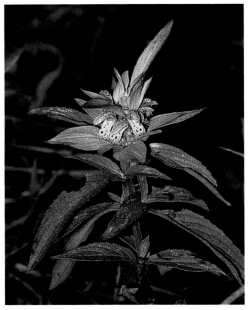

HORSEMINT
Monarda punctata
Mint Family (Lamiaceae)

Description: The pinkish-purple bracts obscure the dull yellow flowers of this plant, which reaches a height to 3', with a finely hairy stem and toothed, opposite leaves on short stalks. The leaves are about 3½" long and up to 1" wide. The flowers are arranged in whorls; with 2–5 whorls stacked one above the other, separated by a whorl of pinkish-purple bracts. Each yellow, tubular flower is about 1" long and peppered with dark spots. The lower lip has 3 lobes.

July—October

Habitat/Range: Sandy fields and woods, dunes, prairies; occasional in the north ½ of the state, rare in the south ½.

Remarks: Native American Indians used leaf tea for colds, fevers, flu, stomach cramps, coughs, and bowel ailments. Historically, doctors used this mint as a stimulant and diuretic.

FLOWER-OF-AN-HOUR
Hibiscus trionum
Mallow Family (Malvaceae)

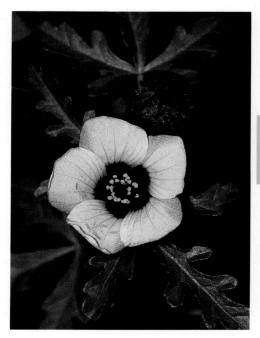

Description: A hairy annual, up to 20" tall, with long-stalked leaves that are deeply 3-parted. There are large lobes along the margins of the leaves. The pale yellow flowers have purple centers. The 5 petals are each about 1½" long.

July—October

Habitat/Range: Disturbed areas; native to Europe; common throughout the state.

Remarks: The flowers open only for a few hours in the morning, which relates to the common name.

YELLOW GIANT HYSSOP
Agastache nepetoides
Mint Family (Lamiaceae)

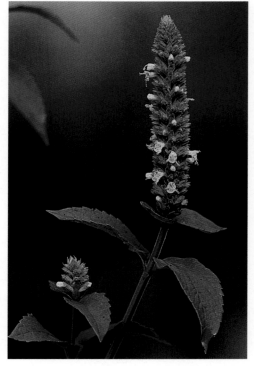

Description: A stout-stemmed plant up to 6' tall, with a sharply 4-sided stem and branching near the top. The leaves are opposite, coarsely toothed along the margins, thin, lance-shaped, up to 6" long, and reduced in size upwards, with fine hairs on the lower surface. The cluster of flowers is cylindrical along a stalk up to 8" long. The flowers are pale yellow, small, numerous, with 2 lips and 2 pairs of long stamens curved in opposite directions.

July—September

Habitat/Range: Open woods, moist woods, borders of woods, and thickets; occasional throughout Illinois.

Remarks: A related species, purple giant hyssop, *Agastache scrophulariaefolia*, has purple flowers; found in open woods; occasional in the north ⅔ of the state. Also, the blue-flowered blue giant hyssop, *Agastache foeniculum*, has been used as a leaf tea for fevers, colds, and coughs; also to induce sweating and to strengthen weak hearts. Found in dry soil; Menard County.

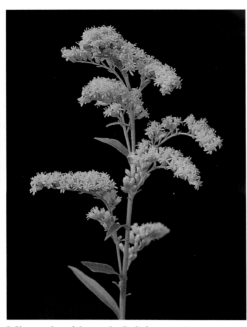

EARLY GOLDENROD
Solidago juncea
Aster Family (Asteraceae)

Description: An upright plant to 3' tall; one of the earliest goldenrods to flower, doing so in early summer. The basal leaves are up to 8" long and 1" wide. The stem leaves are alternate, smaller, tapering at the base and tip, and with some small teeth along the margins. A single prominent vein runs the length of the leaves. The flower heads are crowded together on the tops of arching side branches. Each head has about 14 very small, yellow, petal-like ray flowers.

June—September

Habitat/Range: Prairies, dry open woods, savannas, disturbed soil, and fields; common throughout Illinois.

Remarks: A closely related species, Missouri goldenrod, *Solidago missouriensis*, has 3 prominent veins running the length of the leaves and has basal leaves less than 1" wide that often wither before flowering time.

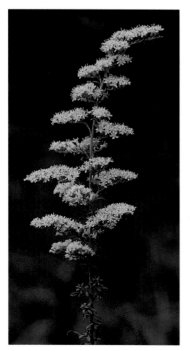

GRAY GOLDENROD
Solidago nemoralis
Aster Family (Asteraceae)

Description: The stems vary from arching to upright, growing up to 2½' tall; dense, short, gray hairs on the stems and leaves give the plant a gray-green appearance, hence the common name. The basal leaves are large and present at the time of flowering. The stem leaves are progressively smaller towards the top of the stem. The flower heads are densely packed on the tops of short branches. Each head is less than ¼" across with 5–9 yellow, petal-like ray flowers.

July—November

Habitat/Range: Prairies, sand dunes, savannas, dry open woods, pastures, old fields, and along roadsides; common throughout Illinois.

Remarks: Also called "old-field goldenrod," the upright form is easy to identify at a distance by its slightly bent tip. There are 25 species of goldenrods in Illinois.

SHOWY GOLDENROD
Solidago speciosa
Aster Family (Asteraceae)

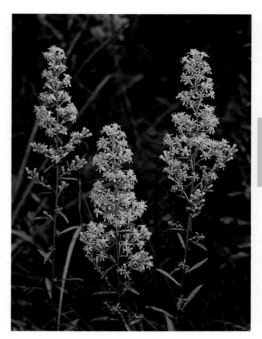

Description: Sturdy unbranched stems, up to 4' tall, with alternate, smooth leaves. The lower leaves are large, around 12" long and 4" wide that wither around flowering time. The upper leaves decrease in size going up the stem. The flowers are densely arranged on branches in an elongate, cylindrical cluster at the top of the stem. Each yellow flower head is about ½" across, with 6–8 petal-like ray flowers and 4–5 small disk flowers.

July—October

Habitat/Range: Prairies, open woods; common throughout Illinois.

Remarks: The common name is appropriate for this is one of the most attractive of the 25 species of goldenrods in Illinois.

GRASS-LEAVED GOLDENROD
Euthamia graminifolia
Aster Family (Asteraceae)

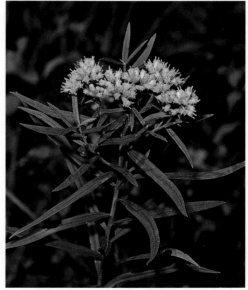

Description: Rather spindly plants, up to 3' tall, with the upper half of the stem branched. The stems and leaves are hairy. The leaves are alternate, up to 5" long, with 3 distinct parallel veins along the length of the blade. The yellow flowers are in a branched flat-topped cluster at the top of the stem. Each flower head is about ¼" across, with 15-25 petal-like ray flowers and 5–10 central disk flowers.

August—October

Habitat/Range: Moist ground to dry sandy fields and shores, marshes; scattered throughout the state.

Remarks: Formerly known as *Solidago graminifolia*, a closely related species, plains grass-leaved goldenrod, *Euthamia (Solidago) gymnospermoides*, differs by having hairless stems and leaves, one central vein along the length of the blade, and found mostly in prairies. It is occasional in the north and west side of the state.

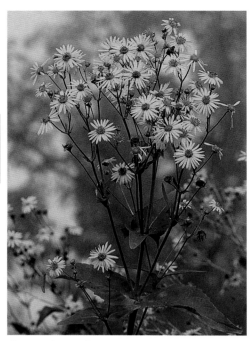

CUP PLANT
Silphium perfoliatum
Aster Family (Asteraceae)

Description: Large plants, branching near the top to 8' tall with stout, square stems. The large upper leaves are cupped around the stem tight enough to hold rainwater. The leaves have wavy margins, large teeth, and are rough to the touch on both sides. The flower heads are at the tops of branches, numerous, and up to 3" across. Each head has 20–30 yellow, petal-like ray flowers surrounding a yellow central disk.

July—October

Habitat/Range: Moist areas along borders of streams, floodplains, low thickets; common throughout Illinois.

Remarks: The Omahas and Poncas used the root as a smoke treatment, inhaling the fumes for head colds, nerve pains, and rheumatism. Also, the resinous sap that exudes from the stem was chewed as a gum to help prevent vomiting. This plant is sometimes called "carpenter's weed" because of its straight, square stem.

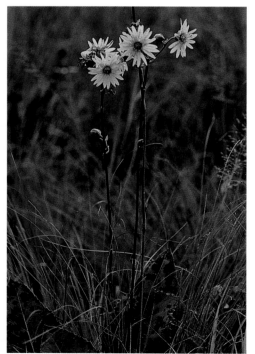

PRAIRIE DOCK
Silphium terebinthinaceum
Aster Family (Asteraceae)

Description: A tall, wand-like stem rises up to 10' above a cluster of large, spade-shaped basal leaves. The leaves are up to 16" long, very rough in texture, with a heart-shaped base and coarse teeth along the margins. The flower heads occur at the top of a smooth, shiny, nearly leafless stalk. The heads are 2–3" across with 12–20 yellow, petal-like ray flowers surrounding a yellow central disk.

July—September

Habitat/Range: Prairies, limestone glades; occasional to common throughout Illinois.

Remarks: Native American Indians used a root tea as a general tonic for feebleness and to expel intestinal worms. Leaf tea was used for coughs, lung ailments, and asthma.

COMPASS PLANT
Silphium laciniatum
Aster Family (Asteraceae)

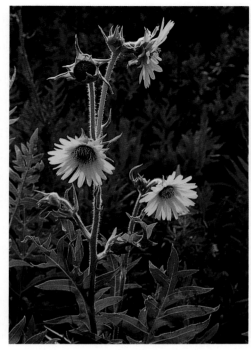

Description: A tall, stout plant, up to 8' in height, with very large basal leaves sometimes over 1' long. The deeply cut basal leaves are commonly oriented in a north-south direction, hence the common name. The stem leaves are smaller, alternate, and clasping at the base. The flower heads are along the upper part of a single, long, hairy stalk. Each head is up to 4½" across with 20–30 petal-like ray flowers surrounding a yellow central disk.

July—September

Habitat/Range: Prairies; common throughout the state.

Remarks: The Omaha and Ponca avoided camping wherever compass plant grew abundantly because they believed the plants attracted lightning. They sometimes burned the dried root during an electrical storm to act as a charm against a lightning strike. The root was used by Native American Indians and early settlers to alleviate head colds or pains. The dried leaves were used for treating dry, obstinate coughs and for treating intermittent fevers.

ROSINWEED
Silphium integrifolium
Aster Family (Asteraceae)

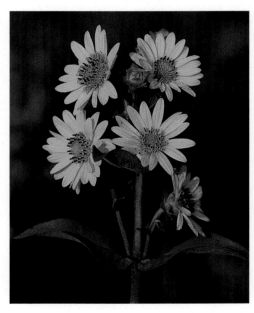

Description: Often occurring in colonies, these stout, mostly smooth plants grow up to 6' tall. The leaves are opposite but may be slightly alternate or even whorled. The leaves lack stalks, have a rough, sandpapery texture, and vary in shape from narrow and long to broad and round; teeth may be present along the margins. The flower heads are about 3" wide, with 15–35 yellow, petal-like ray flowers surrounding a yellow central disk.

July—August

Habitat/Range: Prairies, dry open woods, savannas, limestone glades; common throughout the state.

Remarks: Like others in the genus *Silphium*, rosinweed has a fragrant resin while in flower, which was chewed as gum by Native American Indian children.

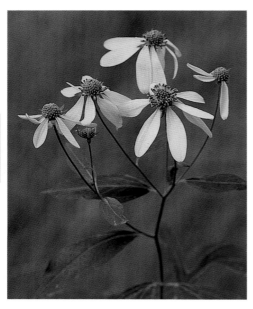

GOLDENGLOW
Rudbeckia laciniata
Aster Family (Asteraceae)

Description: A large plant, up to 9' tall, with a smooth whitish stem that branches near the top. The leaves are alternate, on long stalks, large, up to 10" long and 6" wide, deeply divided into 3–7 segments, and often have teeth along the margins. The flower heads have 6–10 narrow, golden, petal-like ray flowers that angle downward. The rays surround a green central disk.

July—November

Habitat/Range: Low, wet woodlands and along streams; occasional to common throughout the state.

Remarks: Native American Indians used root tea for indigestion, and a mixture of flowers from goldenglow, blue cohosh, and blue giant hyssop applied to burns. They also cooked and ate spring greens for "good health."

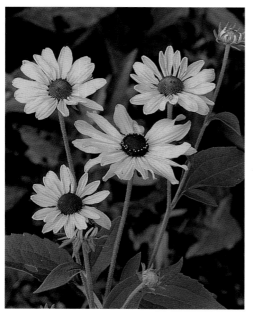

SWEET CONEFLOWER
Rudbeckia subtomentosa
Aster Family (Asteraceae)

Description: Plants up to 6' tall, branched near the top, often with dense short hairs along the upper stem. The stem leaves are alternate with short stalks or stalkless, have large teeth along the margins, and are often covered with soft, dense hairs. The leaves, at least on the lower part of the stem, are divided into 3 deep lobes. The flower heads are on long, individual stalks, with each head up to 3" wide. The heads have 6–20 petal-like ray flowers surrounding a dome-shaped, brown central disk.

July—September

Habitat/Range: Open woods, prairies, thickets, banks of streams; occasional throughout the state.

Remarks: The common name comes from the flower's anise scent. Other common names are "fragrant coneflower" and "sweet black-eyed Susan."

BRISTLY SUNFLOWER
Helianthus hirsutus
Aster Family (Asteraceae)

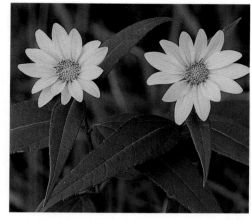

Description: Often in colonies, this plant grows up to 4' tall, with stiff hairs along the stem and leaves. The upper leaves are mostly opposite, short-stalked, with a sandpapery texture and small, widely spaced teeth along the margin. The leaves have 1 central vein and 2 side veins. The flower heads are up to 3" across with 8–15 yellow petal-like ray flowers surrounding a yellow central disk.

July—September

Habitat/Range: Open woods, savannas, thickets, roadsides; occasional throughout Illinois.

Remarks: The heads and upper stems are often nipped by white-tailed deer in mid- to late summer. The following two species have smooth stems: woodland sunflower, *Helianthus divaricatus*, has leaf stalks absent or less than ¼" long; open woods, savannas; common throughout the state. And, pale-leaved sunflower, *Helianthus strumosus*, with leaf stalks over ¼" long; open woods; occasional to common throughout Illinois.

DOWNY SUNFLOWER
Helianthus mollis
Aster Family (Asteraceae)

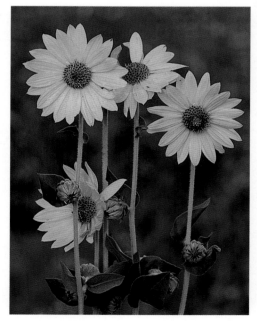

Description: Usually growing in colonies, these grayish-green plants reach a height of 4'. The stem and leaves have dense gray hairs that can be rubbed off. The leaves are opposite, stiff, up to 6" long and 3" wide, with rounded to notched, stalkless bases. The flower heads are on long stalks, with each head 2½–4" across. There are up to 30 yellow, petal-like ray flowers surrounding a yellow central disk.

July—September

Habitat/Remarks: Prairies; common throughout most of Illinois.

Remarks: Also called "ashy sunflower" for the gray-colored leaves that are similar in appearance to ash-covered leaves after a fire. Downy sunflower is sometimes mistaken for rosinweed, but the latter has leaves with a rough, sandpapery surface and lacks the dense gray hairs.

SAWTOOTH SUNFLOWER
Helianthus grosseserratus
Aster Family (Asteraceae)

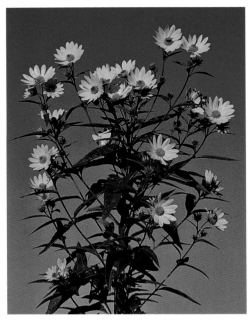

Description: A tall, many-branched, colony-forming sunflower, up to 12' in height, often with several smooth stems emerging from a single base. The leaves are alternate, large, about 8" long and 2" wide, tapering at each end, with hairs on the underside. The margins have teeth, hence the common name. The flower heads are numerous, up to 3½" across, with 10–20 yellow, petal-like ray flowers surrounding a yellow disk.

July—October

Habitat/Range: Prairies, edge of woods, roadsides; common throughout the state.

Remarks: The Mesquakies mashed the flowers and applied them to burns. In the Southwest, Zuni medicine men cured rattlesnake bites by chewing the fresh or dried root and then sucking the snakebite wound. A similar species, Maximilian sunflower, *Helianthus maximilianii*, has white densely hairy stems and leaves curved and folded along the middle; naturalized in prairies and along roadsides; native to the western United States; occasional in Illinois.

COMMON SUNFLOWER
Helianthus annuus
Aster Family (Asteraceae)

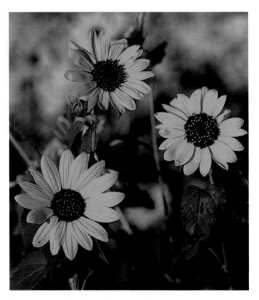

Description: A robust annual, with branching stems often up to 9' tall. The stems are stout and coarsely hairy. The leaves are alternate, on long stalks, large, up to 10" long, heart-shaped, with sandpapery surfaces and coarse teeth along the margins. The flower heads are large, 4–10" across, with 20 or more yellow, petal-like ray flowers surrounding a purplish-brown central disk 1" or more in diameter.

July—October

Habitat/Range: Disturbed ground, pastures, roadsides; native to western United States; occasional to common throughout the state.

Remarks: Originally cultivated by North American Indians, the sunflower seeds were used as food and a source for oil. They used the oil as hair grease and as a warm rub for rheumatic joints. The roots were baked or used in a tea for respiratory ailments, rheumatism, bruises, contusions, snakebites, and malaria. Today, cultivated varieties with larger seed heads and seeds are used to produce oil, food, and birdseed.

WESTERN SUNFLOWER
Helianthus occidentalis
Aster Family (Asteraceae)

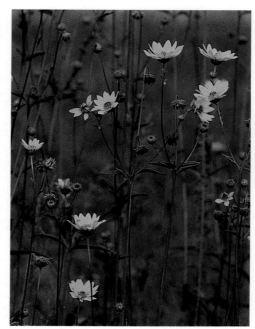

Description: A colony-forming sunflower, up to 3' tall, with spreading white hairs along the stem. There are up to 5 sets of opposite or 3-whorled leaves along the often reddish-colored stem. The basal stem leaves are on long stalks and are 3–6" long and up to 2½" across. The stem leaves are smaller, much fewer, and usually lack stalks. The flower heads are on stalks at the top of the stems. The heads are 1½–2" across with 12–15 narrow, yellow, petal-like ray flowers surrounding a ½" wide yellow central disk.

July—October

Habitat/Range: Sandy prairies, hill prairies; common in the north ½ of Illinois.

Remarks: Of the 22 species of sunflowers in Illinois, western sunflower is distinguished by its almost leafless stem.

JERUSALEM ARTICHOKE
Helianthus tuberosus
Aster Family (Asteraceae)

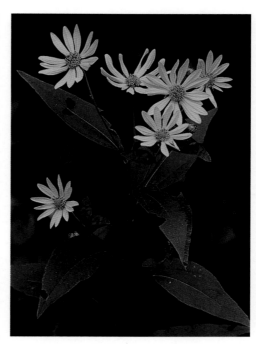

Description: This stout, reddish-stemmed sunflower is up to 7' tall and covered with rough hairs. The leaves are opposite on the lower stem and usually alternate on the upper part. Rough sandpapery hairs are also on the leaves, which are up to 10" long, lance-shaped, and stalked. The flower heads are on individual stalks at the tops of branches, with each head up to 4" across. There are 10–20 yellow, petal-like ray flowers surrounding a yellow central disk.

August—October

Habitat/Range: Moist ground bordering woods, thickets, and prairie draws, and along streams and roadsides; common throughout Illinois.

Remarks: When the roots of this plant grow in good soil, they form edible tubers that have been grown and marketed commercially for centuries. The tubers are cooked as potatoes, sliced and added to salads, and even pickled.

127

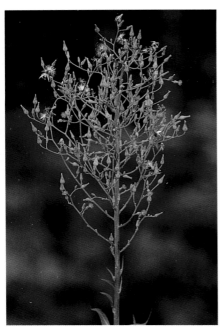

WILD LETTUCE
Lactuca canadensis
Aster Family (Asteraceae)

Description: Often multi-branched at the tips, this smooth-stemmed biennial grows to 8' tall and has milky orange to tan sap. The leaves are alternate, stalkless, and up to 12" long and 6" wide (but usually smaller). The leaves vary from deeply lobed to rounded. The numerous flower heads are small and occur in large branching clusters. Each head is less than ½" across with 15–22 yellow or dull orange, petal-like ray flowers surrounding a yellow central disk. The flower and seed heads resemble miniature dandelions.

July—September

Habitat/Range: Dry open woods, savannas, prairies, pastures, disturbed soil; occasional throughout the state.

Remarks: Native American Indians used a root tea for treating diarrhea, heart and lung ailments, hemorrhaging, and nausea, and to relieve pain. The milky sap from the stems was used for treating skin eruptions. The bruised leaves were applied directly to insect stings. Both Native American Indians and settlers used a leaf tea to hasten milk flow after childbirth. Another species, prickly lettuce, *Lactuca serriola*, (formerly *L. scariola*), has margins of the leaves with deep lobes and prickly teeth. Native to Europe, it occurs in disturbed soil; common throughout Illinois.

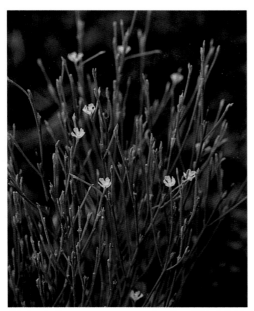

PINEWEED
Hypericum gentianoides
St. John's Wort Family (Clusiaceae)

Description: Looking like a pine seedling (hence the common name), this annual plant has a multi-branched, wiry stem, with a powdery blue-green to reddish color, and grows up to 12" tall. The scale-like leaves are extremely small, opposite, and hug the stem. The flowers are stalkless, singly attached at the stem nodes, with 5 tiny yellow petals that open on bright, sunny days.

July—October

Habitat/Range: Sandy soil in woods and prairies, sandstone glades, on bluffs; occasional; scattered throughout Illinois.

Remarks: Adapted to living in sandy soil, often over bedrock, pineweed minimizes water loss by having scale-like leaves. Pineweed is one of the smallest of 18 species in the genus *Hypericum* in Illinois.

128

YELLOW FALSE FOXGLOVE
Aureolaria grandiflora
Broomrape Family (Orobanchaceae)

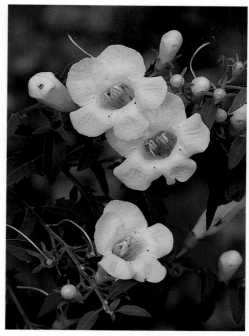

Description: A shrubby plant, with dense short hairs on the branches, up to 3' tall. The leaves are opposite, short-stalked, with the lower leaves deeply cut; the upper leaves are much reduced with small teeth or rounded along the margins. The flowers are large, up to 3" long, yellow, with a long tube and 5 lobes, and emerge from the leaf axils.

July—September

Habitat/Range: Dry woodland; occasional in the north ⅔ of the state, rare elsewhere.

Remarks: A closely related species, smooth false foxglove, *Aureolaria flava*, lacks hairs on the stems, leaves, and flowers; found in rocky woods; occasional; south ½ of the state, less common in north ½. Another species, fern-leaved false foxglove, *Aureolaria pectinata (*formerly *pedicularia)* has finely cut fern-like leaves and gland-tipped hairs on the flower tube; an annual; found in sandy woods; occasional in northeast counties.

SWAMP AGRIMONY
Agrimonia parviflora
Rose Family (Rosaceae)

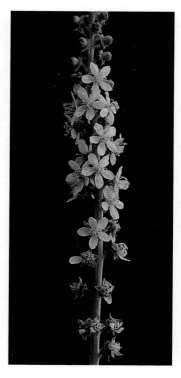

Description: Stout, hairy stems with wand-like branches, up to 6' tall. The leaves are alternate, stalked, and divided into several leaflets, with the larger leaflets interspersed with many smaller ones. The leaflets are hairy, with many teeth along the margins. The flowers are arranged alternately along the stem, small, about ¼" across, with 5 yellow petals. The flowers develop into bur-like fruits with hooked bristles that easily cling to clothes and hair.

August—September

Habitat/Range: Low, wet ground in prairies, woods, marshes, thickets, and along streams; occasional throughout the state.

Remarks: An herbal tea made from the whole plant has been used to stop internal bleeding; also used for diarrhea, inflammation of the gall bladder, jaundice, and gout. There are 3 additional agrimony species in Illinois.

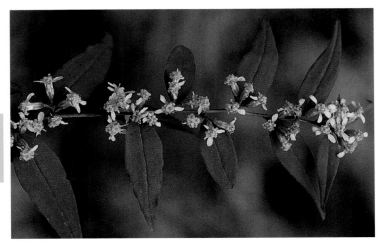

WOODLAND GOLDENROD
Solidago caesia
Aster Family
(Asteraceae)

Description: A graceful, arching, wand-like plant, up to 3' long, with often bluish-gray stems with a whitish coating. The leaves are alternate, smooth, stalkless, lance-shaped, 2–5" long, up to 1" wide, and slightly hairy above. The flower heads are small and appear in tufts along the stem, emerging from the leaf axils. The heads have 3–5 yellow, petal-like ray flowers.

August—October

Habitat/Range: Moist or rocky woods; occasional throughout Illinois.

Remarks: The graceful arching yellow wands of woodland goldenrod are a welcome sight when walking through the woods. The Latin species name, *caesia*, means "bluish gray," which is applied to the other common name, "blue-stemmed goldenrod."

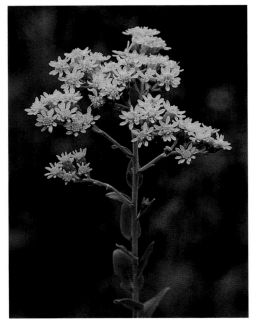

STIFF GOLDENROD
Solidago rigida
Aster Family (Asteraceae)

Description: A coarse plant, with stems to 5' tall, usually hairy, giving the plant a pale to gray-green cast. The large basal leaves are on long stalks and up to 10" long and 5" wide. The stem leaves are alternate, stalkless, and progressively smaller upwards. All the leaves are rough and leathery. The flower heads are in a flat-topped to somewhat rounded, densely packed cluster. Each head is about ½" across, with 7–14 petal-like, yellow ray flowers surrounding a yellow central disk.

August—October

Habitat/Range: Prairies; occasional throughout the state.

Remarks: Bee stings were once treated with a lotion made from the flowers of stiff goldenrod. Leaf tea was used to treat swollen throats.

130

ELM-LEAVED GOLDENROD
Solidago ulmifolia
Aster Family (Asteraceae)

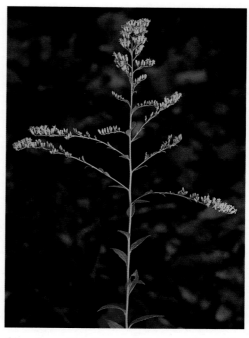

Description: A single-stemmed, smooth plant to 4' tall, with widely spreading branches and leaves similar in appearance to elm leaves, hence, the common name. The leaves are alternate, coarsely toothed along the margins, thin, hairy underneath, with broad stalks on the lower leaves, which fall away by flowering time. The lower leaves are up to 5" long and 2" wide, with the upper leaves much reduced in size. The flower heads are on long, arching branches, with crowded heads. Each head has 3–5 yellow, petal-like ray flowers.

August—November

Habitat/Range: Dry open woods; common throughout the state.

Remarks: Goldenrods, in general, have been unfairly blamed for the allergic reaction of hay fever. It is the wind-blown pollen of the ragweeds that is the primary cause for late-summer hay fever. The pollen of goldenrods is distributed by bees, fall wasps, and beetles and is not wind-blown.

DRUMMOND'S GOLDENROD
Solidago drummondii
Aster Family (Asteraceae)

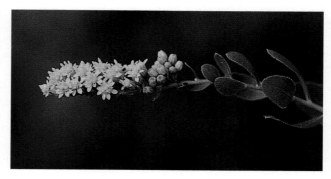

Description: Usually arching over cliffs, the soft-haired stems grow 1½–3' long. The basal and lowermost stem leaves are typically absent at flowering time. The upper stem leaves are broadest in the middle, 1½–3½" long and 1–3" wide, short-stalked, with 3 veins along the leaf, and fine, dense hairs beneath. The flower heads are at the end of the arching stem on short branches. Each head has 3–7 yellow, petal-like ray flowers.

September—October

Habitat/Range: Ledges and cliffs along rivers; occasional in southwest Illinois.

Remarks: This is the only goldenrod that is typically found growing on the face of cliffs; it is also called "cliff goldenrod."

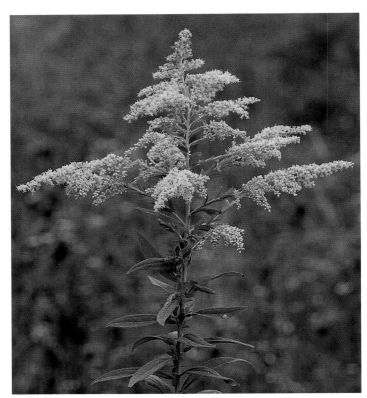

TALL GOLDENROD
Solidago altissima
Aster Family (Asteraceae)

Description: A large, hairy-stemmed goldenrod, up to 7' tall, with many alternate leaves, the largest of which occur along the middle part of the stem. The leaves are up to 6" long and 1¼" wide, with some teeth along the margins, especially toward the tip. The upper side of the leaf is rough, while the underside is hairy, with 3 prominent veins. The flower heads are arranged in a pyramidal cluster with the heads all occurring on the upper side of branches. Each head is about ¼" across, with 10–15 yellow, petal-like ray flowers. The circle of bracts below each flower head is more than ⅛" high.

August—October

Habitat/Range: Disturbed soil in prairies, fields, pastures, roadsides; common throughout the state.

Remarks: Native American Indians made a tea from this plant to treat kidney problems; they also chewed crushed flowers for sore throats. Of the goldenrods, this species is the most commonly infected by the goldenrod gall. This round swelling along the stem is caused by certain moths and flies that lay an egg in the stem. The larva hatches and secretes a chemical that causes the plant tissue to swell around it; the larva then eats the tissue and overwinters in its protected home, emerging in the spring as an adult. A similar species, Canada goldenrod, *Solidago canadensis*, begins flowering one month earlier and has its circle of bracts below each flower head less than ⅛" high. It occupies similar habitats and range as tall goldenrod.

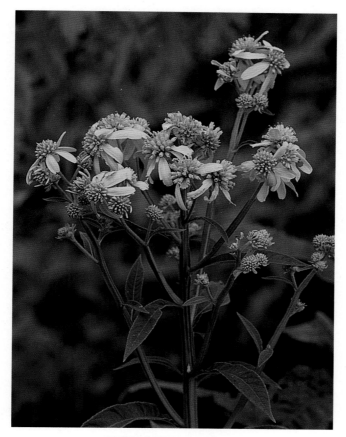

YELLOW IRONWEED
Verbesina alternifolia
Aster Family (Asteraceae)

Description: A tall, coarse, branching plant, up to 7' tall, with narrow wings of leafy tissue extending down the stems from the leaf bases. The leaves are alternate, rough, lance-shaped to broadest in the middle, up to 10" long, with toothed edges. The flower heads have 2–8 yellow, drooping, petal-like ray flowers that often vary in size, surrounding a yellow rounded disk.

August—October

Habitat/Range: Low, moist ground in wooded valleys along streams; occasional throughout Illinois.

Remarks: In September, yellow ironweed often forms large, dense patches of yellow in bottomland forests.

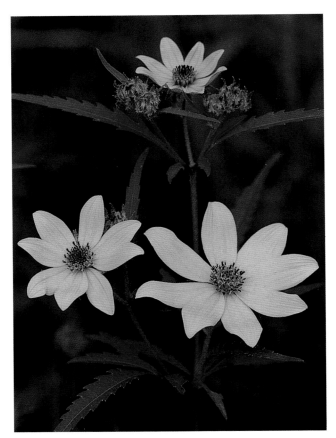

SWAMP MARIGOLD
Bidens aristosa
Aster Family (Asteraceae)

Description: A smooth, much-branched, annual, growing to 3' tall but sometimes to a height of 6' in rich soils. The leaves are opposite, stalked, and divided into 5–11 narrow, coarsely toothed leaflets. The flower heads are on individual stalks, with each head about 1½–2½" across with 8 golden yellow, petal-like ray flowers surrounding a yellow central disk. The seeds resemble ticks and have 2 barbed, needle-like teeth that attach to clothing and hair.

August—October

Habitat/Range: Wet ground in prairies, low cultivated and idle fields, ditches, and along roadsides; occasional; scattered across the state.

Remarks: Also called "tickseed sunflower" and "beggar's ticks." It was formerly known as *Bidens polylepis*. The Cherokees used a similar species of *Bidens* in leaf tea to expel worms. The leaves were chewed for sore throats. Seeds of *Bidens* species are eaten by ducks, bobwhite quail, and some songbirds; the plants are eaten by cottontail rabbits. There are 10 species of *Bidens* in Illinois.

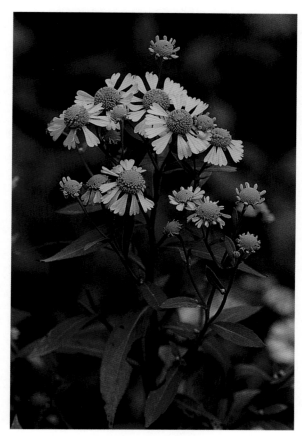

SNEEZEWEED
Helenium autumnale
Aster Family (Asteraceae)

Description: A very leafy-stemmed plant to 5' tall, with branching near the top. The stem has narrow wings of leafy tissue extending downward along the stem from the leaf bases. The leaves are alternate, up to 6" long and 1½" wide, broadest near the middle, and tapering at both ends. There are a few small, widely spaced teeth along the margins. The flower heads have 10–20 drooping, yellow, petal-like ray flowers surrounding a rounded yellow central disk. The ray flowers have 3 lobes along their edges.

August—November

Habitat/Range: Wet to moist ground in prairies, marshes, fens, along streams, and openings in low woods; common throughout the state.

Remarks: The Mesquakies dried the flower heads and used them as an inhalant to treat head colds. To reduce fever, the Comanches soaked sneezeweed stems in water and bathed the patient's body. The dried flower heads were reportedly used as snuff by early settlers. Sheep, cattle, and horses have been poisoned by eating large amounts of the plant, especially the seed heads.

Red/Orange Flowers

This section includes red and orange flowers.
Since red flowers grade into both pink flowers and purple flowers,
those sections should also be checked.

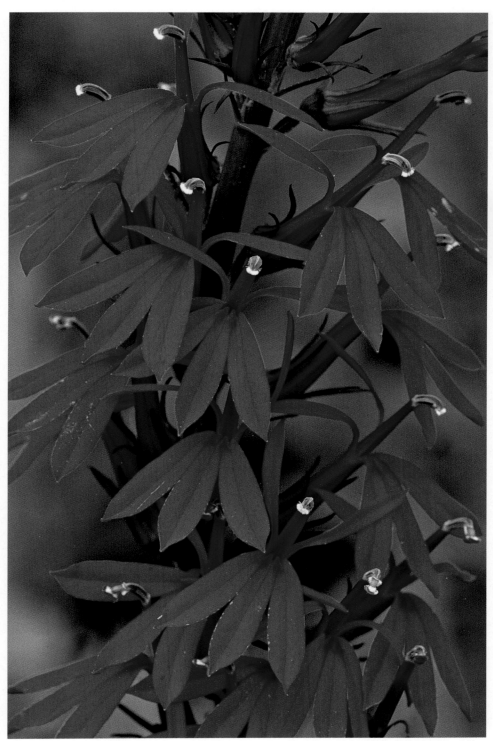

Cardinal Flower, page 143

INDIAN PAINTBRUSH
Castilleja coccinea
Broomrape Family (Orobanchaceae)

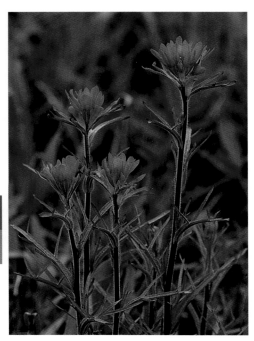

Description: A biennial plant, with single, hairy stems typically about 12" tall. The leaves are alternate, stalkless, yellowish green, hairy, and divided into 3 narrow lobes. The flowers are concentrated in a dense cluster at the top of the stem that elongates as the flowers open. The brilliant red color does not come from the flower but from leafy bracts just under each flower. The inconspicuous flower is greenish yellow, tubular, and up to 1½" long. Although typically red, Indian paintbrush is sometimes yellow.

April—July

Habitat/Range: Prairies, sandy woods; occasional in the north ¾ of Illinois, absent in the south ¼.

Remarks: Typical of many members of this family, Indian paintbrush is a partial parasite, sometimes attaching to roots of other plants to obtain nourishment. Native American Indians used weak flower tea for rheumatism and as a contraceptive; also as a secret love charm in food, and as a poison "to destroy your enemies." A similar species, downy painted cup, *Castilleja sessiliflora*, has green bracts and flowers longer than 1½"; found in hill prairies, sand prairies; rare; north ¼ of Illinois.

INDIAN PINK
Spigelia marilandica
Logania Family (Loganiaceae)

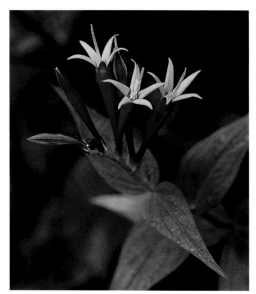

Description: Plants with smooth, square stems, up to 2' tall, with opposite leaves. The leaves are stalkless, lance-shaped, up to 4" long, and lack teeth along the margins. The flowers are showy, bright red with yellow inside and about 1½" long, tubular, with 5 sharp lobes that flare out.

May—June

Habitat/Range: Moist woods and wooded banks along streams; occasional in the south ¼ of the state.

Remarks: Native American Indians used root tea to expel intestinal worms. The plant was also once used by physicians for worms, especially in children. Side effects include increased heart action, vertigo, convulsions, and possibly death.

FIRE PINK
Silene virginica
Pink Family
(Caryophyllaceae)

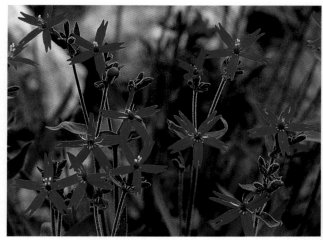

Description: A plant up to 2' tall, with several spreading, hairy, sticky stems. The basal leaves are long, narrow, 1½–4" long and ¼–¾" wide, and stalked, while the stem leaves are opposite, narrow, stalkless, and up to 3" long. The flowers, up to 1½" across, are on long stems that arise above the upper leaves. The brilliant red flowers have 5 narrow petals, with a notch at each tip.

April—June

Habitat/Range: Moist or dry open woods; not common; scattered throughout the state.

Remarks: A common name for the genus *Silene* is "catchfly," which refers to the sticky, insect-trapping hairs on the stem and the cylindrical tube below the petals called the calyx.

COLUMBINE
Aquilegia canadensis
Buttercup Family (Ranunculaceae)

Description: A smooth to slightly hairy plant with openly branching stems, up to 2' tall. The few basal leaves and lower stem leaves have long stalks, with clusters of 3 leaflets, with each leaflet having several lobes. The upper stem leaves have 3 leaflets on short stalks with lobed margins. The distinctive flowers are up to 2" long, nodding, and on slender curved stalks. The 5 triangular sepals are red, and the 5 petals have yellow blades and hollow red spurs that contain the nectar. Numerous stamens extend from the flower.

April—June

Habitat/Range: Moist woods, savannas, fens, shaded limestone cliffs; occasional to common throughout the state.

Remarks: The flower is pollinated by hummingbirds, moths, and butterflies, which all have long tongues in order to reach the nectar. Omaha and Ponca men rubbed pulverized seeds on their palms as a love potion before shaking hands with a loved one. This practice also was supposed to make them more persuasive when speaking to a council. The root was chewed or taken as a weak tea for diarrhea, stomach troubles, as a diuretic, and to stop uterine bleeding.

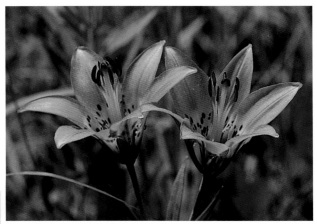

WOOD LILY
Lilium philadelphicum
Lily Family (Liliaceae)

Description: Plants vary from ½–3' tall, with alternate or opposite leaves on the lower stem and whorls of 4–7 leaves on the upper part of the stem. The leaves are pointed and 2–4" long. The 1–3 showy reddish-orange to red flowers are 3–4" across, upright, with 6 petals. Inside the flower, on the lower parts of the petals, there are purplish spots with patches of yellow. Six prominent stamens extend beyond the top of the flowers.

June—July

Habitat/Range: Moist prairies, woodlands; occasional in the north ½ of the state.

Remarks: Wood lily is typically found more in prairies than woodlands and also goes by the name "prairie lily." The presence of this lily is an indicator of a high quality prairie.

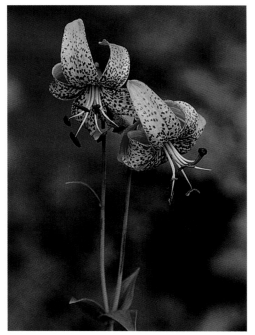

MICHIGAN LILY
Lilium michiganense
Lily Family (Liliaceae)

Description: A stately plant with a smooth, stout stem to 6' tall. The lower leaves are in whorls around the stem, and the upper leaves are alternate. The leaves are waxy and thick, up to 5" long, and tapering at both ends with margins and veins roughened. The flowers hang down from long stalks at the top of the stem. There are 1–12 flowers, depending upon the age of the plant and the growing conditions. Each flower is up to 3" wide, with 6 orange petals that strongly curve back. The orange petals sometimes fade to yellow on the underside and have many dark purple spots. The 6 stamens and the stigma show prominently. The anther, which is the tip of the stamen, is about ½" long.

June—July

Habitat/Range: Moist prairies and low woods; somewhat common throughout Illinois.

Remarks: Also called "Turk's cap lily." Some tribes of Native American Indians used the roots to thicken soups, and others used a tea made from the bulbs to treat snakebites. When chewed to a paste, the flower was a treatment for spider bites. Another species, Turk's cap lily or superb lily, *Lilium superbum*, has smooth leaf margins and veins, and anthers ¾–1" long. Found in low, moist woods; rare; Jackson, Pope, and Williamson counties.

ORANGE DAY LILY
Hemerocallis fulva
Lily Family (Liliaceae)

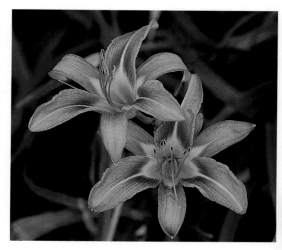

Description: The leafless flower stalks are up to 5' tall and produce flowers that each last but a day. The leaves are at the base, narrow, up to 2' long and ½" wide, and pointed at the tip. The flowers are clustered at the top, orange with yellow centers, and up to 4" across. There are 3 slightly smaller sepals and 3 petals, each with a yellow strip down the center. The 6 stamens are long and curve upward.

May—August

Habitat/Range: Along roadsides, homesites, waste ground; native to Europe and Asia; common across the state.

Remarks: The plants have been eaten in salads, as a cooked vegetable (sometimes as a substitute for asparagus), in fritters, and as a seasoning. In China, a root tea is used as a diuretic; also to treat jaundice, nosebleeds, and uterine bleeding. Recent Chinese reports warn that the roots and young leaf shoots are considered potentially toxic because the toxin accumulates in the body and adversely affects the eyes, even causing blindness in some cases. Their studies also warn that the roots contain colchicine, a carcinogen.

BLACKBERRY LILY
Belamcanda chinensis
Iris Family (Iridaceae)

Description: A stout flower stalk, up to 3' tall, supports attractive orange flowers which each last but a day. The leaves are alternate, up to 12" long and 1" wide, clasping at the base, with parallel veins along the length of the blade. The flowers are clustered at the top of the stem. Each lily-like flower is up to 2" across, with the 3 sepals and 3 petals similar in shape and color. The fruit capsule splits open to reveal shiny black fleshy seeds resembling a blackberry.

June—August

Habitat/Range: Roadsides, rocky open woods, edges of cliffs, old homesites; native to Asia that was introduced as a garden plant and has escaped; scattered throughout Illinois.

Remarks: Although the flowers resemble lilies, the leaves along the stem are typical of irises. The orange rhizome distinguishes this iris from other irises.

May—September

BUTTERFLY WEED
Asclepias tuberosa
Milkweed Family (Asclepiadaceae)

Description: Several stems may arise from a common base, giving the plant a bushy appearance, up to 2½' tall. The stems are covered with coarse spreading hairs and lack the milky latex sap that is typical of the milkweed family. The mostly alternate leaves are stalkless, about 4" long and 1" wide, widest in the middle and tapering at both ends, very hairy, and dark green. The flowers are in clusters at the tops of stems. The flowers vary from deep red to brilliant orange and pale yellow, with each flower less than ¾" long, with 5 reflexed petals below 5 erect hoods. The seedpods are about 6" long and ¾" thick, with fine hairs.

Habitat/Range: Prairies, dry open woods, savannas, old fields, roadsides; common throughout Illinois.

Remarks: Also called "pleurisy root" because it was considered to be a cure for pleurisy, an inflammation of the covering of the lungs. Several tribes revered this plant as a healer. They used the leaves to induce vomiting, and the roots for treating dysentery, diarrhea, constipation, lung inflammations, rheumatism, fever, and pneumonia. The roots were also mashed and applied externally to bruises, swellings, and wounds. Butterfly weed is appropriately named for its popularity with butterflies, especially the monarch butterfly. The larvae consume the leaves, while the adults feed on the nectar.

ROYAL CATCHFLY
Silene regia
Pink Family (Carophyllaceae)

Description: Slender plants, up to 5' tall, with generally smooth stems on the lower part but with sticky hairs near the top. The leaves are opposite, stalkless, with 10–20 pairs along the stem, each leaf is about 5" long and 3" wide, and slightly pointed at the tip. The flowers are crimson, with sticky hairs along the calyx, which is the cylindrical tube below the 5 narrow petals. There are 10 stamens extending beyond the petals.

July—August

Habitat/Range: Prairies, dry soil along roadsides in former prairies; classified as state endangered; Clark, Cook, Lawrence, St. Clair, Wabash, White, Will, and Winnebago counties.

Remarks: A very showy plant that is rare due to loss of prairie habitat. The bright, tubular flowers attract hummingbirds.

SPOTTED TOUCH-ME-NOT
Impatiens capensis
Jewelweed Family (Balsaminaceae)

Description: Annual plants growing to 5' tall, with branched stems that are somewhat weak and watery. The stems are pale green and translucent with leaves alternate, oval, thin, and bluish green. The leaves are up to 3½" long, with long stalks and widely spaced teeth along the margins. The orange flowers are shaped like a cornucopia, up to 1¼" long, hanging on a slender stalk. The smaller end of the flower is a curved spur, which holds the nectar. The fruit is a slender capsule about 1" long, which splits and propels the seed when touched.

June—October

Habitat/Range: Moist to wet woodlands and banks of streams; common throughout the state.

Remarks: Also known as jewelweed. The Potawatomi and settlers applied the juice of touch-me-not to relieve the itch of poison ivy. Even today, the juice is used to relieve the burning sensation of stinging nettle, which often grows not far from touch-me-not. The juice is also thought to neutralize the sap of poison ivy after contact. Livestock have been poisoned by eating large amounts of the fresh green plants.

CARDINAL FLOWER
Lobelia cardinalis
Bellflower Family (Campanulaceae)

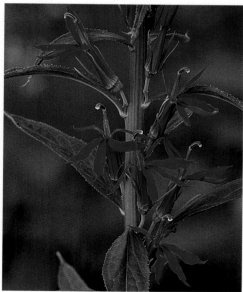

Description: The leafy stem is usually unbranched, up to 4' tall, with milky sap. The basal leaves have short stalks and are up to 6" long and about 2" wide. The stem leaves are alternate, stalkless, narrow, and less than 2" long. The leaves are widest in the middle and taper at both ends, with fine teeth along the margins. The crimson flowers are alternately arranged on individual stalks along a dense spike at the top of the plant. Each flower is about 1½" long with 2 lips; the upper lip has 2 small, narrow deeply cut lobes, and the lower lip has 3 deeply cut lobes. The 5 stamens and style are in a red central column.

July—October

Habitat/Range: Wet ground along borders of streams, spring branches, low wet woods, and ditches; occasional to common throughout Illinois.

Remarks: The crimson, tubular flowers are a favorite with hummingbirds. The Mesquakie crushed and dried the plant and threw it to the winds to ward off approaching storms. It was also scattered over a grave as the final ceremonial rite. Other tribes used a root tea for stomachaches, intestinal worms, and as an ingredient in a love potion. Leaf tea was used for colds, nosebleeds, fevers, headaches, and rheumatism.

Pink Flowers

This section includes flowers ranging from pale pinkish white to vivid electric pink to pinkish magenta. Since pink flowers grade into purple flowers or white flowers, those sections should also be checked.

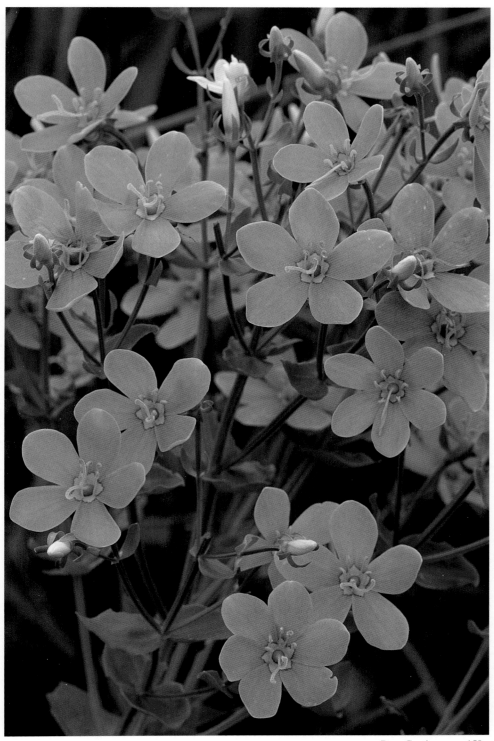

Rose Gentian, page 159

HENBIT
Lamium amplexicaule
Mint Family (Lamiaceae)

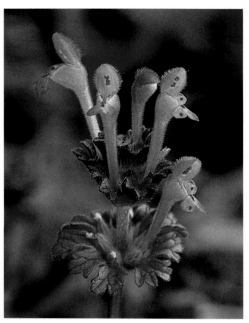

Description: A winter annual, with soft square stems branching from the base, up to 10" tall. The leaves are opposite, roundish, bluntly toothed, and hairy above. The lower leaves have stalks; the upper leaves are up to 1" wide, lack stalks, and clasp the stem. The flowers are about ½" long, hairy, arising from clusters in the axils of the leaves, with long tubes that open to two lips (typical of the mint family), with the lips having red spots.

February—November

Habitat/Range: Disturbed soil in fields, lawns, and along roadsides; native to Europe, Asia, and Africa; common throughout Illinois.

Remarks: Cropfields in spring are often carpeted with a dazzling pink from millions of henbit flowers. In the Old World, the seeds are eaten by chickens, hence the common name. The first flowers in late winter do not open, fertilizing themselves inside the closed tube of the flower.

PURPLE DEAD NETTLE
Lamium purpureum
Mint Family (Lamiaceae)

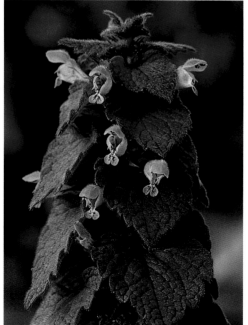

Description: A winter annual with soft, square stems branching from the base, up to 10" tall. The leaves are opposite, overlapping near the top, about 1" long, stalked, triangular-shaped, bluntly toothed, hairy above, and often purplish. The flowers are slightly paler than henbit but are otherwise similar: about ½" long, hairy, arising from clusters in the axils of the leaves, with long tubes that open to two lips (typical of the mint family), with the lips having red spots.

March—October

Habitat/Range: Disturbed soil in fields, lawns, and along roadsides; native to Europe, Asia, and Africa; common in the south ½ of Illinois, uncommon in the north ½.

Remarks: Although the flowers are identical to those of henbit, the triangular, overlapping leaves of dead nettle tend to hide some of the flower color. The overall display is certainly not as showy as its close relative. The nettle-like leaves lack a "sting," hence the common name.

WILD GERANIUM
Geranium maculatum
Geranium Family (Geraniaceae)

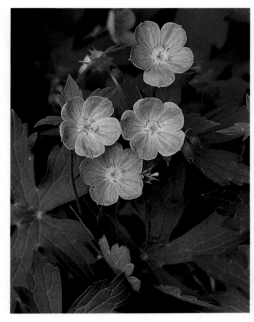

Description: The stems are hairy and sometimes branched, up to 1½' tall. The basal leaves are on long stalks, hairy, about 5" across and divided into 5–7 lobes with prominent teeth along the margins. The stem leaves are few, usually 1 opposite pair, hairy, with short stalks and smaller than the basal leaves. The flowers are in clusters at the top of stems, up to 1½" across, with 5 pink to rose-lavender petals with fine veins.

April—June

Habitat/Range: Moist woods; common; in every county.

Remarks: Wild geranium is considered an astringent—a substance that causes contraction of the tissues and stops bleeding. The Chippewas dried and powdered the roots to provide a treatment for mouth sores, especially in children. Both Chippewa and Ottawa tribes made a tea of the plant for treating diarrhea. The Mesquakie brewed a root tea for toothache and painful nerves, and mashed the roots for treating hemorrhoids.

VIOLET WOOD SORREL
Oxalis violacea
Wood Sorrel Family (Oxalidaceae)

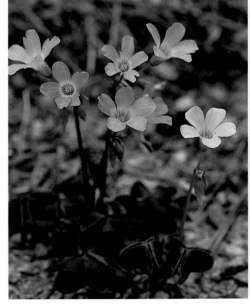

Description: Small plants up to 6" tall with numerous 3-parted leaves arising from the base on stalks. The leaflets are slightly to deeply folded with small notches at the tip, often with spots or blotches of purple on the upper surface, and often solid purple underneath. The flower stems extend past the leaves, with several individually stalked flowers at the top. Each flower is about ½" across, with 5 pink petals.

April—June; also September—November

Habitat/Range: Dry, rocky woods, savannas, prairies, idle fields, along roadsides; common; in every county.

Remarks: The plant parts contain a sour watery juice from which the name "sorrel" is derived, which is Old German for "sour." Native American Indians used powdered leaves boiled in water to expel intestinal worms. The plant was also used to reduce fevers and to increase urine flow.

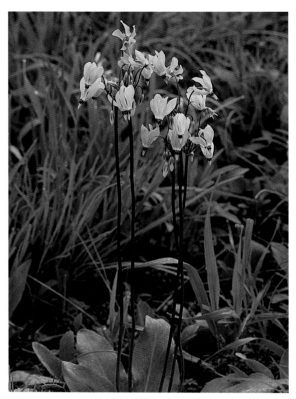

SHOOTING STAR
Dodecatheon meadia
Primrose Family (Primulaceae)

Description: The leaves spread out from the base of the plant, which sends a flower stalk up to 2' tall. The basal leaves are smooth, up to 8" long and 3" wide, gradually tapering to a stalk. The flowers are clustered at the top of a smooth stem on numerous arching stalks, each ending in a single flower. The stalks bend over, causing the flowers to droop. Each flower has 5 petals that bend back, resembling a fanciful tail of a shooting star. The petals vary in color from white to dark pink to lavender. The 5 stamens, with their dark brown bases, are held together to form a beak-like cone. The flower stalks become upright as fruits develop. The fruit capsules are dark reddish brown, with thick, woody walls.

April—June

Habitat/Range: Woods, prairies, shaded ledges of bluffs; occasional to common throughout Illinois.

Remarks: Flowers of shooting star have a fragrance similar to the odor of grape juice. Pollination is by bumblebees, which are strong enough to pry open the beak-like cone. Another species, jeweled shooting star, *Dodecatheon amethystinum*, has the fruit capsule a pale brown to yellow, with thin, papery walls; found on bluffs and wooded slopes; rare; Calhoun, Carroll, Fulton, Greene, Jersey, Jo Daviess, Pike, and Whiteside counties. Another, French's shooting star, *Dodecatheon frenchii*, has leaves abruptly ending at a distinct stalk, broadest below the middle; found under overhangs of sandstone cliffs; classified as state threatened; confined to south ⅙ of Illinois.

148

WILD ONION
Allium canadense var. *lavendulare*
Lily Family (Liliaceae)

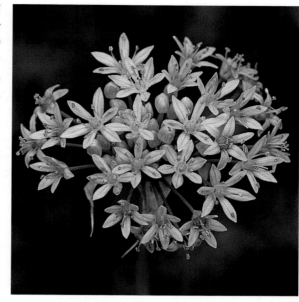

Description: A plant up to 1½' tall, arising from a bulb. The leaves emerge at the base, with long, narrow, flat leaves, about ⅛" across. A single, long stem contains a rounded cluster of flowers at the top of individual stalks. Each pink flower has 6 petals and 6 stamens that do not extend beyond the petals.

May—July

Habitat/Range: On dry areas, limestone glades, prairies; occasional throughout Illinois.

Remarks: Formerly known as *Allium mutabile*. Another species, cliff onion, *Allium stellatum*, is found on hill prairies and limestone glades on bluffs; flowering from July to September; locally common; Jackson, McHenry, Monroe, Randolph, and Union counties.

WILD GARLIC
Allium canadense var. *canadense*
Lily Family (Liliaceae)

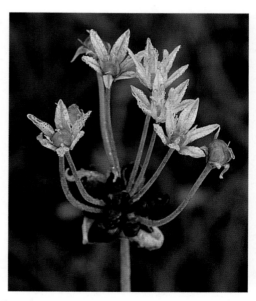

Description: A plant up to 2' tall, arising from a bulb. The leaves, which emerge mostly from the base of the plant, are long, narrow, flat, and about ⅛" across. A single long stem contains a rounded cluster of flowers at the top of individual stalks. Each flower has 6 petals and 6 stamens. All or some of the flowers are replaced by small, hard, stalkless bulbs that fall to the ground to produce new plants.

May—July

Habitat/Range: Dry to moist woods, prairies, disturbed ground, roadsides; common; in every county.

Remarks: Also called "wild onion," the plant has strong antiseptic properties. Native American Indians and settlers often applied the plant juices to wounds and burns. The Dakota and Winnebago used the plant to treat bee stings and snakebites. Settlers used wild garlic for fevers, blood disorders, lung troubles, internal parasites, skin problems, hemorrhoids, earaches, rheumatism, and arthritis. When Father Marquette made his famous journey from Green Bay to the present site of Chicago, in 1673, wild garlic was an important part of his food supply.

149

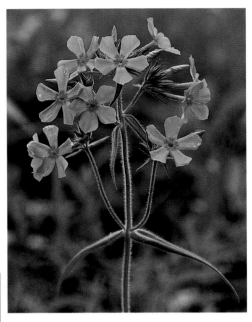

DOWNY PHLOX
Phlox pilosa
Phlox Family (Polemoniaceae)

Description: Hairy, usually single-stemmed to 2' tall, with widely spaced pairs of opposite, stalkless leaves. The leaves are hairy, up to 3" long and ½" wide, broadest at the base, and gradually tapering to pointed tips. The pink-to-purple flowers are grouped into loosely branched clusters. Each flower is about ¾" across, with a long tube and 5 rounded lobes.

May—August

Habitat/Range: Dry open woods, savannas, prairies; occasional to common throughout Illinois.

Remarks: Sometimes downy phlox is found with white flowers and pink centers. The Mesquakie made a tea of the leaves and used it as a wash for treating eczema. They also used the root mixed with several unspecified plants as part of a love potion.

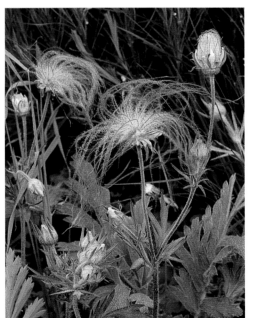

PRAIRIE SMOKE
Geum triflorum
Rose Family (Rosaceae)

Description: Hairy stemmed plants, less than 1' tall, with many basal leaves. The basal leaves are up to 7" long and divided into as any as 19 toothed segments. A pair of smaller, opposite, deeply divided leaves occur along the middle of the stem. Each stem has 3–6 individually stalked, nodding flowers less than ¾" across with 5 triangular, pink to reddish-purple sepals surrounding 5 smaller pinkish petals. The showy fruits have long, feathery plumes up to 2" long.

May—June

Habitat/Range: Dry prairies, sand prairies; occasional in the north ⅙ of the state, absent elsewhere.

Remarks: The graceful feathery plumes resemble smoke at a distance, hence the name. It is also called "prairie avens." The Blackfeet boiled the plant in water to treat sore or inflamed eyes. A root tea was used as a mouthwash for canker sores and sore throat and applied to flesh wounds. It was also scraped, mixed with tobacco, and smoked to "clear the head."

GOAT'S RUE
Tephrosia virginiana
Pea Family (Fabaceae)

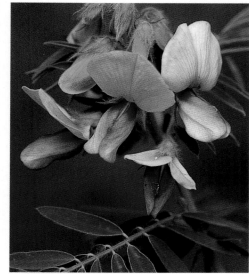

Description: A small plant, up to 2' tall, with one to several hairy stems emerging from the base. The leaves are alternate, hairy, and divided into as many as 15 pairs of leaflets, with a single leaflet at the tip. Each leaflet is up to 1¼" long and ⅜" wide, with a small bristle at the tip. The dense hairs give the plant a gray cast. The flowers are in dense clusters at the tops of stems, with each flower about ¾" long and consisting of a spreading pale yellow upper petal and 2 pink side petals that flank a keel-like lip. The fruits are narrow, whitish, hairy, and about 2" long.

May—August

Habitat/Range: Dry open woods, savannas; occasional throughout the state.

Remarks: Native American Indians and early settlers made a tea from the roots to treat intestinal parasites. Cherokee women washed their hair in it, believing the toughness of the roots would transfer to their hair and prevent it from falling out. Several tribes used the root, which contains rotenone, to stun fish. The plant was fed to goats by settlers in an effort to increase milk production. Some early ball players rubbed their hands, arms, and legs with goat's rue to toughen them.

SELF HEAL
Prunella vulgaris var. *lanceolata*
Mint Family (Lamiaceae)

Description: The stems are hairy and slightly creeping but mostly erect to 12" long. The leaves are opposite, hairy, narrow, and up to 4" long and 1½" wide, with some small teeth along the margins. The lower leaves have stalks. The flowers are in elongated clusters at the tops of stems. Each flower is about ½" long, with the upper lip forming a hood that is darker in color. The lower lip has 3 lobes, with the center lobe rounded and fringed at the tip.

May—September

Habitat/Range: Low woodlands, banks of streams, pastures, old fields, and along roadsides; common; in every county.

Remarks: Many Native American tribes used the aromatic self heal, also called "heal all," for treating sore throats, hemorrhages, diarrhea, stomach troubles, fevers, boils, urinary disorders, liver ailments, gas, colic, and gynecological problems. A closely related species, *Prunella vulgaris* var. *vulgaris*, was introduced into the United States from Europe by early settlers. It differs by having the upper leaves rounded at their bases and about ½ as broad as long. The native self heal has leaves that taper at their base and narrower leaves, about ⅓ as broad as long. The nonnative heal all is found mostly in more disturbed sites.

151

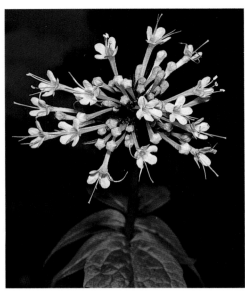

PINK VALERIAN
Valeriana pauciflora
Valerian Family (Valerianaceae)

Description: Upright plants from 12–30" tall with two types of leaves. The leaves at the base of the stem are 2–3" long, long-stalked, undivided, broadly heart-shaped and with wavy margins. The leaves along the stem are on short stalks and are divided into 3–7 leaflets, with the end leaflet largest. There are large, irregular teeth along the margins. The pink flowers are clustered at the top; each flower has a tube about ½" long that opens to five short lobes.

May—June

Habitat/Range: Moist woods; occasional in the south ½ of Illinois.

Remarks: The delicate, pink tubular flowers arranged in a cluster at the top of the stem makes this plant easy to identify when encountered.

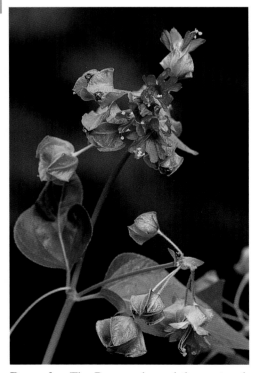

WILD FOUR-O'CLOCK
Mirabilis nyctaginea
Four-o'clock Family (Nyctaginaceae)

Description: The stems are nearly square, somewhat hairy, branching, to 4' tall, with widely spaced opposite leaves. The leaves are short-stalked, with smooth margins, up to 4" long, and heart-shaped with pointed tips. The flowers are in open-branched clusters at the tops of stems. As many as 5 flowers are seated upon a shallow, green, cup-shaped platform, which is 5-lobed and ¾" across. Each flower is ½" across with no petals and 5 pink to red sepal-like bracts, which form a spreading bell with 5 shallow notches and 3–5 yellow-tipped stamens. The flowers open in late afternoon.

May—October

Habitat/Range: Disturbed open ground, pastures, old fields, roadsides, and railroads; native to western United States; common throughout the state.

Remarks: The Poncas chewed the root and spit it into wounds to heal them. The Pawnee ground the dried root and applied it as a remedy for sore mouth in teething babies. Some tribes pounded the root and used it to treat swellings, sprains, and burns. The plant is considered poisonous.

WIDOW'S CROSS
Sedum pulchellum
Stonecrop Family (Crassulaceae)

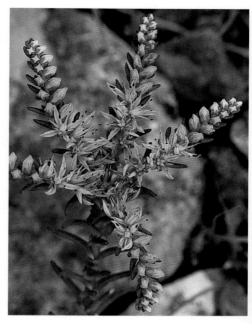

Description: Small, winter annuals, up to 8" tall, with fleshy stems and leaves. The leaves are alternate, crowded along the stem, narrow, round in diameter, and up to ¾" long; lower leaves wither at flowering time. The flowers are densely packed along 3–5 horizontal branches at the top of the stem. Each flower is small, about ⅜" across, with 5 narrow white to pink petals and 5 red-tipped stamens. The stem and leaves often turn red with age and exposure to sun.

May—July

Habitat/Range: Shallow acid soils derived from sandstone, sandstone glades; locally common; south ⅙ of the state.

Remarks: The genus name, *Sedum*, is from the Latin, *sedo*, to sit, referring to the manner in which some species attach themselves to stones and walls. The species name *pulchellum* is Latin for beautiful.

GRASS PINK ORCHID
Calopogon tuberosus
Orchid Family (Orchidaceae)

Description: A slender, smooth, single-stemmed plant less than 2' tall, with a single grass-like leaf that emerges from the base and does not exceed the height of the stem. Up to 10 bright pink flowers occur at the top of the stem. Each flower has 1 upright petal containing dense yellow hairs, 2 narrow petals and 3 broad sepals. Unlike other Illinois orchid flowers the lip is at the top rather than at the bottom.

May—July

Habitat/Range: Marshes, bogs, wet prairies; classified as state endangered; north ½ of Illinois, also Jackson and Macoupin counties.

Remarks: Formerly called *Calopogon pulchellus*, grass pink orchid is closely related to the state endangered Oklahoma grass pink orchid, *Calopogon oklahomensis*. The latter has the flowering stem about as long as or slightly shorter than the leaf and with pale pink flowers. It has been reported from central Illinois prairies and is very rare.

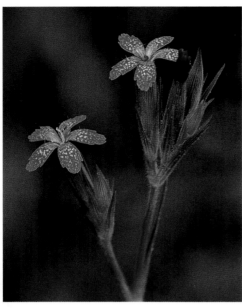

DEPTFORD PINK
Dianthus armeria
Pink Family (Caryophyllaceae)

Description: A slender, but stiff-stemmed annual, sparsely branched, with fine hairs, up to 1½' tall. The leaves are opposite, narrow, up to 3" long and ¼" wide, pointed at the tip, and hairy on the surface and margins. The pink to rose flowers are in clusters at the ends of stems. At the base of each cluster are long, narrow, pointed bracts. Each flower is up to ½" wide, with bright pink to rose petals having white speckles and toothed margins.

May—September

Habitat/Range: Old fields, pastures, along roadsides; native to Europe; scattered throughout the state.

Remarks: The beauty of these flowers is only revealed upon close-up examination. The common name refers to Deptford, England, which is now a part of London.

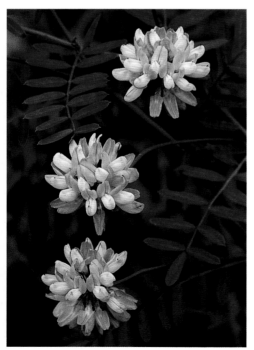

CROWN VETCH
Securigera varia
Pea Family (Fabaceae)

Description: Densely spreading plants, up to 12" tall, with branched, smooth stems. The leaves are alternate and divided into 15–25 leaflets. Each leaflet is up to ¾" long, narrow, abruptly pointed at the tip, lacking hairs, and smooth along the margins. The flowers are in dense clusters (like a crown), on long stalks arising from the axils of the leaves. Each flower is about ½" long, with 5 pink and white petals arranged to form a typical pea family flower.

May—September

Habitat/Range: Roadsides, disturbed sites; native to Europe, Asia, and Africa; often planted and escaped throughout the state.

Remarks: Formerly known as *Coronilla varia*. This plant has been commonly planted along roadsides to control soil erosion. Unfortunately, like soybeans and some other legumes, crown vetch provides no cover in contact with the ground, so the soil remains bare even though there is dense foliage above it. This leaves the soil exposed to surface erosion.

FALSE DRAGONHEAD
Physostegia virginiana
Mint Family (Lamiaceae)

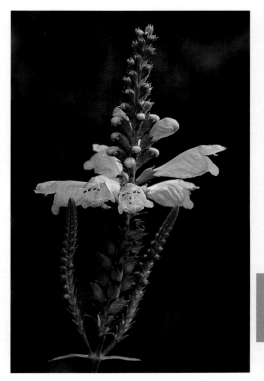

Description: Single or sparingly branched stems, up to 4' tall. The leaves are opposite, stalkless, narrow, up to 5" long and 1½" wide, with teeth along the margins. The flowers are tightly clustered in long spikes at the tops of stems. Each pink tubular flower is about 1" long, with 2 lips, the upper lip resembling a hood, the lower lip divided into 3 lobes.

May—September

Habitat/Range: Moist to dry prairies, savannas; occasional throughout Illinois.

Remarks: Also called "obedient plant," because the flowers, when moved to the side, remain in that position. The closely related narrow-leaved false dragonhead, *Physostegia angustifolia*, has leaves that are narrower (less than ½" wide) and flowers more loosely spaced along the spike. Found in moist soil, low prairies; occasional in the north ¾ of Illinois.

OHIO HORSE MINT
Blephilia ciliata
Mint Family (Lamiaceae)

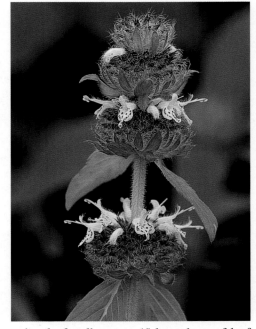

Description: Plants with square stems covered with downy hair, up to 2' tall. The leaves are opposite, without stalks, up to 2½" long, broadest below the middle and tapering to the base, with fine hairs on the underside and small scattered teeth along the margins. The basal leaves remain green through the winter. The pink flowers are packed in a tight cluster, with up to 4 clusters stacked one above another. The flowers are hairy, with 2 lips, the lower lip with 3 lobes and reddish spots.

May—August

Habitat/Range: Open woods, prairies, old fields, roadsides; occasional throughout the state.

Remarks: Also called "pagoda plant." The Cherokee used a preparation of the fresh leaves for headaches. The aromatic leaves can be used as tea when steeped in hot water. Another species, wood mint, *Blephilia hirsuta*, has leaf stalks up to 1" long, base of leaf rounded, edges of leaves noticeably toothed, and the stem usually with 2 or more branches; found in moist woods; occasional throughout the state.

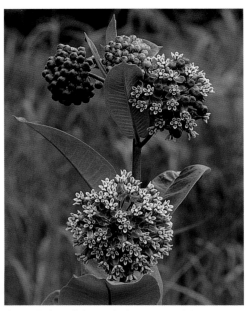

COMMON MILKWEED
Asclepias syriaca
Milkweed Family (Asclepiadaceae)

Description: A robust plant, up to 5' tall, with a stout stem, large leaves, and large flower clusters. The stem is unbranched, with fine hairs and milky sap. The leaves are opposite, thick, leathery, oval, hairy, on short stalks, up to 8" long and 4" wide, and with pinkish veins. The flowers are in large rounded clusters at the tops of the stems and in the upper leaf axils. Each dark pink flower is about ¼" across, with 5 reflexed petals surrounding 5 spreading hoods, each with a tiny, pointed horn arising from it. The fruits are pods up to 4" long, with soft spines on the surface and filled with numerous seeds, each with silky hairs at one end.

May—August

Habitat/Range: Old fields, pastures, degraded prairie, and along roadsides; common; in every county.

Remarks: Native American Indians used root tea as a laxative and as a diuretic to expel kidney stones and dropsy (an abnormal accumulation of blood in the body; edema). The milky latex was applied to warts, moles, and ringworm. Common milkweed was also used by early American physicians for treating asthma and rheumatism.

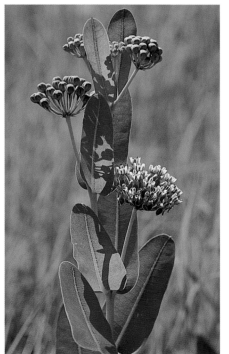

PRAIRIE MILKWEED
Asclepias sullivantii
Milkweed Family (Asclepiadaceae)

Description: Sturdy, thick-stemmed, hairless plants, up to 3' tall, with milky sap. The oval leaves are stalkless, opposite on the stem, up to 7" long and 3½" wide, with pointed tips and broad bases. The midrib of the leaf is typically reddish pink. There are from one to several flower clusters near the top of the stem, with each cluster having up to 40 flowers. Each flower is about ½" across with 5 reddish-pink petals that are reflexed. The fruiting pods are about 4" long, 1½" wide, and usually have soft, pointed projections on the upper half.

June—July

Habitat/Range: Moist prairies; occasional in the north ⅔ of the state, rare elsewhere.

Remarks: Also called "Sullivant's milkweed," it is found in high quality moist to wet prairies.

FIELD MILKWORT
Polygala sanguinea
Milkwort Family, (Polygalaceae)

Description: Small annual plants less than 12" tall, usually with a single, angled stem. The leaves are alternate, widely spaced, narrow, and up to 1¾" long and ⅛" wide. The flowers are in a dense, cylindrical cluster at the tops of branches. The flowers vary from pink to rose-purple to white or greenish and are less than ¼" long. The flowers have 5 sepals, and 3 small petals that are united into a small tube.

May—October

Habitat/Range: Prairies, dry open woods, fields, sandy ground; occasional throughout the state.

Remarks: There are 7 species of milkwort in the genus *Polygala* in Illiniois.

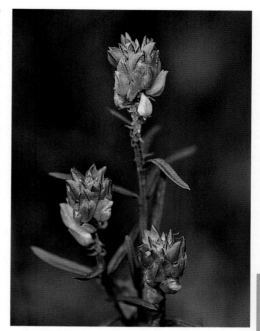

SHOWY LADY'S SLIPPER ORCHID
Cypripedium reginae
Orchid Family (Orchidaceae)

Description: Unbranched plant, up to 3' tall, with fine hairs on the stem and leaves. The leaves are alternate, up to 7 along the stem, and pleated. The leaves are up to 10" long and 7" wide, with the base of the leaf clasping the stem. One to two showy flowers appear at the top of the stem, each with an upright leaf-like bract. The flower has a large pink slipper, up to 2" long, flanked on each side by narrow white petals. There are 2 broader, white, petal-like sepals above and below the slipper.

June—July

Habitat/Range: Marshes, bogs, swamps; classified as state endangered; restricted to the north ½ of the state.

Remarks: Showy lady's slipper was once ranked second in a poll on the most beautiful flowers of the continent. It is the largest and most colorful of the lady's slipper orchids, and its Latin name suggests that it is the "queen" of the lineage. Its rarity is attributed not only to loss of habitat but also to unsuccessful attempts to transplant and commercially market these sensitive orchids.

157

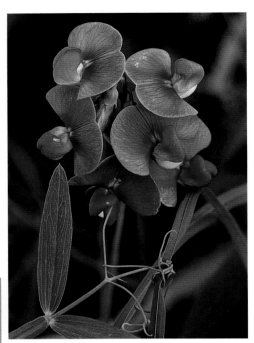

EVERLASTING PEA
Lathryus latifolius
Pea Family (Fabaceae)

Description: A sprawling or climbing plant, up to 3' long, with broadly winged stems. The leaves are alternate, divided into 2 leaflets, with a tendril that emerges from between the leaflets. The leaflets are up to 4" long, narrow, with pointed tips. There are several flower clusters arising from the axils of the leaves. The pink to rose pink flowers are up to 2" across and pea-shaped with 5 petals.

June—September

Habitat/Range: Escaped from cultivation along roadsides, fencerows, and old homesites; native to Europe; occasional; scattered across the state.

Remarks: The common name of this plant refers to its long blooming period. As the vine continues to grow, it produces new flowers along the lengthening stem.

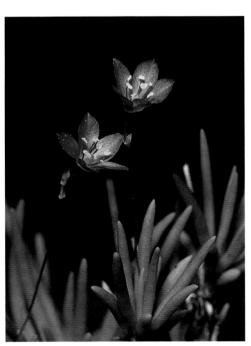

FLOWER-OF-AN-HOUR
Phemeranthus parviflorus
Purslane Family (Portulacaceae)

Description: Small, succulent plants, up to 8" tall. The leaves are numerous, fleshy, round in diameter, up to 2" long, and arising from the base. A thin, wand-like stalk supports several showy pink to rose-purple flowers, about ⅜" across, with 5 petals and 4–8 stamens. The flowers do not open until late in the afternoon.

June—July

Habitat/Range: In thin, acid soils of sandstone glades and cliffs; classified as state threatened; Calhoun, Johnson, Pope, and Union counties.

Remarks: The genus *Talinum* has been replaced with *Phemeranthus*. Two closely related species are *Phermeranthus rugospermus*, with petals ⅜" across and 10–25 stamens; sandy savannas, sandstone cliffs; uncommon in the north ½ of the state; and *Phemeranthus calycinus.*, with petals ½" across and 30 or more stamens; sandstone cliffs; classified as state endangered; Randolph County.

158

SHOWY EVENING PRIMROSE
Oenothera speciosa
Evening Primrose Family (Onagraceae)

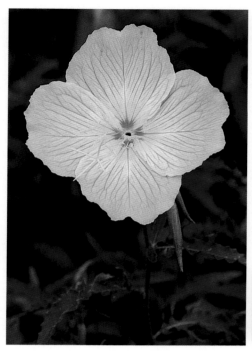

Description: A low-growing, either trailing or somewhat upright plant, with stems up to 2' long. The leaves are alternate, narrow, up to 3½" long and 1" wide, with wavy to weakly toothed margins. The flowers emerge on long stalks from the leaf axils. A showy pink to white flower, up to 3" across, with 4 broad petals tinged with yellow at the base and marked with thin, dark pink lines.

June—July

Habitat/Range: Along roadsides, disturbed ground; native to western United States; occasional throughout Illinois.

Remarks: Of the 17 species of the genus *Oenothera* in Illinois, showy evening primrose is the only one with pink to white flowers.

ROSE GENTIAN
Sabatia angularis
Gentian Family (Gentianaceae)

Description: Annual or biennial plants up to 2' tall, with smooth, square stems and opposite branches, giving it a candelabra-like appearance. The leaves are opposite, clasp the stem, stalkless, up to 1½" long and 1" wide, smooth, and lack teeth. The flowers are on individual stalks, up to 1½" across, with 5–6 rose-pink (rarely white) petals with a yellow inner ring at the base.

June—September

Habitat/Range: Dry to moist soil in open woods, old fields; occasional in the south ⅔ of Illinois, rare or absent in north ⅓.

Remarks: Also called "marsh pink." A related species, prairie rose gentian, *Sabatia campestris*, has alternate branches, somewhat smaller in nature, and with leaves that do not clasp the stem; found in prairies, classified as state endangered, scattered in south central Illinois; also DuPage and Peoria counties.

159

COMMON TEASEL
Dipsacus fullonum
Teasel Family (Dipsacaeae)

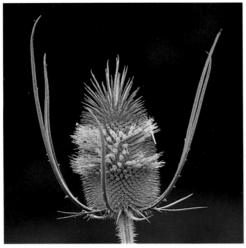

Description: A tall, stout biennial with very prickly, branched stems, up to 8' in height. The leaves are opposite and joined around the stem, up to 12" long, toothed, broadest at the base, narrowing to a pointed tip, and lacking prickles except underneath along the midvein. The flowers are densely packed along a cylindrical head at the top of long stalks. Several stiff, long bracts with prickles curve upward around the flower head. Tiny, tubular pink flowers bloom in rings around the head.

June—October

Habitat/Range: Disturbed soil in fields, pastures, along roadsides; native to Europe; scattered in Illinois and becoming more common.

Remarks: Formerly called *Dipsacus sylvestris*. Common teasel is a noxious weed; once established it is hard to eradicate. The flower heads have been used in dried flower arrangements and on spindles to raise the nap of woolen cloth. Another species, cut-leaved teasel, *Dipsacus laciniatus*, has deeply lobed leaves and long hairs, not prickles, on the margins; native to Europe; habitat and range are similar to common teasel.

SOAPWORT
Saponaria officinalis
Pink Family (Caryophyllaceae)

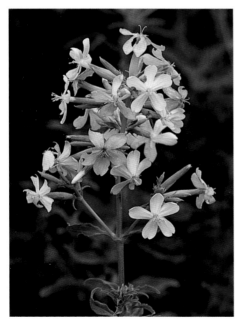

Description: Often forming colonies, the stems are typically branched, and up to 2' tall. The leaves are opposite, stalkless, smooth, up to 4" long and 1½" wide, with 3–5 conspicuous veins along the leaves and often with wavy margins. The flowers are fragrant, in open clusters at the top, with each flower about 1" across. Each flower has a long tube and 5 petals that vary from pink to white, with a notch at the end of each petal.

June—September

Habitat/Range: Disturbed ground, roadsides, railroads, and gravel bars along streams; native to Europe and escaped as a garden plant; common throughout the state.

Remarks: Also called "bouncing bet." A soapy green lather can be made from the plant by rubbing the leaves and stems in water. This natural cleanser, saponin, was used to wash fabrics and tapestries as far back as ancient Greece. Later, soapwort was also used to produce a "head" on beer. The plant has been used to treat asthma, jaundice, gout, syphilis, rheumatism, coughs, and bronchitis. If taken in large doses or over a prolonged period of time, it can cause severe irritation to the gastrointestinal tract.

WILD BEAN
Strophostyles helvola
Pea Family (Fabaceae)

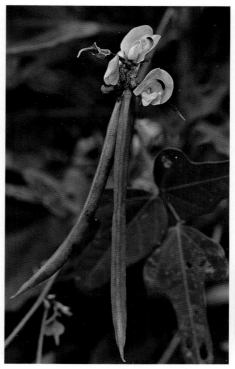

Description: A trailing or twining annual vine, up to 5' long, often branching above. The lowest leaves are usually opposite, the rest are alternate. The leaves are on stalks and divided into 3 rounded leaflets, up to 2½" long, sparsely hairy, usually with a large lobe along one of the margins or on both sides. The flowers are clustered along the vine, and up to ½" long. The pods are narrow and up to 4" long.

June—October

Habitat/Range: Moist rocky woods and thickets, low ground and gravel bars along streams, idle fields, and along roadsides; occasional throughout the state.

Remarks: A smaller wild bean, *Strophostyles leiosperma*, has silky-gray stems and leaflets; its leaflets are narrow, lack lobes, and up to 2" long; prairies, dry woods, fields, roadsides; occasional in the south ½ of the state, less so elsewhere. The only perennial wild bean, *Strophostyles umbellata*, has somewhat leathery leaflets that lack lobes and hairs; dry woods, stream banks; occasional in the south ½ of the state, absent elsewhere.

SWAMP MILKWEED
Asclepias incarnata
Milkweed Family (Asclepiadaceae)

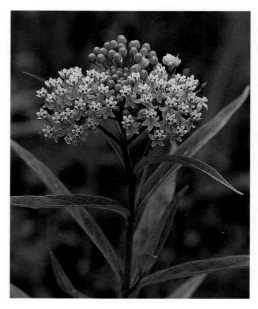

Description: This smooth-stemmed, branching plant, up to 5' tall, has milky sap and narrow, opposite leaves. The leaves are up to 6" long and 1" wide, pointed at the tip, and narrowed at the base, with short stalks. The flowers are clustered at the tops of branches. Each flower is about ¼" across, with 5 reflexed pink petals surrounding 5 light pink to whitish hoods. The seedpods are paired, slender, up to 4" long, and tapering at both ends.

June—August

Habitat/Range: Low wet areas in prairies, borders of marshes, ponds, ditches; common; in every county.

Remarks: New England colonists used swamp milkweed to treat asthma, rheumatism, syphilis, and intestinal worms, and as a heart tonic.

161

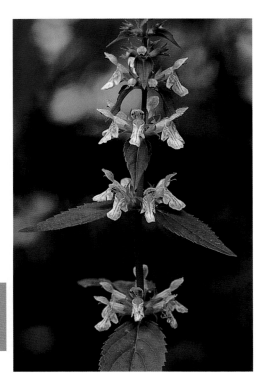

SMOOTH HEDGE NETTLE
Stachys tenuifolia
Mint Family (Lamiaceae)

Description: Plants are square-stemmed, hairy along the ridges, usually unbranched, and up to 3' tall. Leaves are 2–6" long, about 1" wide, with toothed edges along the margins. Pinkish flowers are in whorls of 6, with several whorls along the upper stem. Flowers are about ½" long, with 2 lips; the lower lip broad, spreading, and 3-lobed.

June—September

Habitat/Range: Moist soil, low woods; occasional throughout the state.

Remarks: A closely related species, woundwort or hedge nettle, *Stachys palustris*, has stems that are hairy on the sides as well as the ridges. A native to Europe, it occurs on moist low areas and scattered across the state.

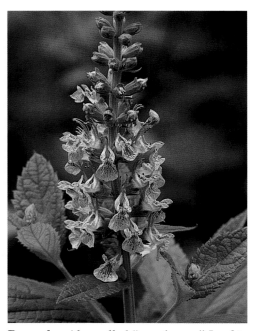

AMERICAN GERMANDER
Teucrium canadense
Mint Family (Lamiaceae)

Description: Usually unbranched plants, up to 4' tall, with fine downy hair on square stems. The leaves are opposite, stalked, up to 6" long and 2½" wide, widest near the base and tapering to a pointed tip, and with coarse teeth along the margins. The flowers are clustered along a narrow column, with each flower on a short stalk about ⅛" long. Each flower is about ¾" long, with the small upper lip divided into small lobes while the lower lip is broad and marked with dark red to purple blotches.

June—September

Habitat/Range: Moist soil in low woods, prairies, ditches, pastures, and roadsides; common; in every county.

Remarks: Also called "wood sage." Leaf tea was used to induce menstruation, urination, and sweating. The plant was also used to treat lung ailments, intestinal worms, piles, and, externally, as a gargle and antiseptic dressing.

NODDING WILD ONION
Allium cernuum
Lily Family (Liliaceae)

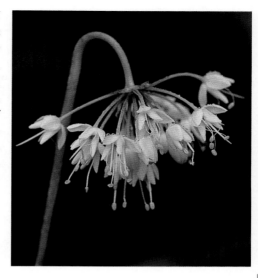

Description: A smooth, leafless, thin-stemmed plant, up to 1½' tall, with several shorter, flat grass-like leaves at the base. The stem bends at the top causing the cluster of flowers to nod downward. Each flower is on about a 1" long stalk. The flowers are small, about ¼" long, with 6 pink to white petals. The fruit capsules are small, rounded, with black seeds.

July—September

Habitat/Range: Moist to dry prairie remnants, wooded banks; uncommon; confined to the northeast part of the state.

Remarks: A closely related species, cliff onion, *Allium stellatum*, differs by having upright flowers and stiff leaves. It occurs in thin soil over limestone bedrock in hill prairies in Jackson, McHenry, Monroe, Randolph, and Union counties.

SPOTTED KNAPWEED
Centaurea stoebe
Aster Family (Asteraceae)

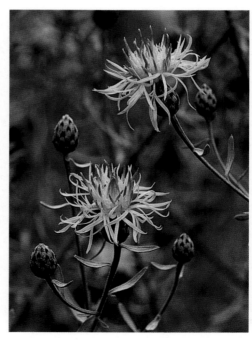

Description: A biennial or short-lived perennial plant, with several stems emerging from the base to 3' tall. The basal leaves are up to 6" long and densely hairy, with shallow to deep lobes. The stem leaves are deeply divided into narrow, finger-like lobes, with the leaves toward the top simple and not divided. The flower heads are at the ends of loosely arranged branches. The bracts at the base of the flowers have dark spots on their tips. The flowers are pink, with the outer ones enlarged.

July—October

Habitat/Range: Disturbed soil, degraded prairies, fields, roadsides; native to Europe; common in the north ½ of the state; uncommon in the south ½.

Remarks: Also known as *Centaurea maculosa*. This plant is a noxious weed that overwhelms other plants by emitting toxic sap through its roots. The sap is also being studied for its potential as a possible cancer-causing agent.

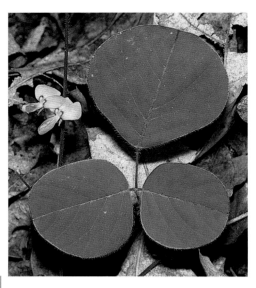

ROUND-LEAVED TICK TREFOIL
Desmodium rotundifolium
Pea Family (Fabaceae)

Description: A plant with trailing stems up to 3' long, with some branching at its base. The distinctive leaves are alternate, stalked, hairy, and divided into 3 nearly round leaflets. The end leaflet is on a long stalk, up to 2½" long and wide, and the side leaflets are on shorter stalks and up to 1½" long and wide. The flowers are in loose clusters on long hairy stalks arising from the leaf axils. Each flower is about ½" long and ranging from pink to pale lavender or white.

July—September

Habitat/Range: Dry woodlands; not common; mostly in the south ½ of the state.

Remarks: Also called "dollarleaf" for the shape of its round leaves.

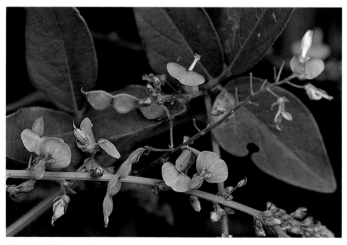

TICK TREFOIL
Desmodium perplexum
Pea Family (Fabaceae)

Description: A slender-stemmed hairy plant, up to 3½' tall, with several branches arising from the base. The leaves are alternate, with 3 leaflets; the middle leaflet is from 1½–2½ times longer than broad and stalked. There are fine hairs flattened on the lower leaf surfaces. The flowers are small, pink, in loose branches, and about ¼" long. The light brown seedpods easily attach to clothing and hair.

July—October

Habitat/Range: Dry woods; uncommon; restricted to the south ½ of the state.

Remarks: There are 17 species of tick trefoils or beggar's lice that occur in the state. The seeds are eaten by songbirds, ruffed grouse, bobwhite quail, and wild turkey.

LARGE-BRACTED TICK TREFOIL
Desmodium cuspidatum
Pea Family (Fabaceae)

Description: A mostly smooth plant, up to 6' tall, with large leaves divided into 3 leaflets. A pair of leafy appendages called "bracts" emerge at the base of the leaf stalk. The leaflets are widest at or below the middle, with the middle leaflet being larger, from 2½–5" long. The small, pink flowers are clustered at the tips of branches.

July—October

Habitat/Range: Dry woods; occasional throughout the state.

Remarks: The genus, *Desmodium*, is Greek for "chain," referring to sections of single seeds attached together along the pod. The common name, tick trefoil, describes each link in the chain resembling a tick and trefoil refers to the 3 leaflets.

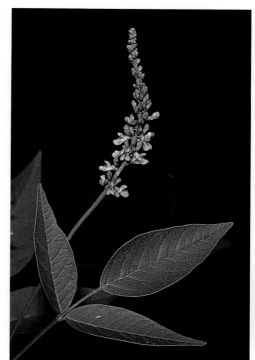

ROUGH BUTTONWEED
Diodia teres
Madder Family (Rubiaceae)

Description: Annual plants, somewhat creeping along the ground, with square, branching stems, up to 2' long. The leaves are opposite, stalkless, narrow, up to 1¼" long and ¼" wide, with pointed tips and a pronounced central vein. At the junction of the leaves, there is a pair of whitish, papery stipules (a leaf-like appendage) with bristles along the edges. The flowers are small, about ¼" across, stalkless, and attached at the axis of the leaf and the stem. The tubular flower has 4 pink petals and 4 small stamens.

July—September

Habitat/Range: Sandy, open ground, woods, fields, roadsides; occasional to common throughout Illinois.

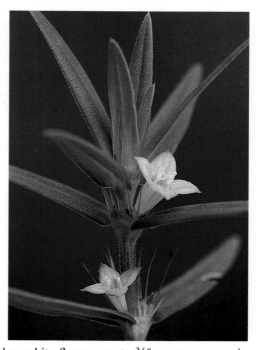

Remarks: A related species, large buttonweed, *Diodia virginiana*, lacks hairs, has white flowers up to ⅜" across; occurs in swamps, wet woods, wet ground along streams and ditches; occasional; confined to the south ¼ of the state.

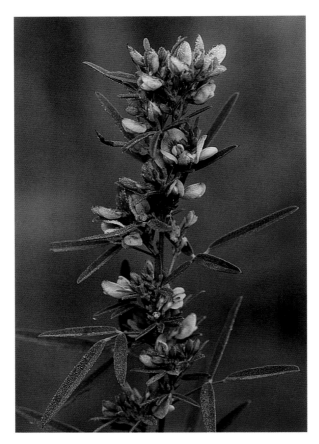

SLENDER BUSH CLOVER
Lespedeza virginica
Pea Family (Fabaceae)

Description: A narrow-stemmed plant, up to 3' tall, with hairy, branching stems. The leaves are numerous, stalked, divided into 3 narrow leaflets, each of which is up to 1½" long and less than ¼" wide. The pink to rose-purple flowers are in dense clusters interspersed with leaves on the upper part of the stem. Each flower is about ¼" long with a spreading upper petal, 2 smaller side petals, and a lower protruding lip. The upper petal has a darker red blotch near its base.

July—October

Habitat/Range: Open dry woods, sandy soils; occasional throughout the state.

Remarks: There are 18 species in the genus *Lespedeza* in Illinois. Slender bush clover is eaten by white-tailed deer and cottontail rabbits, and the seeds are food for ruffed grouse, wild turkeys, and bobwhite quail.

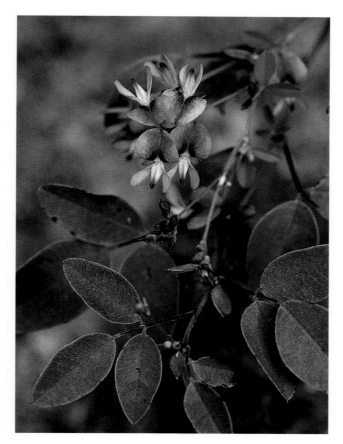

PRAIRIE BUSH CLOVER
Lespedeza frutescens
Pea Family (Fabaceae)

Description: A bushy plant with weak stems that tend to lean, usually not more than 18" tall. The leaves are alternate, stalked, and divided into 3 somewhat oval leaflets. Each leaflet is about 1½" long and ¾" wide. The pink to rose-purple flowers are in sparse clusters at the ends of slender branches. Each flower is less than 3" across. The seedpods are small, flattened, and with a single seed.

July—September

Habitat/Range: Dry woodlands; occasional in the south ½ of Illinois, becoming less common northward.

Remarks: The seeds are eaten by songbirds, ruffed grouse, bobwhite quail, and wild turkey. The plants are eaten by white-tailed deer.

167

Blue/Purple Flowers

This section includes flowers ranging from pale blue
to deep indigo and from lavender to violet.
Since purple flowers grade into pink flowers,
that section should also be checked.

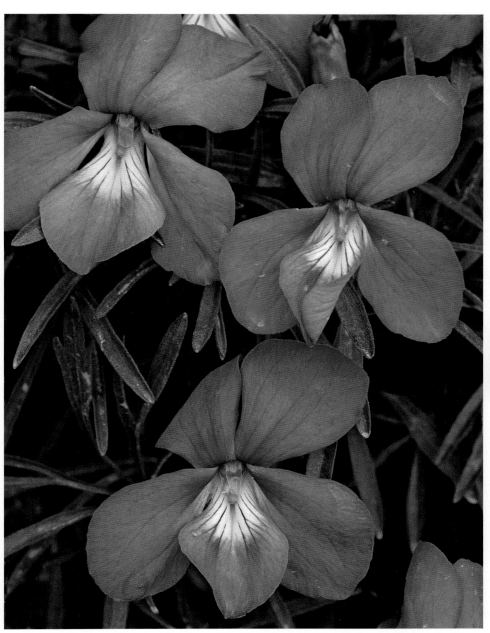

Bird's Foot Violet, page 181

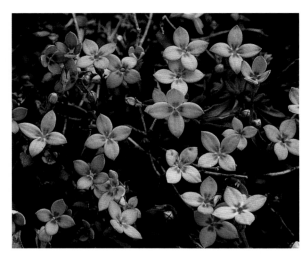

SMALL BLUETS
Hedyotis crassifolia
Madder Family (Rubiaceae)

Description: A small, mat-forming winter annual, with stems usually less than 4" tall. The leaves are opposite, few in number, mostly at the base, and less than ½" long. The blue flowers are at the ends of stalks, about ½" across, with a tubular shape, 4 pointed lobes, and a purplish center.

March—April

Habitat/Range: Rocky woods, fields, pastures, roadsides, and in open areas with sparse vegetation where there is little competition with other plants; occasional in the south ⅓ of Illinois.

Remarks: Formerly known as *Houstonia pusilla* and *Houstonia minima*. The small bluet often forms a carpet of blue in yards and cemeteries.

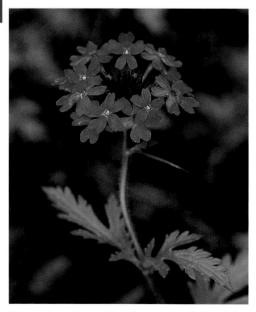

ROSE VERBENA
Glandularia canadensis
Vervain Family (Verbenaceae)

Description: A low spreading plant with hairy stems up to 2' long, often with several stems arising from the base and rooting at the lower nodes. The leaves are hairy, stalked, opposite, up to 4" long, and usually divided into 3 or more lobes with teeth along the margins. The flowers are arranged in a flat-topped cluster, with each flower about ½" wide and shaped like a narrow tube with 5 spreading lobes. The flowers vary from rose-purple to magenta.

March—October

Habitat/Range: Rocky woods, prairies, edges of fields; occasional in the south ⅔ of the state, rare or absent in the north ⅓.

Remarks: Also called "rose vervain" and formerly known as *Verbena canadensis*. The long flowering period is due to the plant's tendency to flower in the spring and then again in the fall if there is sufficient rain.

WOOLLY BLUE VIOLET
Viola sororia
Violet Family (Violaceae)

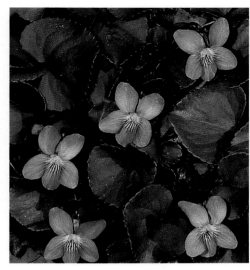

Description: The plant forms a mound of leaves and flowers on usually hairy to densely hairy stalks, less than 6" tall. The leaves are less than 3" across, somewhat rounded, heart-shaped at the base, with rounded teeth along the margins, and often hairy on both surfaces. The flowers are on long, smooth or hairy stalks, up to 2" across, with 5 petals. The base of the petals is white, with a beard of hairs and purple lines.

March—May

Habitat/Range: Rocky or dry open woods, fields, lawns, and degraded prairies; common; in every county.

Remarks: The plants have been used in salads, as cooked greens, soup thickener, tea, and candy. There are 28 species of violets in the genus *Viola* in Illinois. Violets are also the Illinois state flower.

JOHNNY-JUMP-UP
Viola rafinesquii
Violet Family (Violaceae)

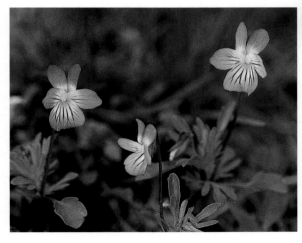

Description: A small, slender, annual, up to 6" tall. The leaves are alternate, the lowermost nearly circular, the upper ones narrower, up to ¾" long, rounded, on long stalks. At the base of each leaf there is a deeply divided leaf-like stipule. The flowers are on stalks arising from the axils of leaves. The flowers are violet, lavender, or white, up to ¾" long, with 5 petals. The base of the petals is white, with a beard of hairs and purple lines.

March—May

Habitat/Range: Disturbed areas, fields, lawns, cemeteries, and along roadsides; native to Europe; common in the south ⅗ of Illinois; rare elsewhere.

Remarks: Johnny-jump-up, which looks like a miniature pansy, often forms dense carpets in lawns and cemeteries. The common name refers to the quick growth of this plant in the spring.

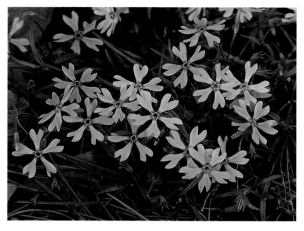

CLEFT PHLOX
Phlox bifida
Phlox Family (Polemoniaceae)

Description: A mat-forming plant, up to 6" high, with wiry, hairy stems. The leaves are opposite, very narrow, up to 2" long and less than ¼" wide, hairy, and lacking teeth along the margins. The flowers are light blue, up to 1" across, on slender, hairy stalks. The 5 narrow petals have deep notches at the tips.

March—June

Habitat/Range: Dry, rocky woods, ledges of bluffs; occasional throughout the state except for some of the central counties.

Remarks: Also called "sand phlox." This attractive, mat-forming phlox has been successfully grown in rock gardens.

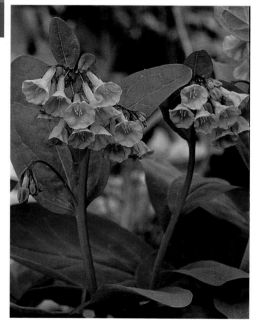

BLUEBELLS
Mertensia virginica
Borage Family (Boraginaceae)

Description: The pale, fleshy stem grows to 2' tall, with alternate blue-green leaves along the stem. The lower leaves are somewhat oval, up to 6" long and 1½" wide, and tapering to the stem. The stem leaves are smaller. The flowers are in loose clusters, hanging from smooth, slender stalks. Each flower is trumpet-shaped, up to 1¼" long, with 5 petals united to form a long tube. The flower buds are initially pink and open to a light blue.

March—June

Habitat/Range: Moist woods, wooded floodplains; occasional throughout the state.

Remarks: Where bluebells are found, they often grow in dense colonies, carpeting the forest floor with a crisp porcelain blue, but the plants completely disappear by midsummer. White flowering plants are occasionally found.

172

DWARF CRESTED IRIS
Iris cristata
Iris Family (Iridaceae)

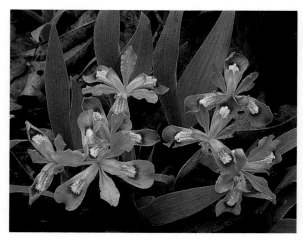

Description: A showy plant, up to 8" tall with a creeping, root-like rhizome. The leaves are mostly basal, up to 8" long and 1" wide, usually slightly curved or arching, light green, with parallel veins. The light violet to purple, rarely white, flowers are 1–2 on a long stalk, about 2½" across, with 3 smaller petals and 3 larger sepals. The sepals each have a 3-ridged yellow crest, bordered with white and outlined with a purple margin.

April—May

Habitat/Range: Lowland woods associated with streams; restricted to the south tip of the state.

Remarks: Native American Indians used root ointment (prepared in animal fats or waxes) on cancerous ulcers. Root tea was used to treat hepatitis.

BLUETS
Houstonia caerulea
Madder Family (Rubiaceae)

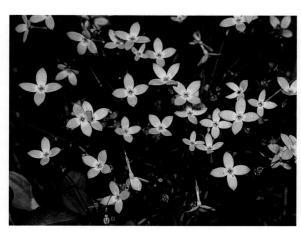

Description: A small, mat-forming winter annual, with stems usually less than 6" tall. The leaves are opposite, few in number, mostly at the base, spatula-shaped, less than ½" long, and narrowed to a stalk almost as long as the leaf. The flowers are at the ends of stalks, about ½" across, sky blue, tubular, with 4 pointed lobes and a yellow center.

April—June

Habitat/Range: Sandy banks and open areas along streams, seepy areas, prairies, open woods, and fields; not common but scattered throughout the state except for the northwest.

Remarks: Formerly known as *Hedyotis caerulea*. Bluets has the largest flowers of the two Illinois bluets and is the only one with a yellow center.

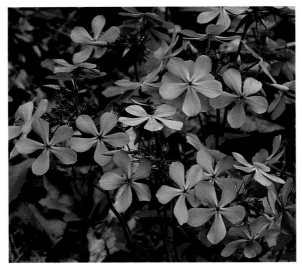

BLUE PHLOX
Phlox divaricata
Phlox Family (Polemoniaceae)

Description: This plant has finely hairy stems, up to 1½' tall, unbranched, with one to several stems arising from the base. The leaves are opposite, widely spaced, stalkless, lance-shaped, up to 3" long, finely hairy, and lacking teeth along the margins. The blue to blue-violet flowers are on slender stalks in loose clusters at the top of stems. Each flower is up to 1" across, tubular, 5-lobed, with the tips either rounded or notched.

April—June

Habitat/Range: Rocky or moist woods; common throughout the state.

Remarks: In pioneer medicine, leaf tea was used to treat eczema and to purify the blood. Root tea was taken to treat venereal disease.

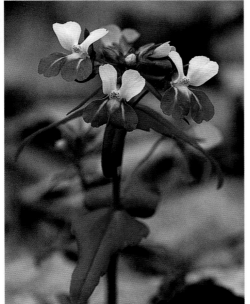

BLUE-EYED MARY
Collinsia verna
Figwort Family (Scrophulariaceae)

Description: A slender, weak-stemmed winter annual, up to 12" tall, often covering large areas on the forest floor. The upper stem leaves are opposite, stalkless, up to 2" long, widest at the base, tapering to a pointed tip, and somewhat toothed along the margins. The lower stem leaves have stalks, are more rounded, and lack teeth. The flowers emerge in whorls in axils of the stem; each flower is about 1½" long, with 2 lips. The upper lip is white with 2 lobes; the lower lip is blue with 3 lobes. The center lower lobe forms a pouch in which the stamens and the pistil are hidden.

April—June

Habitat/Range: Moist woods in ravines and valley bottoms along streams; occasional throughout Illinois and often abundant where found.

Remarks: A closely related species, violet collinsia, *Collinsia violacea*, has the lower lip colored violet. It is found on sandy hillsides; classified as state endangered; Shelby County.

174

GROUND IVY
Glechoma hederacea
Mint Family (Lamiaceae)

Description: A creeping mint with branched stems, rooting at the nodes, up to 15" long. The leaves are opposite, stalked, round, up to 1½" across, with rounded teeth along the margins. The flowers emerge from the axil of the stem and leaf. Each flower is up to ¾" long, with 2 lips. The lower lip is much larger than the upper, usually with 1–2 purple blotches on the inside.

April—July

Habitat/Range: Moist soil in low woodlands, in valleys and banks along streams, lawns, fields, and along roadsides; native to Europe; introduced as a ground cover for residences and now occasional throughout the state.

Remarks: Also known as "gill-over-the-ground." Before Germans began using hops, ground ivy was the primary seasoning used in brewing ale to flavor, preserve, and clarify. During more superstitious times, garlands and headpieces of ground ivy were worn in Midsummer's Eve, June 24, to ward off spells supposedly cast by witches. Europeans used the plant to treat headaches, kidney ailments, and to aid digestion. The fresh shoots and leaves can be added to salads and soups or can be prepared and eaten like spinach.

COMMON FORGET-ME-NOT
Myosotis scorpioides
Borage Family (Boraginaceae)

Description: Plants at first upright and later bent and rooting at the base, loosely branched, and up to 2' long. Leaves are of equal width throughout to broadest towards the base, about 1–3" long. The flowers are about ¼" across with 5 blue petals and a yellow center.

April—October

Habitat/Range: Wet borders along streams, ditches, waste ground; native to Europe; scattered throughout the state.

Remarks: In the years between WW-I and WW-II, the blue forget-me-not was a standard symbol used by most charitable organizations in Germany, with a very clear meaning: "Do not forget the poor and the destitute."

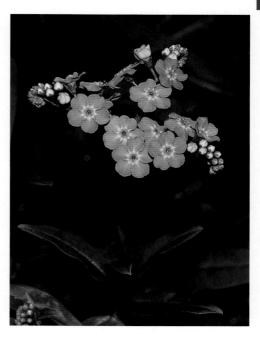

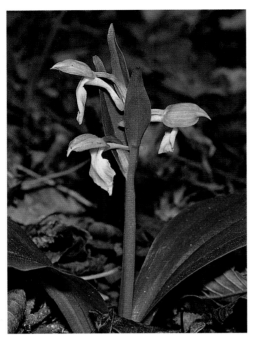

SHOWY ORCHIS
Galearis spectabilis
Orchid Family (Orchidaceae)

Description: A single, stout stem, up to 10" tall, with a pair of shiny leaves emerging from the base. The leaves are broad and up to 7" long. Up to 10 flowers are located along the upper part of the stem, with each flower about ¾" long. The flowers are two-toned with the upper purple hood being composed of 2 small petals and 3 petal-like sepals, while the lower lip is white with crinkled edges. A stout, white spur projects downward from the base.

April—June

Habitat/Range: Moist woods and wooded ravines; not common; scattered throughout the state.

Remarks: Formerly known as *Orchis spectabilis*. The name *Galearis* is from the Greek *galea*, "hood" in reference to the combining of the sepals and petals formed above the lower lip.

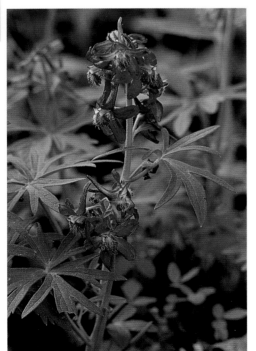

DWARF LARKSPUR
Delphinium tricorne
Buttercup Family (Ranunculaceae)

Description: A single-stemmed, rather succulent plant, with fine downy hairs, that begins flowering at 6–10" tall but may reach 18" later in the season. The basal and alternate stem leaves are shaped like a hand with 5–7 deep lobes; the basal leaves are on stalks. The flowers are loosely clustered along the top of the stem. Each flower is up to 1½" long, stalked, with 5 showy sepals, one of which is developed into a spur, up to 1" long. The 4 petals are small, inconspicuous. The flowers vary from blue to violet to white.

April—May

Habitat/Range: Moist woods; occasional to common in the south ⅘ of the state, absent or rare elsewhere.

Remarks: Larkspurs are poisonous to cattle and horses. Most poisoning is in the spring when the plants are fresh and green.

WILD HYACINTH
Camassia scilloides
Lily Family (Liliaceae)

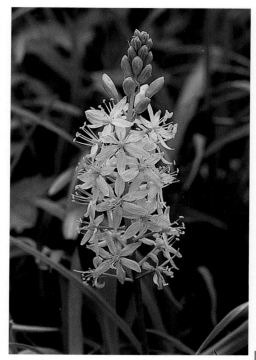

Description: A stout-stemmed plant emerging from a bulb, up to 2' tall. The stem is bare with long, narrow, grass-like leaves, up to 1' long at its base. At the top of the stem there is a cluster of flowers 1¼–2" wide with up to 50 stalked flowers, about 1" across, that display 6 petals that vary in color from pale blue to lilac and, rarely, pure white.

April—June

Habitat/Range: Moist prairies and open woodlands, savannas; occasional throughout Illinois.

Remarks: The other wild hyacinth in Illinois, *Camassia angusta*, has the flower cluster ¾–1¼" wide; deep lavender to pale purple flowers that begin to flower in May; prairies and open woodlands; classified as state endangered; Macon and Peoria counties.

BEE BALM
Monarda bradburiana
Mint Family (Lamiaceae)

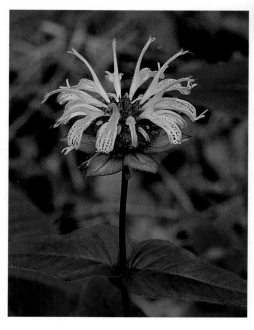

Description: A square-stemmed plant, up to 1½' tall, with one to several unbranched stems emerging from the base. The leaves are opposite, hairy, without stalks, up to 2½" long and 1¼" wide, broadest at the base and narrowest at the tip, and slightly toothed along the margins. The flowers are in a round cluster at the top of the stem. The flowers are up to 1½" long ending in 2 lips, the lower lip broad and recurving, with numerous purple spots; the upper lip arching upward with stamens protruding.

April—June

Habitat/Range: Dry open woods, bluffs, roadsides; occasional in the south ⅗ of the state, absent elsewhere.

Remarks: Also called "horsemint." The crushed leaves are aromatic and minty. A tea can be prepared from the leaves of bee balm.

177

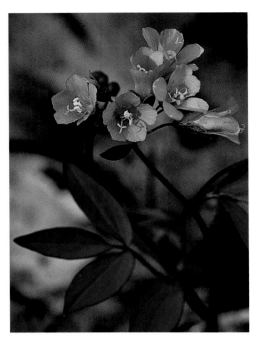

JACOB'S LADDER
Polemonium reptans
Phlox Family (Polemoniaceae)

Description: Low, weak-stemmed plants, up to 15" tall. The alternate leaves are up to 12" long, with each leaf divided into 3–13 leaflets, which form a "ladder." The leaflets are up to 1½" long, widest in the middle, and tapering at both ends. The flowers are in a loose cluster at the top of the stem. Each bell-shaped flower is about ½" across and often nodding. The 5 pale blue petals are united for about half their length.

April—June

Habitat/Range: Moist woods, woodlands, prairies, fens; common throughout the state.

Remarks: The Menomini tribe used this plant to treat eczema and skin sores. The Mesquakie and Potawatami used it for treating hemorrhoids. Root tea was used to induce sweating and to treat fevers, snakebites, bowel complaints, and bronchial afflictions.

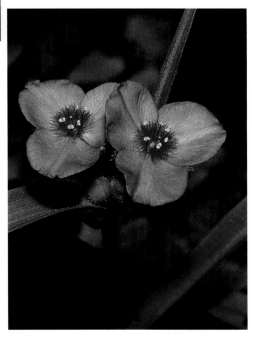

VIRGINIA SPIDERWORT
Tradescantia virginiana
Dayflower Family (Commelinaceae)

Description: A smooth-stemmed plant, up to 16" tall, with 2–5 leaves along the stem. The leaves are up to 1' long, less than 1" wide, becoming wider towards the base that forms a sheath that clasps the stem. The flowers are blue, purple, or magenta and occur in clusters, with each flower containing 3 petals, each about ½" long. There are 3 hairy, green sepals beneath the petals. Each flower has 6 bright yellow stamens.

April—June

Habitat/Range: Woods, prairies; common in the south ⅔ of the state, rare in the north ⅓.

Remarks: A similar species, prairie spiderwort, *Tradescantia bracteata*, differs by having gland-tipped (swollen-tipped) hairs on the sepals which are below the petals; found in prairies; scattered in the west side of Illinois.

GREAT WATERLEAF
Hydrophyllum appendiculatum
Waterleaf Family (Hydrophyllaceae)

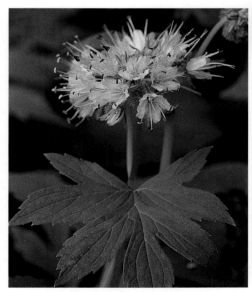

Description: Plants often forming dense colonies, with hairy stems, often branched, and up to 2' tall. The leaves are fan-shaped, up to 6" long and about as wide, with 5–7 shallow lobes, hairy, and coarsely toothed along the margins. The upper surface of the leaves is often mottled gray or light green. The flowers are in loose clusters at the tops of long, hairy stalks. Each flower is up to ½" across, on slender, hairy stalks, with 5 petals and 5 stamens that are equal to or extend just beyond the petals.

April—July

Habitat/Range: Moist woods; occasional throughout Illinois.

Remarks: Also called "woollen breeches." A closely related species, broad-leaved waterleaf, *Hydrophyllum canadense*, lacks hairs and has the upper leaves often above the flowers; rich woods; occasional in the south ¾ of the state, absent elsewhere.

VIRGINIA WATERLEAF
Hydrophyllum virginianum
Waterleaf Family (Hydrophyllaceae)

Description: Plants often forming dense colonies, with smooth stems, up to 2' tall. The lower leaves are deeply divided into 5–7 lobes with the lower pair of lobes at the base quite separate from the others. The upper leaves are closer to being fan-shaped with the lobes not all deeply cut. The flowers are in clusters on long stalks, with the heads extending beyond the leaves. Flowers are violet to white, up to ½" long, and shaped like a tiny fluted, narrow bell. The 5 petals are joined together at their bases, with 5 stamens extending well beyond the petals, giving the flowers a rather hairy appearance.

April—July

Habitat/Range: Moist woods; occasional to common throughout the state.

Remarks: Native American Indians used root tea as an astringent (a substance that causes tissue to contract) to stop bleeding and for diarrhea and dysentery. Tea or mashed roots were used to treat cracked lips and mouth sores. The Iroquois used the tender young leaves as greens. A similar species, large-leaved waterleaf, *H. macrophyllum*, has 9–13 lobes and very hairy stems; moist woods; confined to the south ¼ of the state.

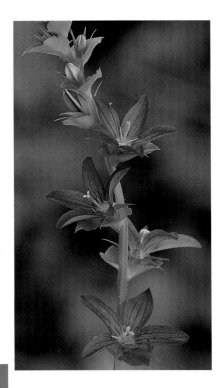

VENUS' LOOKING GLASS
Triodanis perfoliata
Bellflower Family (Campanulaceae)

Description: A slender, mostly unbranched, annual, up to 18" tall, with stems angled with hairs along the ridges. The leaves are roundish, about as long as broad, and clasp the stem with a heart-shaped base. There are teeth along the margin and the veins are fan-shaped. Several star-shaped flowers arise from the leaf axils, stalkless, about ½" across, with 5 petals. Those flowers on the lower stalk do not open but produce the seed.

April—August

Habitat/Range: Disturbed often sandy soil in pastures, old fields, open woodlands and along roadsides; common; probably in every county.

Remarks: The genus name was formerly *Specularia*. Another species, small Venus' looking glass, *Triodanis biflora*, has leaves not clasping the stem, leaves longer than broad, and only 1–2 flowers with petals at the top of the stem; dry, often disturbed soil; confined to the south ⅙ of the state.

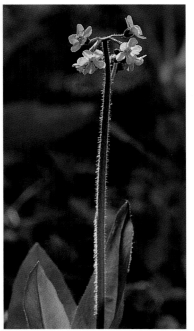

WILD COMFREY
Cynoglossum virginianum
Borage Family (Boraginaceae)

Description: An attractive plant with large leaves and a hairy, wand-like stem, up to 2½' tall. The basal leaves and lower stem leaves are up to 1' long, on stalks, rough-hairy, and oval. The upper stem leaves are smaller, lack stalks, and clasp the stem. The flowers are on short, branching clusters at the top of the stem. The bluish-white flowers are about ½" across, with 5 rounded lobes and 5 stamens.

April—June

Habitat/Range: Moist woods, wooded slopes; occasional in the south ⅓ of Illinois, rare or absent elsewhere.

Remarks: Cherokees used root tea for "bad memory," cancer, and milky urine. A related species, common hound's tongue, *Cynoglossum officinale*, is a downy-covered biennial with a branched stem; it is leafy to the top and has lance-shaped leaves, dark purple to reddish-purple flowers, and a musty odor; pastures, fields, roadsides; native to Europe and Asia; occasional to common in the north ⅔ of Illinois, rare elsewhere.

BIRD'S FOOT VIOLET
Viola pedata
Violet Family (Violaceae)

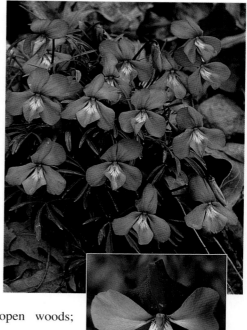

Description: Small, sparse violets, up to 6" tall, with leaves and flowers emerging from the same base. The leaves are deeply cut, resembling a bird's foot, and are often further divided into smaller lobes. The bare flower stems extend above the leaves and are sharply curved at the top with a single flower. The flowers are about 1½" across, with 5 petals; the lowest one is white at the base, with purple lines. The orange stamens form a column in the center of the flower. There are two color variations, one with all 5 petals pale lilac or lavender; the other with the upper 2 petals deep, velvety purple and the lower 3 petals pale lilac to lavender.

April—June

Habitat/Range: Prairies, savannas, dry open woods; occasional throughout Illinois.

Remarks: The bi-colored form has been considered by some as the most beautiful violet in the world. Bird's foot violet sometimes flowers in the fall if conditions are right.

CLEFT VIOLET
Viola palmata
Violet Family (Violaceae)

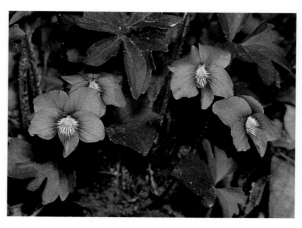

Description: A stemless plant with leaves and flower stalks emerging from the base. The leaves are hairy or smooth, about 2–4" across on long stalks, and deeply 3–11 lobed with the earliest leaves being more heart-shaped. The flowers are on long stalks, large, up to 1" across, blue-violet to white, or sometimes streaked, or blotched violet and white.

April—June

Habitat/Range: Moist to dry woods; occasional in the south ½ of Illinois.

Remarks: Also known as *Viola triloba*, cleft violet is very mucilaginous and has been used in the South to make soup, where it was known as wild okra. The bruised leaves were used to soften and soothe the skin.

CANCER WEED

Salvia lyrata
Mint Family (Lamiaceae)

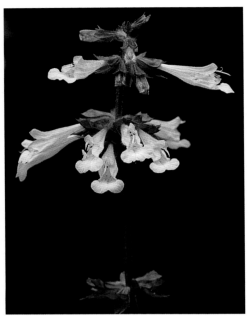

Description: A hairy plant with a single, square stem, up to 2' tall. The basal leaves have long stalks, up to 8" long and 3" wide, with wavy to lobed margins. There is usually 1 smaller pair of stem leaves attached without stalks. The flowers are in a series of whorls on the upper part of the stem, with about 6 flowers in a whorl. Each flower is about 1" long, light blue, with the upper lip much shorter than the lower lip.

April—June

Habitat/Range: Moist woods, open woods; occasional to common in the south ⅕ of the state.

Remarks: Also called "lyre-leaved sage." Native American Indians used the root in salve for sores. Tea from the whole plant was used for coughs, colds, nervous debility, and, taken with honey, for asthma. It was a folk remedy for cancer and warts.

BLUE STAR

Amsonia tabernaemontana
Dogbane Family (Apocynaceae)

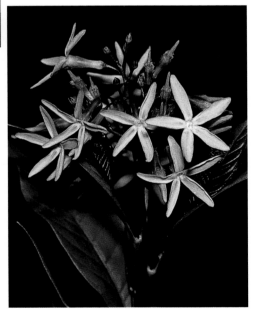

Description: A branched, smooth plant, up to 3' tall, with milky sap. The leaves are alternate, firm, somewhat leathery, up to 6" long and 2" across, with a dull surface on the upper leaves. Numerous flowers are arranged at the tops of stems. Each flower is star-shaped, light blue, and about ½" across. The narrow seedpods are about 4" long and turn up. The plants turn an attractive pale yellow in autumn.

April—June

Habitat/Range: Woods, low, moist ground, roadsides; occasional in the south ¾ of Illinois.

Remarks: The genus *Amsonia* was named for Charles Amson, a 18th century physician of Gloucester, Virginia, by friend John Clayton, a botanist. The species name *tabernaemontana* was named for Jacob Theodore Bergzabern, physician to the Count of the Palatine at Heidelberg and author of the celebrated *Neww Kreuterbuch (New Herb-book) of 1588*, who Latinized his name to Tabernaemontanus.

PHACELIA
Phacelia bipinnatifida
Waterleaf Family (Hydrophyllaceae)

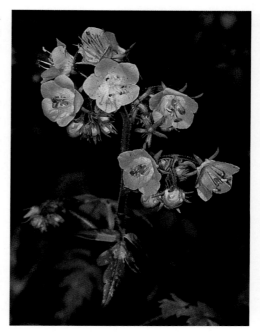

Description: An annual, from 8–20" tall, with spreading hairs on the stem and branched above. Leaves are 2–3" long, hairy, deeply lobed with coarse teeth, and often covered with white blotches. The blue-lavender flowers are clustered at the top of stems with each flower about ½" across. The hairy stamens extend beyond the 5 petals.

April—June

Habitat/Range: Moist woods; occasional in the south ½ of the state, rare elsewhere.

Remarks: The name Phacelia is from the Greek *phakelos*, a bundle; relating to the clustered arrangement of the flowers. There are 200 species of annual and perennial phacelias from the Andes and North America with 4 species occurring in Illinois.

MIAMI MIST
Phacelia purshii
Waterleaf Family (Hdrophyllaceae)

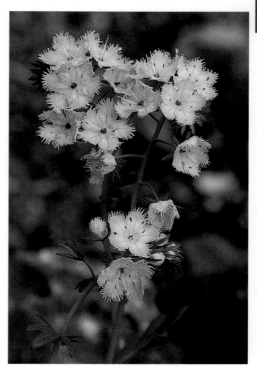

Description: An annual, from 8–16" tall with weak stems and branches. Lower leaves are on stalks and deeply cut to the central vein. Upper leaves are stalkless and clasp the stem with 3–11 lobes along the leaf. The leaves, stem, and flowers have flattened hairs. The blue to pale lavender flowers have a white center and are about ½" across. The 5 petals are distinctly fringed along the margin.

April—June

Habitat/Range: Moist woods, thickets; occasional in the south ½ of the state.

Remarks: An attractive spring flower with its fringed petals; the name refers to the effect it produces in the Miami Valley, Ohio.

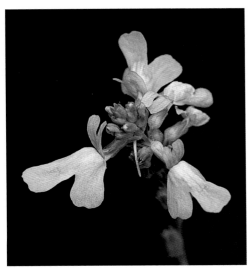

BLUE TOADFLAX
Nuttallanthus canadensis
Plantain Family (Plantaginaceae)

Description: Plants with smooth, slender stems, up to 18" tall, with trailing offshoots at the base that display rosettes of leaves that stay green all winter. The leaves are alternate on the upper stem and opposite or whorled below, narrow, and up to 1" long and ⅛" wide. The light blue flowers are in a loose cluster along the upper part of the stem. Each flower is about ½" long, with 2 lips: the upper has 2 lobes; the lower has 3. A long, down-curved spur emerges from the back of the flower.

April—September

Habitat/Range: Sandy soil in open ground; occasional in the north ½ of the state, uncommon in the south ½.

Remarks: This plant was formerly known as *Linaria canadensis*.

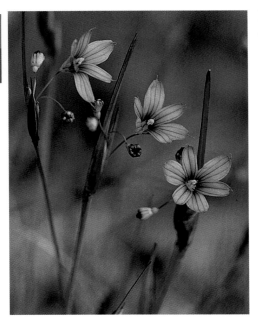

BLUE-EYED GRASS
Sisyrinchium campestre
Iris Family (Iridaceae)

Description: Small, clump-forming plants, with stems not branching at the top, up to 12" tall, with pointed, upright, grass-like leaves. The flower stems are flat, about ⅛" wide with 2 narrow wings, and typically longer than the leaves. There are several flowers, each on a slender stalk, that emerge from two overlapping leaf-like bracts at the top of the stem. Each flower is light to dark blue with a yellow center, about ½" across, with 3 sepals and 3 petals, all looking like petals. The tips of the sepals and petals vary from rounded with a hair-like point, to notched, to shallowly toothed.

April—June

Habitat/Range: Prairies, often in sandy soil; mostly in the north ½ of Illinois.

Remarks: A similar blue-eyed grass, *Sisyrinchium albidum*, has flowers that emerge from 3–4 leaf-like bracts at the top of the stem, with flowers sometimes white; found in open woods, prairies, fields; common; probably in every county. Another blue-eyed grass, *Sisyrinchium angustifolium*, has branching, conspicuously winged stems; low woods, moist prairies; common; probably in every county.

PURPLE ROCKET
Iodanthus pinnatifidus
Mustard Family (Brassicaceae)

Description: Mostly smooth plant up to 40" tall. Leaves are up to 8" long, thin, sharply toothed with the lower leaves deeply lobed at the base. The flowers are arranged in an elongated cluster at the top of the stems with 4 pale violet to nearly white petals. The fruit is slender, from ¾–1½" long.

May—July

Habitat/Range: Low, moist woods; occasional throughout the state except for the northwest counties.

Remarks: The genus name is from the Greek *iodes* (violet-colored) and *anthos* (flower).

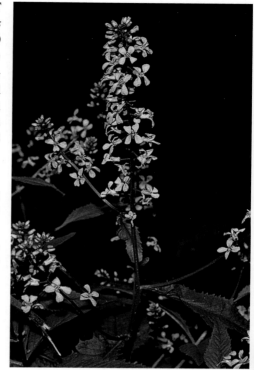

DAME'S ROCKET
Hesperis matronalis
Mustard Family (Brassicaceae)

Description: Usually a single, hairy-stemmed plant, up to 4' tall. The leaves are alternate, lance-shaped, hairy above, sharply toothed, with short stalks or stalkless. The purple flowers are fragrant, showy, with 4 petals, each up to 1" long.

May—July

Habitat/Range: Escapes from plantings, where it is grown as an ornamental; a native to Europe and Asia; scattered throughout the state.

Remarks: Also called "purple rock." Dame's rocket is a well-known flower of old-fashioned gardens and English cottage gardens. Twenty-four species are known from the Mediterranean region to central Asia.

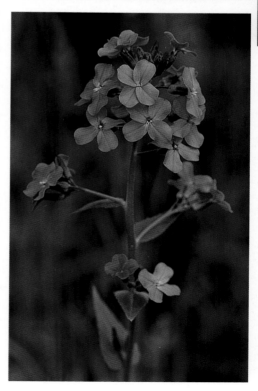

185

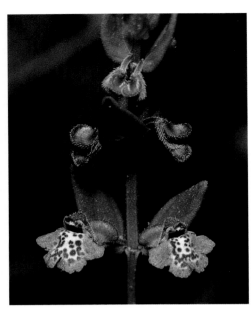

SMALL SKULLCAP
Scutellaria parvula
Mint Family (Lamiaceae)

Description: A short, slender plant, up to 8" tall, with a hairy, square stem. The leaves are opposite, stalkless, hairy, less than 1" long and about ¼" wide, lance-shaped, rounded at the base, and blunt-tipped. The flowers are opposite each other on short stalks that emerge from the leaf axils. Each flower is about ⅜" long with a small, hooded upper lip and a broad, lobed lower lip. The lower lip has a white center with purple spots.

May—July

Habitat/Range: Rocky, open woods, prairies, savannas, limestone glades, fields; occasional in the south ½ of Illinois; also Tazewell County.

Remarks: There are 9 skullcap species in the genus *Scutellaria* in Illinois. The unusual shape of the upper lip of the flowers accounts for the name "skullcap."

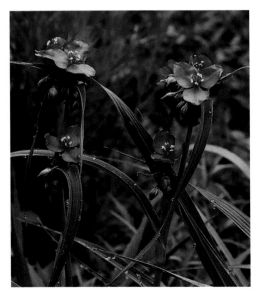

OHIO SPIDERWORT
Tradescantia ohiensis
Dayflower Family (Commelinaceae)

Description: Slender plants, up to 3' tall, with smooth, bluish to silvery-green stems and leaves. The arching leaves are alternate, up to 15" long and about 1" wide, and tapering to a long point, with a sheath that wraps around the stem. The flowers are in a tight cluster at the top of the stem. Each flower is about 1½" across, with 3 blue to purple, rounded petals, and 6 yellow-tipped stamens covered with long purple hairs.

May—August

Habitat/Range: Savannas, prairies, along roadsides and railroads; common; probably in every county.

Remarks: The plant was once thought to be a cure for spider bites. Native American Indians used the stems as potherbs. Each showy flower lasts but a day.

PURPLE MILKWEED
Asclepias purpurascens
Milkweed Family (Asclepiadaceae)

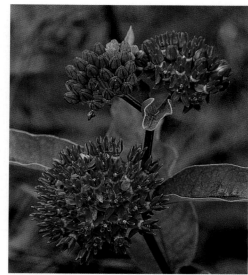

Description: Plants with stout stems, up to 4' tall, with milky sap and opposite leaves. The leaves are thick, up to 6" long, tapering at each end, on short stalks, and with fine hairs on the underside. The smaller side veins are at right angles to the central vein, which is also typically red. The flowers are in large, round clusters at the top of the stem. Each flower has 5 reflexed petals, surrounding 5 spreading hoods, each with a tiny, pointed horn arising from it. The fruit pods are about 6" long and ¾" thick, with fine hairs, and filled with numerous seeds, each with silky hairs at one end.

May—July

Habitat/Range: Prairies, open woods, edge of woods, thickets; occasional throughout the state.

Remarks: Milkweeds have a long medical history, but they have also been used for food. The young shoots were cooked as an asparagus substitute. The flowers, buds, and immature fruits were cooked in boiling water; the water had to be changed to remove the bitter tasting toxins. During World War II, the milky latex was tested as a rubber substitute, and the plumes of the seed heads were collected by schoolchildren and others as part of the war effort. The fluffy material was used as a substitute in life preservers when there was a shortage of kapok, the silky down surrounding the seeds of the kapok tree of Africa and tropical America.

WINTER VETCH
Vicia villosa
Pea Family (Fabaceae)

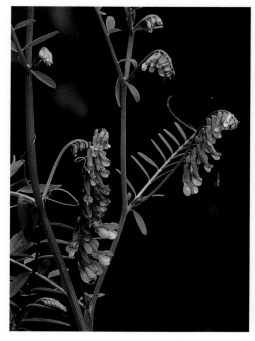

Description: Annual plants with soft hairs on the spreading stems, up to 2' long. The leaves are alternate and divided into 16–24 leaflets with a grasping tendril at the tip. The leaflets are narrow, up to ¾" long, with a small, pointed tip and tapering or rounded at the base. The flowers are on 1-sided stems, about 4" long, that arise from the leaf axils. Each flower is up to ½" long, on a short stalk, with 5 violet and white flowers having the typical structure of members of the pea family.

May—October

Habitat/Range: Disturbed ground in fields, and along roadsides; native to Europe; common throughout Illinois.

Remarks: There are 2 native and 6 exotic species of vetches in Illinois.

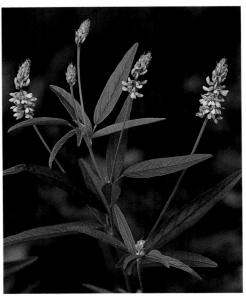

SAMPSON'S SNAKEROOT
Orbexilum pedunculatum
Pea Family (Fabaceae)

Description: A slender, sparingly branched plant, up to 3' tall. The leaves are alternate, stalked, and divided into 3 leaflets. Each leaflet is up to 3" long and ½" wide, with the center leaflet on a longer stalk. The flowers are in cylindrical clusters at the top of long stalks. Individual flowers are light blue to bluish purple, about ¼" long, and shaped like other flowers in the pea family.

May—August

Habitat/Range: Dry open woods, prairies; occasional in the south ⅖ of Illinois; absent elsewhere.

Remarks: Formerly known as *Psoralea psoralioides*. Another species, French grass, *Orbexilum (Psoralea) onobrychis*, has some or all of the leaflets ¾" wide; found in prairies, thickets; not common; in most parts of the state except for the northwest counties.

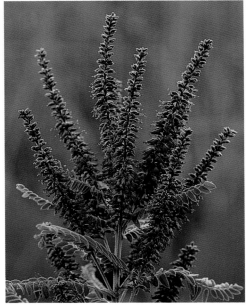

LEAD PLANT
Amorpha canescens
Pea Family (Fabaceae)

Description: A small shrub, up to 3' tall, with grayish hairs on a stem that becomes woody with age. The leaves are stalked, up to 4" long, and divided into as many as 51 leaflets. The leaflets are covered with gray hairs giving the plant a lead-gray color, which was thought to indicate the presence of lead ore below. Each leaflet is up to ¾" long and ½" wide. The tiny purple flowers are in a spike-like mass along the upper part of the stem. Each flower has a single ¼" long petal curling around 10 orange-tipped stamens.

May—August

Habitat/Range: Dry and moist prairies; occasional in the north ⅔ of the state, less so in the south ⅓.

Remarks: Native American Indians used the dried leaves for smoking. A tea was made for treating pin worms and was used externally for eczema. The Omahas powdered the dried leaves and blew them into cuts and open wounds to help promote scab formation. Lead plant is sensitive to disturbance and its presence is an indicator of a high-quality prairie. A closely related species, false indigo, *Amorpha fruticosa*, is a larger shrub, up to 10' tall, lacking hair, with 11–31 leaflets, each up to 2" long and over 1" wide. It is found in moist soil in thickets along streams, edge of ponds, low areas, and in prairie draws; occasional throughout the state.

SCURF PEA
Psoralidium tenuiflorum
Pea Family (Fabaceae)

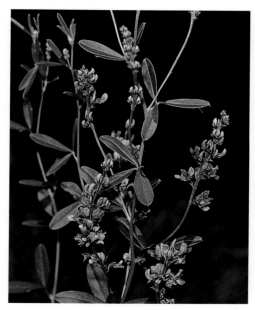

Description: A bushy plant, up to 3' tall, with gray-hairy stems. The leaves are alternate, stalked, with usually 3 leaflets, each up to 2" long and less than ½" wide. The blue flowers are in loose clusters on long stalks that arise from the leaf axils. Each flower is about ⅜" long and shaped like other flowers in the pea family.

May—September

Habitat/Range: Prairies; occasional in the north ¾ of the state.

Remarks: Formerly known as *Psoralea tenuiflora*. The Lakotas made a root tea to treat headaches, and they burned the root as incense to repel mosquitoes. The Dakotas took the tops of the plants and made garlands that were worn on very hot days to protect the head from the heat of the sun.

WILD BERGAMOT
Monarda fistulosa
Mint Family (Lamiaceae)

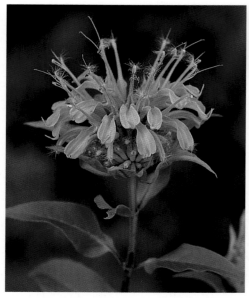

Description: The plants have a fragrant aroma and square stems; both characteristics are typical of the mint family. They branch and grow up to 5' tall, with the upper stem usually with fine hairs. The leaves are opposite, on short stalks, up to 5" long and 2" wide, widest towards the base and narrowing to a long pointed tip, with teeth along the margins. The flowers are numerous in dense round heads, at the tops of the stem. The tubular, lavender flowers have 2 long lips: the upper narrow, arching upward and hairy, with stamens protruding; the lower broad and 3-lobed.

May—August

Habitat/Range: Prairies, savannas, dry woods, fields, and roadsides; common throughout the state.

Remarks: Many Native American tribes made tea from the flower heads and leaves to treat colds, fevers, whooping cough, abdominal pain, headaches, and as a stimulant. The Lakotas wrapped boiled leaves in a soft cloth and placed it on sore eyes overnight to relieve pain. Chewed leaves were placed on wounds under a bandage to stop the flow of blood. Wild bergamot is still used in herbal teas.

189

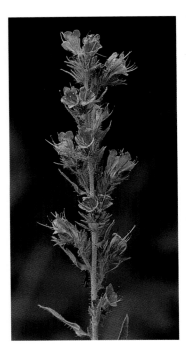

VIPER'S BUGLOSS
Echium vulgare
Borage Family (Boraginaceae)

Description: Mostly single-stemmed plants, up to 3' tall, with bristly hairs on the stems and leaves. The basal leaves are stalkless, narrow, up to 6" long. The stem leaves are progressively smaller up the stem. The flowers are on the upper stem in crowded, curled spikes. Each flower is funnel-shaped, about ¾" long, with uneven petals. The pink buds turn purple when open.

May—October

Habitat/Range: Open disturbed ground, along roadsides and railroads; native to Europe; occasional in the north ½ of the state, rare elsewhere.

Remarks: Also called "blueweed." Bugloss is an English word given to several plants of the borage family. Viper refers to the resemblance of the seed to the head of a viper snake. In early folk medicine, a leaf tea was used for fevers, headaches, nervous conditions, and to ease pain from inflammation. The hairs may cause a rash.

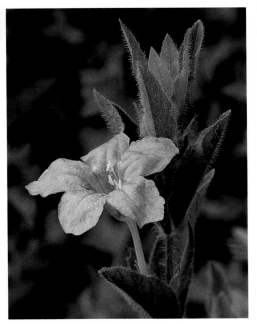

WILD PETUNIA
Ruellia humilis
Acanthus Family (Acanthaceae)

Description: Plants with hairy, squarish stems, often branched, usually less than 12" tall. The leaves are opposite, on very short stalks or stalkless, about 2" long and 1" wide, with long hairs along the veins and leaf margins. The showy, light lavender to purple flowers emerge from the leaf axils on the upper half of the plant. Each flower is up to 2½" long, tubular, and flaring to 5 broad lobes. The mouth of the flower is often marked with dark purple lines.

May—October

Habitat/Range: Dry woods, savannas, prairies, limestone glades; occasional; throughout the state.

Remarks: Another species, smooth wild petunia, *Ruellia strepens*, has sparsely hairy stems and leaves, short stalks, and stems up to 3' tall; grows in moister sites in moist or lowland woods, and borders of streams; occasional; south ⅘ of the state.

PALE PURPLE CONEFLOWER
Echinacea pallida
Aster Family (Asteraceae)

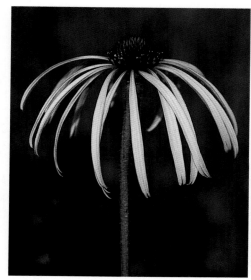

Description: A stout-stemmed, showy plant, up to 3' tall, with coarse, bristly hairs on the stems and leaves. The leaves at the base are on long stalks, up to 10" long and 1½" wide, tapering at both ends with parallel veins running along the length of the blade. The stem leaves are few, smaller, with short stalks. The flower heads are single on long stalks, with several drooping, pale purple petal-like ray flowers, each about 3½" long surrounding a purplish-brown, dome-shaped central disk. The pollen on the anthers is white.

May—August

Habitat/Range: Prairies, open woods; occasional throughout the state.

Remarks: Native American Indians used the root to treat snakebites, stings, spider bites, toothaches, burns, hard-to-heal wounds, flu, and colds. It is widely used today in pharmaceutical preparations. A closely related species, glade coneflower, *Echinacea simulata*, differs by having yellow pollen; it grows on limestone glades, dry prairies, open woods; not common but scattered in Illinois.

CALAMINT
Clinopodium arkansanum
Mint Family (Lamiaceae)

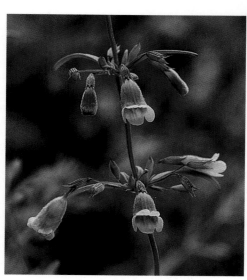

Description: A sparse, low-growing mint, with smooth, branching, square stems, up to 12" tall and very fragrant. The stem leaves are opposite, stalkless, slender, less than ½" long, often with a smaller pair of leaf-like bracts emerging from each leaf axil. The basal leaves are round and rose-purple underneath. The flowers are on stalks attached at the leaf axils. Each light purple flower is tubular, about ⅜" long, with 2 lips. The upper lip has 2 small lobes; the lower lip is larger with 3 lobes.

May—October

Habitat/Range: Rocky ground, fens, seepy areas, sand flats; occasional; northeast ¼ of Illinois.

Remarks: Formerly known as *Calamintha arkansana* and *Satureja arkansana*. A leaf tea has been used for colds, fevers, coughs, indigestion, kidney and liver ailments, and headaches. The essential oil, which can be lethal if taken internally, has been used as an insect repellant but may cause dermatitis.

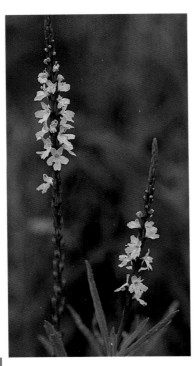

NARROW-LEAVED VERVAIN
Verbena simplex
Vervain Family (Verbenaceae)

Description: Short, slender plants, 12–18" tall, with ridges along the stem. The leaves are opposite, stalkless, narrow, up to 3½" long and 1" wide, with sparse teeth, and tapering at both ends. The flowers are crowded along a spike at the top of the stem. Each flower is lavender to purple, small, about ¼" across, with a short tube and 5 spreading petals.

May—September

Habitat/Range: Prairies, fields, along roadsides, disturbed soil; occasional; scattered throughout Illinois.

Remarks: Another species, creeping vervain, *Verbena bracteata*, is shorter, stems spreading or sprawling, with leaves deeply lobed; disturbed soil; common throughout Illinois.

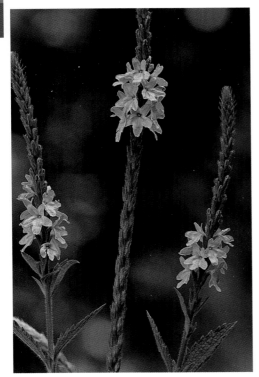

HOARY VERVAIN
Verbena stricta
Vervain Family (Verbenaceae)

Description: Stout, densely hairy plants, up to 4' tall, branching in the upper half. The leaves are opposite, with very short stalks, gray-hairy, broadly rounded, up to 4" long and 2½" wide, and toothed along the margins. The flowers are crowded along 1 to several narrow spikes at the top of the plant. Each purple flower is about ¼" across, with 5 spreading, rounded lobes.

May—September

Habitat/Range: Prairies, pastures, old fields, roadsides, disturbed soil; common; probably in every county.

Remarks: There are 14 species in the genus *Verbena* in Illinois and around 3,000 worldwide, with most occurring in the tropics.

BLUE VERVAIN
Verbena hastata
Vervain Family (Verbenaceae)

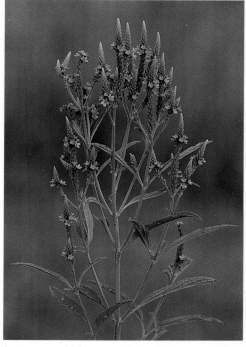

Description: Tall, slender plants, up to 6' tall, with rough hairs and branching stems. The leaves are opposite, on stalks, up to 7" long and 2" wide, pointed, and coarsely toothed along the margins. The larger leaves have 2 lobes at the base. The flowers are crowded along narrow spikes at the top of the stem. Each flower is about ¼" across, with 5 spreading, rounded lobes.

June—October

Habitat/Range: Low wet areas, including wet prairies, wet woodlands, borders of streams, edges of ponds, low pastures, and along roadsides; common; in every county.

Remarks: The Omahas used the leaves for a beverage tea. The Mesquakies used the root as a remedy for fits. The Chippewas took the dried, powdered flowers as a snuff to stop nosebleed. During the American Revolution, doctors used blue vervain to induce vomiting and to clear respiratory tracts of mucus. Settlers used a leaf tea as a spring tonic known as "simpler's joy"—*simpler* is an old term for "herbalist."

SMOOTH PHLOX
Phlox glaberrima
Phlox Family (Polemoniaceae)

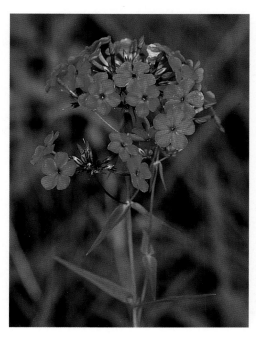

Description: Smooth, hairless plants, up to 3' tall, but usually less than 2' in height. The leaves are stalkless, smooth, opposite on the stem, up to 5" long, ⅝" wide, broadest at the base and gradually tapering to a point tip. The bright magenta flowers are tubular and open into 5 broad lobes, about ½" across.

May—August

Habitat/Range: Moist prairies, woods; occasional throughout the state.

Remarks: Smooth phlox is the only tall phlox to bloom in the spring. The name phlox means flame, in reference to the bright colors of the blooms. The species name *glaberrima* means "very smooth."

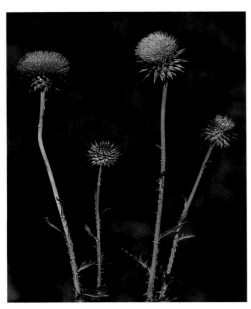

NODDING THISTLE
Carduus nutans
Aster Family (Asteraceae)

Description: A sturdy biennial with a spiny, winged-stem, up to 7' tall. First year's leaves spread over the ground, radiating out from a central core and overwinter, sending up branching stems the second year. Leaves are up to 10" long, 4" wide, smooth, deeply lobed with spiny tips. The flower heads are about 2" across, solitary, nodding at the ends of very long stalks, with numerous reddish-purple flowers.

May—November

Habitat/Range: Pastures, fields, roadsides, and other disturbed places; native to Europe; occasional throughout the state.

Remarks: Also called musk thistle, this is an aggressive, noxious weed and hard to eradicate once established. A related exotic, plumeless thistle, *Carduus acanthoides*, differs by having several flowering heads per stalk, upright, not nodding, and a spiny-winged flower stalk. It occurs in disturbed sites in the north ⅙ of Illinois.

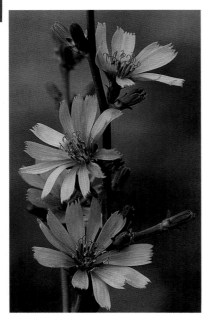

CHICORY
Cichorium intybus
Aster Family (Asteraceae)

Description: A branched, hairy plant, up to 3' tall, with milky sap and ridges along the stem. The leaves are alternate, lobed or toothed along the margins, with the upper leaves clasping the stem. The flower heads are up to 1½" across, lack stalks, and emerge all along the stem. Each head has blue (white or pink), petal-like ray flowers with 5 notches at the tip of each narrow ray.

June—October

Habitat/Range: Disturbed soil, roadsides, fields, pastures; native to Europe; common throughout the state.

Remarks: Chicory was used as a medicinal herb, vegetable, and salad plant in ancient Egyptian, Greek, and Roman times. Since the 17th century, dried, roasted, ground roots have been used as a coffee substitute. Chicory is a gentle, but effective, bitter tonic, which increases the flow of bile and is used to treat gallstones.

194

WINGED LOOSESTRIFE
Lythrum alatum
Loosestrife Family (Lythraceae)

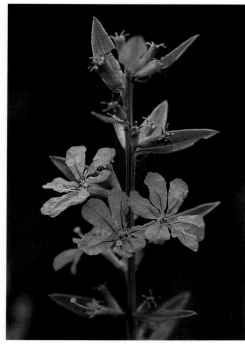

Description: A smooth, loosely branching plant to 2' tall, with squarish stems that may support shallow wings or flaps of tissue. The leaves are opposite on the lower stem and alternate above, narrow, up to 2" long, progressively smaller toward the top, broadly rounded at the base and pointed at the tip. The flowers, up to ½" wide, arise singly from the upper leaf axils. Each flower has a narrow tube with 6 petals.

June—August

Habitat/Range: Wet, open areas in marshes, prairies, margins of streams, ponds, and ditches; occasional to common throughout Illinois.

Remarks: The genus, *Lythrum*, is Greek for "gore," as in the blood-and-guts kind that would be seen in battle; the species, *alatum*, is Latin for "winged." Winged loosestrife should not be confused with purple loosestrife, which is a taller plant with flowers arranged in clusters along an end spike.

PURPLE LOOSESTRIFE
Lythrum salicaria
Loosestrife Family (Lythraceae)

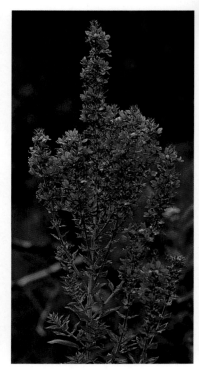

Description: A multi-branched plant with a 4-sided stem, up to 5' tall with opposite leaves or in whorls of 3. The leaves are stalkless, narrow to lance-shaped, 1–4" long. The reddish-purple flowers are in clusters at the tips of stems from 4–16" long. The flowers are ½–1" across with 6 petals.

June—September

Habitat/Range: Moist areas along edges of marshes, ponds, roadsides; native to Europe; occasional in the north ⅔ of the state.

Remarks: Purple loosestrife often occurs in dense stands that shade out native flora. The plant was introduced to the east coast of North America in the early 1800s by immigrants as an ornamental and herb. It spread into the Midwest in the 1880s and reached Illinois in the 1950s. Difficult to eradicate, each plant can produce 1000s of seeds a year that can lay dormant in the soil for many years. It can also reproduce from roots and broken stems. Its planting as an ornamental should be discouraged.

195

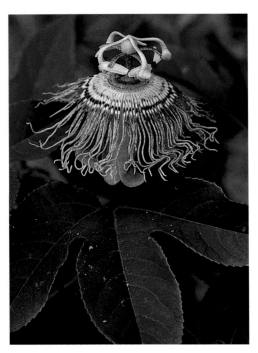

PASSION FLOWER
Passiflora incarnata
Passion Flower Family (Passifloraceae)

Description: A vine, up to 20' long, that climbs or sprawls with the help of tendrils. The leaves are alternate, with 3 broad, toothed lobes, usually smooth, and up to 5" across. The unusual flowers are single, arising on stalks from the axils of leaves. Individual flowers are up to 3" across, with several petals and a purple fringe. There are 5 drooping stamens around the pistil, which has 3–4 curved stigmas. The fruit is oval, smooth, yellow when ripe, up to 2" long, and contains many seeds with gelatinous coverings.

June—September

Habitat/Range: Edge of woods, ditch banks, fencerows, and along roadsides and railroads; occasional in the south ⅓ of Illinois.

Remarks: Also known as "maypops," which comes from children in the South stomping on the fruit to make it pop. Native American Indians used the root to treat boils, cuts, earaches, and inflammation. A tea was made from the plant to soothe the nerves. The fruit is edible.

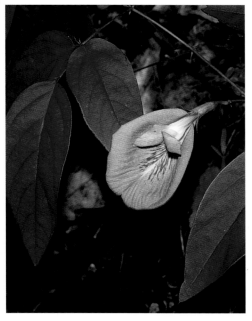

BUTTERFLY PEA
Clitoria mariana
Pea Family (Fabaceae)

Description: A smooth, twining but not climbing plant, up to 3' long. The leaves are stalked and divided into 3 leaflets with the center leaflet on a long stalk. The leaflets are up to 3½" long, broadest at the base and tapering to a pointed tip. There are 1–3 flowers on short stalks attached along the stem. The showy lavender to pale blue flowers are about 2" long with purple markings along the center of the large, upper petal (the *standard*).

June—August

Habitat/Range: Dry woods; not common; occurring in the south ⅙ of Illinois.

Remarks: Flowers late in the season may pollinate without opening. There are 35 species in the genus *Clitoria*, mostly native to warm regions of the world.

CLUSTERED POPPY MALLOW
Callirhoe triangulata
Mallow Family (Malvaceae)

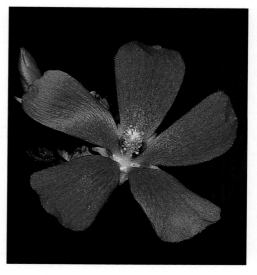

Description: A densely hairy perennial, up to 3' tall, with triangle-shaped leaves at the base. The margins of the leaves have rounded teeth with the upper stem leaves much narrower to even grass-like. The flowers are in clusters, each about 2" across. There are 5 reddish-purple petals.

June—September

Habitat/Range: Sandy soil in prairies and woodlands; uncommon; mostly in the north counties.

Remarks: Another poppy mallow, *Callirhoe involucrata*, has low, vine-like stems that sprawl along the ground with leaves sharply divided and not triangular shaped; found in disturbed soil; native to the western United States; central and northern counties.

MONKEY FLOWER
Mimulus alatus
Figwort Family (Scrophulariaceae)

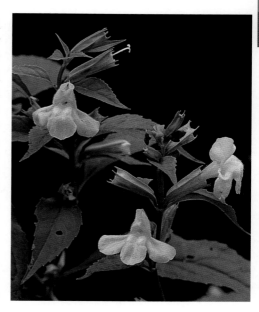

Description: Smooth, often branched plants, up to 3' tall, with squarish stems or at least a ridge down the sides. The stems are also winged with strips of green tissue. The leaves are opposite, stalked, up to 4" long, broadest toward the base, tapering at the tip, and toothed. The flowers are on stalks arising from the leaf axils. Each blue flower is about 1" long, with 2 lips: the upper small, the lower broad with 3 lobes.

June—September

Habitat/Range: Wet ground along streams, spring branches, and ponds, and in low wet woods; common in the south ½ of the state, less common in the north ½.

Remarks: The common name refers to the flower's resemblance to a grinning monkey's face. Another species of monkey flower, *Mimulus ringens*, has leaves without stalks, blue flowers up to 1½" long, and angles of the stem without wings; habitat similar; occasional in the north ¾ of the state.

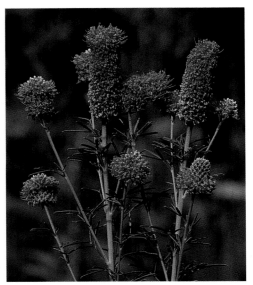

PURPLE PRAIRIE CLOVER
Dalea purpurea
Pea Family (Fabaceae)

Description: Slender, leafy plants, up to 2' tall, with 1 to several stems arising from a common base. The leaves are divided into 3–9 shiny, narrow leaflets, each about 1" long and ⅛" wide. The flowers are densely packed in a cylindrical head at the tops of the branches, with the flowers opening in a circle around the head from bottom to top. Each flower is about ¼" long, with a large petal and 4 smaller petals, with 5 orange stamens.

June—September

Habitat/Range: Dry to moist prairies, sand prairies, limestone glades; occasional throughout Illinois.

Remarks: Formerly known as *Petalostemum purpureum*. Sensitive to overgrazing, purple prairie clover is an indicator of high-quality habitat. Native American Indians used the plant medicinally by applying a tea made from the leaves to open wounds. The Pawnee took root tea as a general preventive medicine. Settlers mixed the bark from white oak trees together with the flowers of purple prairie clover to make a drink used for diarrhea. Native American Indians gathered the tough, elastic stems to make brooms.

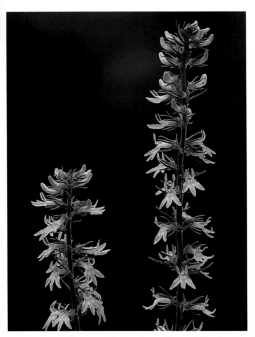

SPIKED LOBELIA
Lobelia spicata
Bellflower Family (Campanulaceae)

Description: Slender, smooth, single-stemmed plants, up to 3' tall, with milky sap and ridges along the stem. The leaves are alternate, narrow, up to 3½" long and 1" wide, with teeth along the margins. The pale blue to nearly white flowers are on short stalks that alternate along the stem. There is a small leaf-like bract at the base of each flower stalk. The flowers are less than ½" long, with 2 lips; the small upper lip has 2 lobes that are stiffly erect; the broad lower lip has 3 larger spreading lobes.

June—August

Habitat/Range: Dry woods, prairies; occasional throughout Illinois.

Remarks: Native American Indians used a tea of the plant to induce vomiting. Root tea was used to treat trembling by applying the tea to scratches made in the affected limb. A related species, Indian tobacco, *Lobelia inflata*, differs by having the base of the flower inflated (this later becomes the seed pod), and hair on the lower stem. Occurs in woods, old fields, disturbed areas; common; in every county.

AMERICAN BELLFLOWER
Campanulastrum americanum
Bellflower Family (Campanulaceae)

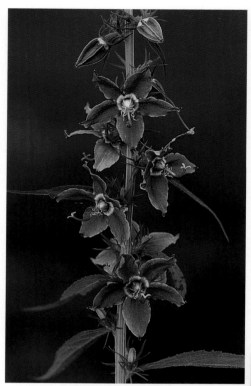

Description: A tall, slender, annual plant, up to 6' in height, with ridges along the stem. The leaves are alternate, stalked, up to 6" long, lance-shaped, with fine teeth along the margins. The flowers emerge at the leaf axils and are about 1" across, with 5 pointed, spreading petals. A white ring is present at the base of the petals. The style is long and curves upwards.

June—November

Habitat/Range: Moist open woods and borders of woods, wooded streamsides, and thickets; common throughout the state.

Remarks: Also called "tall bellflower," and formerly known as *Campanula americana*. The Mesquakie used leaf tea to treat coughs and tuberculosis and the crushed root to treat whooping cough.

PURPLE FRINGELESS ORCHID
Platanthera peramoena
Orchid Family (Orchidaceae)

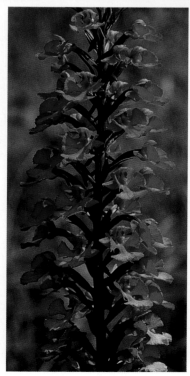

Description: A striking orchid with a smooth stem, up to 3' tall. There are from 2–5 leaves along the stem, each from 4–8" long, progressively reduced in size upward. A cylindrical cluster of 30–50 reddish purple flowers are found at the top of the stem. The flower lip has 3 lobes with the middle lobe notched. A 1-inch spur reflexes downward from the rear of the flower.

June—September

Habitat/Range: Low, moist woods, wet prairies; occasional in the south ⅓ of the state.

Remarks: Formerly called *Habenaria peramoena*. This is a very showy orchid; unfortunately, it does not bloom every year. This is typical of many orchids in the genus *Platanthera* that seem to rest a year or more after flowering to gain strength to bloom again. A closely related species, the purple-fringed orchid, *Platanthera (Habenaria) pyscodes*, has the lobes of the lip deeply fringed. Found in low woods, bogs; classified as state endangered; Cook, Lake, LaSalle, and Winnebago counties.

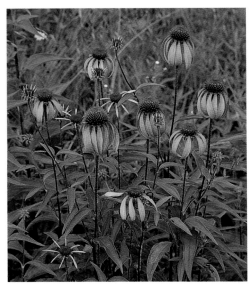

PURPLE CONEFLOWER
Echinacea purpurea
Aster Family (Asteraceae)

Description: A showy plant, up to 4' tall, with branching stems and with rough hairs on the stems and leaves. The basal leaves are on long stalks, coarsely toothed, up to 6" long, broadest at the base, and tapering to a pointed tip. The stem leaves are alternate, on shorter stalks, coarsely toothed, and smaller. The large flower heads are at the ends of long stalks and up to 5" across. The 10–20 petal-like reddish-purple ray flowers surround a cone-shaped central disk. The cones are golden red when in flower.

June—September

Habitat/Range: Moist areas in prairies, open woods, wooded floodplains; occasional throughout the state.

Remarks: Plains Indians used the root to treat snakebites, bee stings, headaches, stomach cramps, toothaches, and sore throats, and for distemper in horses. Some tribes discovered that the plant was like a burn preventative, enabling the body to endure extreme heat. They used the plant's juice in sweat baths and for ritual feats such as immersing hands in scalding water or holding live coals in the mouth. Coneflowers are widely used today in pharmaceutical preparations.

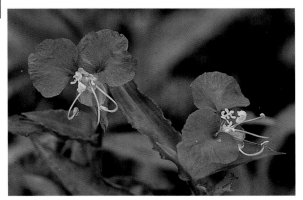

DAYFLOWER
Commelina erecta
Dayflower Family
(Commelinaceae)

Description: A perennial plant, up to 3' tall, with branching, upright stems. The leaves are lance-shaped with parallel veins, up to 6" long and 1½" wide, and clasping the stem. The flowers emerge from a boat-like sheath, one at a time. Each flower, which lasts but a day, is up to 1" across, with 2 rounded blue petals and 1 smaller white petal. There are 6 yellow-tipped stamens.

June—September

Habitat/Range: Moist or dry sandy soil along streambanks, roadsides; occasional throughout Illinois.

Remarks: Another species, common dayflower, *Commelina communis*, is annual, has smaller leaves and flowers, and shorter, sprawling stems, up to 2' long, which often root at the nodes; native to Asia; disturbed moist sites; common throughout the state. Another, small dayflower, *Commelina diffusa*, has the lower petal blue; moist woodlands and disturbed ground; native; occasional in the south ⅔ of the state.

BROAD-LEAVED SPIDERWORT
Tradescantia subaspera
Dayflower Family (Commelinaceae)

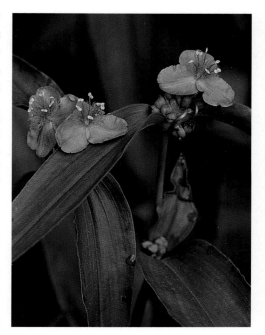

Description: A somewhat hairy plant, up to 3' tall, with a zigzag stem and long arching leaves. The leaves are up to 12" long and 2" wide, hairy, and gradually tapering toward the tip. The flowers are in clusters arising from the axils of the upper leaves. Each flower is about 1" across, with 3 purple petals, 3 green, hairy sepals, and 6 stamens on feathery stalks.

June—September

Habitat/Range: Moist woods and borders of woods, wooded streamsides, and thickets; occasional in the south ⅔ of the state, rare in the north ⅓.

Remarks: Broad-leaved spiderwort is the last of the spiderworts to begin flowering in the state.

SCALY BLAZING STAR
Liatris squarrosa
Aster Family (Asteraceae)

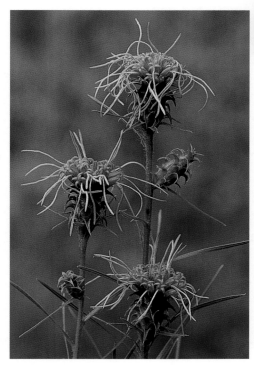

Description: Often hairy, single-stemmed plants to 2½' tall, with narrow, somewhat rigid leaves. The lower leaves are up to 10" long and ½" wide but are progressively smaller upward along the stem. The flower heads are few to solitary, each about ½" across, and emerging from the upper leaf axils. The bracts below the flower head overlap with spreading pointed tips that look spine-like or scaly. Each flower head has 20–40 small, purple, disk flowers that are tubular with 5 lobes. The top flower head tends to be larger with more disk flowers.

June—September

Habitat/Range: Prairies, dry open woods; occasional in the south ⅓ of Illinois.

Remarks: Scaly blazing star was used as a diuretic, a tonic, and a stimulant. It was also used to treat gonorrhea, kidney trouble, and uterine disease.

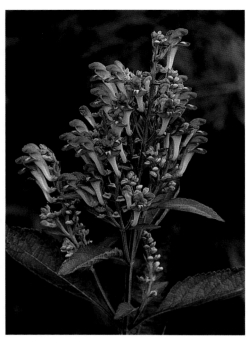

DOWNY SKULLCAP
Scutellaria incana
Mint Family (Lamiaceae)

Description: This plant has fine, downy hairs that cover the square stems, which are up to 3' tall. The leaves are opposite, stalked, with the largest up to 6" long, occurring towards the center of the stem. The lance-shaped leaves have tapering or rounded bases, coarse, blunt teeth along the margins, and soft, downy hairs on the underside. The flowers occur along several stalks. Each flower is about 1" long with 2 lips; the upper lip is a hood, the lower is divided into 3 lobes with a white center.

June—September

Habitat/Range: Dry rocky woods; occasional in the south ⅔ of Illinois.

Remarks: Another downy skullcap, *Scutellaria ovata*, has leaves with a heart-shaped base; rocky woods, moist woods; occasional throughout the state. And mad dog skullcap, *S. lateriflora*, with flowers stalkless, and 1–3 flowers emerging from leaf axils; marshes, wet woods, borders of streams; occasional to common throughout Illinois.

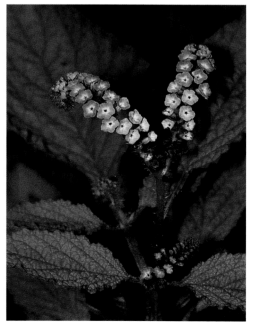

INDIAN HELIOTROPE
Heliotropium indicum
Borage Family (Boraginaceae)

Description: An upright, coarsely hairy annual from 1–3' tall. The leaves are from 1½–4" long, broadest below the middle, with a wrinkled surface. The flowers appear on one side of the stem that uncurls as the flowers mature. Flowers are 5-lobed, small, less than ¼" across, and lavender blue.

July—November

Habitat/Range: Moist, disturbed areas; native to Asia; occasional in the south ½ of Illinois.

Remarks: Also called "turnsole" from the Latin *tourner*, to turn, and *sol*, the sun, a name for plants such as heliotropes and sunflowers whose flowers turn towards the sun.

WESTERN IRONWEED
Vernonia baldwinii
Aster Family (Asteraceae)

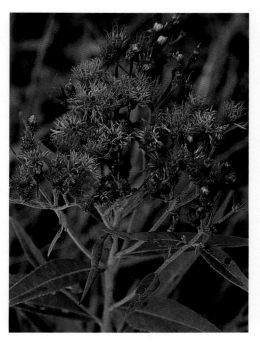

Description: Hairy plants up to 5' tall, with alternate leaves up to 7" long and 2½" wide. The leaves are broadest near the middle and tapering at both ends, densely hairy underneath, and toothed along the margins. The flower heads are numerous, up to ½" across, with about 30 small purple flowers in each head. Each flower head is surrounded at the base with a cup of small, overlapping bracts with pointed, spreading tips.

July—September

Habitat/Range: Prairies, open ground; scattered in the south ½ of the state.

Remarks: Another species, tall ironweed, *Vernonia gigantea* (formerly *V. altissima*), has the lower surface of leaves with sparse hairs, the bracts along the cup of the flower heads blunt instead of pointed and less than 30 small flowers per flower head; moist soil, low woods; occasional throughout the state.

MISSOURI IRONWEED
Vernonia missurica
Aster Family (Asteraceae)

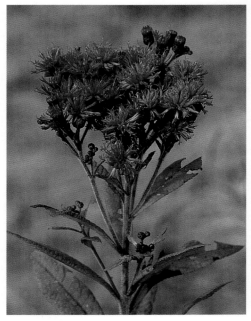

Description: A densely hairy, single-stemmed plant, up to 6' tall. Leaves are up to 8" long and 2½" wide, with long crooked hairs on the lower surface. The flower heads are in clusters on several branches at the top of the stem. There are 34–55 purple flowers in each flower head.

July—September

Habitat/Range: Low open woods, prairies, roadsides, fields; common throughout the state.

Remarks: Another species, common ironweed, *Vernonia fasciculata*, has the lower surface of leaves without hairs but with conspicuous small dots; moist prairies, moist soil on terraces near streams; common in the north ½ of the state, occasional in the south ½.

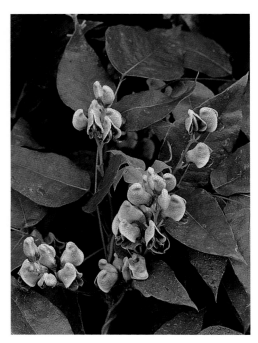

GROUNDNUT
Apios americana
Pea Family (Fabaceae)

Description: A climbing or sprawling vine with milky sap and widely spaced, stalked, alternate, divided leaves. The leaves have 3–7 leaflets on short stalks, up to 3" long, with smooth edges along the margins, broadly rounded bases and pointed tips. Flowers are in dense clusters on short stalks emerging at the bases of leaves. The flowers are brownish purple, fragrant, up to ½" long, with an upper hooded petal, 2 smaller side petals, and a strongly curved, keel-like lower petal. The fruits are wavy pods 2–4" long.

July—September

Habitat/Range: Moist soil in prairies, thickets, borders of marshes, ponds, lakes, and streams; common throughout Illinois.

Remarks: Groundnuts were important food sources of the Osage, Pawnee and many other tribes. The Osage gathered them in late summer and fall and stored them in caches for winter use. Also an important food of New England colonists, the pilgrims were dependent on the potato-like tuber for their survival that first winter. The tubers can be used in soups or stews, or fried like potatoes with 3 times the protein of the latter. The seeds in summer can be eaten cooked like peas.

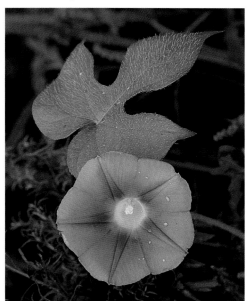

IVY-LEAVED MORNING GLORY
Ipomoea hederacea
Morning Glory Family (Convolvulaceae)

Description: An annual vine, up to 6' long, with twining or climbing hairy stems. The leaves are alternate, hairy, stalked, usually deeply 3-lobed with a heart-shaped base, without teeth, and up to 5" long. From 1–3 flowers appear opposite each leaf. Each flower is funnel-shaped, stalked, blue, up to 1½" long, with 5 united petals.

July—October

Habitat/Range: Cultivated and idle fields, open areas, and along railroads; native to tropical America; occasional to common throughout Illinois.

Remarks: The flowers are open only for a short time in the morning, and each flower lasts but a day. There are 6 species of morning glory in the genus *Ipomoea* in Illinois.

CLAMMY CUPHEA
Cuphea viscosissima
Loosestrife Family (Lythraceae)

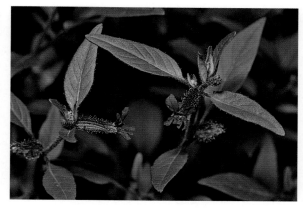

Description: A sparsely branched annual, up to 2' tall, with sticky, purplish hairs. The stalked leaves are opposite on the stem, broadest below the middle, and from ¾" to 2" long. There are 1–2 small, reddish-purple flowers arising at the junctions of the upper stem and leaves. The flowers have 6 petals, with the upper 2 larger than the lower 4.

July—October

Habitat/Range: Dry soil in open areas; occasional in the south ¾ of the state, rare or absent elsewhere.

Remarks: Formerly called *Cuphea petiolata*, clammy cuphea or blue waxweed was once used to treat infant cholera in the late 1800s. This plant has recently been tested for its potential cancer fighting properties.

DITTANY
Cunila origanoides
Mint Family (Lamiaceae)

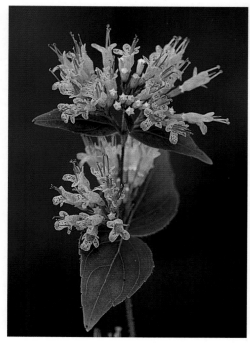

Description: A low, much-branched, wiry plant, up to 12" tall, sometimes with fine hairs along the square stem. Leaves are opposite, stalkless, hairless, up to 1½" long, broadest at the base and tapering to a pointed tip, and usually with a few teeth along the margins. The rose-purple flowers are in clusters arising from the leaf axils. Each flower has 2 lips: the smaller upper lip has 2 lobes, and the larger lower lip has 3. The lips have purplish dots.

July—November

Habitat/Range: Dry, rocky or open woods, sandstone cliffs; occasional in the south ½ of the state.

Remarks: In late fall, during hard freezes, dittany produces "frost flowers." These are ribbons of ice oozing out of cracks at the base of the stem. Sap from still-active roots freezes as it emerges from the dead stem, growing like a white ribbon as more fluid is pumped out.

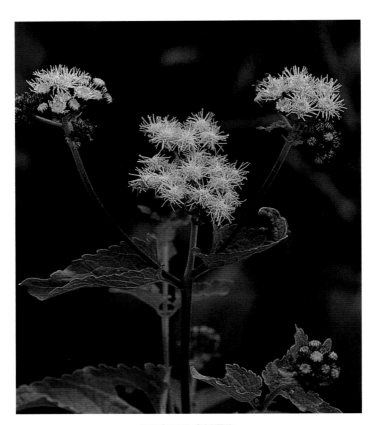

MISTFLOWER
Conoclinium coelestinum
Aster Family (Asteraceae)

Description: Downy, branching, purplish stems, up to 18" tall, which can spread by underground runners. The leaves are opposite, on short stalks, oval to triangular, with large teeth along the margins. The flower heads are in flat-topped clusters at the tops of stems. Each head has 35–70 bright blue or purplish disk flowers.

July—October

Habitat/Range: Moist ground along streams, spring branches, ditches, and low areas in pastures; common in the south ⅔ of the state; rare northward where it may be introduced.

Remarks: Also called *Eupatorium coelestinum*. Another name, "wild ageratum," relates to its similarity to the annual ageratum grown in gardens. From a distance the color and shape of the flower clusters resembles low-lying foggy mist.

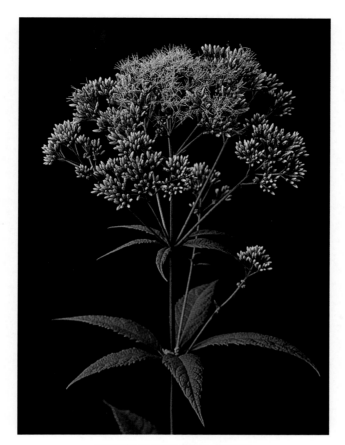

PURPLE JOE PYE WEED
Eutrochium purpureum
Aster Family (Asteraceae)

Description: A tall, slender plant, sometimes growing to a height of 10'. The stem is solid, not hollow, and green, but it may be tinged with purple, especially at the nodes where the leaves are attached. The large, thin leaves are in whorls of 3–4, on short stalks, and up to 12" long and 3" wide, tapering at both ends with numerous small teeth along the margins. The tiny fragrant flower heads are in large dome-like clusters 6" across or more. Each cylindrical flower head contains 3–7 petal-like ray flowers that vary from pink to purple to almost white.

July—September

Habitat/Range: Woodlands; common in the north ¾ of the state, occasional in the south ¼.

Remarks: Formerly the genus Eupatorium. Legend has it that Joe Pye, a Native American Indian herb doctor of the Massachusetts Bay Colony, used this plant to cure fevers. The Iroquois and, more recently, people in some areas of Appalachia, used parts of these plants to treat urinary disorders. Chippewa mothers bathed fretful children in a tea made from this plant to bring restful sleep. It was also traditional for Mesquakie men to nibble the leaves to ensure success in courtship. Another species, hollow Joe Pye weed, *Eutrochium fistulosum*, has hollow stems and leaves often more than 4 in a whorl; found in low, wet ground; occasional in the south ½ of the state, less common or rare elsewhere.

207

SHOWY TICK TREFOIL
Desmodium canadense
Pea Family (Fabaceae)

Description: Plants up to 6' tall, branched above, with long, soft hairs on the stem. Leaves are alternate along the stem and divided into 3 leaflets. The leaflets are 2–3 times longer than broad on short stalks. The flowers are in elongated clusters with bright purple flowers, each about ½" long. The bean-shaped petals have a large, flaring upper petal, two small side petals flanking a keel-like lower lip. The fruit pods are in 3–5 hairy segments resembling flattened chained beads that easily attach to clothing.

July—September

Habitat/Range: Prairies; occasional throughout the state.

Remarks: "There is something witch-like about them; though so rare and remote, yet evidently, from those bur-like pods, expecting to come in contact with some traveling man or beast without their knowledge, to be transported to new hillsides; lying in wait, as it were, to catch by the hem of the berry-picker's garments and so get a lift to new quarters" (Henry David Thoreau, 1856).

ILLINOIS TICK TREFOIL
Desmodium illinoense
Pea Family (Fabaceae)

Description: Plants 3–6' tall, typically unbranched, with alternate, stalked leaves. The leaves are divided into 3 leaflets, with the middle leaflet shorter than the leaf stalk. The stem and leaves are covered with hooked hairs that easily attach to clothing. The flowers are loosely clustered along the upper part of unbranched stems. The pink to purple flowers are about ⅓" across, with a large, flaring upper petal, two small side petals flanking a keel-like lower lip. The fruit pods are in 3–6 flattened, hairy segments that easily attach to clothing.

July—September

Habitat/Range: Dry prairies, open woods, roadsides; occasional throughout Illinois.

Remarks: This tall tick trefoil can surprisingly withstand close roadside mowing and yet emerges with very tall stems between mowings.

BLUE LETTUCE
Lactuca floridana
Aster Family (Asteraceae)

Description: Tall, slender plants, up to 7' tall, with milky sap. The leaves have deep lobes, up to 12" long, hairless, with the tip broadly triangular, and the base tapering to a stalk edged with leafy tissue. The flower heads are numerous, on widely branching stems, light blue, small, and about ½" across. Each head has 11–16 petal-like ray flowers.

July—September

Habitat/Range: Woods, woodland borders; common throughout the state.

Remarks: The young leaves have been eaten in salads and as cooked greens. The milky sap is bitter.

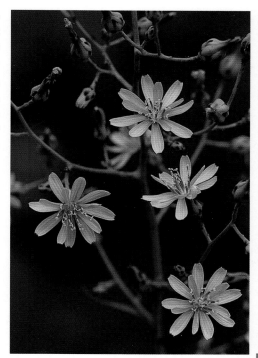

GARDEN PHLOX
Phlox paniculata
Phlox Family (Polemoniaceae)

Description: A showy, late-blooming phlox, up to 5' tall. The leaves are opposite, stalkless, up to 6" long and 2" wide, broadest along the middle and narrowing at both ends, with the side veins prominent. The flowers are often in large, pyramidal clusters at the tops of the stems. The reddish-purple (sometimes white) flowers are on short stalks, up to ¾" across, with a short-hairy tube, 5 lobes, and with 1 of the yellow stamens extending just beyond the mouth of the flower.

July—September

Habitat/Range: Rich woods, low woods along streams and in valleys, and edge of woods; scattered in Illinois, except for the northwest part of Illinois.

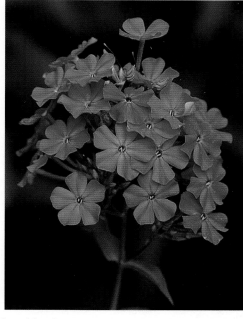

Remarks: Also called "perennial phlox." Garden phlox is so named because of its popularity as a garden plant and the many horticultural varieties that have been developed from it.

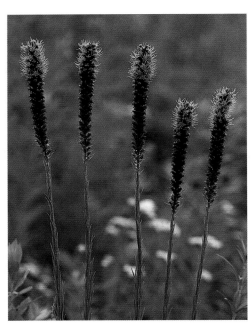

PRAIRIE BLAZING STAR
Liatris pycnostachya
Aster Family (Asteraceae)

Description: Hairy, slender, unbranched, spikes up to 5' tall, arising from a corm. The leaves are alternate, stalkless, and numerous, with the lower leaves sometimes over 12" long and up to ½" wide, gradually reducing in size up the stem. The flower heads are in a long dense spike, often over 12" long, at the top of the plant. Each small head is about ¼" across, with hairy, outward curving bracts. There are 5–10 disk flowers in each head, each with 5 lobes.

July—October

Habitat/Range: Prairies, some fens; common throughout Illinois.

Remarks: Also called "gayfeather." Cultivated varieties of prairie blazing star are grown for the cut-flower market. The flowering spikes can be air-dried for use in winter arrangements. A similar species, marsh blazing star, *Liatris spicata*, has smooth stems, with bracts below the flowers pressed against the stem; moist or wet prairies, sand flats; scattered throughout the state.

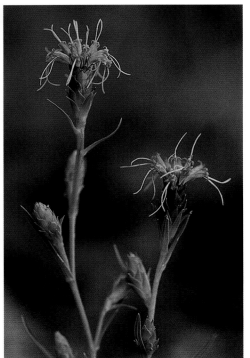

CYLINDRICAL BLAZING STAR
Liatris cylindracea
Aster Family (Asteraceae)

Description: There are few flower heads on this stiff, short-stemmed plant that may grow up to 2' tall. The grass-like leaves are stalkless, smooth, up to 10" long and ½" wide but becoming progressively smaller upward along the stem. The flower heads are cylindrical, alternate along the upper stem, about ½" across, and on short stalks. The bracts are smooth, flat, and not extending outward. The heads have 10–35 small, reddish-purple disk flowers with 5 narrow, pointed tips that curl backward.

July—October

Habitat/Range: Dry prairies, sand flats; occasional in the north ¾ of the state, rare elsewhere.

Remarks: North American Indians would sometimes eat the corms of blazing stars in desperate times.

ROUGH BLAZING STAR
Liatris aspera
Aster Family (Asteraceae)

Description: A single-stemmed plant that is hairy or smooth, up to 4' tall, arising from a corm. The basal leaves are short-stalked and up to 16" long and 2" wide. The stem leaves are progressively shorter upwards on the stem. The flower heads are alternately arranged and loosely spaced along a wand-like spike, up to 1½' long. The bracts on the head are rounded with white to purplish, papery tips. The heads are up to 1" across, with 15–25 small, purple disk flowers, each with 5 lobes.

July—October

Habitat/Range: Prairies, savannas; occasional to common throughout the state.

Remarks: The Mesquakies used the plant for bladder and kidney troubles. The Pawnees boiled the leaves and root together and fed the tea to children with diarrhea. Root tea was used as a folk remedy for kidney and bladder ailments, gonorrhea, and colic and was gargled for sore throats. The root was mashed and applied to snakebites. Another species, savanna blazing star, *Liatris scariosa* var. *nieuwlandii*, has 25–80 purple disk flowers; found in savannas, dry open woods; occasional in central Illinois; also Cook and Will counties.

GREAT BLUE LOBELIA
Lobelia siphilitica
Bellflower Family (Campanulaceae)

Description: Unbranched plants, up to 3' tall, with milky sap. The leaves are alternate, stalkless, up to 6" long and 1½" wide, widest in the middle and tapering at both ends, with teeth along the margins. The flowers are crowded along the upper part of the stem. Each flower is ¾–1½" long, deep blue, with pale stripes along the tube and with 2 lips. The upper lip is split into 2 upright lobes, and the lower lip into 3 spreading lobes with a white base.

August—October

Habitat/Range: Wet ground, marshes, fens; occasional to common throughout Illinois.

Remarks: The Mesquakies finely chopped the roots and mixed them into food of a

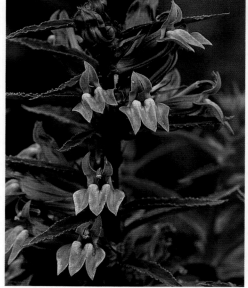

quarrelsome couple without their knowledge. This, they believed, would avert divorce and make the pair love each other again. Other tribes used root tea for syphilis and leaf tea for colds, fevers, upset stomachs, worms, croup, and nosebleeds. A similar species, downy lobelia, *Lobelia puberula*, has stems densely hairy throughout; wet ground; occasional in the south ⅓ of the state.

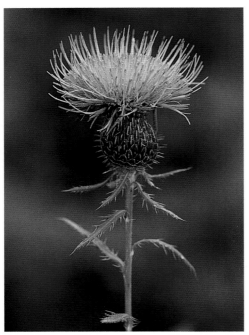

TALL THISTLE
Cirsium altissimum
Aster Family (Asteraceae)

Description: A tall, branching biennial to short-lived perennial plant, up to 8' in height. The alternate, deep green leaves grow to 12" long. The leaves are not lobed but have coarse teeth along the leaf margins that end in spines. The undersides of the leaves have whitish woolly hairs. The flower heads are at the ends of long stalks, up to 2' tall, with a short spine at the end of each bract. Each rose-purple flower is tubular, about 1" long, with 5 narrow lobes, each about ⅜" long.

August—September

Habitat/Range: Dry, open, or rocky woodland, borders of woods, disturbed soil, and along roadsides; common throughout the state.

Remarks: The fluffy down from mature thistle heads is a favorite nest lining for American goldfinches. Another species, Canada thistle, *Cirsium arvense*, has numerous small flower heads, less than 1" tall, with spines lacking at the end of each bract; found in disturbed soil; native to Europe; a noxious weed; common throughout the state.

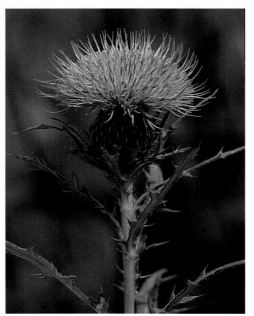

FIELD THISTLE
Cirsium discolor
Aster Family (Asteraceae)

Description: A robust biennial plant, up to 6' tall with a hairy, ridged stem. The leaves are deeply divided into stiff, narrow, spiny lobes. The leaves are 4–8" long with dense white woolly hairs below. The flower heads are 1–1½" long with spine-tipped bracts below the rose-purple heads.

August—October

Habitat/Range: Fields, pastures, roadsides, open woods, degraded prairies; common throughout the state.

Remarks: Also called pasture thistle, a similar looking species, bull thistle, *Cirsium vulgare*, differs by having the upper stem and branches winged by a wavy strip of prickly green leafy tissue running from the base of the leaf down the stem. This thistle comes from Europe and is a noxious weed. It is found in disturbed soil throughout the state.

SLENDER FALSE FOXGLOVE
Agalinis tenuifolia
Broomrape Family (Orobanchaceae)

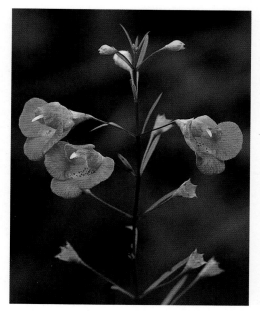

Description: A much-branched annual plant, less than 2' tall, with narrow ridges along the main stem. The leaves are opposite, very narrow, up to 3" long and often less than ⅛" wide, with smooth edges. The upper leaves have smaller leaves emerging from the same axils. Single flowers arise on short stalks from the leaf axils. Each rose-purple flower is about ¾" across and resembles a funnel, with a short tube opening to 5 rounded lobes. There are purple spots and 4 hairy stamens in the mouth of the flower.

August—October

Habitat/Range: Moist soil; occasional to common throughout Illinois.

Remarks: Formerly called *Gerardia tenuifolia*. There are 8 species of false foxgloves in the genus *Agalinis* in Illinois.

ROSE TURTLEHEAD
Chelone obliqua var. *speciosa*
Plantain Family (Plantaginaceae)

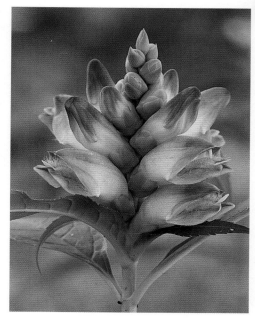

Description: An upright, usually unbranched plant, up to 3' tall, with angled stems. The leaves are opposite along the stem, broadest at the middle, toothed along the margin, and up to 6" long and 1½" wide. The reddish-purple flowers are clustered at the top, each about 1" long. The upper lip of the flower has two lobes, which extend over the 3-lobed lower lip.

July—October

Habitat/Range: Low areas in wet soil, marshes, wet woods; uncommon; scattered throughout the state.

Remarks: Also called "pink turtlehead," the common name is very fitting especially when viewing the profile of the flower. A leaf tea was said to stimulate appetite, also a folk remedy for worms, fevers, jaundice, and as a laxative.

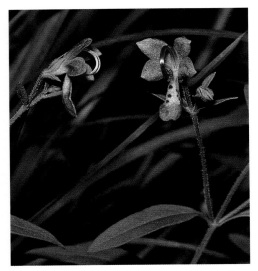

BLUE CURLS
Trichostema dichotomum
Mint Family (Lamiaceae)

Description: A much-branched, annual plant, up to 2' tall, with square stems, and covered with dense, gland-tipped hairs. The leaves are opposite, broadest in the middle to lower half, up to 2½" long and ¾" wide, with usually smooth margins, and tapering at the base to a short stalk about ½" long. The flowers are about ¾" long with the lower lip having a patch of white with purple spots. The 4 stamens are long and curve downward.

August—October

Habitat/Range: Woods, sand savannas, edge of fields; not common; scattered in Illinois.

Remarks: The attractive flowers with their lavender-blue corolla and long curving stamens must be viewed up-close to be appreciated.

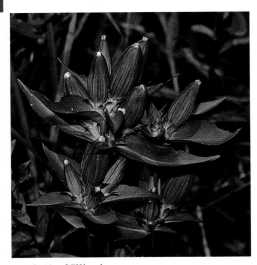

CLOSED GENTIAN
Gentiana andrewsii
Gentian Family (Gentianaceae)

Description: Unbranched stems up to 2½' tall, with stalkless leaves that are opposite along the stem. The upper leaves are usually the largest, up to 5" long and 1½" wide. The flowers occur in 1–3 clusters along the stem with leaf-like bracts below each cluster. Each flower is about 1½" long, deep blue, with petals that remain closed except for a tiny-fringed opening at the tip.

August—October

Habitat/Range: Moist woods, moist borders, prairies, fens; occasional in the north ½ of Illinois.

Remarks: Also known as "bottle gentian," for the shape of the flowers. A similar species, soapwort gentian, *Gentiana saponaria*, lacks the fringed tip on the flower and has leaves less than 1" wide. It occurs in sandy moist prairies and oak woodlands; occasional in the northeast counties; also Gallatin, Pope, and Randolph counties.

214

STIFF GENTIAN
Gentianella quinquefolia
Gentian Family (Gentianaceae)

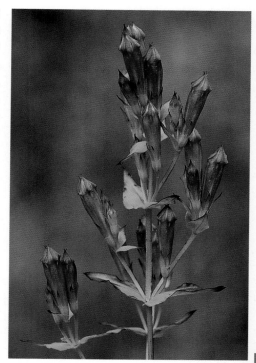

Description: Annual or biennial plants, up to 16" tall, with 4-sided stems, and several upper branches. The leaves are opposite, stalkless, up to 2½" long and 1" wide, broadest at the base and abruptly tapering to a pointed tip. The flowers are lilac to pale lavender-blue, tubular, upright, up to 1" long, and mostly closed at the top, with 5 bristle-tipped lobes.

August—October

Habitat/Range: Prairies, meadows, rocky wooded slopes; occasional in the north ⅔ of the state, also Harden County.

Remarks: Formerly known as *Gentiana quinquefolia*. Root tea was once used as a bitter tonic to stimulate digestion and weak appetite. Also used for headaches, hepatitis, jaundice, and constipation.

DOWNY GENTIAN
Gentiana puberulenta
Gentian Family (Gentianaceae)

Description: A plant with stout, unbranched stems, up to 12" tall, with shiny, pointed, opposite leaves. The leaves are without stalks, broadest toward the base, up to 2" long and 1" wide. The showy flowers are in dense clusters of 3–10. Each flower is deep blue to bluish purple, up to 1½" long and about as wide, with 5 spreading lobes.

August—October

Habitat/Range: Dry to moist prairies; occasional in the north ⅔ of Illinois, rare in the south ⅓.

Remarks: This is one of the last flowers to bloom in the fall, even surviving the first frosts. The Winnebagos and Dakotas took root tea as a tonic. The Mesquakies used the root to treat snakebite.

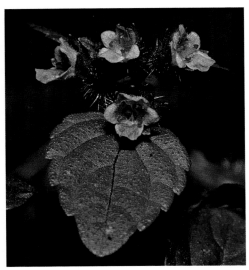

BEEFSTEAK PLANT
Perilla frutescens
Mint Family (Lamiaceae)

Description: An annual, up to 3' tall with coarse hairs along the 4-sided purple stem. Leaves are opposite, stalked, toothed along the margins, up to 4" long and 3" wide, and purple-green to entirely purple below with hairs along the veins. The flowers emerge along an expanding purple, hairy stalk, 6–10" long. The purple flowers are small, hairy, with a 3-lobed upper lip and a single-lobed lower lip.

August—October

Habitat/Range: Disturbed ground in low areas, especially along streams; native to Asia; common in the south ¼ of the state, less common northward.

Remarks: All parts of the plant are fragrant and have been used as a culinary herb by some Oriental cultures; also to treat a variety of ailments from diarrhea to morning sickness and various nervous conditions. Perilla oil is used in food products and also in making lacquers and finishes for wood. It is a less expensive substitute for linseed oil. The plant is named for the color of its leaves in the fall (not the taste!).

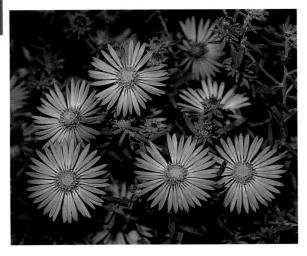

AROMATIC ASTER
Symphyotrichum oblongifolium
Aster Family (Asteraceae)

Description: Fragrant, hairy plants, up to 2½' tall, with spreading branches. The leaves are alternate, crowded, hairy, up to 3" long and less than 1" wide, with clasping bases and a rough surface. The flower heads are at the end of short branches, with numerous, small, leaf-like bracts along their length. Each flower head is 1" across and has 20–40 purple, petal-like ray flowers surrounding the yellow disk flowers.

August—November

Habitat/Range: Dry open woods, hill prairies, limestone glades; uncommon; scattered throughout the state.

Remarks: Formerly known as *Aster oblongifolius*. Aromatic aster takes on a shrub-like look with hundreds of attractive flowers when grown in the garden and given full sun. It continues to flower well after the first frost.

BLUE ASTER
Symphyotrichum anomalum
Aster Family (Asteraceae)

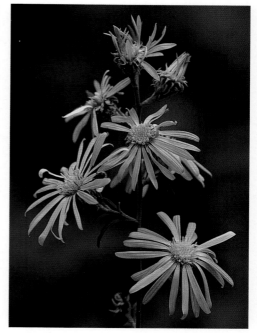

Description: Plants with stiff, erect stems, up to 4' tall. The leaves are alternate, the lower leaves lance-shaped, up to 3½" long and 1½" wide, heart-shaped at the base, with a wing of tissue along the leaf base. The upper leaves are lance-shaped, smaller, and without leaf stalks. The flower heads are ½" across, with numerous bracts at the base that curve downward. Each flower head has 30–45 bright lavender, petal-like ray flowers surrounding a yellow disk.

August—October

Habitat/Range: Dry woods; occasional in southwest Illinois, to Peoria and Woodford counties.

Remarks: Formerly known as *Aster anomalus*. Also called "woodland aster." The flowers and fruits of blue aster are eaten by wild turkey, and the leaves by white-tailed deer.

SMOOTH BLUE ASTER
Symphyotrichum laeve
Aster Family (Asteraceae)

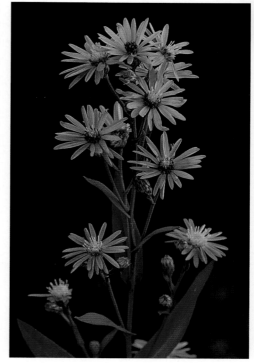

Description: Single-plants, up to 3' tall, with smooth leaves and a noticeable bluish green cast to the leaves and stem. The leaves at the base of the stem are rounded and stalked, with a leafy fringe along two sides of the leaf stalk. The stem leaves are alternate and somewhat clasp the stem. There are several flowers on long stalks at the upper end of the stem. The flower heads are ¾–1½" across, with up to 25 petal-like blue ray flowers surrounding a yellow disk.

August—October

Habitat/Range: Moist prairies, sandy soil in oak woodlands; common throughout Illinois.

Remarks: Formerly known as *Aster laevis*. The attractive silvery to bluish green stem and leaves contrasting with the numerous bluish-purple rays and yellow disks have accounted for the many cultivated garden varieties that have been developed from this aster.

217

STIFF-LEAVED ASTER
Ionactis linariifolius
Aster Family (Asteraceae)

Description: Plants with more than 1 stem emerging from a base, less than 2' tall, with stiff, roughish, minutely hairy leaves. The leaves are alternate, stalkless, narrow, up to 1½" long and ⅛" wide, and tapering to fine points. Several flowers are at the tops of stems on short individual stalks. Each flower head is up to 1¼" wide, with 10–15 satiny purple, petal-like ray flowers surrounding a yellow disk.

August—October

Habitat/Range: Savannas, sand prairies, sandy barrens; occasional in the north ½ of the state.

Remarks: Formerly known as *Aster linariifolius*. Also called "flax-leaved aster" and *Ionactis linariifolius*. Stiff-leaved aster is easily identified by its low stature, its crowded, stiff, narrow leaves, and its few to solitary flower heads.

NEW ENGLAND ASTER
Symphyotrichum novae-angliae
Aster Family (Asteraceae)

Description: Showy plants, with hairy branching stems, up to 6' tall. The leaves are alternate, numerous, up to 4" long and 1" wide, hairy, with pointed tips and leaves clasping the stem. Several flower heads are clustered along the upper stems. Each head is about 1½" across, with over 40 bright purple, petal-like ray flowers surrounding a yellow disk. The flowers can also be pinkish purple or pale lavender.

August—October

Habitat/Range: Moist or wet prairies, fens, pastures; common in the north ⅔ of Illinois, less common elsewhere.

Remarks: Formerly known as *Aster novae-angliae*. This aster is quite easily grown in gardens. The Mesquakie burned the plant and blew the smoke up the nose of an unconscious person to revive him or her. Other tribes used root tea for diarrhea and fevers.

SILKY ASTER
Symphyotrichum sericeum
Aster Family (Asteraceae)

Description: Attractive plants with widely branching stems, up to 2½" tall. The leaves are alternate, somewhat stiff, up to 1¾" long and ½" wide, with soft silky hairs that lie flat on both sides of the leaves giving them a silvery green color. Numerous flower heads are in an open cluster at the tops of stems. Each flower head is about 1¼" across, with 15–30 violet-purple, petal-like ray flowers surrounding a yellow disk.

August—October

Habitat/Range: Dry prairies, sandy woodlands; occasional in the north ½ of the state, rare or absent elsewhere.

Remarks: Formerly known as *Aster sericeus*. Silky aster is very attractive with its violet-purple rays contrasting intensely with the silvery white foliage.

SKY BLUE ASTER
Symphyotrichum oolentangiense
Aster Family (Asteraceae)

Description: This species has rough, slightly hairy stems, up to 3' tall. The leaves are alternate, thick, sandpapery on both sides, and lack teeth along the margins. The basal leaves have long stalks and heart-shaped leaf bases and are lance-shaped and up to 5" long and 2" wide. The stem leaves are much smaller and lack stalks. The flower heads are in spreading clusters at the tops of stems. Each head is about 1" across, with 10–25 blue petal-like ray flowers surrounding a yellow disk.

August—November

Habitat/Range: Prairies, savannas, woods; not common; in the south ½ of the state.

Remarks: Formerly known as *Aster oolentangiensis* and *Aster azureus*.

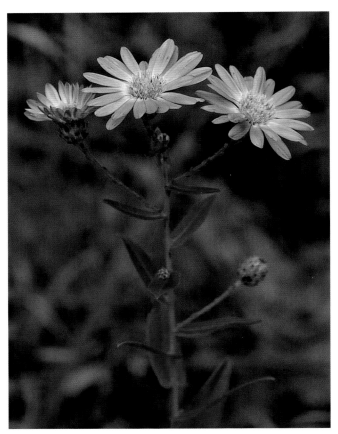

SPREADING ASTER
Symphyotrichum patens
Aster Family (Asteraceae)

Description: This plant has slender, hairy, somewhat brittle stems, up to 2½' tall. The leaves are alternate, sandpapery, hairy, lance-shaped, up to 2" long and 1" wide, with bases clasping the stem. The flower heads are single on branches arising from the leaf axils. Each head is about 1" across, with about 15–25 blue, petal-like ray flowers surrounding a yellow disk.

August—October

Habitat/Range: Open woods; occasional in the south ⅓ of the state.

Remarks: Formerly known as *Aster patens*. Spreading aster is one of 38 species of the genus Aster that occur in Illlinois.

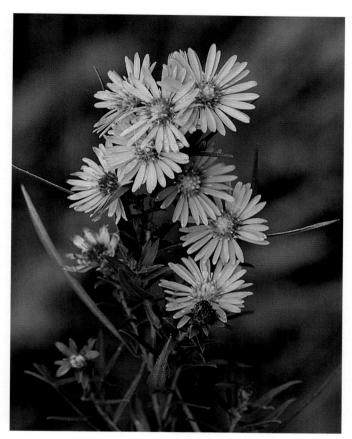

WILLOW ASTER
Symphyotrichum praealtum
Aster Family (Asteraceae)

Description: Plants up to 5' tall, often growing in dense colonies. The leaves are alternate along the stem, up to 5½" long, about ¾" wide, with the lower surface having conspicuous net-shaped veins. Numerous flowers are clustered in a pyramid-like column near the top. The flower heads are about 1" wide, with pale lavender petal-like ray flowers surrounding a small yellow disk.

September—October

Habitat/Range: Moist places including wet prairies, moist open woods, and open thickets; occasional in the north ½ of Illinois.

Remarks: Formerly known as *Aster praealtus*. Willow aster is named for its long, linear, willow-like leaves. The species name *praealtus* means "very tall."

Green Flowers

This section includes green flowers
and flowers that have a greenish cast.
Since green flowers grade into white flowers,
that section should also be checked.

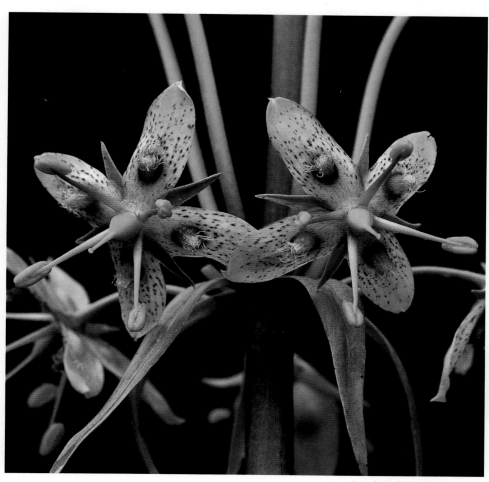

American Colombo, page 227

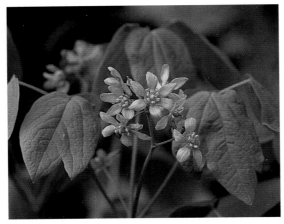

BLUE COHOSH
Caulophyllum thalictroides
Barberry Family (Berberidaceae)

Description: A low, spreading plant from 1–2' tall with one large leaf that is divided into many small leaflets and a smaller many-divided leaf just below the flowers. The leaflets are 1–3" long, smooth, and irregularly lobed above the middle. The flower clusters arise above the leaves on 1–2 stalks, with 6 yellowish-green, petal-like sepals. The six gland-like petals are inconspicuous. The round fleshy fruit is a deep iridescent blue.

April—May

Habitat/Range: Moist woods; occasional throughout the state.

Remarks: Cohosh is an Algonkin word meaning "rough," referring to the rhizome with its many old stem scars. A root tea was used extensively by North American Indians to aid in labor, treat menstruation, abdominal cramps, urinary tract infections, lung ailments and fevers. It is a folk remedy for rheumatism, cramps, epilepsy, and inflammation of the uterus.

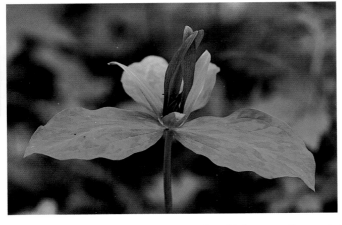

GREEN TRILLIUM
Trillium viride
Lily Family (Liliaceae)

Description: Unbranched plants, up to 20" tall, with a whorl of 3 leaves at the top of a stout, smooth stem. The leaves are attached to the stem without stalks, are smooth, lance-shaped, up to 5" long, and 2½" wide, with the upper surface green and often mottled. The flowers arise directly from the stem, with the 3 green sepals widely spreading and the 3 yellow-green to purple-green petals upright, each up to 3" long. The purple stamens are also upright.

April—May

Habitat/Range: Moist woods, prairies; classified as state endangered; Adams, Jackson, Macoupin, Perry, Pike, Union, and Williamson counties.

Remarks: Green trillium closely resembles sessile trillium, *Trillium sessile*, but the former is twice as large (about 20" tall), and its petals are twice as long (about 3" in length). There are 9 species in the genus *Trillium* in Illinois.

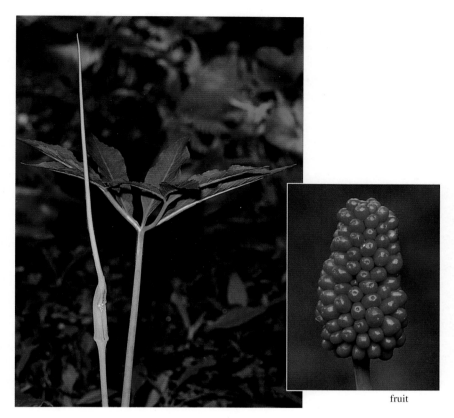

fruit

GREEN DRAGON
Arisaema dracontium
Arum Family (Araceae)

Description: A single, highly dissected leaf with deep, narrow lobes is attached to a smooth green stalk, up to 3' tall. The leaf is divided into 5–15 segments; each segment is lance-shaped, up to 10" long and 4" wide, smooth, and lacking teeth along the margins. The flower branches off the leaf stalk near the base. The flowers are wrapped in a tubular green sheath called a *spathe*. Inside the *spathe*, the flowers are crowded together along a column called a *spadix* and at the top emerges a green, tail-like, cylindrical column, up to 7" long. In the fall, a cluster of shiny orange-red fruit is arranged along a thick head.

April—June

Habitat/Range: Moist woods; common; probably in every county.

Remarks: Native American Indians first dried the bulb-like corm and used it for food. Fresh corms, however, contain calcium oxalate crystals, which cause intense burning in the mouth and throat.

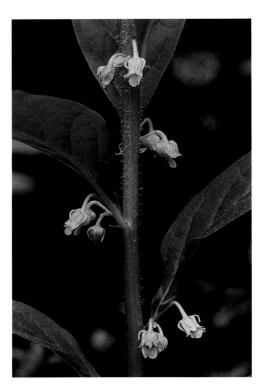

GREEN VIOLET
Hybanthus concolor
Violet Family (Violaceae)

Description: Hairy, unbranched plants, up to 2' tall, often in large colonies. The dark green leaves are alternate, hairy, lance-shaped, up to 4" long and 1¼" wide, tapering at both ends, and usually lacking teeth along the margins. There are 1–3 flowers arising from the leaf axils. Each flower is about ⅜" long, green, attached to a drooping stalk, with 5 green, narrow sepals and 5 greenish white petals. One petal is wider than the others and swollen at the base.

April—June

Habitat/Range: Moist woods; somewhat common; scattered across the state but absent in the northwest part.

Remarks: Although belonging to the violet family, this plant looks nothing at all like any of the 29 species of violets in Illinois.

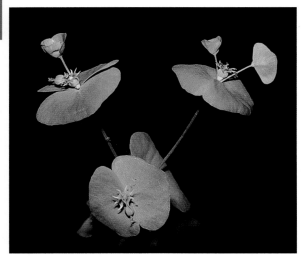

WOOD SPURGE
Euphorbia commutata
Spurge Family (Euphorbiaceae)

Description: Several stems may arise from the base, up to 16" tall, with milky sap and light green leaves. The leaves are alternate, stalkless, smooth, oval, and rounded at the tip. The leaves just below the flowers are often joined at the base. The tiny flowers are nested in a cup of small leaves.

April—July

Habitat/Range: Wooded slopes, along streams, and in gravelly soils; rare; mostly in the north ⅓ of the state, also Pope County.

Remarks: There are 13 species in the genus *Euphorbia* that occur in Illinois.

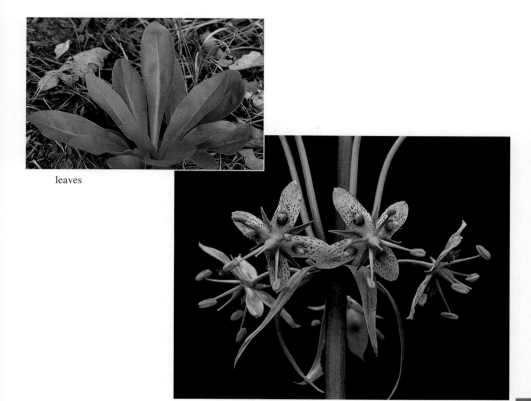

leaves

AMERICAN COLUMBO
Frasera caroliniensis
Gentian Family (Gentianaceae)

Description: Stiff, smooth plants, with single purple stems, up to 8' tall. The large leaves are whorled at the base and along the stem, broadest at the tip, narrowing towards the stem, and up to 16" long. The whitish-green flowers are in a large cluster at the top of the stem. Each flower is up to 1" across, with brownish-purple dots and a large gland on each of the 4 petals.

May—June

Habitat/Range: Moist woods, sandy woods; occasional in the south ½ of Illinois; also Cook and DuPage counties.

Remarks: Also known as *Swertia caroliniensis*. The plant produces large basal leaves for several years before sending up a flowering stem. After blooming, the plant dies and spreads its seed to begin new plants. A root tea was formerly used for colic, cramps, dysentery, diarrhea, stomachaches, lack of appetite, nausea, and as a general tonic.

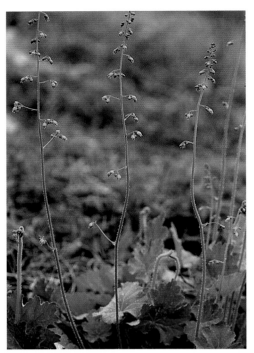

PRAIRIE ALUMROOT
Heuchera richardsonii
Saxifrage Family (Saxifragaceae)

Description: Hairy plants with tall, leafless, flowering stalks, up to 2½' high, arising from a base of long-stalked leaves. The leaves are round, up to 3½" across, with shallow lobes and toothed edges, and a heart-shaped leaf base. Small flowers are arranged along the top half of a long flowering stem. The flowers are somewhat bell-shaped and droop on individual short stalks that branch from the main flower stalk. Each flower is up to ½" long, with 5 green sepals and 5 spatula-shaped petals that vary from pale green to white to lavender. The stamens are tipped with brilliant orange and extend beyond the petals.

May—July

Habitat/Range: Prairies, open woods; occasional in the north ¾ of the state, absent in the south ¼.

Remarks: Native American Indians and early settlers used a root powder as an astringent to close wounds and to treat diarrhea and sore throats. The Mesquakie used the leaves as a dressing for open sores. A similar species, tall alumroot, *Heuchera americana*, has smaller flowers, about half the size, and is found in dry woods; occasional in the south ½ of the state, also Jo Daviess County.

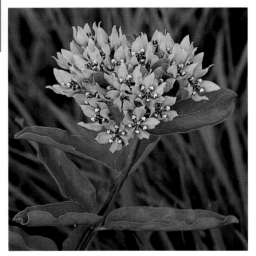

GREEN-FLOWERED MILKWEED
Asclepias viridis
Milkweed Family (Asclepiadaceae)

Description: A large, somewhat sprawling plant, up to 2' tall, with thick stems and milky sap. The leaves are alternate, fleshy, up to 5" long and 2" wide, with wavy margins. The flowers appear in a large cluster, up to 5" across, at the top of the stem. Each flower is up to 1" across, with 5 green petals spread upward. Inside the flower are 5 purple structures called *hoods*. The seedpods are up to 6" long and 1" thick, with each seed tipped with a tuft of long white hairs.

May—July

Habitat/Remarks: Prairies; occasional in the south ⅓ of the state.

Remarks: Also called "spider milkweed," it has the largest flowers of the 19 species of milkweeds known to occur in Illinois.

GREEN MILKWEED
Asclepias viridiflora
Milkweed Family (Asclepiadaceae)

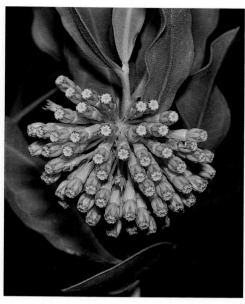

Description: Plants with unbranched, hairy stems, up to 2' tall, with milky sap and opposite leaves. The leaves are thick and vary from narrow to broadly oval, up to 5" long and 2½" wide, with wavy margins. There are from 1 to several dense flower clusters arising from the leaf margins. Each greenish flower is about ½" long, with 5 petals bent backwards and 5 structures called *hoods*. The smooth, narrow seedpods are up to 6" long and 1" wide.

May—August

Habitat/Range: Prairies, sandy and gravelly soils, old fields; common throughout Illinois.

Remarks: Formerly known as *Acerates viridiflora*. The Lakota gave the pulverized roots to children with diarrhea. The Blackfeet chewed the root to relieve sore throat and also applied the root to swellings and rashes.

TALL GREEN MILKWEED
Asclepias hirtella
Milkweed Family (Asclepiadaceae)

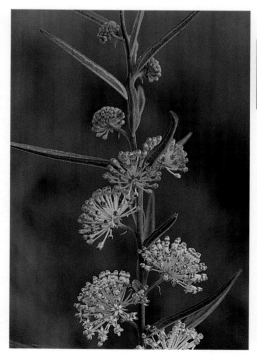

Description: Stout-stemmed plants, up to 3' tall, with milky sap. The leaves are mostly alternate, hairy, and narrow, up to 6" long and 1" wide, with pointed tips. Several flower clusters arise on stalks from the upper leaf axils. Each flower is up to ½" long and pale greenish, with 5 petals bent backwards and sometimes white-tinged or purple-tipped, with 5 green structures called *hoods*. The seedpods are smooth, slender, and up to 4" long and 1" thick.

May—August

Habitat/Range: Prairies, old fields; occasional throughout Illinois.

Remarks: Formerly *Acerates hirtella*. Although not as showy as some of the other milkweeds, this tall, narrow-leaved milkweed casts a stately appearance.

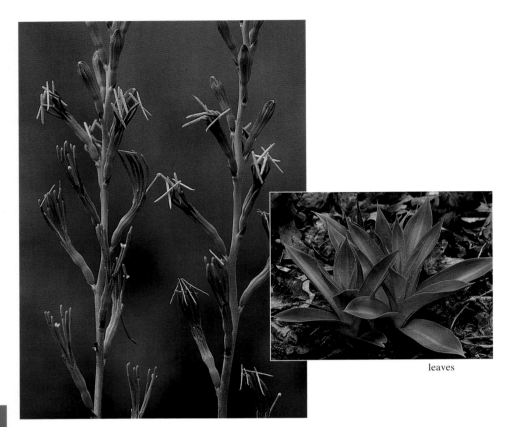

leaves

AMERICAN AGAVE
Manfreda virginica
Agave Family (Agavaceae)

Description: Tall, smooth, slender plants, up to 6' in height, with fleshy, dark green leaves at the base. The basal leaves are thick, smooth, and succulent, up to 16" long and 2" wide, pointed at the tip, and often purple-blotched across the surface. The stem leaves are much reduced in size. The flowers are arranged along a long spike at the top of a wand-like stem. Each green, tubular flower is about 1" long, with large, green to brown stamens extending well beyond the flower.

May—July

Habitat/Range: Sandstone outcrops and glades, dry woods; occasional; restricted to the south ¼ of Illinois; also Jersey County.

Remarks: Also called "false aloe" and formerly known as *Agave virginica* and *Polianthes virginica*. The flowers are fragrant, similar to Easter lilies. Native Americans used a root tea for dropsy and a wash for snakebites.

GIANT RAGWEED
Ambrosia trifida
Aster Family (Asteraceae)

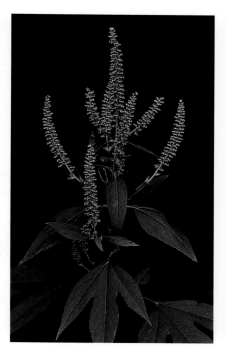

Description: A branched, hairy, annual plant, up to 15' tall, sometimes forming dense stands in disturbed sites. The leaves are opposite, stalked, deeply 3-lobed, rough, toothed along the margins, with the lower leaves up to 12" across. The upper leaves are unlobed and smaller. The flowers are arranged on long stalks with the pollen-producing male flowers much more numerous than the female flowers, which are nearly hidden in leaf axils.

July—October

Habitat/Range: Moist soils in low woods, along floodplains and streams, fields, disturbed sites, and along roadsides; common; in every county.

Remarks: The seed of giant ragweed has been found in several archaeological sites where it is thought to have been cultivated as a food source. The seeds are an important food for wildlife. Ragweed pollen is a major contributor to hay fever. Another species, common ragweed, *Ambrosia artemisiifolia*, is up to 2½' tall with leaves divided into numerous small leaflets; found in disturbed soil; common; in every county.

POKEWEED
Phytolacca americana
Pokeweed Family
(Phytolaccaceae)

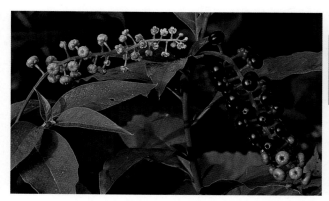

Description: Tall, smooth, red-stemmed plants, up to 10' in height. The leaves are smooth, up to 12" long and 3" wide, with long stalks. The small, greenish-white flowers are arranged along a long stalk with each flower individually stalked. The flowers are about ¼" across, lack petals but have 5 greenish sepals and from 5–30 stamens. The purple to black berries have a juice that stains.

June—October

Habitat/Range: Disturbed soil in woods, fields, farm lots, and around dwellings; common throughout the state.

Remarks: Also called "pokeberry." The leaves of young plants are cooked and served as "poke salad." The purple juice has been used for coloring foods such as frostings, candies, and beverages, and also as a red dye and ink. The root and stem are poisonous. The berries are quickly eaten by birds.

Brown Flowers

This section includes brown flowers that grade into maroon.
Brown flowers may also grade into green,
so that section should also be checked.

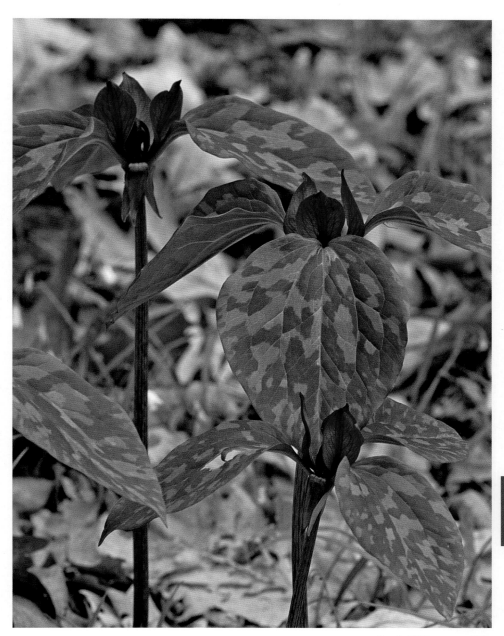

Purple Trillium, page 237

SKUNK CABBAGE
Symplocarpus foetidus
Arum Family (Araceae)

Description: Plants with foul-smelling flowers and large cabbage-like leaves that grow up to 20" long. The large leaves emerge from the base near the end of flowering; have heart-shaped bases, and a network of connected veins. The flowering part has a short stalk and a green to purplish-brown pointed hood, called a *spathe*, 3–6" long that encloses a dense cluster of flowers. The cylindrical, fleshy column, called a *spadix*, has tiny male flowers at the top and small, greenish-yellow female flowers below. There are no petals or sepals. The fruits are bright scarlet and about ⅜" thick.

February—March

Habitat/Range: Wet woods, swamps, seepy areas, often forming large colonies; occasional in the north ¾ of the state.

Remarks: Being one of the first to flower in the spring, skunk cabbage can produce enough heat while growing to melt through snow. The flowers produce a rotting smell that attracts early-season scavengers such as carrion flies for pollination. North American Indians used the root for cramps, convulsions, whooping coughs, and toothaches. Early physicians used the root as an antispamodic for epilepsy, spasmodic coughs, and asthma; externally in lotion for itching, rheumatism; a diuretic; and emetic in large doses. Today, the roots are considered toxic and eating the leaves can cause burning and inflammation.

SPRING CORAL-ROOT ORCHID
Corallorhiza wisteriana
Orchid Family (Orchidaceae)

Description: Single-stemmed, brown to purplish, up to 16" tall and lacking green color. Leaves are reduced to 3 alternating, sheathing scales along the stem. There are 5–25 purplish-brown flowers. The flower lip is white with purple spots and a wavy margin.

March—May

Habitat/Range: Moist woods; scattered in the south ½ of Illinois; also LaSalle County.

Remarks: Orchids in the genus *Corallorhiza* have coral-shaped roots as the name implies. Lacking green, the plants must obtain their nutrients from decaying organic matter.

fruit

JACK-IN-THE-PULPIT
Arisaema triphyllum
Arum Family (Araceae)

Description: This plant has a leaf divided into 3 leaflets, which is attached to a smooth green stalk, up to 18" tall. Each leaflet is lance-shaped, smooth, up to 7" long, and lacks teeth along the margins. The flower stalk branches off from the leaf stalk near the base. The flowers are wrapped in a tube-like green sheath called a *spathe,* which folds over at the top. The underside of the hood or flap is typically brown with white stripes. Inside the spathe the flowers are crowded together along the lower end of a cylindrical brown or green column called a *spadix.* In the fall, a cluster of shiny orange-red fruit is arranged along a thick head.

April—May

Habitat/Range: Moist woods; common in every county.

Remarks: The Chippewas used the bulb-like underground stem, called a *corm,* to treat sore eyes, and the Pawnee applied a powder made from the corm to the head or temples for headache. The corm was also used to treat snakebite, ringworm, stomach gas, rheumatism, and asthma; and it was also boiled or baked for food. If eaten raw, however, the corm's calcium oxalate crystals render it poisonous.

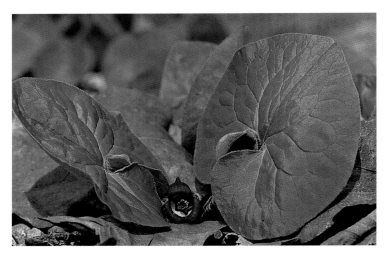

WILD GINGER
Asarum canadense
Birthwort Family (Aristolochiaceae)

Description: A low-growing plant, up to 6" tall, with 2 leaves emerging on hairy stalks from the base. The dark green leaves are round, heart-shaped, as much as 7" across when fully grown, hairy, and leathery with a shiny surface. A single reddish-brown flower, up to 1" across, emerges from the base of the 2 leaves on a hairy stalk. The flower is bell-shaped, lacks petals, but has 3 pointed sepals that curve backwards.

April—May

Habitat/Range: Moist woods; sometimes forming dense colonies; common throughout the state.

Remarks: The Mesquakie considered the root of wild ginger to be one of the most important native seasonings. They also thought its use eliminated danger of poisoning when eating an animal that had died of unknown causes. They also chewed the root and spit it upon bait to improve the chances of catching fish. Settlers used the root as a spice substitute for tropical ginger. In frontier medicine it was used for the treatment of several ailments.

PURPLE TRILLIUM
Trillium recurvatum
Lily Family (Liliaceae)

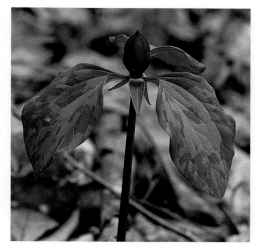

Description: Unbranched, stout-stemmed plants, up to 18" tall, with a whorl of 3 leaves at the top. The leaves are broadest in the middle and tapering at both ends, up to 4" long, smooth, and mottled on the surface. The bases of the leaves are stalked. The single flower is attached to the top of the stem without a stalk. The 3 green sepals are curved down, while the 3 reddish-brown (sometimes yellow) petals are upright and surround the 6 stamens.

April—May

Habitat/Range: Moist woods; common; in every county.

Remarks: Also called "purple wake robin." Several North American tribes used the root to treat open wounds and sores, menstrual disorders, menopause, and internal bleeding; to induce childbirth; and as an aphrodisiac. Frontier physicians used the crushed fresh leaves to treat snakebites, stings, and skin irritations.

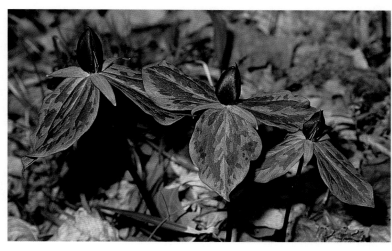

SESSILE TRILLIUM
Trillium sessile
Lily Family
(Liliaceae)

Description: Plants with smooth, stout stems, up to 10" tall, with a whorl of 3 leaves at the tip. The leaves are oval, rounded or pointed at the tip, rounded at the base, smooth, up to 4" long, without stalks, and usually mottled on the surface. A single stemless flower arises just above the leaves to 1½" long. The 3 green sepals are spreading and up to 1" long, while the 3 purplish-brown petals point upwards enclosing the 6 stamens.

April—May

Habitat/Range: Moist woods; occasional; scattered throughout Illinois.

Remarks: Also called "sessile wake robin." The term "sessile" refers to the leaves lacking stalks. Sessile trillium has had much the same uses as purple trillium.

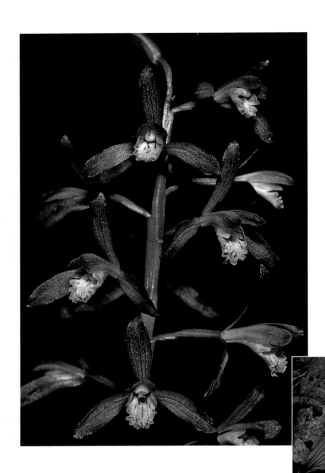

leaf

PUTTY ROOT ORCHID
Aplectrum hyemale
Orchid Family (Orchidaceae)

Description: This orchid has a leafless stem, up to 1½' tall, and produces one leaf, emerging from the root, that withers away by flowering time. The evergreen leaf appears from September through early May. The leaf is broadest at the middle and narrowing at both ends, up to 6" long and 3" wide, blue-green, and strongly ribbed or pleated. The flowers are stalked and attached along the upper 8" of the stem. Each greenish-maroon flower is about ½" long, with 3 sepals and 3 petals. The lower petal is a 3-lobed lip with a wavy edge.

May—June

Habitat/Range: Moist woods; occasional; scattered throughout Illinois.

Remarks: The name for putty root is derived from the sticky juice from the corm (bulblike underground structure), which was once used to glue broken pottery. Another common name, Adam-and-Eve, comes from the plant's production of a new corm every year that is connected by a slender branch to the old one. Native American Indians mashed the corm and applied it to boils. Root tea was formerly used for bronchial troubles.

TWAYBLADE ORCHID
Liparis liliifolia
Orchid Family (Orchidaceae)

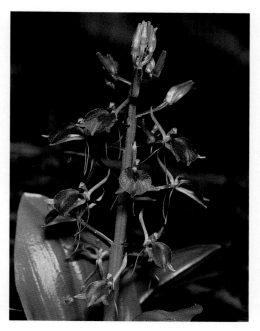

Description: A smooth, hairless plant, from 4–8" tall, with a pair of glossy green leaves arising from the base. Sterile plants have a single leaf. The leaves are broadest at or below the middle, about 4" long and 3" wide, with smooth margins and parallel veins. The flowers are purplish-brown, from 5–20, with a broad, showy lip that is somewhat translucent, about ⅜" long, and pointed at the tip. Two thread-like petals hang below the lip.

May—July

Habitat/Range: Moist woods; occasional; scattered throughout Illinois.

Remarks: Also called "purple twayblade," it is closely related to Loesel's twayblade, *Liparis loeselii*, with a yellowish lip less than ¼" long and yellowish lateral petals; found in wetland habitats of low woods, seep springs, bogs; rare; restricted to the north ½ of the state.

COMMON HORSE GENTIAN
Triosteum perfoliatum
Honeysuckle Family (Caprifoliaceae)

Description: Stems with gland-tipped hairs, up to 3' tall, with dark green, thick leaves that encircle the stem. The hairy leaves are opposite, stalkless, up to 10" long, broadly lance-shaped, with those in the middle of the stem distinctly fiddle-shaped. The flowers emerge at the leaf axils on short stalks. Each cluster typically has 3–4 purplish-brown flowers that are tubular, up to ¾" long, with 5 overlapping petals. The fruit resembles little oranges in color and shape.

May—July

Habitat/Range: Dry open woodlands, thickets, fencerows; occasional in the north ⅔ of the state, less common in the south ⅓.

Remarks: Native American Indians made a tea of this plant for treating fevers. The roots were mashed and applied to painful swellings. The Pennsylvania Dutch collected the orange fruits and dried the seeds, then roasted and ground them as a coffee substitute. Another species, early horse gentian, *Triosteum aurantiacum* var. *illinoense*, has hairs without gland tips and leaf bases that narrow and do not encircle the stem; dry open woods; occasional throughout the state. Yellow-flowered horse gentian, *T. angustifolium*, has yellow flowers and leaves up to 6" long that are narrowed at the base but do not encircle the stem; low ground, rocky woods; not common; restricted to the south ½ of Illinois.

239

leaves

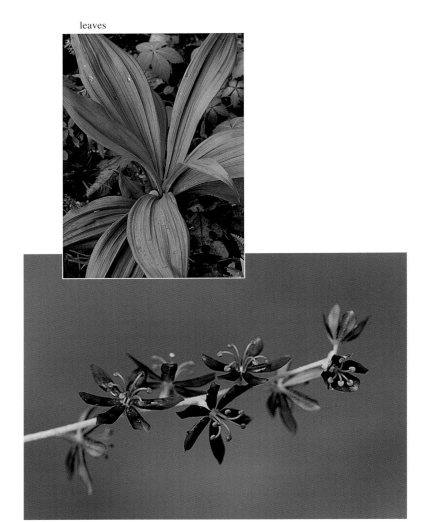

FALSE HELLEBORE
Veratrum woodii
Lily Family (Liliaceae)

Description: Plants with long slender stems, up to 6' tall, with ribbed or pleated basal leaves. The basal leaves are broadest at the middle and tapering at both ends, up to 12" long and about 3" wide, and somewhat clasping the stem. The stem leaves are few and narrow. The upper stem is widely branched, hairy, with several flowers on short stalks. Each flower has 5 purplish-brown petals up to ¾" across.

July—August

Habitat/Range: Moist woods; rare; restricted to a few central counties.

Remarks: Also called *Melanthium woodii*. It is a perennial that can go for several years without flowering. All parts of the plant are considered highly toxic. Most grazing animals avoid the plant because of its sharp burning taste. A similar species has been used in pharmaceutical drugs to slow the heart rate, lower blood pressure, and to treat arteriosclerosis.

LATE FIGWORT
Scrophularia marilandica
Figwort Family (Scrophulariaceae)

Description: A stout, square-stemmed plant, up to 7' tall, with multiple branches. The leaves are opposite, long-stalked, lance-shaped, up to 6" long and 3" wide, with teeth along the margins. The tiny flowers are in a loose cluster. Each flower is shaped like a scoop, with 2 brown lips, the upper lip larger and forming the scoop.

July—October

Habitat/Range: Low moist woods; occasional throughout Illinois.

Remarks: Also called "carpenter's square," for the grooved, 4-angle stem. Native American Indians used root tea to treat fevers and piles, and as a diuretic and tonic. It is also a folk remedy for treating sleeplessness in pregnant women, restlessness, anxiety, and cancer. Another species, early figwort, *Scrophularia lanceolata*, has leafy flaps along the leaf stalk and flowers May—June; found in woods, fencerows; occasional in the north ½ of the state, rare in the south ½.

FALL CORAL-ROOT ORCHID
Corallorhiza odontorhiza
Orchid Family (Orchidaceae)

Description: Single-stemmed, brown to purplish, up to 1' tall and lacking green color. Leaves are reduced to 3 alternating, sheathing scales along the stem. There are 5–15 flowers that alternate along the stem. Each small purplish-brown flower has a conspicuous lower lip that is white with small purple dots and crinkled along the margin.

August—October

Habitat/Range: Woods; uncommon; scattered throughout the state.

Remarks: Also called "autumn coral-root orchid," this is one of the smallest-flowered orchids in Illinois. A similar species, spotted coral-root orchid, *Corallorhiza maculata*, has two lateral lobes on the lip; flowers from June—August; found in moist woods; classified as state threatened; limited to the north ¼ of the state.

241

Selected Reading

Foster, Steven, and James A. Duke. 1990. *A Field Guide to Medicinal Plants.* New York: Houghton Mifflin. *Provides illustrations and descriptions of medicinal plants and their uses.*

Kaye, Connie, and Neil Billington. 1997. *Medicinal Plants of the Heartland.* Vienna, Ill.: Cache River Press. *Provides illustrations and descriptions of medicinal plants and their uses.*

Kindscher, Kelly. 1987. *Edible Wild Plants of the Prairie.* Lawrence: University Press of Kansas. *Discusses many edible plants and their preparation, use, and history.*

Kindscher, Kelly. 1992. *Medicinal Wild Plants of the Prairie.* Lawrence: University Press of Kansas. *Discusses many medicinal plants and their historic uses.*

Ladd, Doug, and Frank Oberle. 2005. *Tallgrass Prairie Wildflowers*. 2nd ed., Guilford, Connecticut: Falcon Guide, Globe Pequot Press. *A field guide that can be used in the prairie region of Illinois.*

McFall, Don, and Jean Karnes, Editors. 1995. *A Directory of Illinois Nature Preserves, 2 Vols.* Springfield: Illinois Department of Natural Resources. *An invaluable guide to the Illinois Nature Preserves; including a topographic map, county map, directions, and descriptions of each preserve.*

Mohlenbrock, Robert H. 2002. *Vascular Flora of Illinois*. Carbondale: Southern Illinois University Press. *A technical field guide with keys and information on plant distribution and frequency in the state.*

Peterson, Lee Allen. 1977. *A Field Guide to Edible Wild Plants*. New York: Houghton Mifflin. *Provides illustrations and descriptions of edible plants and their preparation and uses.*

Swink, Floyd, and Gerould Wilhelm. 1994. *Plants of the Chicago Region.* 4th ed., Indianapolis: Indiana Academy of Science. *A list of the plants of the Chicago Region with keys and notes on local distribution.*

Fire Pink, page 139

Index

248

253

About The Author

After completing masters' degrees in botany and zoology from Southern Illinois University, Carbondale, Don Kurz spent the next 30 years working to inventory, acquire, protect, and manage natural areas, endangered species sites, and other special features. Growing up in Illinois, some of his early jobs included working for the Illinois Environmental Protection Agency, the Illinois Natural Areas Inventory, and the Natural Land Institute. Later, he was employed by the Missouri Department of Conservation, where he held various supervisory positions in the Natural History Division, including that of Natural History chief.

For over 40 years, Don has been writing about nature and photographing landscapes, wildlife, and plants. His work has appeared in several calendars and magazines and in numerous wildflower books including *Tallgrass Prairie Wildflowers* and *North Woods Wildflowers*. He is also the author of *Ozark Wildflowers*, *Scenic Driving the Ozarks*, *Trees of Missouri*, *Trees of Missouri Field Guide*, *Shrubs and Woody Vines of Missouri*, *Shrubs and Woody Vines of Missouri Field Guide*, *Arkansas Wildflowers*, *Missouri Natural Wonders Guidebook*, *Prairie Wildflowers*, and *Wildflowers of the Midwest*.

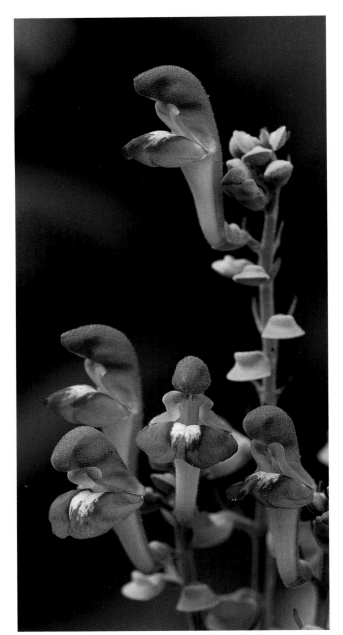

Downy Skullcap, page 202

To order individual copies of this guidebook, or for dealer information, contact:

Tim Ernst Publishing
www.TimErnst.com